AN ILLUSTRATED DICTIONARY
OF
NARRATIVE PAINTING

AN ILLUSTRATED DICTIONARY
OF
NARRATIVE PAINTING

ANABEL THOMAS

JOHN MURRAY
in association with
NATIONAL GALLERY PUBLICATIONS, LONDON

© Anabel Thomas 1994

First published in 1994
by John Murray (Publishers) Ltd,
50 Albemarle Street, London W1X 4BD
in association with National Gallery Publications, London

The moral right of the author has been asserted

A catalogue record for this book is available from the British Library

Cased ISBN 0 7195 5289 3
Paper ISBN 0 7195 5290 7

Typeset in 11/12pt Minion by Wearset, Boldon, Tyne and Wear
Printed and bound in Great Britain by
Butler & Tanner Limited, Frome and London

To J.H.H.

Contents

Introduction *ix*

Using this Dictionary *xvii*

Greek and Roman Deities *xviii*

Acknowledgements *xix*

The Dictionary *1*

Select Bibliography *251*

Index *257*

Introduction

THERE are many kinds of painting in Western European art: portraiture, landscape, genre, still life, the religious image, narrative and, more recently, abstract art. This book, based on the National Gallery collection in London, is concerned with those paintings which tell or recall a story. The National Gallery is a particularly rich source for a dictionary of this kind, since many of its paintings contain religious, mythological and historical subject matter in narrative form.

The paintings described in this dictionary were produced by Western European artists between the twelfth and the nineteenth century. Throughout this period artists drew on three main sources for their narrative subjects: the Bible, other religious texts which expand the stories of the Bible and describe the lives of the saints, and classical mythology. Myths, legends, history and stories are all closely connected. As people these days are less familiar with these narrative sources, it has become necessary to explain the stories behind the images.

Depictions of Old Testament stories and of the Life and Passion of Christ have a long lineage in the history of Western art. They played an essential role in the religious life of the community. In 1492 the Dominican theorist Michele da Carcano promoted narrative images as a means of instructing unlearned people who were unable to read. They not only aroused devotion in those who were not inspired by reading but also provided a potent reminder for people already acquainted with the Bible.

Michele da Carcano was not the first to extol the power of narrative art. Nine centuries earlier, in the sixth century, Pope Gregory I described the benefits of harnessing an image in the service of the text. Serenus, Bishop of Marseilles at that time, had ordered all the religious images to be taken out of the churches so that people would be encouraged to concentrate on the words of the clergy and the texts themselves. In a letter to Serenus, Gregory argued that the image often took the place of the text. 'It has come to our notice that you, brother, seeing certain worshippers of images, broke up and threw away these same images. We commend you, indeed, for your zeal, lest anything made with human hands be worshipped, but we suggest that you ought not to have broken these images. For a picture is introduced into a church so that those who are ignorant of letters may at least read by looking at the walls and seeing there what they cannot read in books.'

The Renaissance theorist Alberti took up Pope Gregory's theme. According

to Alberti, the best kind of image was one that 'captures the eye of whatever learned or unlearned person is looking at it and moves his soul'. Leon Battista Alberti – son of an old Florentine family, long exiled from Florence – had been so impressed on returning to his native city in the late 1420s by the renewal of the arts there that he set about writing a book, *Della Pittura* – the art of painting. *Della Pittura* (first produced in Latin in 1435 and then in Italian in 1436) includes much practical information on the art of making images, from the art of measurement to the treatment of colour. However, a large part of the text concentrates on the art of telling stories.

The main difficulty the painter faces with narrative painting is how to convey a story (which, by its nature, consists of a sequence of incidents) in a single image or, at the most, in a small number of stills. Clearly the problem is more easily solved if the painter can assume that those looking at the painting are familiar with the story. It is no coincidence that most narrative paintings of the period covered by this book portray stories that would have been well known at the time, and that as general knowledge of these stories diminished towards the end of the period, narrative painting moved towards historical subjects.

Individual entries in this dictionary discuss the different ways in which painters of narrative have solved the problem of telling a story. Over the centuries painters have used many different techniques.

In one technique, the painter may, like the strip cartoonist, present a number of images or 'stills'. Wall paintings or frescoes have often employed this method. Individual stills develop the story, using figures, architecture and landscape background to inform us about the people involved in the story and the place or places in which the narrative is unfolding.

Giotto's frescoes in the Arena chapel in Padua show in one still the Annunciation of the Angel to St Anna, who is on her knees in prayer, of the birth of her child, the Virgin Mary, and in another the birth scene, where the same figure of St Anna is shown, but this time in bed. These two stills tell an elaborate tale. The second advances the action several months in time, and as we look at the birth scene we anticipate further episodes in the story. Jacopo da Voragine's *The Golden Legend* describes the early life of the Virgin in great detail. Giotto was clearly familiar with the text, and attended closely to da Voragine's descriptions. Thus as we witness the elderly mother stretching out to take her baby, we remember that before long the young child will be dedicated by her grateful parents to service in the Temple.

A variation of this cartoon technique, which many late medieval painters used, involved simultaneous or sequential action taking place within the same still. In Giotto's scene of the birth of the Virgin there are a number of people who bring gifts to the mother and prepare to wash her newborn child. Yet in the same still the baby is being offered, washed and swaddled, to her proud mother. This is known as sequential narrative. The same person appears more than once in the same still, yet we understand through the actions of the people that we are witnessing two different scenes and therefore different moments of time.

Several paintings in the National Gallery contain sequential narrative. In the

predella painting by Duccio entitled *Jesus opens the Eyes of a Man born Blind* [*see* Christ: Ministry – 8], the figure of the blind man appears twice within one frame. It is clear this is the same man because he not only looks the same, but also wears identical clothes. In one instance he stands blind before Jesus; in another he is beside a trough of water to the right having discarded his stick on the ground, with his sight regained. His body language indicates that between these two poses a miracle has taken place.

A second technique is the use of a trigger image. The figure of the blind man at the moment of regaining his sight could be described as a trigger image, since it reminds us that a miracle has taken place. The effectiveness of the trigger image depends, however, on the viewer's familiarity with the story.

Painters have often used trigger images to suggest a significant moment in the story and to trigger a response to the whole narrative. Pintoricchio's *Penelope with the Suitors* [*see* Odyssey – 2] is clearly using such a device. The trigger image is Penelope who sits quietly at her loom. Looking at her we have a flashback to all the other episodes in the story; her refusal of new suitors during the absence of Odysseus; her artful ruse of weaving and unpicking a shroud for her father-in-law, Laertes; Odysseus's years of wandering and adventure, the sweet song of the Sirens and the blinding of the Cyclops Polyphemus [*see* Odyssey – 1].

One kind of trigger image derives from the use of iconography: that is the technique where signs, symbols and colour are employed to identify individual figures and situations. An image of the Dominican St Peter dressed in the black and white robes of his Order and with a bloody wound in his head may act as a trigger to the story of his life and death. This thirteenth-century saint founded the Dominican Order and was murdered by a group of hired assassins after accusing a couple of Venetian noblemen of heresy [*see* St Peter Martyr].

A third technique employed in narrative painting is the introduction of circumstantial detail such as architectural features, ships in the background, discarded weapons, tombstones and even inscriptions. These details, of course, cannot carry the story on their own, but they often play an important supporting role. For example, in Titian's *Bacchus and Ariadne* Ariadne indicates a distant ship which is clearly that of the departing Theseus. Likewise the inscription in Domenico Beccafumi's *Tanaquil*, although discreetly positioned at her side, includes in condensed form the story of her life.

The expression of the emotion engendered by a story, or by a critical moment or episode from a longer sequence, is a fourth important way in which a painting can convey the essence of a narrative. Light, colour, painting technique and other features of the scene depicted may all be crucial. In many instances our attention is drawn to key incidents in the story through the use of light. One particular figure may be caught in a blaze of light whilst others merge into the shadows.

The last technique, and one of the most important, concerns the use of facial expression and bodily gesture. They can serve a number of purposes: the expression of emotion; the indication of direction and movement, which may in effect convey a sequence of action; and a suggestion of the relationships between the characters and other features shown – love for each other, fear of a

monster or the tranquillity of St Jerome in his study.

Alberti argued that the gestures of the body and the expression of the face were the key elements to understanding a story. 'We weep with the weeping, laugh with the laughing, and grieve with the grieving. These movements of the soul are made by the movements of the body.' For Alberti the most appropriate way of understanding the mood or state of mind of the person was to study their facial expressions and body gestures – 'In the melancholy the forehead is wrinkled, the head drooping, all members fall as if tired and neglected. In the angry, because anger incites the soul, the eyes are swollen with ire and the face and all the members are burned with colour, fury adds so much boldness there. In gay and happy men the movements are free and with certain pleasing inflections.'

Alberti encouraged the artists of his time to aim to achieve an emotional effect and to construct narrative paintings that would touch the souls of those who saw them. *Della Pittura* contains practical advice on how this can be achieved: 'In an *istoria* [a narrative painting] I like to see someone who admonishes and points out to us what is happening there; or beckons with his hand to see; or menaces with an angry face and with flashing eyes, so that no one should come near; or shows some danger or marvellous thing there; or invites us to weep or to laugh together with them . . .'

The power of gesture was understood well before the Renaissance period. St Augustine described how the bodily movements of those praying for the dead manifested the movement of the soul, and how this invisible movement of the soul was augmented by the exterior expression of the body. 'Thus the affection of the heart, which has come first in order to produce the movements, in turn grows stronger by the fact of their performance.'

Very early depictions of the life of Christ and of those saints who were martyred in his cause often depend almost exclusively on hand gestures to tell the story. But the sheer variety of gesture and body pose can be confusing.

The single image of one person making a specific gesture or adopting a particular pose of suffering or revelation cannot be defined as narrative painting unless it is involved as part of a wider story. Narrative requires some kind of development or sequential interaction. Without this we are dealing only with a static image which represents rather than unfolds. Two people, however, gesturing and interacting amounts to a story. In depictions of the Noli me tangere – that moment when Christ met the Magdalen after his death, but turned away from her because he was not yet fully risen – there is a sequence of actions and emotions, despite the fact that the figures are often 'frozen' against the background [*see* Christ: Resurrection – 3].

The early Renaissance eye understood mood by reading the gestures of the figures. Throughout history, gesture has been regarded as a natural language understood by all people, but Renaissance artists were particularly aware of its significance. Leonardo maintained that the gestural communication of the deaf and the dumb was far more sophisticated for the expression of feelings than mere words. 'When you wish to represent a man speaking among a group of persons, consider the matter of which he has to treat and adapt his action to the subject. That is, if the subject be persuasive let his action be in keeping . . .

[with] face alert and turned towards the people, with mouth slightly open to look as though he spoke . . . If you represent him standing, make him leaning slightly forward with head and shoulders towards the people. These you should represent silent and attentive and all watching the face of the orator with gestures of admiration, and make some old men in astonishment at what they hear, with the corners of their mouths pulled down drawing back the cheeks in many furrows with their eyebrows raised where they meet . . .'

Two centuries later, John Bulwer wrote a book about deaf and dumb language entitled *Chirologia: or the Naturall Language of the Hand* (1644). Bulwer argued that hand gestures can be understood by everyone regardless of their mother tongue. The hand 'speakes all languages, and as universall Character of Reason is generally understood and knowne by all Nations, among the formall differences of their Tongue. And being the onely speech that is naturall to man, it may well be called the Tongue and Generall language of Humane Nature, which, without teaching, men in all regions of the habitable world doe at the first sight most easily understand.'

Modern studies continue to recognise the significance of body language. A. Mehrabian's 'Posture and Position in the Communication of Attitude and Status Relationships', published in the *Psychological Bulletin* of 1969, explores the way in which we understand relationships between people in terms of their positioning and gesture. He analyses the physical distance established between individuals, their body orientation and the amount of eye contact they allow. Analysing the state of relaxation of the trunk and the degree of asymmetry in the arrangement of arms and legs, he charts the emotions and feelings of his subjects. He notes the degree to which women open their arms in gestures of friendship and openness, and shows how an attentive posture is often accompanied by a forward lean of the body, whereas a withdrawal or negative, repulsed posture involves a drawing back and a turning away.

Twentieth-century psychological studies have also revealed that a change in posture is more important than a change of hand gesture in suggesting the state of mind. Mehrabian concludes that if the body is seen to change position the person is either about to make a new point, or is physically reacting to something that has been said, or is moving out of the communication area for the moment.

This is particularly significant in the context of narrative painting. Many of the National Gallery paintings involve verbal and physical communication. Paintings such as the *Noli me tangere* by the Master of the Lehman Crucifixion [*see* Christ: Resurrection – 3] suggest that these artists were sophisticated psychologists.

Seeing the Magdalen reach out without inhibition to touch Christ, the viewer realises that Christ has in this moment revealed himself to the Magdalen but is also rejecting her embrace. Looking at the positioning of the figure of Christ the viewer understands also that we have reached that part of the story where Christ changes the conversation, removes himself from the confrontation, turns away and distances himself from the Magdalen, although he cannot resist reaching out to her as if to caress. The conversation these two people have had, the love they have for each other and yet the distance that

now must remain between them, despite their physical proximity, is revealed to us through their facial expressions and the gestures of their bodies.

In the *Noli me tangere* Christ is clearly on the point of turning away from the Magdalen, but we also understand that he is experiencing a number of different emotions. He has answered the Magdalen's question 'Where have they taken our Lord?' He has revealed his true identity, but at the same time he draws back from her. When the Magdalen learnt his real identity, she turned to him, calling him by name. But Christ turned away, rejecting her embrace. Despite the fact that he has revealed his identity, he must not let her touch him. Christ withdraws from the Magdalen, yet his gesture shows that he has communicated with her, and that he would like to touch her. The position of his body, the turning of the trunk and the gesture of the arm and hand suggest his conflicting emotions.

Two other general matters are worth mentioning. The first is the relationship between the painting and the text of the story from which it derives. The second is the aesthetic notion of decorum and propriety, which is important in relation to many of the narrative paintings discussed in this book.

Connections between the painted image and its textual source have frequently been made. The Renaissance theorist Bartolommeo Facius (basing himself on comments made by the classical writer Plutarch) wrote, 'There is, as you know, a certain great affinity between painters and poets. A painting is indeed nothing else but a wordless poem . . .' In Plutarch's *Moralia*, painting is described as wordless poetry and poetry as verbal painting. 'For the actions which painters portray as taking place in the present, literature narrates and records as having taken place in the past. And if artists with colours and lines, and writers with words and phrases, represent the same subjects, yet they differ in the material and manner of their imitation; but the underlying aim of both is the same, and the successful historian is one who makes his narrative like a painting by representing vividly emotion and character.'

This book looks at the way artists of the past have used the written word as an inspiration for their narrative painting. A number of texts emerge as the most common sources: the Old and New Testaments; the thirteenth-century Jacopo da Voragine's *The Golden Legend*; and the classical Roman writer Ovid's *Metamorphoses*.

The notion of images being 'appropriate' is one aspect of the long-standing and much wider aesthetic concept of propriety and decorum. Throughout this period – or at least until 'Romantic' ideas of art developed during the eighteenth century – the idea of conveying emotion was governed by certain aesthetic principles. The most important of these was the concept of decorum. This demanded that images should be 'appropriate', that emotion should be 'proportionate', that the form and content should bear a consistent relationship with each other and that there should be a 'harmony of parts': that is, each aspect of the work should combine to form a coherent whole.

Alberti counselled great caution in the matter of embellishment. 'A certain suitable number of bodies gives not a little dignity . . . I cannot praise any copiousness which is without dignity . . . for this reason be careful not to

repeat the same gesture or pose.' And when discussing movement Alberti argued that it should be appropriate to the action in the story. 'We painters who wish to show the movements of the soul by the movements of the body are concerned wholly with the movement of change of place. Anything which moves its place can do it in seven ways: up, the first; down, the second; to the right, the third; to the left, the fourth; in depth moving closer and then away; and the seventh going around. I desire all these movements in painting. Some bodies are placed towards us, others away from us, and in one body some parts appear to the observer, some drawn back, others high and others low . . . All bodies ought to move according to what is ordered in the *istoria*.'

But, at the same time, Alberti was anxious that the painting should have a certain dignity. He did not want so much movement or so great a variety of movement that confusion broke out. Alberti advised artists therefore to strive for a harmony of parts. 'Bodies ought to harmonise together in the *istoria* in both size and function to what is happening in the *istoria* . . . That which first gives pleasure in the *istoria* comes from copiousness and variety of things . . . However, I prefer this copiousness to be embellished with a certain variety, yet moderate and grave with dignity and truth.'

Dignity and appropriateness are terms which occur over and over again in descriptions of *istoria* painting in *Della Pittura*. Alberti argued that each part of the *istoria* should reflect the mood and the action. Thus if a dead body is included in the scene of a battle it must really seem dead. If a figure is running, the hands and feet should be thrown forward as if really in motion. If fighting is involved everything in the *istoria* should indicate anger, disorder and confusion.

Alberti laid great stress on the fact that only a certain number of figures should be shown in an *istoria*, and that as well as being in harmony with each other, their individual actions should be readily understood in the context of their varying states of mind. Clarity of composition was essential. Alberti had strong feelings about the overfilling of space. 'I blame those painters who, where they wish to appear copious leave nothing vacant. It is not composition but dissolute confusion which they disseminate. There the *istoria* does not aim to do something worthy but rather to be in tumult.'

Many of the narrative paintings in the National Gallery suggest a careful selection of events and trigger images to illustrate individual stories. One such painting is Piero di Cosimo's *Fight between the Lapiths and the Centaurs*. This painting includes much detail, and many different sequences. Yet the careful organisation makes each of the separate parts appropriate to the story.

Della Pittura includes a detailed passage concerning a fight between the centaurs. 'It would be absurd for one who paints the centaurs fighting after the banquet to leave a vase of wine still standing in such tumult.' Piero di Cosimo's painting suggests a familiarity with Alberti's text in the disorder of the background feast with its upturned jugs and rumpled tablecloth. But there is also a suggestion that the painter was familiar with a much earlier text, Ovid's *Metamorphoses*.

Ovid describes in detail the fate of two centaurs, Cyllarus and Hylonome. When Cyllarus was wounded in the battle, Hylonome cradled him in her arms,

fondling his wound and pressing her lips to his in an attempt to breathe life into his dying body. When she realised he was dead she threw herself upon the point of the spear that had wounded him and fell back upon Cyllarus in a dying embrace.

Piero di Cosimo includes these two figures in the centre stage of his painting. We witness both the embrace of Cyllarus and Hylonome and the spear that has wounded him. Together they act as trigger images for the rest of the story. Indeed Ovid employed over one hundred lines of poetry to chart the bloody course of the battle which raged throughout the day until half of the centaurs were destroyed and only flight and darkness saved the rest.

The *Fight between the Lapiths and the Centaurs* reflects the contemporary aesthetic theories, including those of Alberti, the close adherence to an original text and a number of the narrative techniques discussed in this Introduction.

The entries in this dictionary concentrate on explaining the stories which each painting illustrates. Nonetheless there are some references to the narrative techniques and aesthetic principles discussed in this Introduction. In any event it is hoped that this brief discussion of some of the technical issues which the painters, no doubt to a varying degree, had in mind will enhance the enjoyment of those using this book and, more important, looking at the pictures.

Using this Dictionary

THE individual entries explain the stories of specific paintings, relating them to the texts or other sources from which they are drawn. In many cases the entries explain the narrative in terms of the techniques described in the Introduction.

The paintings are arranged alphabetically according to title, or by reference to the principal characters shown. (For example, Giovanni Battista Piazzetta's *Sacrifice of Isaac* is cross-referenced to the main heading Abraham.)

Some main headings such as Christ and Virgin Mary which involve a large number of entries are divided into subsections. These subsections are arranged alphabetically according to the main events of the person's life. Thus Christ: Baptism precedes Christ: Childhood, and Virgin Mary: Annunciation precedes Virgin Mary: Birth.

Where main headings are broken into numerical sections, paintings are listed in chronological sequence rather than alphabetical order. Thus the *Nativity of Christ* [*see* Christ: Childhood – 1] appears before the *Adoration of the Kings* [*see* Christ: Childhood – 3].

There is also a full index at the back of the book enabling the reader to identify paintings by title, character and subject.

A number of paintings in the National Gallery collection deal with the same story. Where this is the case the relevant entry in the dictionary indicates all the titles, including alternative titles where they are current, and identifies the painter of each.

The numbers shown after the painters in each main entry are the 'acquisition numbers' which relate to the National Gallery's central index of its collection. Where an L is shown this indicates that the painting is held, sometimes on a long-term basis, on loan.

Greek and Roman Deities

MANY of the Greek gods and goddesses are better known to us now by their Roman names. In order to avoid too many complications within the main text, a list of Greek and Roman deities and heroes is included here.

Greek	Roman
Asclepius	Aesculapius
Eos	Aurora
Dionysus	Bacchus
Demeter	Ceres
Eros	Cupid
Artemis	Diana
Pluto	Hades
Heracles	Hercules
Hera	Juno
Zeus	Jupiter
Ares	Mars
Hermes	Mercury
Athena (Pallas Athene)	Minerva
Poseidon	Neptune
Persephone	Proserpina
Cronus	Saturn
Helios	Sol
Odysseus	Ulysses
Aphrodite	Venus
Hephaestus	Vulcan

Acknowledgements

———

I owe this project to two editors in different camps. An Illustrated Dictionary of Narrative Painting was first suggested to me by Patricia Williams, Director of Book Publishing, National Galleries Publications Ltd., and Caroline Knox, Senior Editor at John Murray. I would like to thank both of these individuals and their publishing houses for their mutual understanding and generous advice.

I am particularly grateful to Patricia Williams who was a constant source of encouragement, and to John Murray whose exuberant enthusiasm swept the whole project along.

For help in the preparation of the text I am grateful to the staff of the National Gallery Library and especially to Elspeth Hector for access to National Gallery dossier information on individual paintings. I would also like to thank the Curatorial and Education staff of the National Gallery for their comments and in particular Dr Nicholas Penny, Clore Curator of Renaissance painting, for his collation of many useful pieces of advice. I am grateful to Diana Davies, Gallery Editor, for her careful examination of the index and information about recent attributions and titles. I am grateful also to Christopher Baker and Tom Henry who offered help in reading the finished manuscript and synchronising information concerning attributions and source material.

Finally, I would like to thank Ian and Helen Humphreys for their assiduous proof-reading, and Quentin Thomas for wise advice about structure, form and content.

The Dictionary

Abduction of Helen by Paris *see* Paris – 2
Abraham
Departure of Abraham
Abraham and Isaac
Landscape with Abraham and Isaac approaching the Place of Sacrifice
Sacrifice of Isaac
[Biblical: Genesis 13.14–16; 17.1–19; 18.1–15; 21.1–8; 22.1–19]
When Abraham (the first patriarch of Israel) was in his hundredth year he
was visited by three angels disguised as men who told him that he and his
aged wife Sarah would at last have a son. Although Abraham had a number of
children born to him out of wedlock, he and Sarah had remained childless
throughout their long marriage. Indeed Sarah was sceptical about the angels'
message. But the couple did subsequently have a son, Isaac. Isaac represented
the beginning of a powerful dynasty promised to Abraham by God, a dynasty
which was to rule all the lands between Egypt and the river Euphrates. In
Genesis we read how the Lord said unto Abraham, 'Lift up now thine eyes,
and look from the place where thou art northward, and southward, and
eastward, and westward. For all the land which thou seest, to thee will I give
it, and to thy seed for ever. And I will make thy seed as the dust of the earth:
so that if a man can number the dust of the earth, then shall thy seed also be
numbered.'

The National Gallery painting known as *The Departure of Abraham*, by a
follower of Jacopo Bassano, could depict the moment when Abraham is told
about the lands he and his family will rule. The figure of God is shown
leaning forward out of the clouds in a shaft of light – one hand pointing to
the family group below, the other pointing into the distance, as if indicating
the land beyond. However, the presence of a small child suggests that it
illustrates a later episode in the story.

The Bible tells us that when Isaac was born God tested Abraham's faith by
commanding him to take his son into a far land and, on one of the moun-
tains there, to sacrifice him as a burnt offering to the Lord. Genesis does not
describe the leave-taking between Abraham and his wife Sarah. But *The
Departure of Abraham* shows the figure of a woman, albeit a young one,
handing a child up to a horseman who turns his back to us whilst gesticulat-
ing to the left, as if pointing out the journey ahead. A number of animals are
gathered together as if they too are about to move off with the figure on
horseback.

According to the Bible the aged Abraham set off with his son Isaac, two
servants, wood for the burnt offering and a mule, to make the long journey to
the place where God had commanded Isaac should be sacrificed. Abraham
travelled for three days until, lifting up his eyes, he saw the appointed place
still some way ahead. Telling the servants to remain behind with the ass, he
went ahead with his son to the place of sacrifice. Abraham carried the lighted
torch and knife, whilst Isaac toiled along beside him under the load of wood.

Gaspard Dughet's *Landscape with Abraham and Isaac approaching the Place
of Sacrifice* catches Abraham's loneliness and despair as he encourages his son
up the wooded slopes of a deserted mountainside. Ferdinand Olivier's

painting of *Abraham and Isaac* on the other hand emphasises Abraham's sense of purpose, since he already carries a flaming torch with which to light the funeral pyre. In neither painting is there any hint that God is about to offer an alternative sacrifice.

The Bible describes how, when Abraham and his son arrived at the appointed place, Abraham built an altar and arranged the wood ready for a burnt sacrifice. He then took Isaac, bound him and laid him on the altar. But just as he was about to kill Isaac with his knife he heard the voice of an angel calling out to him to stop. The angel told Abraham that he had proved his faith in the Lord by showing that he was ready to sacrifice this beloved son of his old age. As Abraham looked up he saw a ram caught by his horns in a thicket close by. He therefore offered this as a blood sacrifice instead of Isaac.

Giovanni Battista Piazzetta's *The Sacrifice of Isaac* adopts the conventional approach to the subject showing all the emotional release of the moment as an angel flings out an arm with outstretched hand to push Abraham back from Isaac. The limp body of Isaac rests unresisting under his father's fierce grip, hardly daring – even in this moment of deliverance – to turn his head.
[After Jacopo Bassano (2148); Dughet (31); Olivier (6541); Piazzetta (3163)]
Abraham and Isaac see Abraham

Landscape with Abraham and Isaac approaching the Place of Sacrifice
Gaspard Dughet (1615–75)

Abraham and Isaac approaching the Place of Sacrifice, Landscape with *see*
Abraham

Adam and Eve [Biblical: Genesis 2.15–25; 3.1–6] The Book of Genesis
describes how God created Man and took him to the Garden of Eden so that
he could 'dress it and keep it'. Adam's first role in life was thus equivalent to
that of head gardener. Adam was given free rein to eat any of the fruit of the
trees in the garden, except for that which grew on the Tree of the Knowledge
of good and evil. The penalty for eating that fruit was death.

God understood that Adam might be lonely in the Garden of Eden, and so
he created animals and birds, and finally a creature similar to Adam, indeed
drawn out of his own body – the woman, Eve. The Bible describes how both
Adam and Eve were naked in the Garden of Eden, but were not ashamed of
their nudity. Only after eating the fruit from the forbidden tree did they look
down at their bodies and become conscious of their bare flesh. We learn how
Eve was the first to succumb to temptation. Persuaded by the serpent that it
was her right to taste also from the Tree of Knowledge, and that rather than
dying as a result she would in fact achieve wisdom, Eve reached out and
plucked a fruit, and, having tasted it, offered it also to her husband Adam.

Jan Gossaert's painting of *Adam and Eve* (which is on loan to the National
Gallery) depicts the moment after Eve has tasted the fruit from the Tree of
Knowledge. She holds an apple in her left hand, hidden from Adam's sight.
But her bodily pose and gesture suggest that she is about to persuade the
guileless Adam to taste also of the forbidden fruit. The serpent inclines
towards Eve as if in encouragement. Gossaert takes advantage of the original
story which informs us that neither Adam nor Eve attempted to cover their
bodies in shame until both had tasted the fruit. We are thus offered two close-
up views of proudly displayed nudity.

[Gossaert (L14)]

Adoration of the Golden Calf *see* Moses – 6

Adoration of the Kings *see* Christ: Childhood – 3

Adoration of the Magi *see* Christ: Childhood – 3

Adoration of the Shepherds *see* Christ: Childhood – 2

Aeneas at Delos, Landscape with [Classical mythology: Virgil, *The Aeneid* III,
73–82] The story of Aeneas, a young Trojan prince born from the union
between Anchises the mortal and Venus (the goddess of Love), is told in the
Aeneid. The *Aeneid* is an epic poem written in Latin by the Roman writer
Virgil in the years shortly before the birth of Christ. It describes how Aeneas
left his homeland after the Trojan War and wandered the world together with
his father Anchises and son Ascanius, encountering numerous adventures
before reaching the mouth of the River Tiber and settling in Italy. According
to Virgil, Aeneas was the founder of Rome.

One of the places visited by Aeneas was the Island of Delos in the Aegean
Sea. Delos was a holy place dedicated to the worship of Apollo and Diana.
According to Virgil, Anius, the king of Delos, was also the priest of Apollo
(the Sun god). When the Trojans arrived in Delos Anius came out to greet
them wearing holy bay leaves and ribbons on his brow. Recognising Anchises
as an old friend, he welcomed the Trojans and walked with them up to his

palace. Aeneas prayed for guidance in the Temple of Apollo, beseeching the god to grant a homeland to the Trojans who had been scattered after the fall of Troy. The Delian oracle commanded Aeneas to seek out the origins of the Trojan race, promising that his family would prosper there and that his descendants would rule all over the world.

Believing that his ancestors came from Crete, Aeneas set sail for that island, only to be driven away by pestilence. But before his flight from Crete he dreamed that Dardanus, from whom the Trojan royal family was descended, originally came from Italy. After many adventures, Aeneas finally reached the mouth of the River Tiber and landed in Latium.

Claude's *Landscape with Aeneas at Delos* shows some of the holy sites of Delos as well as the Trojan fleet in the harbour. In the foreground we see Aeneas and Anchises talking with Anius. The young prince Ascanius stands a little way off, as if listening to their conversation. Anius, who stands with his back to us, gestures back towards the harbour as if commanding Aeneas to set off on his travels again. Perhaps the lightening sky towards which Anius points bears some reference to the passage in Virgil where Anchises, eager to embark for Crete, declaims, 'Come! Let us take the path shewn by the divine command. Let us gain the favour of the winds and sail for the realm of Cnossus. With Jupiter's help the voyage need not be long; the third dawn will see our fleet at the Cretan shores.'
[Claude (1018)]

Landscape with Aeneas at Delos Claude Lorraine (1604/5(?)–82)

Aeneas *see also* Dido
Aeneas descends into the Underworld *see* Barque of Charon
Agony in the Garden *see* Christ: Passion – 4
Agony in the Garden of Gethsemane *see* Christ: Passion – 4
Angel appearing to Hagar and Ishmael *see* Hagar
Angel appearing to St Joachim *see* Virgin Mary: Conception
Angel appearing to St Zacharias *see* St John the Baptist – 1
Angel appears to Hagar and Ishmael *see* Hagar
Angelica saved by Ruggiero [Italian 16th-century literature: Ariosto, *Orlando Furioso*, canto X, stanzas 92ff] Ruggiero, a warrior hero from the romantic epic *Orlando Furioso* (written by Ariosto during the early years of the sixteenth century), came upon the beautiful Angelica chained to a rock on the Island of Tears. This rock, set somewhere in the outer Hebrides, was where a fearsome sea monster, or orc, came to devour lovely young maidens offered as a sacrifice by the local city. Ariosto's tale describes how Ruggiero finally overcame the monster by dazzling him with his magic shield, though that is not shown in Ingres' picture. Ingres has depicted instead that part of the story where Ruggiero first discovers Angelica.

Jean-Auguste-Dominique Ingres' painting of *Angelica saved by Ruggiero*

Angelica saved by Ruggiero
Jean-Auguste-Dominique Ingres
(1780–1867)

follows Ariosto's text closely, depicting the statue-like paleness of Angelica's skin and the initial confrontation between Ruggiero mounted on his hippogriff steed (a mixture of a griffin and a mare) and the writhing sea monster. Ariosto describes how Angelica in shame at her nudity – 'no veil or flimsiest of gossamers had she to hide her lily whiteness' – would have hidden her face had her hands not been fastened to the rock. In Ingres' painting we sense Angelica's desire to twist her body into a less exposed position, caught in a cold shaft of foreground light between the deadly lashing of the sea monster's tail and Ruggiero's piercing glance.

[Ingres (3292)]

Anna and the Blind Tobit see Tobias and Tobit

Annunciation *see* Virgin Mary: Annunciation

Annunciation with St Emidius *see* Virgin Mary: Annunciation

Apollo and Daphne

Apollo and Daphne

Apollo pursuing Daphne

[Mythological: Ovid, *Metamorphoses* I, 452ff; Hyginus, *Fabulae*, 203]

After being transfixed by one of Cupid's golden arrows, Apollo (the Sun god) was smitten with love for Daphne (the daughter of the River god Peneus). But Cupid, irritated that Apollo had dared to question his supremacy as a marksman with the bow and arrow, decided to wound Daphne with an arrow of rejection. Thus when Apollo sought to woo Daphne, she rejected his advances and fled his embraces. But Apollo, swift in his pursuit, soon caught up with Daphne, and (as Ovid tells us) triumphantly 'about to fasten on her', assumed she was his. But Daphne, her clothes fluttering and her hair in disarray, called desperately for help from her father Peneus.

The River god answered his daughter's prayers by turning her into a beautiful laurel tree. Ovid tells us how, even then, Apollo yearned for Daphne, as, embracing her trunk and branches, he felt her beating heart still fluttering beneath the bark. Determined to possess Daphne even in her arboreal state, Apollo swore always to entwine himself with her branches. He promised moreover that his victory over Daphne would be symbolised for eternity through the wreaths of laurel which would be placed upon the heads of triumphant Roman generals.

The painting of *Apollo pursuing Daphne* attributed to Domenichino and assistants clearly suggests Daphne's despair as she reaches her father's river. Yet the *Apollo and Daphne* by Antonio Pollaiuolo follows Ovid's text more closely. Daphne is indeed caught within Apollo's embrace as she metamorphoses into a laurel tree. One leg is already encased in bark, whilst the other is lifted off the ground as if still in flight from the lover she spurns. Yet in this moment of deliverance Daphne turns her head to Apollo and seems to look at him with mild submission as she lifts her laurel branches to the skies. It is as if we witness that moment in the text where Ovid describes Daphne's reaction to Apollo's promise: 'Paean was done. The laurel waved her new-made branches, and seemed to move her head-like top in full consent.'

[Attr. Antonio Pollaiuolo (928); Domenichino and assistants (6287)]

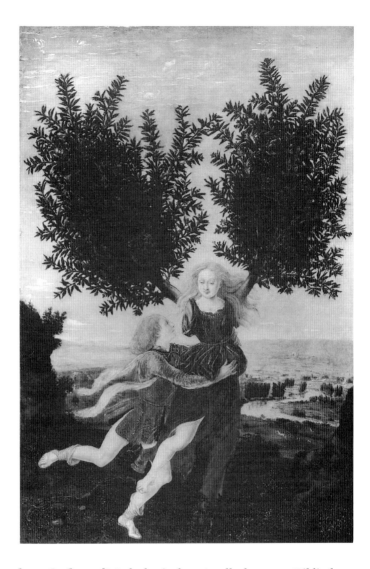

*Apollo and
Daphne*
Attr. Antonio
Pollaiuolo
(about 1432–98)

Apollo killing the Cyclops [Mythological: Apollodorus, *Bibliotheca* III] According to Greek mythology Asclepius, the son of Apollo (the Sun god) and a Greek princess Coronis, was killed by a thunderbolt sent from Zeus (king of the gods). Pluto (king of the underworld) had persuaded Zeus to kill Asclepius after Asclepius had chosen to interfere in matters of life and death by resurrecting Hippolytus (the son of Theseus).

But Asclepius' death was avenged by his father. Apollo decided to punish the Cyclops – a race of one-eyed giants – since they had supplied Zeus with his thunderbolts. The painting of *Apollo killing the Cyclops* by Domenichino and assistants shows Apollo slaughtering the Cyclops for their part in Asclepius' death. In this painting the artists create the illusion that the scene forms part of a series of wall hangings. The diminutive man in the lower right corner, prancing in chains upon a table which holds the remains of a

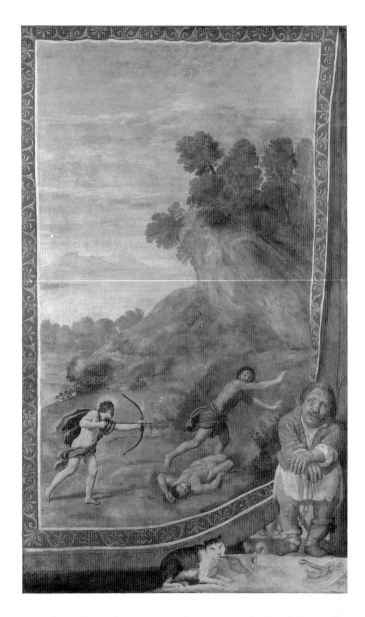

Apollo killing the Cyclops
Domenichino
(1581–1641) and
assistants

meal and a sedentary cat, bears no relationship to the story of Apollo, but serves rather to suggest that the scene of Apollo killing the Cyclops is depicted on material that can be drawn aside from the wall behind.
[Domenichino and assistants (6290)]

Apollo and Neptune advising Laomedon on the Building of Troy [Mythological: Homer, *The Iliad*, 21] Laomedon, king of Troy and father of the more famous Priam, received help from Apollo (the Sun god) and Neptune (the god of the Sea) after they had been condemned by Zeus (the king of the gods) to act like mortals, working for and receiving wages from another mortal. Reduced to this humiliating state the gods, disguised as

ordinary human beings, were employed by Laomedon for the period of one year. They advised the king how to build a circle of walls for the city of Troy. In fact Laomedon refused to pay for the work when the gods had finished, and both he and the city of Troy were later punished by a series of disasters.

However, in the painting of *Apollo and Neptune advising Laomedon on the Building of Troy* attributed to Domenichino and assistants we witness a moment of co-operation between Laomedon and the gods. The city of Troy, still without its walls, is shown in the background, whilst the three figures in the foreground appear to engage in a discussion of designs on a large piece of parchment. Laomedon, in the centre and wearing a crown, points both to the designs and back to the distant city as if discussing the preliminaries to the work. [Domenichino and assistants (6289)]

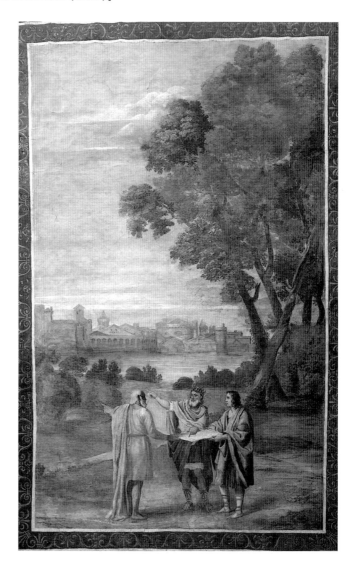

Apollo and Neptune advising Laomedon on the Building of Troy Domenichino (1581–1641) and assistants

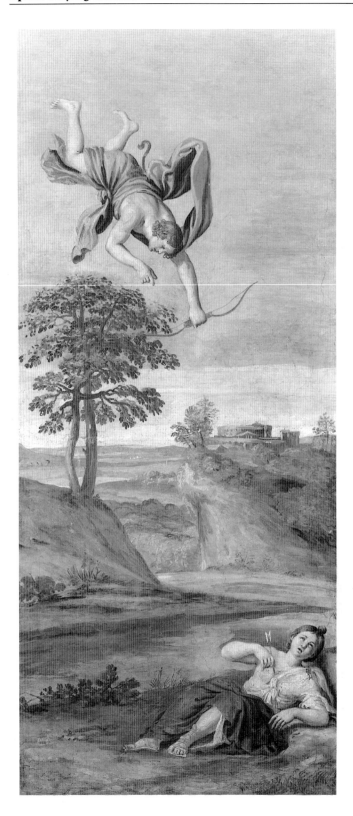

*Apollo slaying
Coronis*
Domenichino
(1581–1641) and
assistants

Apollo pursuing Daphne *see* Apollo and Daphne

Apollo slaying Coronis [Mythological: Ovid, *Metamorphoses* II, 602–20] Coronis was a Greek princess who was loved by Apollo the Sun god, but who then transferred her affections to a mortal. Ovid describes how Coronis' infidelity was reported to Apollo by the white crow he had set to spy on his beloved. In fury Apollo cursed the crow, turning its snow-like feathers black. Apollo then turned to slay Coronis with his bow and arrow.

The painting of *Apollo slaying Coronis* attributed to Domenichino and assistants shows that moment when, according to Ovid, the princess groaned in agony and attempted to pull the arrow out of her body, thereby staining her white flesh red with her blood. As she died Coronis admitted that Apollo was right to mete out his vengeance in this way, but lamented the fact that their unborn child should also be destroyed.

Domenichino and his assistants chose neither to depict Apollo's subsequent remorse and bitter lamentations, nor to show how the god snatched the unborn child Asclepius from his mother's womb shortly before her body was consumed by the flames of her funeral pyre. The artists concentrated instead on the moment of vengeance and acquiescence between the two lovers.

[Domenichino and assistants (6284)]

Appearance of St Jerome with St John the Baptist to St Augustine *see* St Augustine

Ark of the Covenant – 1

Plague at Ashdod [Biblical: I Samuel 5. 1–7] The Book of Samuel describes how the people of Ashdod were punished for having set up the ark of God as a pagan idol beside their own god Dagon. The next morning they found their

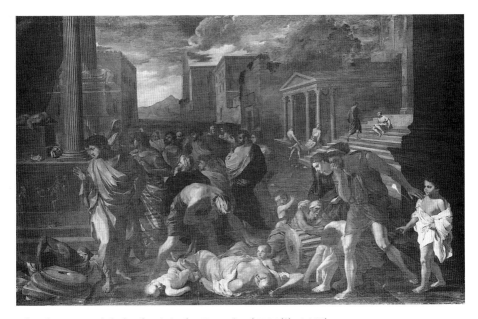

The Plague at Ashdod After Nicolas Poussin (1594(?)–1665)

own idol Dagon flat on his face before the ark. Not heeding this warning, the people of Ashdod reinstated their god beside the ark, only to find it once more prostrate on the ground. This time Dagon's head and hands had been cut off, leaving only the stump of his body. Panic-stricken, the people of Ashdod refused to enter the temple of Dagon.

A mysterious plague of emerods (a form of haemorrhoids) then hit the town, destroying the people themselves. All over Ashdod and the surrounding countryside people lay dying, until the men of the city called upon the Lords of the Philistines to remove the ark.

The National Gallery painting after Nicolas Poussin of *The Plague at Ashdod* shows the people of the city lamenting over their dead. Many gesticulate in front of the temple of Dagon aghast at the vengeful power of the Israelite ark which has destroyed their own idol and, they believe, brought the plague.

[After Nicolas Poussin (165)]

Ark of the Covenant – 2

Return of the Ark [Biblical: I Samuel 6. 1–16] After the plagues and destruction at Ashdod, Gath and Ekron, the Philistines called for help and advice from their priests and diviners about what they should do with the stolen Ark of the Lord. They were advised to send away the ark. Specific instructions were given that a peace offering of five golden mice and five golden emerods (a form of haemorrhoids) representing the plague that struck the land should be placed in a casket beside the ark and that the ark itself should be transported on a new cart, pulled by two white cows newly brought to calf.

The wise men told the Philistines to take the calves away from their mothers, and then to watch carefully which way the cows transported their awesome burden. If the cows took the road by the coast to Beth-shemesh the Philistines would know that it was the God of Israel who had sent them so much woe and destruction.

Sure enough, the cows set off straight up the road to Beth-shemesh, turning neither to the right nor to the left. And when they arrived in the land of the Beth-shemites and into the field of a man called Joshua, they stopped by a large stone. The Beth-shemites crowded round, rejoicing to see the return of the ark. They unharnessed the cows, took wood from the cart and offered up the cattle as a burnt offering. The Philistines, who had followed and witnessed all, returned much chastened to their own land.

Sebastien Bourdon's painting of *The Return of the Ark* shows the ark being greeted at the end of its long journey, the two cows marching purposefully along the straight road. Behind the cart we see the shadowy figures of the Philistines who have accompanied it on its journey.

[Bourdon (64)]

Ascension of Christ *see* Christ: Resurrection – 6
Ascension of St John the Evangelist *see* St John the Evangelist
Assassination of St Peter Martyr *see* St Peter Martyr
Assumption of the Virgin *see* Virgin Mary: Death – 2
Attack on Cartagena [Roman literature: Livy, *History of Rome from its*

Foundation, Book XXVI, 42ff] Cartagena, or Carthage (which was reputed to have been founded by Dido), had been a great commercial centre on the coast of northern Africa, long before the period of Roman supremacy. But her interests and colonies in the Mediterranean sea led her into direct conflict with the Roman republic from the third century BC onwards. This confrontation resulted in the Punic Wars. The Third Punic War saw the destruction of Carthage.

The National Gallery painting of *The Attack on Cartagena* attributed to an unidentified Italian artist shows various episodes of the attack on Carthage by Publius Cornelius Scipio Aemilianus (who was known as Africanus Minor) during the Third Punic War. Scipio in the centre directs the attack on the city, whilst to the left and the right we see ranks of Roman soldiers, protected behind their shields and on the point of attack, or attempting to scale the city walls. In the right-hand background we see the Roman soldiers setting off across the lagoon to attack Carthage on its vulnerable side. The city was finally destroyed.
[Italian School (643A)]

Augustus and the Sibyl [Roman history] According to tradition Augustus had a vision of the Virgin Mary holding her Child, and at the same time he received a message from one of the sibyls telling him that the ground upon which he was kneeling was the place where a new church, S Maria in Aracoeli, should be built.

There are many similar traditions in which saints and those inspired with the holy faith receive messages about the foundation of new churches. Bayeu's National Gallery painting of *St James being visited by the Virgin with a statue of the Madonna of the Pillar* refers to the founding of the church of Nuestra Senora del Pilar at Saragossa. And the two panels attributed to Masaccio and Masolino in the National Gallery originally formed part of an altarpiece celebrating the foundation of S Maria Maggiore in Rome.

The National Gallery painting of *Augustus and the Sibyl*, attributed to the Venetian School, depicts both the vision of the Virgin and Child and the kneeling figure of Augustus on an open stretch of ground appropriate for the building of a new church. Behind Augustus, with her hands raised as if in amazement, stands the sibyl, a prophetess of the ancient world. She seems not to have imparted her message yet, but rather to be caught in a moment of inner reflection. The city in the background, sprawling across the river plain and up over the slopes of the hill, could have topographical links with the city of Rome, but has tentatively been identified as Monselice.
[Venetian School (3086)]

Aurora abducting Cephalus *see* Cephalus – 1
Bacchanal *see* Bacchanalia
Bacchanalia
Bacchanal
Bacchanal (also known as *The Nurture of Bacchus*)
Bacchanalian Revel before a Term of Pan
Triumph of Pan
Bacchanalian Festival (also known as *The Triumph of Silenus*)

Silenus gathering Grapes
Drunken Silenus supported by Satyrs
[Mythological: Ovid, *Metamorphoses* III]
Bacchanalian scenes deal with the festivities and often raucous activities of the followers of Bacchus (god of Wine).

According to classical mythology, Bacchus (a son of Zeus) was looked after in his childhood by nymphs from Mount Nysa. The painting by Nicolas Poussin known as *The Nurture of Bacchus* probably refers to this since it shows a young child being offered goat's milk in a woodland glade.

Bacchus introduced the cultivation of the vine on the slopes of Mount Nysa and came to be worshipped as the god of Wine. His followers – Satyrs, Sileni, Maenads and Bassarids – are frequently depicted as if in ecstasy, and intoxicated with wine. They dance and make music, the nymphs often embracing lascivious-looking satyrs. The male followers of Bacchus were known as the Bacchi.

An old man called Silenus often leads a drunken group of Bacchi. The National Gallery painting by a follower of Rubens known as *Drunken Silenus supported by Satyrs* shows a grotesquely fat old man lurching along with his companions, too drunk to support himself, yet not so drunk that he fails to notice the luscious bunches of grapes offered by two urchins at his side. Annibale Carracci's painting *Silenus gathering Grapes* shows Silenus gesturing clumsily upwards to tear the grapes from the vines himself.

Silenus is usually depicted perching precariously on an ass, or lolling in a drunken stupor in his chariot, as is the case in the National Gallery painting of a *Bacchanalian Festival* by a follower of Nicolas Poussin. This painting, also known as *The Triumph of Silenus*, depicts an orgy of drinking and dancing with excited satyrs playing on musical instruments, coming to blows with each other and giving passionate embraces to willing nymphs. (Dosso Dossi's painting of a *Bacchanal* takes up the same theme, although in a slightly more restrained manner.) Despite his physical torpor, Silenus was believed to be extraordinarily wise, because of his great age. He was therefore accorded a position of some authority among the Bacchi, and often depicted as a lovable rogue rather than a dissipated fool. Female worshippers were known variously as Bacchae, Bacchante or Maenads.

Although Bacchus is best known as the god of Wine, his cult was originally associated with fertility. In this guise Bacchus is often depicted in the form of a bull or goat, worshipped by frenzied followers who brandish the limbs of animals they have torn apart and consumed. By eating this raw flesh the Bacchi and Bacchae symbolically assumed the nature of their god. The satyrs (half men, half goats) often entwined their bodies with snakes during Bacchic revels, whilst others played pipes for the general entertainment and dancing. Pan of the reed pipe and goat legs is sometimes shown in their midst.

Bacchanalia often depict physical abandonment and orgiastic transports of both Bacchi and Bacchae. Nicolas Poussin's *A Bacchanalian Revel before a Term of Pan* suggests very well the passion and the ecstasy of the dance. Such lack of control and transformations of character are sometimes symbolised by the inclusion of masks in Bacchanalian scenes, as for example in Nicolas

Poussin's *The Triumph of Pan*.

Bacchic attributes are the vine leaf and the thyrsus, a stick tipped with a pine cone and entwined with ivy and vine leaves. The vine clearly reflects the cult of Bacchus, the god of Wine. The cone, fruit of the pine tree which was worshipped in ancient procreation rites, links more closely with the earliest fertility cult which is known to have been particularly popular with female worshippers.

[Annibale Carracci (93); Dosso (5279); Poussin (39); Poussin (62); Poussin (6477); follower of Poussin (42); studio of Rubens (853)]

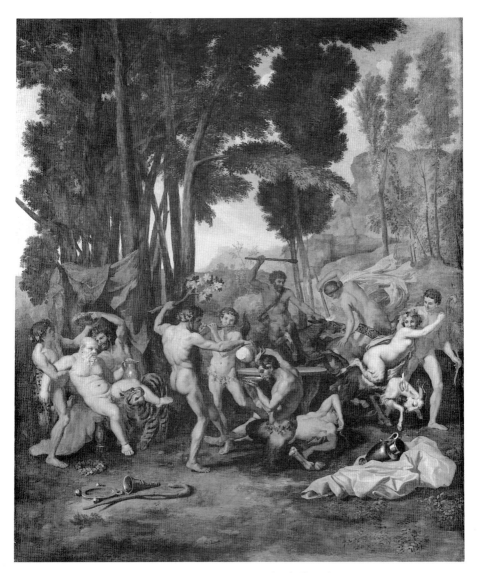

Bacchanalian Festival (also known as *The Triumph of Silenus*)
Follower of Nicolas Poussin (1594(?)–1665)

Bacchanalian Festival (also known as *The Triumph of Silenus*) *see* Bacchanalia

Bacchanalian Revel before a Term of Pan *see* Bacchanalia

Bacchus and Ariadne [Mythological: Ovid, *Metamorphoses* VIII, 176–82; Ovid, *Ars Amatoria* I, 525–66; Ovid, *Fasti* 3, 459–516; Catullus, *Carmina* LXIV, 257–65; Philostratus, *Imagines* 1, 15 and 19; Pliny, *Natural History*, XXXV, 99] Ariadne, a Cretan princess, helped the young Athenian prince Theseus to slaughter the Minotaur and escape from the labyrinth, or maze, belonging to Ariadne's father, King Minos of Crete. When Theseus set sail from Crete, Ariadne – in love with the young hero – went with him, only to be abandoned on the Island of Naxos. Bacchus, triumphantly escorted by his worshippers, discovered Ariadne in her moment of despair, alone and unloved. Overcome by her beauty, he declared his love for her and offered her a place amongst the constellations of heaven. Some texts describe how the god tore the jewelled crown from Ariadne's head, whisking it up into the sky to form a circlet of stars.

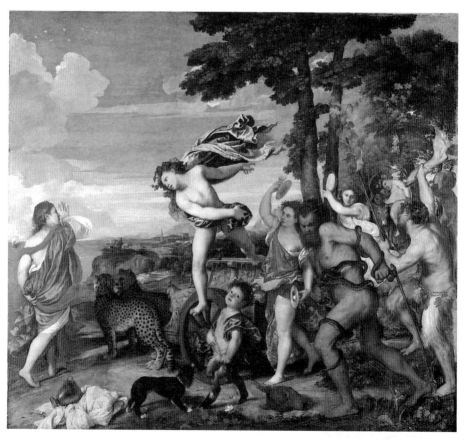

Bacchus and Ariadne Titian (active before 1511, died 1576)

Titian's painting of *Bacchus and Ariadne* suggests this declaration in the
god's somewhat curious pose. Bacchus seems both to be leaping towards
Ariadne, and yet at the same time fixed in mid-air as if caught in the middle
of some other action. Ariadne is likewise caught between two actions. She
gestures after her lover's disappearing boat, while fixing her glance on
Bacchus, and seeming to shudder away from the god and his orgiastic
followers.
[Ricci (851); Titian (35)]
Banquet of Cleopatra *see* Cleopatra
Baptism of Christ *see* Christ: Baptism – 2
Barque of Charon (also known as *Aeneas Descends into the Underworld*)
[Mythological: Virgil, *The Aeneid* VI] According to Virgil, Aeneas (son of
Anchises and the goddess Venus) went down into the underworld (also
known as Hades) to embrace for one last time his dead father. In the comp-
any of the Cumaean sibyl who had granted him this wish, and protected
by the life-giving branch of mistletoe which the sibyl had hidden in her
garment, Aeneas approached the River Styx, the great watery divide between
the living and the dead.
 Traditionally it was believed that the souls of the dead were ferried across
the Styx by a fearsome boatman, Charon, who was often depicted as an old
man with long white hair and piercing eyes. Virgil tells us that Charon, who
at first refused to carry two living souls across to Hades, looked in awe at the
mistletoe, and cleared a way on the banks of the river so that his two
passengers could climb aboard his fragile craft. We learn that the boat settled
heavily under the weight of these passengers, letting in stinking marsh water
through its creaking sides.
 The National Gallery painting of *The Barque of Charon* after Pierre
Subleyras, although breaking with tradition in showing Charon as a youthful
nude, conjures up much of Virgil's imagery. In the foreground we see two
heavily shrouded figures who are thought to represent the sibyl and Aeneas;
in the background two other ghostly figures stand, as if waiting for the return
of the boatman. Charon, the boatman, leans his knee on the side of his
shallow boat as he pushes off from the bank with his pole.
[After Subleyras (4133)]
Battle of San Romano (also known as *Niccolò Maruzi da Tolentino at the
Battle of San Romano*) [Italian history] Uccello's painting of *Niccolò Maruzi
da Tolentino at the Battle of San Romano* shows one of the Florentine leaders
– Niccolò da Tolentino – leading his army into battle against the Sienese in
1432. Contemporary documents describe how Niccolò drew up some of his
men on the plain and sent others up through the brambles and on to the
hillside to effect a separate attack. Niccolò is identifiable through the banner
with its devices of knotted cords which is carried by one of his followers.
Uccello also clearly identifies Niccolò as the hero by the elaborate headdress,
known as a marzocco, and the symbolic white colouring of his horse.
[Uccello (583)]
Beheading of St James *see* St James
Beheading of St John the Baptist *see* St John the Baptist – 3

Belshazzar's Feast [Biblical: Daniel 5. 1–28] In the Book of Daniel we read how Belshazzar held a great feast and drank from the silver and gold vessels that his father Nebuchadnezzar (king of Babylon) had stolen from the temple in Jerusalem. Whilst drinking from these sacred vessels, Belshazzar and his company of princes, wives, concubines and courtiers, praised the gods of gold, silver, brass, iron, wood and stone. The Bible tells us that at that moment the fingers of a man's hand appeared and began to write on the plaster of the wall near a flaming candle. Seeing this strange phenomenon the king was much startled even to the point of a violent trembling in his limbs. Belshazzar immediately sent for his wise men and astrologers but they could not interpret the writing. His wife then suggested he call Daniel, a Jewish slave, who came and deciphered the words written on the wall.

Rembrandt's painting of *Belshazzar's Feast* catches the moment of anxiety and fear, both in the lurching figure of Belshazzar and in the disorder of tumbling goblets and gesticulating guests. The light around the writing suggests the hazy radiance of candlelight. Through this we dimly perceive the Hebrew script: Mene, Mene, Tekel, Upharsin (Mene: God hath numbered thy kingdom, and finished it; Tekel: Thou art weighed in the balance, and art found wanting). Daniel told Belshazzar that the last part of the writing on the

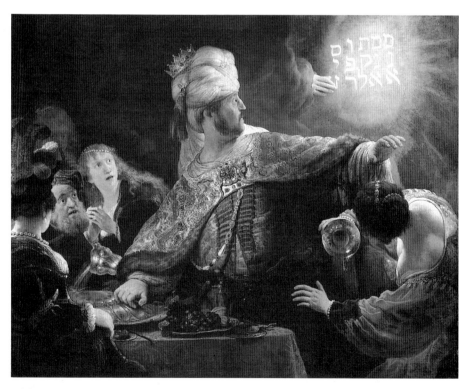

Belshazzar's Feast Rembrandt (1606–69)

wall decreed the king's fate: 'Thy kingdom is divided, and given to the Medes and Persians.'
[Rembrandt (6350)]

Betrayal *see* Christ: Passion – 5
Betrayal of Christ *see* Christ: Passion – 5
Birth of St John the Baptist *see* St John the Baptist – 1
Birth of Venus *see* Venus – 1
Birth of the Virgin *see* Virgin Mary: Birth
Brazen Serpent *see* Moses – 3
Building of the Trojan Horse *see* Troy – 1
Cadmus

Two Followers of Cadmus devoured by a Dragon [Mythological: Ovid, *Metamorphoses* III, 1–151] Cadmus was the young Phoenician prince sent in search of his sister Europa, who had been carried away by Zeus in the form of a bull [*see* Rape of Europa]. Cadmus was warned by his father not to return home without Europa. After fruitless searching Cadmus, realising he was doomed to exile, sought help from the oracle of Apollo. The oracle advised him to follow a cow who would lead him to a new land where he could settle. The cow led Cadmus to the site which later became Thebes.

Thankful to find the place where he might build a great new city, Cadmus sent some of his followers to find water so that he could make a libation in thanksgiving. Ovid describes how these men found themselves in a primeval forest where there was a watery cave guarded by a monstrous serpent. As the men lowered their urns into the water the serpent descended on them in fury, hissing horribly. It then reared up into the air to look down upon the wood before crashing down to tear the men apart with its fangs or suffocate them with its poisonous breath.

Cornelis van Haarlem's *Two Followers of Cadmus devoured by a Dragon* shows the moment when one of the men lies pinioned beneath the beast, possibly suffocating from the weight of the serpent's swollen body. At the same time we witness the monster swerving its neck across to bury its rows of sharp teeth into the face of a second man, who finds himself caught beneath the first victim. A head torn from the torso and a cleanly picked bone in the foreground remind us of the other victims of the serpent's fury. In the background we see Cadmus, alerted by the absence of his friends, encountering the beast – whom he subsequently slays.

Although Ovid referred to a serpent, Cornelis van Haarlem chose to show the monster as a hybrid creature with beating wings, vicious claws and coiling tail. Dragons were often depicted as a mixture of land beast and sea serpent, possibly because of the original Latin word *draco*, meaning both dragon and snake.
[Cornelis van Haarlem (1893)]

Capture of the Golden Fleece *see* Jason
Carlo and Ubaldo see Rinaldo conquered by Love for Armida *see* Rinaldo

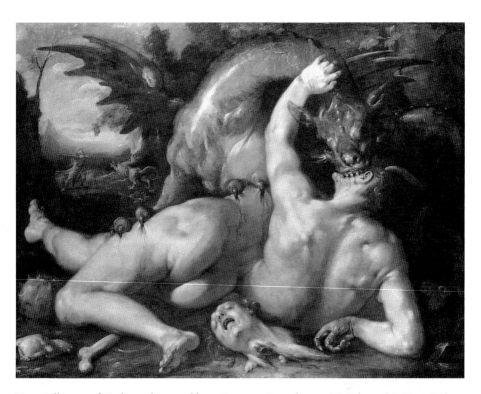

Two Followers of Cadmus devoured by a Dragon Cornelis van Haarlem (1562–1638)

Cephalus – 1

Aurora abducting Cephalus
Cephalus and Aurora
Cephalus carried off by Aurora in her Chariot
[Mythological: Ovid, *Metamorphoses* VII, 849–54]

According to classical mythology, Aurora (goddess of the Dawn) rose every morning to lead her brother Sol (the Sun god) into the heavens. This daily duty was forgotten, and chaos threatened, when Aurora fell in love with and was spurned by Cephalus. The story of Aurora and Cephalus was embroidered by later writers such as Gabriello Chiabera (1552–1637, *Il rapimento di Cefaló*) who described how the mortal finally succumbed to the charms of the goddess, after the intervention of Cupid.

In Rubens' painting of *Aurora abducting Cephalus* we see Aurora stepping out of the clouds from a chariot driven by two white horses and stretching out her arms to embrace Cephalus. Cephalus seems to respond to her, lifting himself from his sleeping position and reaching out one arm to the pearly flesh of the goddess, radiant in the light of the dawn.

In Nicolas Poussin's painting of *Cephalus and Aurora* we are offered a more detailed rendering of the story. The reclining figure to the left is probably Tithonus, the husband of Aurora, left sleeping each morning as the goddess rose to seek the sun. (We note a similar reclining figure in the painting of *Cephalus carried off by Aurora in her Chariot* by Agostino Carracci.) In

Poussin's painting Cephalus turns away from Aurora's embrace, to gaze steadfastly at a portrait of his wife Procris. Yet at the same time a cupid to our right seems about to sweep away the last furls of drapery from Aurora's body, revealing her in her full glory to her reluctant lover. We anticipate their naked embrace as we notice that their legs are already intertwined. We also anticipate their flight into the heavens by means of the champing and winged white horse in the background. The chariot of Helios meanwhile surges across the background sky.

[Agostino Carracci (147); Poussin (65); Rubens (2598)]

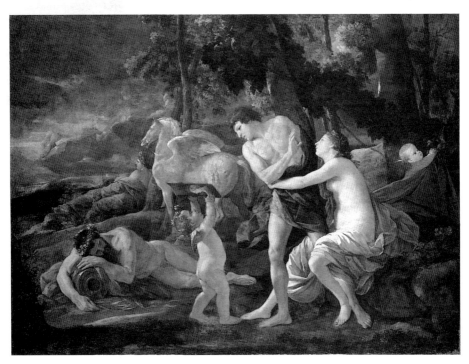

Cephalus and Aurora Nicolas Poussin (1594(?)–1665)

Cephalus – 2

Cephalus and Procris reunited by Diana
Death of Procris, Landscape with the

[Mythological: Ovid, *Metamorphoses* VII, 795–866; Italian 15th-century literature: Niccolò da Correggio, *Cefaló*]

Ovid describes how Aurora (goddess of the Dawn), rejected by Cephalus and mortified by his faithfulness to Procris, casts seeds of distrust in the young husband's mind which lead to a burning desire to test his wife's fidelity. Cephalus disguises himself as a rich merchant and presents himself to Procris, wooing her, and offering her great riches. Tempted by these gifts, Procris is about to yield to the charms of this stranger when she discovers that he is none other than her husband, Cephalus. Overcome with shame and confusion, Procris flees to join the virgin nymphs who follow Diana.

But in time the two lovers are reunited, partly as a result of Cephalus' own willingness to betray Procris in order to obtain certain magic gifts from Diana. Diana gives Procris a fine hunting dog and a magic spear which always finds its mark. Procris knows these will be irresistible to Cephalus. Testing Cephalus, as he before has tested her, Procris comes to him in disguise, to see if he will fall for the riches with which she now can tempt him. Cephalus falls straight into the trap. Greedy for Diana's gifts, he declares his love, only to find himself confronted by his own wife Procris. Ovid describes how Procris tenderly forgives Cephalus, and how the lovers are reconciled with a new understanding of each other's vulnerability. Procris even gives Cephalus the magic spear and hunting dog.

But the tale of testing does not end here. Procris, suspicious at the lengthy periods Cephalus spends away from her when out hunting, is encouraged by a faun to spy upon her husband. To complicate matters, the faun has fallen in love with Procris. Following Cephalus into the forest, Procris hides in a bush to watch. Cephalus, hearing the rustling of the branches, hurls his spear into the bush and accidentally kills his beloved Procris. The National Gallery painting of a mythological subject by Piero di Cosimo may refer to this episode since it shows a faun kneeling beside the dead body of a woman with a single wound to the neck.

Niccolò da Correggio's *Cefalò*, a fifteenth-century account of this story, was written for performance at a wedding as a cautionary tale to warn young married couples against jealousy and mistrust. However, unlike Ovid's version, there is a happy ending when the jealous lovers are reunited after death by the goddess Diana.

Claude's painting of *Cephalus and Procris reunited by Diana* combines a number of episodes from the story, and appears to concentrate on the moment when, according to later texts, Diana brought Procris to life and reunited her again with Cephalus.

On the other hand the National Gallery depiction of a *Landscape with the Death of Procris* (thought to have been painted by an imitator of Claude) concentrates on the original version of the story by Ovid where Cephalus is racked with bitter anguish at the discovery of his wife's dead body.

[Claude (2); after Claude (55)]

Cephalus and Aurora *see* Cephalus – 1
Cephalus carried off by Aurora in her Chariot *see* Cephalus – 1
Cephalus and Procris reunited by Diana *see* Cephalus – 2
Ceres and Harvesting Cupids [Mythological: Ovid, *Metamorphoses* II, 27–8] According to classical mythology Ceres was the goddess of Agriculture. She was also the mother of Proserpina who was carried away into the underworld by Pluto. Ceres spent many months searching for her daughter during which time she left the earth untended: all crops withered and the ground remained barren until Proserpina was returned. In penance for this destruction Ceres is said to have travelled to Attica. There she taught the people of Attica everything she knew about tilling and sowing the ground, as well as about reaping the harvests and caring for the fruit trees. Ceres is often shown with a crown of ears of corn to remind us of her

Ceres and Harvesting Cupids Studio of Simon Vouet (1590–1649)

association with the harvest.

In the painting of *Ceres and Harvesting Cupids*, attributed to the studio of Simon Vouet, the goddess is surrounded by cupids who bundle the corn into sheaves. Ceres herself appears to look towards a man working in the cornfield. Perhaps this refers to her teaching of one, Triptolemus of Eleusis, about the art of agriculture when she went to Attica.

[Studio of Vouet (6292)]

Charlemagne, and the Meeting of Sts Joachim and Anne at the Golden Gate *see* Virgin Mary: Conception

Christ addressing a Kneeling Woman *see* Christ: Conversion

Christ among the Doctors *see* Christ: Childhood – 8

Christ and the Woman taken in Adultery *see* Christ: Conversion

Christ appearing to the Magdalen *see* Christ: Resurrection – 3

Christ appearing to St Anthony Abbot during his Temptation *see* St Anthony Abbot

Christ appearing to St Peter on the Appian Way (also known as *Domine quo vadis?*) [Apocryphal: *The Acts of Peter;* Italian 13th-century literature: Jacopo da Voragine, *The Golden Legend;* Christian writings: Eusebius, *The History of the Church*] St Peter is believed to have been martyred during the reign of Nero (AD 54–68). Tradition has it that as Peter was fleeing from Rome and Nero's persecution of the Christians he had a vision of Christ carrying his cross and moving in the opposite direction. According to The Acts of St Peter,

when Peter asked his Lord where he was going, Christ said he was returning to Rome to be crucified a second time. Peter's question, 'Domine quo vadis?' is often used as the title for depictions of this scene.

In Annibale Carracci's painting of *Christ appearing to St Peter on the Appian Way* we sense not only St Peter's amazement at seeing his Lord, but also a turning of the body which suggests the saint has already made up his mind to go back to Rome to face his own death. According to the fourth-century Christian historian Eusebius, Peter commanded his persecutors to crucify him upside down, since he felt he was unworthy of suffering the same martyrdom as his Lord.
[Annibale Carracci (9)]

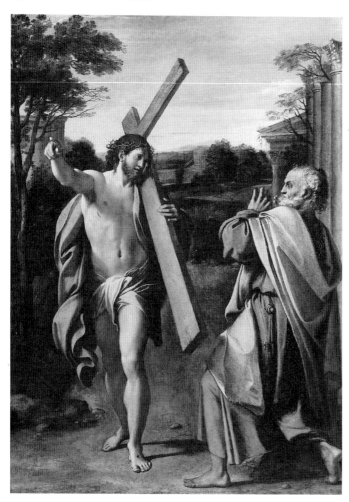

Christ appearing to St Peter on the Appian Way (also known as *Domine quo vadis?*) Annibale Carracci (1560–1609)

Christ appearing to the Virgin *see* Christ: Resurrection – 2
Christ appearing to the Virgin with the Redeemed of the Old Testament *see* Christ: Resurrection – 2
Christ as the Light of the World *see* Christ: Ministry – 9

Christ at Gethsemane *see* Christ: Passion – 4

Christ: Baptism – 1

Christ blessing St John the Baptist [Biblical: Matthew 3. 13–17; Mark 1. 1–11; Luke 3. 1–22; John 1. 6–34] All the Gospels describe how St John the Baptist baptised in the Wilderness using the waters of the River Jordan and foretelling the greatness of the one who would subsequently come to baptise with the Holy Ghost. However, it is only in the Gospels of John and Matthew that we are given any detailed description of the first meeting between John and his cousin Jesus. In John we learn that the Baptist saw Jesus coming and declared to those standing around: 'Behold the Lamb of God, which taketh away the sin of the world'. In the Gospel of Matthew we learn also how John at first refused to baptise Christ, pleading rather that Christ should baptise him.

Moretto da Brescia's painting of *Christ blessing St John the Baptist* seems to refer to both of these texts. John in traditional camel cloth and loincloth of animal skins kneels as if in obeisance in front of Jesus, with head bowed in humility. Christ, stretching out his hand in blessing, seems however about to issue some command. It is as if we witness that moment when Christ responds to John's reluctance to baptise him by saying 'Suffer it to be so now: for thus it becometh us to fulfil all righteousness.'

[Moretto (3096)]

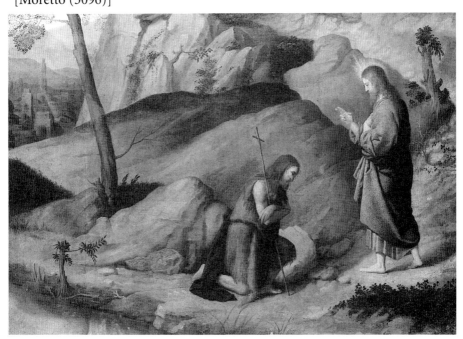

Christ blessing St John the Baptist Moretto da Brescia (about 1498–1554)

Christ: Baptism – 2

Baptism of Christ [Biblical: Matthew 3. 13–17; Mark 1. 9–11; Luke 3. 21–2; John 1. 29–34] In most depictions of the Baptism Christ is shown standing

in the waters of the River Jordan, whilst St John the Baptist stretches out from his position on the bank and upturns a dish of water over Christ's head. Often angels stand or kneel on the opposite bank witnessing the event and discussing it among themselves, whilst they hold Christ's clothes, or offering towels with which to dry Christ's body after his baptism. Occasionally other figures are included in the scene: adoring angels massed in the sky above, and other human witnesses or hopeful neophytes below on the ground.

All the Gospels describe the moment immediately after Christ's baptism, when the heavens opened and the Holy Spirit in the form of a dove descended towards him. The first three Gospels in addition refer to the voice of God the Father acknowledging his Son at this moment of purification. But only one text, that of Matthew, indicates St John's reluctance to baptise Christ. It is probably this Gospel that Piero della Francesca chose to follow in his depiction of *The Baptism of Christ*. We sense that Christ has given his final

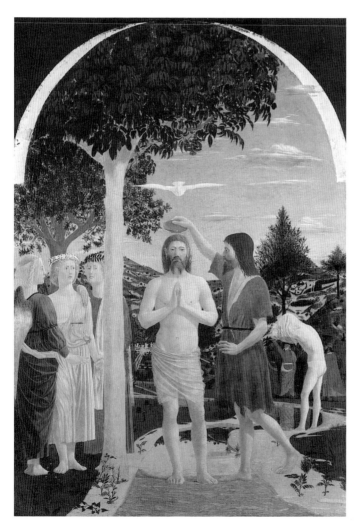

The Baptism of Christ
Piero della Francesca (about 1417–92)

command, 'Suffer it to be so now'. He stands resolutely in the water, willing St John to step towards him. John has, in fact, to put one foot into the water in order to balance while he raises the shallow baptismal bowl above Christ's head.

It is also in the Gospel of Matthew that we read of John's prophecy that 'every tree which bringeth not forth good fruit is hewn down, and cast into the fire'. This possibly explains the large number of tree stumps depicted in the back of the Piero della Francesca Baptism.

The National Gallery paintings of *The Baptism of Christ* by Adam Elsheimer and Francesco Zaganelli are unusual in that they include details unrelated to the main action. Elsheimer's work includes scenes from the life of St Peter, whilst Zaganelli's painting contains the additional figures of the Virgin Mary and another female, variously identified as the Virgin's mother St Anne, or her cousin Elizabeth who was the mother of St John.
[Elsheimer (3904); Florentine School (4208); Giovanni di Paolo (5451); attr. Niccolò di Pietro Gerini (579); after Perugino (1431); Piero della Francesca (665); Zaganelli (3892)]

Christ baptising St John Martyr, Duke of Alexandria [Legends of the Saints: B.H. Vanderberghe, *Saint Jean Chrysostome et la parole de Dieu*] Accounts of the life of the fourth-century St John Chrysostom (Duke of Alexandria) describe how John developed a firm commitment to Christianity and rose through the clerical ranks at Antioch to become archbishop of Constantinople. John's attacks on what he regarded as misappropriation of wealth in the society of his day resulted in animosity from the rich and powerful members of the imperial court, as well as the archbishopric of Alexandria. John was arrested and exiled over a period of years to ever more distant parts of the empire. He died of exhaustion on the way to a final place of exile in Iberia.

According to tradition, St John Chrysostom – whose writings included a text on the ceremony of baptism – was himself baptised as an adult by Christ. This miraculous event was said to have taken place in prison.

Paris Bordone's *Christ baptising St John Martyr, Duke of Alexandria* shows the saint kneeling before Christ in the murky interior of a prison cell. Christ annoints the head of the saint, whilst a pair of angels hover in the background holding towels and a jug of holy water. To this extent the painting follows traditional iconography of St John baptising. Attendant angels frequently hold cloths with which to dry the newly purified soul in scenes of baptism. But they are traditionally in attendance to John the Baptist rather than Christ, and such scenes invariably take place in the open air, by the banks of the River Jordan.
[Bordone (3122)]

Christ before the High Priest *see* Christ: Passion – 6
Christ before Pilate *see* Christ: Passion – 7
Christ blessing the Children *see* Christ: Ministry – 7
Christ blessing St John the Baptist *see* Christ: Baptism – 1
Christ carried to the Tomb *see* Christ: Death – 3
Christ carrying the Cross *see* Christ: Passion – 10

Christ: Childhood – 1

Nativity
Nativity with God the Father and the Holy Ghost
Nativity at Night
Nativity with Saints
Mystic Nativity
Holy Family with Saints in a Landscape
[Biblical: Luke 2. 1–7]

Many paintings described as the Nativity of Christ in fact combine this scene with a number of other episodes from the early life of the Christ child, such as the Adoration of the Shepherds, the Rejoicing of the Angels, and even the later apocryphal meeting between the child Christ and his slightly older cousin John the Baptist. (This final scene is depicted in the National Gallery painting of *The Holy Family with Saints in a Landscape* ascribed to the studio of Rubens.)

The National Gallery paintings offer a number of variations on the subject of the Nativity. The only pure Nativity is that ascribed to the Venetian School which shows only the Christ child and his parents Mary and Joseph, in reverence before him.

The Bible describes how when Mary's time was near she travelled up to Bethlehem with her husband Joseph to be taxed. Luke tells us that whilst they were at Bethlehem Mary felt the first birth pangs and, after delivering her son, wrapped him in swaddling clothes and laid him in a manger because there was no room in the inn.

With time the iconography of the Nativity became increasingly elaborate, including not only the more obvious details such as the animals of the stable, but also an augmented human cast – midwives who bathe and clothe the child and attendant cherubs who kneel in adoration. The setting itself also changed: from the background of the simple stable artists gradually developed fantastic ruins of classical architecture. Many of these details evolved under the influence of medieval texts such as the thirteenth-century *Meditations on the Life of Christ*. Indeed the author of that text (perhaps following earlier sources) described Christ's birthplace as a cave, rather than the stable of the Bible.

Depictions from the Byzantine period frequently show the Nativity taking place in a cave. Some of these variations have symbolic significance. For example, changes of architecture from the old vocabulary of the classical period into something more contemporary in style were understood to symbolise the development of Christianity out of the old pagan order.

Only one of the National Gallery paintings remains clearly outside the general iconographical tradition for the Nativity. This is the altarpiece attributed to Pietro Orioli depicting *The Nativity with Saints*. In the background we see the combining of two traditions since the birth scene is set against both a cave and a shed. Joseph and Mary kneel in adoration before the Christ child who is laid on a bed of straw, as described in the *Meditations on the Life of Christ*. But this is where adherence to existing conventions ends. Apparently startled in their devotions, both Joseph and the ox glance up to

The Nativity Venetian School (?) (17th century)

look at the attendant adult figures of Saints Nicholas, Jerome, John the Baptist and Stephen. Clearly none of these could have been in attendance at the time of the Nativity. Although John the Baptist was already born, he was only a few months old. The other saints lived and were sanctified many years later. This painting thus fits more easily into the category of a Sacra Conversazione, or Holy Conversation. We pray before the saints who in turn offer their devotions to the Holy Family, and intercede for us with them.

[Botticelli (1034); Jacopo di Cione (573); Costa (3105); Crivelli (predella) (724); Geertgen tot Sint Jans (4081); Giusto de' Menabuoi (side panel) (701); after Van der Goes (2159); Margarito (side scene) (564); follower of Masaccio (3648); Mazzolino (3114); attr. Pietro Orioli (1849); Piero della Francesca (908); Pittoni (6279); Romanino (297); Rubens (L396); attr. studio of Rubens (67); follower of Sodoma (4647); attr. Spinelli (1157); Venetian School (?) (3647)]

Christ: Childhood – 2

Adoration of the Shepherds [Biblical: Luke 2. 8–16] Although the Gospel of St Matthew describes the coming of the Wise Men from the East to find the newborn Christ child, it is in Luke that we find descriptions of the Annunciation to the Shepherds and of their subsequent journey back into town to find Mary and Joseph and the baby lying in the manger. Luke describes how the shepherds were out in the fields keeping watch over their

sheep during the long dark night hours. After being visited by the angel of the Lord the shepherds decided to leave their flocks and hurry back to Bethlehem to find the child wrapped in swaddling clothes and lying in a manger.

Most of the National Gallery depictions of the Adoration of the Shepherds reflect the biblical text in showing the Christ child either tightly swathed in cloth, or lying in loose swaddling drapes, often in a wattle manger or on a bed of straw. The humble surroundings of the child's birth are often suggested through ricketty wooden structures representing the stable, and the shadowy interior one might expect for an animal's stall. An intimate atmosphere is often generated by the soft light from lanterns and the heavenly glow of the Christ child himself. There are also frequent elaborations to this humble scene.

It became fashionable, particularly in the early Renaissance period, to insert classical ruins within the area of the stable. The wooden structure erected within these ruins to shelter and protect the young child served to symbolise the new religion growing out of the old order. Furthermore, the

The Adoration of the Shepherds
Anon. Spanish
(17th century)

shepherds themselves were frequently depicted bearing gifts of bread, fruit, lambs and birds which often refer to Christ's impending Passion. The shepherds sometimes even play musical instruments to entertain the baby, whilst heavenly and luminous cherubs cavort in the night sky above, censing their Saviour and brandishing scrolls which glorify God in Heaven.

[Follower of the Bassano (1858); attr. Bernardino (1377); Butinone (3336); Fabritius (1338); Louis(?) Le Nain (6331); North Italian School (1887); attr. Pietro Orioli (L471); Nicolas Poussin (6277); Rembrandt (47); Reni (6270); attr. Roberti (1411); Signorelli (1133); Signorelli (1776); anon. Spanish (232); Titian(4)]

Christ: Childhood – 3

Adoration of the Kings
Adoration of the Magi

[Biblical: Matthew 2. 1–11; Christian writings: Tertullian, *On Idolatry* IX; Origen, *Against Celsus* I, LX]

Sometimes described also as the Adoration of the Magi, this episode in the life of Christ is only referred to in one of the Gospels of the New Testament. According to Matthew, it was Herod, acting on the information of his own counsellors, who directed the Wise Men who came from the East to Bethlehem so that they might worship the child 'born King of the Jews'. We are told that the Wise Men – quite possibly skilled in the arts of astronomy – had seen a star in the East which they had recognised as the portent of the birth of a new king. They had travelled to Jerusalem to offer this new king gifts of gold, frankincense and myrrh. The Bible does not elaborate on the nature or character of the Wise Men; indeed it is not until the writings of Tertullian and Origen in the second and third centuries AD that any reference was made to the royalty of the Wise Men or to their precise number.

The Feast of Epiphany, originating in the East, and celebrated on 6 January (twelve days after the presumed birth of the Christ child), was traditionally seen as representing the Gentiles' recognition of the power and divinity of Christ. Biblical use of the term Gentile usually denotes those who were not of the Jewish faith. The Wise Men, or Magi, were useful symbols of those outside the faith. They were seen as representing a vast and exotic people in the East prepared to submit to the powers of the West. It was also significant that the Magi, clothed in wisdom and royal authority, had chosen in all humility to recognise and accept a new authority in the form of a vulnerable and unknown child. The very act of genuflection is central to these paintings. The kings kneel or prepare to kneel and often reach out to kiss Christ's hand or foot, thus underlining their humility in the presence of this new king.

Later descriptions and visual representations of the kings distinguished between their ages and ethnic origins. Melchior, the one who bore gold (symbolic of royalty), was seen as the oldest of the three, whereas Caspar, bearing frankincense (a symbol of divinity), was frequently depicted as a mere youth. Balthazar, bearing myrrh which was used to embalm the dead and was also a symbol of sacrifice, was frequently depicted as middle aged and with dark skin. Between them, the Magi symbolised through their adoration and offerings acceptance of Christ as both King and God, whilst at

the same time making it clear that they understood the ultimate sacrifice Christ was prepared, even as a child, to make.

Although most of the National Gallery depictions of the Adoration of the Kings distinguish between their ages and show them in humble reverence before the Christ child, there is considerable variation in the degree of interest shown in their ethnic origins and accompanying retinue. And in only one depiction, that ascribed to Bonfigli, is there any overt reference to Christ's Passion.

[Follower of Fra Angelico (582); attr. Bonfigli (1843); Botticelli (592); Botticelli (1033); Bramantino (3073); Pieter Bruegel the Elder (3556); Jan Bruegel the Elder (3547); attr. Carpaccio (3098); David (1079); Dolci (6523); Dosso Dossi (3924); Foppa (729); Giorgione (1160); attr. Girolamo da

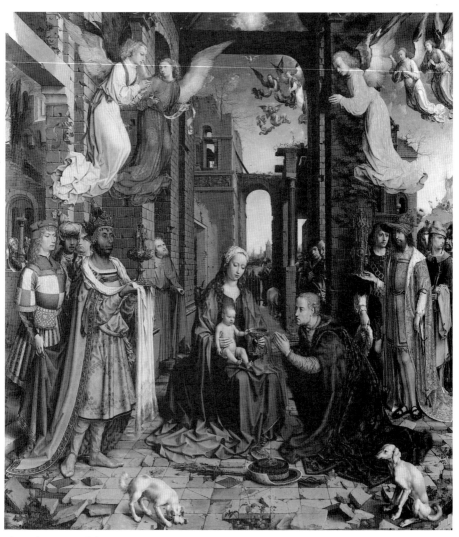

The Adoration of the Kings Jan Gossaert called Mabuse (active 1503, died 1532)

Treviso (218); Gossaert (2790); Jacopo di Cione (574); Filippino Lippi (1124); after Master of the Death of the Virgin (2155); Master of Liesborn (258); North Italian School (640); Peruzzi (167); Spranger (6392); Veronese (268)]

Christ: Childhood – 4

Presentation of Jesus in the Temple
Presentation in the Temple
[Biblical: Leviticus 12; Numbers 18. 15–17; Luke 2. 22–39]
The Bible describes how after Mary's period of purification she and Joseph brought the Christ child to Jerusalem. Under Mosaic law (the law of Moses) a woman was deemed unclean for a period of forty days after the birth of a male child. (The birth of a female resulted in a period of seclusion twice as long.) At the end of the period of purification, the woman had to bring a young lamb and a young pigeon or turtle dove as a sin offering to the door of the tabernacle of the congregation and place these before the priest. The priest then put these offerings to the Lord and prayed that the woman would be cleansed of the flow of blood issuing after birth. If the woman was unable to offer a lamb she was allowed to substitute two turtles or two young pigeons, one for a burnt offering, and the other for a sin offering.

The law of Moses also decreed that the first born of all living things should be sacrificed, although human babies could be redeemed on the payment of five shekels. Although Mosaic law commanded that the new born should be brought to the temple when a month old (before the purification of the mother), depictions of the Presentation in the Temple often combine the two scenes. Both of the *Presentation in the Temple* paintings belonging to the permanent collection of the National Gallery show the Virgin and her Child in the Temple precincts. The Master of Liesborn painting shows one caged bird, whereas that by the Master of the Life of the Virgin includes the detail of a woman holding two doves or pigeons at the left. Another woman at the right holds a single bird. These paintings clearly depict a purification scene. The Master of the Life of the Virgin scene also includes the figure of Joseph holding a candle. From an early date the Feast of the Purification included a procession with candles. For this reason it is often referred to as Candlemas.

Despite the reference to purification, it is quite clear also that the Child has a part to play. In the painting by the Master of the Life of the Virgin, Mary seems to hold her child out to the priest. In the other work, the Christ child clings anxiously to his mother's shoulder, either scrambling back to the safety of her arms or resisting being placed into the shrouded arms of an awesome-looking priest.

Luke describes how a just and devout man named Simeon had been told that he would not die before seeing Christ. Guided by intuition, Simeon came into the temple just as Jesus' parents were bringing the child in to pay the necessary dues for their first born. The Bible describes how Simeon took the child into his arms, praising God and exclaiming that he was now happy to face death. Simeon was not necessarily the officiating priest. Depictions of the Presentation in the Temple often neglect this detail from the biblical text.

Luke also refers to the old prophetess Anna who spent all her days fasting

and praying in the temple. She, likewise, offered thanks to the Lord on seeing the Christ child. Although Anna is often very clearly distinguished in depictions of the Presentation in the Temple, the National Gallery paintings are unusual in omitting any obvious reference to her. It is curious also that the figure of Joseph is missing from the Master of Liesborn's work, since the Bible refers specifically to both parents marvelling at the words of Simeon. [Guercino (L34); Master of Liesborn (257); Master of the Life of the Virgin (706)]

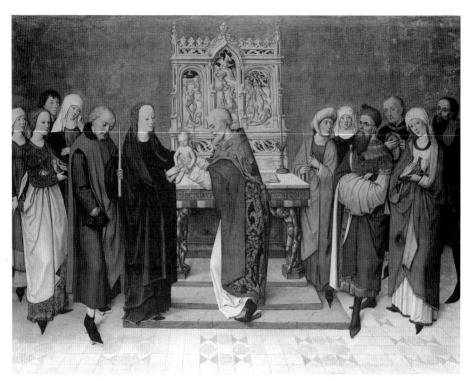

The Presentation in the Temple
Master of the Life of the Virgin (active second half of 15th century)

Christ: Childhood – 5

Circumcision [Biblical: Luke 2. 21] Only the Gospel of Luke refers to the circumcision of the Christ child which took place when he was eight days old. Luke tells us that it was on this occasion that the child was named Jesus, as foretold by the angel Gabriel.

Luke does not describe where the circumcision took place or how many people witnessed the event, but most depictions of this scene suggest that Christ was taken to the temple and was received and circumcised by a priest, even though – according to the law of Moses – the parents themselves could perform this task. Some painters combined the scene of the Circumcision with the Presentation in the Temple. In both Marco Marziale's and Luca Signorelli's paintings of *The Circumcision* the background clearly suggests a

religious sanctuary; indeed Marziale not only depicts the sanctuary lamp hanging from the vault, but also shows the Christ child seated on an altar-like pedestal. The arches of the building in Marziale's painting are also inscribed with verses from Luke's Gospel.

Mary is often shown holding the child in her lap or supporting him as the priest reaches forward to cut his foreskin. This first shedding of Christ's blood is usually thought to be symbolic of his Passion. The child rarely shows any pain; indeed in the Signorelli painting he reaches forward as if to welcome the figure who kneels at his side, scalpel poised above his thigh. This figure's clothing, as well as the book and other utensils placed on the floor suggest that he is a medical man rather than a priest.

[Workshop of Giovanni Bellini (1455); Marziale (803); Signorelli (1128)]

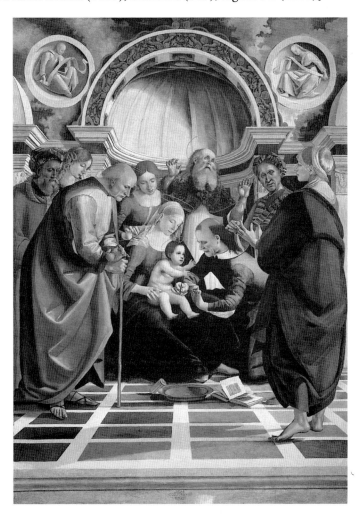

The Circumcision
Luca Signorelli
(1441(?)–1523)

Christ: Childhood – 6

Flight into Egypt
Rest on the Flight into Egypt
[Biblical: Matthew 2. 13–15; Apocryphal: *Gospel of the Pseudo-Matthew*]

The Gospel of Matthew describes how after the kings had left the Holy
Family to return to the East, Joseph was warned by an angel in a dream to
take his young wife and son away to safety in Egypt. The angel told Joseph
that Herod would seek to kill the child and that they should stay in Egypt
until they received word that it was safe to return. We read how the family set
off by night and how Herod subsequently ordered that all children under the

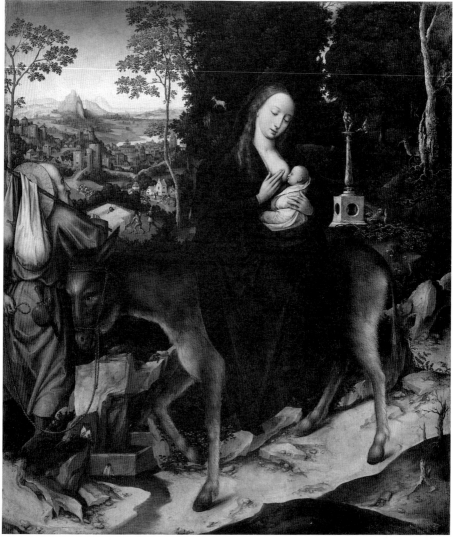

The Flight into Egypt Studio of the Master of 1518 (active early 16th century)

age of two should be killed. It was not until after the death of Herod that Joseph was once more visited by an angel in a dream and advised to return to Israel.

In the Master of 1518's painting of *The Flight into Egypt* we see Joseph turning back anxiously towards Mary who sits on the back of the mule suckling her child. Joseph's glance directs our attention to the background where we witness not only the Massacre of the Innocents but also scenes drawn from later apocryphal texts.

According to the apocryphal *Gospel of the Pseudo-Matthew* the statues of baalim, or pagan gods, crumbled to the ground when the Virgin and Child went into an Egyptian temple. Depictions of the Flight into Egypt often refer to this incident by including a column with a tumbling statue in the background, as in the National Gallery painting by the Master of 1518. Another elaboration on the biblical text describes how the Holy Family passed a worker sowing seeds of corn in the fields as they fled the wrath of Herod. Pausing for a moment, they begged the farmer not to betray them in their flight, the Virgin suggesting that if he were questioned he should say that he saw the family pass by at the time of sowing.

The National Gallery painting of a *Landscape with the Rest on the Flight into Egypt* attributed to the workshop of Joachim Patenier shows the Virgin pausing to suckle her child, whilst a farmer tills the fields in the background. The apocryphal text describes how overnight the seeds miraculously grew into ripe corn ready for harvesting. Thus, when Herod's men arrived in hot pursuit the next day and questioned the farmer about the fugitives, they gave up the chase, believing the Holy family to have passed by many weeks before, when the corn was first seeded in the ground.

[Lastman (L162); studio of the Master of the Female Half-Lengths (720); studio of the Master of 1518 (1084); Mola (160); Patel (6513); attr. workshop of Patenier (3115); Van der Werff (3909)]

Christ: Childhood – 7

Massacre of the Innocents [Biblical: Matthew 2. 16] When Herod realised that the Wise Men had gone back to their own countries without telling him where the Christ child lay, he was filled with great anger. Not only was he angry to have been tricked, but he was also conscious that this new 'King of the Jews' posed a real threat to his own authority. The Bible describes how Herod ordered his soldiers to kill all the new born babies and children under the age of two, both in Bethlehem and in all the surrounding countryside. This episode became known as the Massacre of the Innocents.

Most depictions of the Massacre of the Innocents show Herod enthroned in his palace in the act of giving this dreadful order, or intent on watching the subsequent slaughter. Gerolamo Mocetto's two paintings of *The Massacre of the Innocents* suggest an elaboration of the traditional iconography by including a group of cowed and frightened women (clasping their babies) who are gathered in front of Herod. It seems that after hearing Herod speak they will hand their precious bundles over to the soldiers in the foreground. Yet in the left-hand scene many women and children are being attacked outside the palace. The soldiers are already carrying out Herod's order,

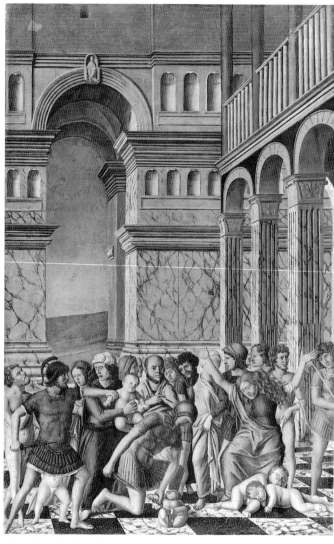

*The Massacre of the
Innocents* (left)
Gerolamo Mocetto
(about
1458–1531(?))

despite the fact that those inside still hope for a reprieve.
[Mocetto (1239); Mocetto (1240)]

Christ: Childhood – 8

Christ among the Doctors
Christ disputing with the Doctors
[Biblical: Luke 2. 41–50]

According to Luke, when Christ was twelve years old he went up to Jerusalem
to celebrate the feast of the Passover. Luke tells us that this was a yearly
custom. There was nothing strange therefore in Jesus going to the city with
his parents Joseph and Mary. However, on this occasion, something unusual
happened. After Passover, Joseph and Mary left Jerusalem and travelled a
whole day before discovering that Jesus was not among their group of
relatives and friends. They hurried back to the city and spent several anxious

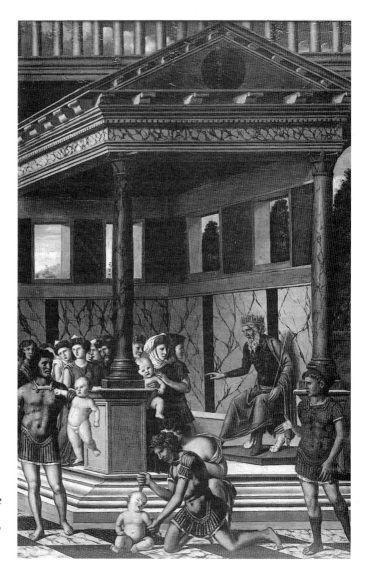

The Massacre of the Innocents (right) Gerolamo Mocetto (about 1458–1531(?))

days looking for Jesus. On the third day they found him in the Temple, unconcerned and discussing religious matters with the elders with great maturity and understanding.

Ludovico Mazzolino's *Christ disputing with the Doctors* catches the atmosphere of serious discourse between adult and child. It has sometimes been suggested that Bernardino Luini's painting of *Christ among the Doctors* shows Christ disputing with the Pharisees as an adult since he seems not to have the body or face of a young boy. However, Luke tells us that when the Virgin chastised her son, telling him how anxious and worried they had been at his disappearance, Jesus answered with precocious independence, 'How is it that ye sought me? Wist ye not that I must be about my Father's business?' Luini's figure suggests both the confidence of the child prodigy and the quiet

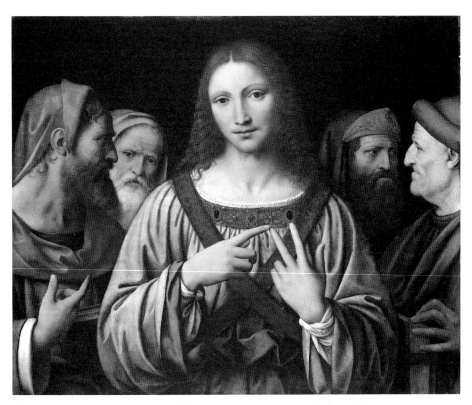

Christ among the Doctors Bernardino Luini (active 1512, died 1532)

sense of purpose of the mature adult.

[Luini (18); Mazzolino (1495); Neapolitan School (1676)]

Christ: Conversion

Conversion of the Magdalen

Christ and the Woman taken in Adultery

Woman taken in Adultery

Christ addressing a Kneeling Woman

[Biblical: Mark 16. 9; Luke 8. 2; John 8. 2–11]

The Bible tells us how when Jesus was in the Temple the Pharisees brought a woman to him whom they had caught in the act of adultery. Testing Jesus, they asked how the woman should be punished, reminding him that according to ancient law such sinners should be stoned to death. John tells us that Jesus refused to respond immediately to the Pharisees, but bent down instead and wrote on the ground. Jesus then answered that if there was any person in the crowd who was without sin that person should be the first to cast a stone at the adulteress.

Both Ludovico Mazzolino's *Christ and the Woman taken in Adultery* and Rembrandt's *The Woman taken in Adultery* appear to depict the moment of this command. Rembrandt's painting is particularly evocative of the Gospel text, since it emphasises the quiet circle around Jesus as well as the pressing

throng. With Rembrandt we also anticipate the end of the story when the woman was left alone with Jesus and was told she was free to go and that she should sin no more.

The central pool of light and the pale figure of the kneeling woman in the Rembrandt painting seem to suggest both her salvation and her purification. The Gospel of John describes how the woman's accusers gradually slunk away in embarrassment and shame under Christ's command. When the woman was finally left alone in the midst of the crowd who had come to hear Jesus teaching in the Temple, he turned to her, saying, 'Where are those thine accusers? Hath no man condemned thee?'

The conversion of Mary Magdalene is also often depicted as taking place in the precincts of the Temple, although the Gospels of Mark and Luke do not elaborate on this, merely noting that she was cured of seven devils. The National Gallery's painting of *The Conversion of the Magdalen*, attributed to a follower of Zuccari, shows Jesus gesturing towards a finely clothed woman as if blessing her, whilst one of the figures standing close by encourages her to lift herself up and draw near. The Veronese work, which was for some time known as *St Mary Magdalene laying aside her Jewels* and is now called *Christ addressing a Kneeling Woman*, no doubt also depicts a moment of conversion although it is uncertain whether it refers to the Magdalen or to the woman taken in adultery. There is an air of both intimacy and protection which fits well with the Gospel description when Christ said to the woman taken in adultery, 'Go and sin no more'. Her loosened hair and the broken necklace hanging from one side of her neck could well reflect the anger and violence of

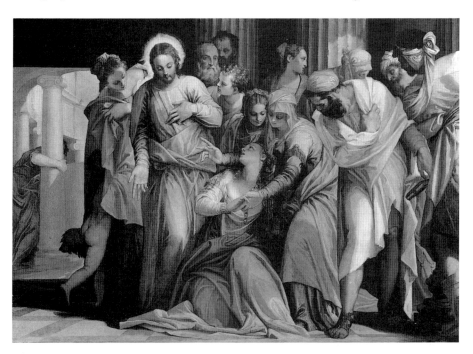

Christ addressing a Kneeling Woman Paolo Veronese (1528(?)–88)

the people who discovered her adultery and dragged her in front of Christ. But these same details could also suggest that this is the conversion of Mary Magdalene who is about to cast aside the evidence of her previous life as a prostitute.

[Mazzolino (641); Rembrandt (45); Veronese (931); follower of Zuccari (1241)]

Christ crowned with Thorns *see* Christ: Passion – 8

Christ Crucified *see* Christ: Crucifixion

Christ: Crucifixion
Christ nailed to the Cross
Christ Crucified
Christ on the Cross
Crucified Christ with the Virgin Mary, Saints and Angels (also known as *The Mond Crucifixion*)
Coup de Lance
Crucifixion
Scenes from the Passion
Symbolic Representation of the Crucifixion

[Biblical: Matthew 27. 33–56; Mark 15. 22–41; Luke 23. 33–49; John 19. 18–37]

Although Christ is sometimes shown hanging alone on the cross against a desolate or rocky background (as, for example, in Delacroix's *Christ on the Cross* and Giusto de' Menabuoi's *Christ Crucified*) most depictions of the scene include the other two crosses on which two thieves were crucified along with Christ.

In nearly all depictions of the Crucifixion a number of mourning figures are shown gathered around Christ's cross. The Virgin Mary usually stands to our left, whilst John (Christ's most beloved disciple) stands to the right. Indeed the Gospel of John tells us how Jesus turned to Mary and consigned John to her as a son, and then, turning to John, recommended Mary to him as a mother. We are told how John then took care of the Virgin Mary, taking her into his own home and treating her like his own mother.

Sometimes depictions of the Crucifixion show the Virgin swooning in the arms of her female companions; at other times she sits at the base of the cross as if in resigned despair. Antonello da Messina's painting of *Christ Crucified* is unusual in showing the figures of the Virgin and St John quietly waiting for the end. Yet the Virgin's bowed head and John's gesture suggest that we may be witnessing the conversation with Christ.

Few artists chose to show the moment when Christ was stripped of his clothes and attached to the cross, perhaps because the subject was so particularly gruesome. Yet Gerard David's painting of *Christ nailed to the Cross* depicts the forceful cruelty of those who stretch Christ's body and pierce his limbs with vicious nails.

According to John, shortly after Christ expired on the cross, these same soldiers came to break the legs of those being crucified in order to hasten their deaths. But finding Jesus apparently already dead, they left him untouched. One of the soldiers, however, thrust his spear into Christ's side,

and marvelled at the issue of blood and water from the corpse. This soldier is traditionally identified as St Longinus.

Rubens' painting of the *Coup de Lance* contrasts the grotesquely distorted bodies of the thieves at either side with the central corpse of Christ which hangs straight on the cross. To the left the figure of a soldier on horseback, placed somewhat high in the composition, is shown in the act of piercing Christ's side with his lance, hence the title *Coup de Lance*.

The Gospels also describe how the soldiers gambled for Christ's clothes, whilst others stood and mocked his suffering. Many depictions of the Crucifixion include the great throng of people who witnessed the various

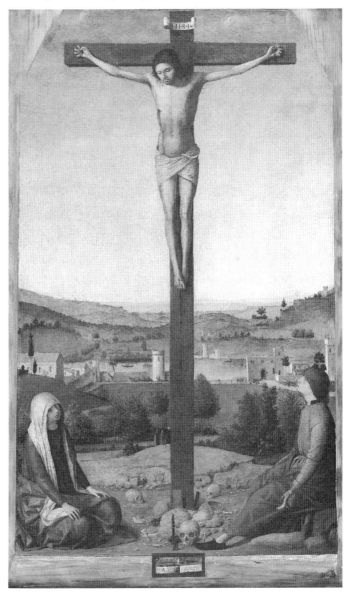

Christ Crucified
Antonello da
Messina (active
1456, died 1479)

events that took place during the last hours of Christ's life. The painting of *The Crucifixion* attributed to Jacopo di Cione vividly captures the confusion, argument, violence and despair of the event.

[Antonello (1166); Barnaba da Modena (side panel) (2927); attr. Bonfigli (1843); Castagno (1138); David (3067); Delacroix (6433); Giusto de' Menabuoi (side panel) (701); attr. Jacopo di Cione and workshop (1468); Mansueti (1478); studio of Massys (715); Master of the Aachen Altarpiece (1049); follower of the Master of the Death of the Virgin (1088); Master of Delft (2922); Master of Liesborn (259); attr. Master of Liesborn (262); Master of Riglos (6360); studio of the Master of 1518 (718); Niccolò di Liberatore (1107); attr. Pietro Orioli (predella) (1849); Raphael (3934); Rubens (1865)]

See also Christ: Passion – 10

Christ: Death – 1

Deposition

Deposition from the Cross

[Biblical: Matthew 27. 57–8; Mark 15. 42–6; Luke 23. 50–4; John 19. 38–40]

A number of paintings described as the Deposition of Christ show the dead Christ already taken down from the cross and lamented over at its base. Both paintings of *The Deposition from the Cross* in the National Gallery by Giovanni Domenico Tiepolo in fact depict the Lamentation. Strictly speaking, the Deposition should show that moment when Christ was physically lifted away, or removed from the cross and then lowered to the ground. Ugolino di Nerio and the Master of the St Bartholomew Altarpiece are thus the only two artists in the National Gallery's collection to show an actual Deposition. Other paintings fit more easily under the title of Lamentation over the Dead Christ.

Although all the Gospels describe how Joseph of Arimathea took the body of Jesus and laid it in his own tomb, none of the biblical texts describes the physical action required in taking the body off the cross. Nor is there any reference to figures standing at the base of the cross. However, later texts such as the thirteenth-century *Meditations on the Life of Christ* describe the Deposition in great detail. We learn that Joseph attempted to take the right-hand nail out first, but had to exert great pressure on Christ's body in order to remove it, because it was long and heavy and was firmly attached to the wood. We read that Joseph then handed this nail down to John so that the Virgin should not be made so acutely aware of her son's suffering. At the same time Nicodemus, who is only mentioned in the Gospel of John, is said to have pulled the nail from the left hand. Then both Joseph and Nicodemus gently lowered the body of Christ to the ground where the Virgin Mary and others came forward to gather him in their arms and lament.

The Master of St Bartholomew's depiction of *The Deposition* is particularly chilling in its observation of the stiff, outstretched arms of Christ – assuming the form of the cross even when lifted away from it. The Ugolino de Nerio painting of *The Deposition* by comparison suggests a soft and limp embrace between Mother and Son. In this painting also we see how a third nail in Christ's feet has still to be levered away with a pair of tongs. We are thus made acutely aware of the support required from the other two male figures

The Deposition
Master of the
St Bartholomew
Altarpiece (active
about 1470–about
1510)

if the Virgin is not to crumble under the weight of her son's corpse.
[David (1078); Master of the St Bartholomew Altarpiece (6470); Giovanni
Domenico Tiepolo (1333); Giovanni Domenico Tiepolo (5589); Ugolino di
Nerio (3375)]

Christ: Death – 2

Lamentation
Lamentation over the Body of Christ
Lamentation over the Dead Christ
Dead Christ mourned (also known as *The Three Maries*)
[Biblical: Matthew 27. 55–6; Mark 15. 40 and 47; Luke 23. 49; John 19. 25–7]
Although there is some reference in the Gospel of Luke to the Deposition of

Christ, involving the physical lowering of his body from the cross, there is no description in any of the Gospels of the Lamentation over the Dead Christ taking place at the base of the cross.

Both Matthew and Luke do, however, describe how many of Christ's friends and the women who had followed him from Galilee stood some distance from the cross witnessing Christ's agony. And Matthew and Mark make specific reference to Mary Magdalene, Mary (the mother of James the less and Joses) and Mary Salome being among the crowd. But it is in John that we find a reference to the three Maries (the Virgin Mary, her sister Mary,

The Lamentation over the Dead Christ Rembrandt (1606–69)

the wife of Cleophas, and Mary Magdalene) and the disciple John standing by the cross, close enough to hear the words delivered to them by Christ in the last moments of his life.

Matthew and Mark also describe how Mary Magdalene and Mary the mother of Joses saw where Joseph of Arimathea laid the body of Christ after he had taken him down from the cross.

It was probably a combination of all four Gospels which led to the iconography of the dead Christ laid out on the ground and mourned over by his close family and friends. Later religious texts embroidered the biblical sources, so that the subject was well established by the Middle Ages. Annibale Carracci's *The Dead Christ mourned* adheres closely to Matthew and Mark in showing the Maries clustered around Christ's body. The background suggests that Joseph of Arimathea has already brought Christ to the tomb and laid a cloth on the ground to prepare him for burial.

The dead Christ is often shown cradled in the Virgin's arms whilst the Magdalen caresses his feet and John the Evangelist stands in deep sadness nearby. Sometimes – as in the Rembrandt painting of *The Lamentation over the Dead Christ* – the Virgin herself is supported by John or by one of the other Maries. And very occasionally – as in the painting of *The Lamentation over the Dead Christ* by Jusepe Ribera – John lifts Christ into a half sitting position so that the Virgin can contemplate her dead son.

In keeping with many other Lamentations over the Dead Christ, Rembrandt's painting evokes the spirit and character of a public crucifixion in the place of skulls, just outside the walls of Jerusalem. By comparison Ribera's work suggests a quieter place. Perhaps we are meant to see here the moments before Christ was entombed – already carried a little way from Golgotha, and laid out on a winding sheet so that his body can be anointed with spices. Ribera's painting asks us to witness a moment of private grief and awe in the face of death.

[Annibale Carracci (2923); Dosso Dossi (4032); attr. Francia (2671); Guercino (22); Rembrandt (43); Ribera (235); Giovanni Domenico Tiepolo (1333); Giovanni Domenico Tiepolo (5589); workshop of Van der Weyden (6265)]

Christ: Death – 3

Christ carried to the Tomb
Dead Christ in the Tomb, with the Virgin Mary and Saints
Entombment
Entombment of Christ
Lamentation over the Dead Christ
Mourning over the Dead Christ
Pietà (also known as *Lamentation*)
Pietà with Two Angels
[Biblical: Matthew 27. 57–61; Mark 15. 42–7; Luke 23. 50–6; John 19. 38–42]
After Christ's death on the cross, Joseph of Arimathea – one of the bystanders who had thronged to Golgotha to witness the crucifixion – asked Pilate if he could take the body and bury it in a cave in a nearby garden. The Gospels describe how the body of Jesus was wrapped in a clean linen cloth and laid at

the dead of night in a tomb that had been hewn out of the rock. Matthew and Mark tell us that this was Joseph's own tomb; they also refer to the solitary figures of Mary Magdalene and Mary the mother of Joses who are said to have seen where Joseph of Arimathea laid Christ's body.

However, there is an elaboration of the story in Luke and John. Luke tells us that several women followed Joseph to the tomb. Dosso Dossi's *Pietà* (recently retitled *Lamentation*) shows the Virgin Mary and two other women in great distress as they gather round the body of Christ. Christ has clearly been taken away from Golgotha, since the crosses appear on the hill in the background. It is also clear that the instruments of his torture, the nails and the crown of thorns, have been removed. Christ's body is supported by a cushion which lies on the ground in front of the entrance to the tomb.

The Gospel of John is the only one to refer to Nicodemus who helped Joseph prepare Christ's body before laying it in the tomb. Nicodemus may well be the figure who holds Christ's feet and helps to lower his body into the tomb in Dieric Bouts' painting of *The Entombment*. And presumably the same Nicodemus helps Joseph of Arimathea to carry the sagging body of

Christ carried to the Tomb
Sisto Badalocchio
(1585–after 1621(?))

Christ in its winding sheet in Sisto Badalocchio's painting of *Christ carried to the Tomb*.

[Badalocchio (86); Bouts (664); Busati (3084); Dosso Dossi (4032); Francia (180); Guercino (22); studio of the Master of the Prodigal Son (266); Michelangelo (790); Niccolò di Liberatore (side panel) (1107); attr. Pietro Orioli (predella) (1849); Palmezzano (596); style of Ysenbrandt (1151)]

Christ disputing with the Doctors *see* Christ: Childhood – 8

Christ driving the Traders from the Temple *see* Christ: Ministry – 10

Christ after the Flagellation contemplated by the Christian Soul *see* Christ: Passion – 7

Christ healing the Paralytic at the Pool of Bethesda *see* Christ: Ministry – 4

Christ: Ministry – 1

Christ teaching from St Peter's Boat on the Lake of Gennesaret [Biblical: Luke 5. 1–3] Luke describes how a great crowd gathered around Jesus to hear him speak when he was standing by the Lake of Gennesaret. Seeing two empty boats lying idle in the water, Jesus stepped into one and asked the owner, Simon (better known as Peter, but often referred to as Simon Peter), to thrust the boat out into the water a little way. Then Jesus sat down and preached to the people from the boat.

Herman Saftleven's painting *Christ teaching from Saint Peter's Boat on the Lake of Gennesaret* shows a number of vessels on the lake. Christ has entered the largest one close to shore.

[Saftleven (2062)]

Christ: Ministry – 2

Miraculous Draught of Fishes [Biblical: Luke 5. 1–11] After Jesus had

The Miraculous Draught of Fishes Peter Paul Rubens (1577–1640)

preached from a boat on the Lake of Gennesaret, he commanded the owner of the boat, Simon Peter, to take it into the deep waters and cast out his nets. Simon Peter answered that they had been toiling all night without success; but he did what Jesus suggested, and to his amazement the nets filled immediately with fish – to such an extent that the nets themselves broke. Simon Peter had to call to his partners (James and John, the sons of Zebedee) in the other boat to come and help with the catch.

In the end both boats were so full of fish that they started to sink. At this Simon Peter fell down in front of Jesus in fear, calling him Lord and imploring him to leave: 'Depart from me; for I am a sinful man, O Lord'. The Bible describes how Jesus calmed Simon Peter's fears, telling him that he would thereafter become a fisher of men. This story marks the calling of the first three disciples, since, having brought their ships back to land, the fishermen decided to leave their old lives and follow Jesus.

Rubens' painting of *The Miraculous Draught of Fishes* shows the two boats lying low in the choppy water, so laden with fish that some of the men have had to get out to help drag the nets on land. In the nearest boat Simon Peter is shown in a position of humility (tinged with some apprehension), as with averted gaze he appears to beg the standing figure of Jesus to leave.
[Rubens (680)]

Christ: Ministry – 3

Marriage at Cana [Biblical: John 2. 1–11] The Bible describes how Jesus, his disciples and the Virgin Mary were invited to a wedding in Cana. When Jesus and his disciples asked for wine the Virgin told them that there was no wine at the feast. This is one of the occasions when Jesus seems to have answered his mother somewhat brusquely. Turning to her he delivered a curious little speech which not only set up a barrier between them ('Woman, what have I to do with thee?'), but also seemed to hint at Christ's future Passion ('Mine hour is not yet come').

Mary understood both the rebuke and the foresight. Going to the servants she told them to do whatever Christ ordered. Then Jesus ordered that six great stone pots should be filled with water and that some of the liquid should be drawn out and taken to the 'governor' of the feast. Expecting it to be water but finding that it tasted of wine, the governor called the bridegroom and congratulated him on the quality of his wine. Indeed he praised the groom for putting out his best wine at the end of the feast rather than offering it first to impress his guests. The governor noted that it was more usual for inferior wines to be offered at a later stage in the feast in the hope that people's palates would no longer be so discerning. The Bible does not reveal the bridegroom's reply, but this miracle of the changing of the water into wine was clearly a turning point in the relationship between Jesus and his disciples. Such a transformation confirmed their belief in their new master's special powers.

In Mattia Preti's painting of *The Marriage at Cana* the bride and groom are not immediately recognisable, although it seems likely that they are the two figures seated to the left of the guest who leans forward to have his glass filled. To the right we see the Virgin Mary, quietly watchful, and mindful of

The Marriage at Cana Mattia Preti (1613–99)

her tongue as Jesus (to her left) gestures down to a great pot which is being filled with water from a pitcher held by a servant. In the centre, and with his partially clothed back to us, another servant pauses to look over his shoulder as a Moorish figure pours liquid into the glass. The guest offering his glass is presumably the governor, since none of the other guests has yet been offered the miraculous draught.
[Preti (6372)]

Christ: Ministry – 4

Christ healing the Paralytic at the Pool of Bethesda [Biblical: John 5. 2–8] The Gospel of John describes how Christ came upon a cripple lying by the pool of Bethesda in Jerusalem. Many people who were sick or infirm congregated round this water in the hope that one day they might be cured. It was known that the pool was occasionally visited by an angel who stirred up the surface of the water. Whoever went down into the water first after the angel's visit was miraculously cured.

Murillo's painting of *Christ healing the Paralytic at the Pool of Bethesda* keeps close to the original text. Not only does it show an angel descending, but also a view of the porches surrounding the pool which gave it its Hebrew

Christ healing the Paralytic at the Pool of Bethesda
Bartolomé Esteban Murillo (1617–82)

name Bethesda. In the foreground we see Christ gesturing to the cripple who stretches out his hands as if in despair. John describes how this individual, having no one to help carry him to the pool, was never able to enter the waters first after the angel's visit. Christ's response was to tell the cripple to get up, take his bed and walk. Whilst the surrounding figures seem to commiserate with the sick man's lament, Christ's own stance seems both to encourage and to beckon him upwards.

[Murillo (5931)]

Christ: Ministry – 5

Transfiguration [Biblical: Matthew 17. 1–3; Mark 9. 2–4; Luke 9. 28–32] Depictions of the Transfiguration usually show Christ standing on a hill between two bearded and venerable figures, whilst three of his disciples lurch back in astonishment at a lower level, as if blinded by a great light, and amazed at the scene above them.

Three of the Gospel texts refer to this event, describing how Christ took Peter, James and John on to a high mountain and was transfigured before them, his face lit up and his clothes appearing white as snow. All three

Gospels refer also to the appearance of the prophets Moses and Elijah who seemed to talk with Christ. But Luke describes the scene in particular detail. We read that Christ's face changed as he prayed, and that his clothes were 'white and glistering'.

We also learn something about the conversation between Christ and the prophets. Luke tells us that Moses and Elijah prophesied that Christ would die in Jerusalem. An interesting textual variation is Luke's suggestion that the disciples had only just woken from a deep sleep, when they witnessed their Lord transfigured by light.

The Russian school painting in the National Gallery of *The Transfiguration* catches this moment well. Great rivers of light flood out from Christ's body towards the huddled forms of the disciples on the lower slopes. Only Peter seems, for the moment, aware of the vision on the mountain top. It was in fact an established convention to show one of the disciples witnessing the Transfiguration.

[Duccio (1330); Russian School (4163)]

Christ: Ministry – 6

Tribute Money [Biblical: Matthew 22. 15–22; Mark 12. 13–17; Luke 20. 20–6] Depictions of the Tribute Money are sometimes also described as the Tribute to Caesar, since they show the moment when Christ, questioned by cunning Pharisees, answered that coins bearing the head and inscription of Caesar should be rendered to Caesar rather than to any other. Christ went on to say that what belonged to God should be rendered to God.

The basic issue here was the payment of tax. The Pharisees hoped that Christ would compromise himself by refusing to acknowledge his civic duty.

As is often the case, the Gospel of Luke embroiders the story told in the other Gospels. We learn, for example, that the chief priests and scribes sent out spies to test Jesus, but disguised, so that Christ would assume that their enquiries were innocent, and thus possibly lower his guard. Luke also tells us that these same spies were struck dumb by Christ's response, and were left marvelling.

None of the Gospels gives precise details about the surroundings in which this incident took place. But the scene is often shown in the Temple in Jerusalem where Jesus was preaching.

Titian, in his painting of *The Tribute Money*, appears to pay close attention to the biblical texts, and particularly to Luke. Jesus stands against a rough masonry wall, turning slightly backwards, as if caught moving away. His clear gaze and gestures suggest that he has already dismissed the question about the payment of tax, and has proceeded to the next point which deals with obligations towards God the Father. The sinister character of Christ's questioners is suggested by the piercing eyes and cunning profile of the bespectacled man leaning forward in the background, and by the wheedling pose of his companion in the foreground. This man looks up into Christ's face as if willing him to turn his attention once again to the coin. At the same time, he clutches the purse attached to his belt as if fearful of pickpockets. These two heads, so engrossed in Christ's response, and so obviously rendered speechless by it, are clear visual reflections of Luke's text.

[Titian (224)]

Christ: Ministry – 7

Christ blessing the Children (also known as *Suffer the Little Children to come unto Me*) [Biblical: Matthew 19. 13–15; Mark 10. 13–16] The Bible tells us that when Christ was preaching in Judaea, many thronged around him. Some came to be healed; others – the Pharisees – came to pose difficult questions. Many also came with their children, hoping that Christ would touch them and pray for them. Both Matthew and Mark tell us that the disciples attempted to hold them back. But Jesus intervened, telling the disciples not to bar their way: 'Suffer the little children to come unto me, and forbid them not: for such is the kingdom of God. Verily I say unto you, Whosoever shall not receive the kingdom of God as a little child, he shall not enter therein.'

In Nicolaes Maes' painting of *Christ blessing the Children* we witness the moment when the throng, mainly of mothers and their children, has pressed forward around Christ. One nudges her young one towards the seated Christ

Christ blessing the Children (also known as *Suffer the Little Children to come unto me*) Nicolaes Maes (1634–93)

to receive his blessing; another thrusts a young child in the air, perhaps hoping that a mere glimpse will guarantee salvation.
[Maes (757)]

Christ: Ministry – 8

Jesus opens the Eyes of a Man born Blind [Biblical: John 9. 1–7] The Gospel of John describes how when Jesus was preaching and teaching in Jerusalem, he came upon a man who had been blind from birth. The disciples questioned Jesus whether this disability was a punishment for the man's own sin or that of his parents. Jesus answered that neither was to blame, and that the man had been born blind so that one day he should see the light. His meaning, as the subsequent miracle showed, was that the man should not only regain his sight, but at the same time should recognise that Jesus was the light of the world.

The Bible tells us how Jesus spat on the ground and made a soft clay with the spittle, before reaching out and placing some of it on the man's eyes. He then told the blind man to go to the pool of Siloam to wash.

Duccio's painting known as *Jesus opens the Eyes of a Man born Blind* shows two separate episodes: first the anointing of the eyes, and then the regaining of sight. We know the blind man sees, since he has laid his stick down by the water, and raises a hand in astonishment as he lifts his eyes in wonder. Duccio catches beautifully the straining figures of the disciples, still worrying no doubt about the concept of sin passing from the father to the son, yet conscious that something strange and wonderful is about to happen.
[Duccio (1140)]

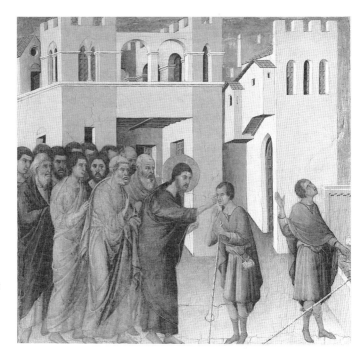

Jesus opens the Eyes of a Man born Blind
Duccio (active 1278, died 1319)

Christ: Ministry – 9

Christ as the Light of the World [Biblical: John 8. 12] After Christ had been tested in the Temple by the Pharisees, who brought a woman taken in adultery to him for judgement [*see* Christ: Conversion], he turned to the people and said, 'I am the light of the world: he that followeth me shall not walk in darkness, but shall have the light of life.'

Paris Bordone's painting of *Christ as the Light of the World* shows Christ, right hand raised in gesture as if about to declaim, and left hand holding a scroll. Inscribed on the scroll is the first part of the text from John written in Latin: 'Ego sum lux mu[n]d[i]' ('I am the Light of the World').
[Bordone (1845)]

Christ as the Light of the World
Paris Bordone (1500–71)

Christ: Ministry – 10

Christ driving the Traders from the Temple
Purification of the Temple
[Biblical: Matthew 21. 12–13]
The Bible tells us how Jesus went into the Temple after his triumphal entry into Jerusalem on the back of an ass. This was the last time Christ went to the city before the Crucifixion. His arrival was greeted with great joy; crowds of people cut branches from the trees and strewed them on the ground in front of him, along with the clothes that they tore from their own backs. This was truly a moment of triumph, and it was followed by a very purposeful gesture on Christ's part. Matthew describes how Christ strode into the Temple, casting out all those who were trading there, and overturning their tables and stalls.

The paintings by Bernardo Cavallino and El Greco of *Christ driving the Traders from the Temple* adopt strong contrasts of light and shade to draw attention to the vengeful figure of Christ in the centre of the composition. By comparison Christ's action and the traders' response is calmer in *The Purification of the Temple* by Michelangelo. Indeed their figures seem almost

lost in the majestic space of the Temple precinct.

Although many depictions of Christ driving the Traders from the Temple show the enraged figure of Christ raising his fist against those who have set up their stalls there, few embellish the scene to such an extent as Jacopo Bassano in his great painting of *The Purification of the Temple*. Here we not only find the money changers and sellers of doves cowering away from the vengeful figure of Christ, but many other figures falling back in horror and fleeing through the open doors. Even a couple of doves fly out to freedom. And all around sheep, cows, goats, and even a dog, scatter in disorder. In the background a number of figures, who appear to be elders of the Temple, converse with each other, seemingly unaware of the chaos beyond.
[Jacopo Bassano (228); Cavallino (4778); El Greco (1457); Michelangelo (1194)]

The Purification of the Temple Jacopo Bassano (active about 1535, died 1592)

Christ: Ministry – 11

Kitchen Scene with Christ in the House of Martha and Mary [Biblical: Matthew 26. 6–13; Mark 14. 3–9; Luke 10. 38–42; John 12. 1–8] Although Velázquez's painting known as *Kitchen Scene with Christ in the House of Martha and Mary* has not been firmly identified as a depiction of Christ in these two sisters' house, there are a number of details which support such an identification, the most significant being the somewhat truculent-looking female preparing a meal in the foreground.

The Gospels describe how Jesus visited the house of the sisters Martha and Mary in Bethany, but only Luke describes how Martha prepared the food whilst her sister Mary sat at Jesus' feet, hanging upon his words. Luke relates how Martha resented being left to work alone, and how she voiced her indignation to Jesus, begging him to send Mary back into the kitchen to help.

Velázquez's painting appears to show Martha some moments before this

request for sisterly assistance. In the right-hand background (possibly reflected in a mirror, or through an opening in the wall) we notice a seated figure who seems to gesture towards two other figures, as if recounting a story. Although the standing figure is recognisable as a female, that seated on the ground could well be male. Perhaps this is meant to be Lazarus, brought back to life from death, and once more in the bosom of his family [*see* Christ: Ministry – 12]. The Gospel of John describes how Christ went back to the house of Martha and Mary after the raising of Lazarus. John relates how Martha served whilst Lazarus was one of those who sat at the table. We learn also that it was on this occasion that Mary anointed the feet of Christ with costly ointment.

The expression of the young woman in the foreground of Velázquez's painting suggests both indignation and pique. She seems almost on the point of weeping with vexation, if it were not for the calming presence of an old woman (perhaps a servant of the house) at her side, who points to her as if to a model of patient domesticity. Martha was in fact traditionally revered as the patroness of housewives.
[Velázquez (1375)]

Kitchen Scene with Christ in the House of Martha and Mary
Diego Velázquez (1599–1660)

Christ: Ministry – 12

Raising of Lazarus [Biblical: John 11. 1–46] The Bible tells us that after performing a number of miracles in Judaea, Jesus was accused of blasphemy and forced to flee into the Wilderness. The Jews had tried to stone Jesus when he claimed that he was equal to God. Jesus sought refuge in the desert where his cousin John the Baptist had first preached and baptised. Whilst there Jesus received a message from two sisters, Martha and Mary, who lived in

Bethany [*see* Christ: Ministry – 11]. The sisters sent word to Jesus that their brother Lazarus was sick. We learn that Jesus was not unduly worried to hear that his friend was ill. Indeed the Gospel of John tells us that when Christ received the sisters' message he exclaimed that the sickness was not 'unto death but for the Glory of God'. Two days later Jesus decided to return to Judaea to see Lazarus, despite the reluctance of his disciples who feared for their master's safety. On the way Jesus told his disciples that Lazarus was sleeping, but that he was going to wake him out of his sleep. But when his disciples appeared to take these words at face value Jesus told them plainly that Lazarus was already dead.

When Jesus arrived at Bethany he found that Lazarus had been dead for four days. In turn the sisters came to him weeping, exclaiming in their grief that if only he had been there Lazarus would not have died. John tells us how Jesus himself wept at this, but, going to the tomb, he commanded the covering stone to be moved aside. Martha, ever practical, warned Jesus that the corpse would stink after four days of death. But Jesus responded by reminding Martha of his promise that if she believed she would see the glory

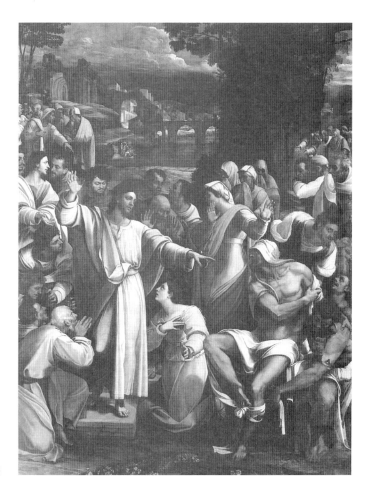

The Raising of Lazarus
Sebastiano del Piombo
(about 1485–1547)

of God. As the stone was moved away Jesus lifted up his eyes, thanked God for hearing his prayer and with a loud voice called Lazarus to come out. The Bible describes how the corpse, bound hand and foot with grave-clothes and with his face covered by a napkin, came out of the tomb. Jesus commanded that the shrouds should be loosened and that Lazarus should be allowed to go.

Both National Gallery paintings of *The Raising of Lazarus* give a gruesomely accurate depiction of the disinterred Lazarus, but it is the Sebastiano del Piombo painting which seems to reflect the biblical text most closely. Not only are we immediately aware of the authoritative figure of Christ and the deathly figure of the corpse, regaining life by the minute, but our attention is also drawn to many other secondary details: several of the people hold cloths to their faces against the stench of death; there is much amazement, even horror and consternation that a corpse should be brought out of the tomb; and there are equally many clear references to the reverence and devout belief produced by this miracle.

The Bible describes how many of the Jews who had come to comfort the sisters in their mourning began to believe in Jesus when they saw Lazarus brought back to life. We learn also how some remained sceptical and went away to deliver the news of yet one more unorthodox action on the part of Jesus to the Pharisees. The gestures employed by Sebastiano del Piombo vividly reflect the various degrees of emotion and conversion suggested in the text.

[Sebastiano del Piombo (1); attr. de Vos (6384)]

Christ on the Cross *see* Christ: Crucifixion
Christ nailed to the Cross *see* Christ: Crucifixion
Christ: Passion – 1

Christ taking Leave of his Mother [Christian writings: Pseudo-Bonaventura, *Meditations on the Life of Christ* LXXII; Brother Philip the Carthusian, *Marienleben, c.* 1330] Although not discussed in the Bible, the story of Christ bidding farewell to his mother before going up to Jerusalem for the last time is described in such texts as the thirteenth-century *Meditations on the Life of Christ*.

The National Gallery depictions of *Christ taking Leave of his Mother* by Albrecht Altdorfer and Correggio show the distraught Virgin swooning at the prospect of her son's imminent departure and death. The Altdorfer painting depicts the Virgin collapsed in the lap of Mary Magdalene whilst three other female figures, identifiable as Mary Cleophas, Mary Salome and Mary Jacobi, look on and gesticulate towards Jesus as if in disbelief. A relief on the column of the ruined architecture in the background shows the Flagellation of Christ, reminding us that Christ's entry into Jerusalem also marked the beginning of his Passion. Jesus appears to bless his mother in the moment before leaving with two of his disciples. One of these, the young man in the right foreground, has already turned to leave, whilst the older figure – possibly Peter – pauses to witness the Virgin's grief. Altdorfer also includes a group of small figures in the right-hand foreground, who kneel in veneration before the grief-stricken mother. These are identifiable as the artist's patron and his

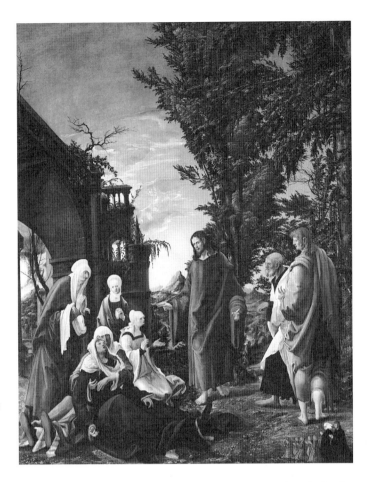

*Christ taking Leave
of his Mother*
Albrecht Altdorfer
(shortly before
1480–1538)

family. Although they have nothing to do with the original story they help fix
our attention on the Virgin's despair.

In many ways Correggio's painting of *Christ taking Leave of his Mother*
depicts a more private and yet rather stylised moment of farewell. The Virgin
swoons and is supported by a female figure at the right, whilst another
background figure contemplates Christ as he kneels quietly in front of his
mother. Yet, although we witness the Virgin's despair, there is no indication
that Christ is about to leave.

[Altdorfer (6463); Correggio (4255)]

Christ: Passion – 2

Christ washing his Disciples' Feet [Biblical: John 13. 4–17] John tells us how
after the last supper together with his disciples, Jesus got up from the table,
took off his outer garments and girded himself with a towel. He then poured
water into a basin and began washing the disciples' feet.

Tintoretto's painting of *Christ washing his Disciples' Feet* shows the
moment when Peter, having finally agreed to let his Lord perform such a
humble task, pauses with foot dangling above the surface of the water, as if in
conversation with Christ. We are probably witnessing Christ's warning to

Peter that although this washing of the feet symbolises the cleansing of the entire body, yet there is a part of Peter which will remain unclean. Christ knows that Peter will deny him when he is taken prisoner and brought before Caiaphas. But Peter, filled with zeal and love, appears to catch his breath, raising his hand in disbelief and seeming about to draw back his foot. In the right foreground of the painting we see the back view of another figure (unaware of the conversation between Peter and Christ) who twists away from them to dry his feet before donning his sandals once again. This figure is possibly Judas, who already harbours his evil plan to betray Jesus for thirty pieces of silver.
[Tintoretto (1130)]

Christ: Passion – 3

Institution of the Eucharist [Biblical: Matthew 26. 17–30; Mark 14. 12–26; Luke 22. 7–38; John 13. 1–30] Although all four Gospels refer to the Last Supper, it is treated with greatest detail in the first three. We learn that Christ sent two disciples (identified as Peter and John in Luke's Gospel) ahead into town to find the room where they would all meet to celebrate the feast of the Passover. Jesus told the disciples that they would find an upper room made ready for them.

The first three Gospels describe how, when they were all assembled in the evening, Jesus sat down with them. According to Luke, Jesus first took wine, passing the cup round the table, and then took bread, breaking it and giving each one of the disciples a piece saying, 'This is my body which is given for you: this do in remembrance of me.' This action is known as the Institution of the Eucharist. Although Matthew and Mark refer to the taking of wine during supper, Luke describes how after supper Jesus took the cup of wine again, saying, 'This cup is the new testament in my blood, which is shed for you.' Luke also tells us that it was only at this moment that Christ indicated to his disciples that one of them would betray him. Matthew and Mark place this shattering statement at the beginning of the meal, before the taking of wine or the breaking of bread. All the Gospels describe how the disciples reacted with sorrow and questioning, pressing Christ to be more specific. According to Matthew and Mark, Christ's answer was that his betrayer was he who would dip his hand together with him into the dish. Reading Matthew we find that even after this Judas persisted in asking Christ if it was he who would betray him.

John's description of the Last Supper differs from all the other three. He gives the supper itself very little coverage, lingering rather on the washing of the disciples' feet after supper [*see* Christ: Passion – 2]. It was only after this symbolic act of humility, according to John, that Christ and his disciples returned to the table and Christ revealed to them that he would be betrayed.

Many depictions of the Last Supper seem to follow the first two Gospels, since they show the assembled company about to eat together. There is usually an air of anticipation to the scene, and very often a variety of gestures in the figures of the disciples which suggests that they have just heard Christ's words and are in various states of shock and disbelief.

In Ercole de' Roberti's painting of *The Institution of the Eucharist* (which is

curious in showing the company assembled on three sides of a table instead of the more conventional arrangement along the back of a long rectangular table) each of the individual gestures reveals a different emotion, including even the dark figure in the right foreground who turns away from the scene. This is surely Judas, who realises in this moment that his treachery is discovered. Perhaps he is yet to turn to add his own gesticulation and denial. The Gospel of John is interesting here as it tells us that Christ announced quite openly that his betrayer was the disciple to whom he would first pass the sop (piece of bread) after he had dipped it in the wine. John describes how Christ then dipped his sop in the wine and passed it to Judas, saying, 'That thou doest, do quickly'. John then tells us how the other disciples, bewildered by these events, were uncertain of Judas' intentions as he left the table. Some thought he was going to buy provisions, others that he was going to distribute money to the poor.

Sitting beside Christ in the Roberti painting we recognise Peter (the older

The Institution of the Eucharist
Ercole de' Roberti
(active 1479, died
1496)

man on his right) and Christ's favourite, the young John (to his left). The chamber itself is more grandiose and sumptuously decorated than in most depictions of the Last Supper.

[Roberti (1121)]

Christ: Passion – 4

Agony in the Garden
Agony in the Garden of Gethsemane
Christ at Gethsemane

[Biblical: Matthew 26. 36–46; Mark 14. 26–42; Luke 22. 39–46]

The Bible tells us that after the Last Supper [*see* Christ: Passion – 3] Jesus and his disciples went up to the Garden of Gethsemane on the Mount of Olives, outside the walls of Jerusalem. The Gospel of Matthew is very precise in saying that Christ left his disciples at the entrance to the garden, whereas Luke merely informs us that Christ moved away from them, about a stone's throw.

It is interesting to see with what care Giovanni Bellini suggests the path running up to the garden gate, and how precisely he places the figures of Christ's followers close to this entrance. We imagine them coming up the Mount of Olives from our right, leaving the ravine of the Kidron Brook and the city of Jerusalem behind them. In the Gospels of Matthew, Mark and Luke, our attention is drawn specifically to Christ's crisis of conscience, rather than to the particular setting. Mark describes how Christ tells the disciples to sit down and pray when they reach Gethsemane. He then goes on ahead with Peter, James and John.

Luke embroiders on Christ's sense of isolation and fear. This is reflected in the paintings of *The Agony in the Garden* by Giovanni Bellini and Andrea Mantegna where Christ is shown praying while the disciples sleep and danger approaches. Christ's isolation is given even greater prominence in the painting of *Christ at Gethsemane* ascribed to Lo Spagna, where he is shown completely alone in the garden. The Gospel of Mark lays great emphasis on the fact that Christ's disciples failed him by falling asleep, exhausted after their long vigil. This failure to keep watch contributes to our sense of Christ's vulnerability at the moment of his betrayal.

A precise and significant moment is depicted in the paintings by Bellini and Mantegna. This is the point when Christ accepts that his Passion is inevitable, having prayed that the cup or chalice (which in the Old Testament symbolises the anger and judgement of the Lord) should be taken away from him. In Ambrogio Bergognone's painting of *The Agony in the Garden* the chalice even contains a miniature crucifix, showing us that Christ accepts both his Father's decision and the painful death that awaits him. In a moment Christ will rise and call his sleeping companions: 'Rise, for he is at hand that doth betray me.'

Traditional renderings of the Agony in the Garden in Italian art tend to stress the powerful divinity of Christ, rather than hint at any human reluctance to be a victim. In some early images of the Agony in the Garden Christ is even shown with arms raised in benediction, a far cry from the frail and human individual depicted by such artists as Bellini. Christ is also often

shown, marked out and separated from his followers by olive trees which are silhouetted against a flat background, sometimes with a suggestion of a rocky landscape, but with little real sense of urban or country setting. It is only in the later fifteenth century that the scene of the Agony in the Garden is extended to include a view of Jerusalem in the background, or figures of Christ's betrayers approaching.

It is significant how few trees are in fact shown even in the more realistic depictions of the Garden of Gethsemane. And where they do appear, they are hardly suggestive of olive trees with their squat, bushy outline. This is curious, since it was presumably the preponderance of these trees that gave this particular place its name – the Mount of Olives. Yet there may be a reason for this. Early descriptions of the outskirts of Jerusalem refer to the olive groves on the slopes leading up to the Garden of Gethsemane. But the Bible describes Christ moving away from his disciples, and therefore presumably to the eastern edge of the garden. In this case Christ would have left the olive trees some way behind him. It seems possible therefore that some artists were actually attempting topographical accuracy in their paintings in showing Christ silhouetted against a bare landscape.

Giovanni Bellini was certainly one of the earliest Italian masters to develop landscape as a way of opening out credible space in the pictorial composition. His landscape backgrounds also allowed him to develop an extraordinary luminosity in the treatment of light. Apart from the one or two rather strange discrepancies in Bellini's painting of *The Agony in the Garden*, the light which falls in the background is essentially the same as that which touches the figures and objects in the foreground. There is as a result a great sense of realism. We are encouraged to relate to all parts of the picture equally. The contemporary architectural details in the background add to the

The Agony in the Garden Giovanni Bellini (active about 1459, died 1516)

sense of realism. They remind us of the fortified walls of the medieval villages and castles which even now straddle the sides of Italian hills. We can even pick out spires and apses of Romanesque or Italian Gothic-style churches.

[Giovanni Bellini (726); Bergognone (1077A); after Correggio (76); Garofalo (642); studio of El Greco (3476); Mantegna (1417A); Niccolò di Liberatore (side panel) (1107); attr. Pietro Orioli (predella) (1849); Lo Spagna (1032); attr. Lo Spagna (1812)]

Christ: Passion – 5

Betrayal of Christ

Betrayal

[Biblical: Matthew 26. 47–56; Mark 14. 43–52; Luke 22. 47–53; John 18. 1–12]

According to the Bible the Betrayal of Christ (also known as the Kiss of Judas and, less commonly, the Arrest), took place in the Garden of Gethsemane, where Christ had gone to pray with his disciples after the Last Supper [*see* Christ: Passion – 3 and Christ: Passion – 4]. Ugolino di Nerio's painting of *The Betrayal* shows that moment in time when Christ, surrounded by soldiers and Pharisees, turns his cheek to Judas to receive the traditional kiss of greeting. At the same time, Peter moves away from his master to cut off the ear of Malchus, the High Priest's servant. In Ugolino's painting the soldiers already surround Christ whereas the predella scene of *The Betrayal of Christ* by Orioli shows them following behind Judas. The contrast of loving embrace and menacing approach adds a particularly sinister dimension to Orioli's betrayal.

[Attr. Pietro Orioli (predella) (1849); Ugolino di Nerio (1188)]

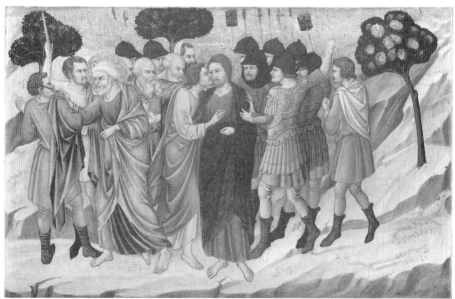

The Betrayal Ugolino di Nerio (active 1317–27)

Christ: Passion – 6

Christ before the High Priest [Biblical: Matthew 26. 57–66] The Bible tells us

how Christ was brought in front of Caiaphas, the High Priest, after his betrayal by Judas in the Garden of Gethsemane [*see* Christ: Passion – 5]. Christ's persecutors – the chief priests, the elders and all the council – try in vain to produce evidence against him that will be sufficient to condemn him to death. Finally two false witnesses are produced who say they have heard Jesus boast not only that he can destroy the temple of God but that he can also rebuild it in three days. At this Caiaphas turns to Jesus, willing him to break his silence and protect himself.

In Gerrit van Honthorst's painting of *Christ before the High Priest* we witness the moment when the two false witnesses – one slightly hesitant, the other set in smug expectation of Christ's conviction – confront Jesus from their positions at the side of the seated Caiaphas. Jesus, shoulders sagging with the burden of pain he holds within him, looks steadfastly at the illuminated face and raised finger of the High Priest, but 'holds his peace'.
[Gerrit van Honthorst (3679)]

Christ before the High Priest
Gerrit van
Honthorst
(1590–1656)

Christit: Passion – 7

Christ before Pilate

Christ after the Flagellation contemplated by the Christian Soul

[Biblical: Matthew 27. 11–14 and 19–24; Mark 15. 1–5; Luke 23. 1–7; John 18. 33–9 and 19. 1–11]

All the Gospels describe how Jesus was brought in front of Pilate to be questioned. However, only the Gospel of Matthew tells us that Pilate's wife Claudia Procula warned him to have nothing to do with Jesus. When Pilate sat down in the judgement seat she sent a message to him saying that she had been much troubled by a dream which revealed that Jesus was an innocent man. It is in Matthew that we read also how Pilate – seeing that the chief priests and elders had already whipped up the rabble against Jesus – realised things had gone too far and were out of his control. The Bible tells us how Pilate took water and symbolically washed his hands in front of the crowd, saying, 'I am innocent of the blood of this just person: see ye to it.'

The Master of Cappenberg's painting of *Christ before Pilate* shows us the moment when Pilate washes his hands in the salver which a servant is balancing on the side of the judgement seat. Pilate's wife Claudia leans over behind the servant, as if interceding for Jesus, who stands bound and dejected to the other side. Jesus is crowned with thorns and his stance suggests that he has suffered physically at the hands of the soldiers who surround him. Indeed, the foreground figure raises his fist as if to beat Jesus, and at the same time seems to turn as if to lead him away. The Master of Cappenberg was probably following the Gospel of John for these details. This text describes how, after a first interrogation, Pilate sent Jesus away to be

Christ before Pilate
Master of Cappenberg (active early 16th century)

scourged. (Velázquez's painting of *Christ after the Flagellation contemplated by the Christian Soul* refers to this punishment.) Pilate then took Christ (crowned with thorns and dressed in a purple gown) to present him to the people saying, 'I find no fault in him'. John tells us how the chief priests and officers called out for Christ's crucifixion, and how Pilate made one last attempt to get Christ to defend himself and save his life.

In the Master of Cappenberg's painting we sense that Christ has been hustled from one place to another; his arms hang loose, his shoulders sag. We realise he has suffered, and yet refuses to respond. The figure of Christ seems limp and fragile by comparison with the regal figure of Pilate who both turns away to cleanse his hands and yet even at this last moment confronts the prisoner as if hoping for a response.

[Master of Cappenberg (2154); Velázquez (1148)]

Christ: Passion – 8

Christ crowned with Thorns
Crowning with Thorns (also known as *Christ mocked*)
[Biblical: Matthew 27. 26–31; Mark 15. 15–20]

According to the Bible, when Pilate had washed his hands of Jesus, he had him whipped and then handed him over to be crucified [*see* Christ: Passion – 7]. Christ was taken away by the soldiers of the governor and subjected to a humiliating ceremony of mock obeisance. The soldiers tore Christ's clothes off and, after draping a brilliantly coloured robe about his shoulders, thrust a crown made out of twisted and plaited twigs with sharp thorns onto his head. They then knelt down in front of him, mocking him and calling him King of the Jews. Later they spat on him and beat him about the head with the reed sceptre they had made him hold.

Many depictions of Christ crowned with thorns show only the head and upper torso of Christ. Sometimes he is bound and carrying the reed sceptre and on occasions even the bunch of twigs used to scourge him.

The Crowning with Thorns (also known as *Christ Mocked*)
Hieronymous Bosch (living 1474, died 1516)

In the National Gallery collection only the painting by Bosch of *The Crowning with Thorns* shows mocking figures around Christ. But this painting is not entirely true to the text, since only two of the four figures are identifiable in any way as soldiers. Christ is on this occasion clothed in white. Perhaps this painting therefore shows him after his humiliation, when the soldiers clothed him in his old clothes and led him out to be crucified.

[Bosch (4744); early sixteenth-century Italian School (691)]

Christ: Passion – 9

Christ presented to the People (also known as *Ecce Homo*) [Biblical: John 19. 1–5 and 13–16] Although all the Gospels describe how Jesus was brought in front of Pilate to be judged, and how Pilate could find nothing concrete with which to condemn him [*see* Christ: Passion – 7], only John refers to the moment when Pilate physically presented Christ to his persecutors. John describes how Jesus came out wearing a crown of thorns and dressed in a

Christ presented to the People (also known as *Ecce Homo*)
Master of the Bruges Passion
Scenes (active early 16th century)

purple robe and Pilate, turning to the Jews, said, 'Behold the Man' ('Ecce Homo'). At this the rabble, incited by the chief priests, called for Christ's crucifixion.

In each of the National Gallery paintings Christ is shown, already mocked and crowned with thorns, and in the Master of the Bruges Passion Scenes' *Christ presented to the People* we also see the Flagellation [*see* Christ: Passion – 7] in the background. The inclusion of the swooning figure of Mary in Correggio's design is highly unusual. There is certainly no reference to this in the Gospel text.

[Correggio (15); after Correggio (96); Master of the Bruges Passion Scenes (1087); Rembrandt (1400)]

Christ: Passion – 10

Christ carrying the Cross
Procession to Calvary
Way to Calvary

The Procession to Calvary Ridolfo Ghirlandaio (1483–1561)

[Biblical: Matthew 27. 31–2; Mark 15. 20–2; Luke 23. 26–8; John 19. 16–17]
Although all the Gospels describe how Jesus was led away to be crucified, it is
only John who tells us that Jesus carried his own cross. The other texts
describe how a certain Simon – a stranger coming into town – was forced to
take the cross and carry it behind Jesus on the way up to Golgotha.

All of the National Gallery depictions of this scene follow John in showing
Christ staggering under the weight of the cross. It is only in the small predella
scene by Raphael known as *The Procession to Calvary* that we have any sense
of another individual easing Christ's suffering.

Ambrogio Bergognone isolates the figure of Christ in his *Christ carrying
the Cross*, but several of the National Gallery paintings show a great crowd of
people clustered around him. The Gospel of Luke is probably the source for
this, since he tells us that a great company of people and wailing women
followed Jesus. The Virgin Mary is often included in this group, and at times
is supported as she swoons in an excess of grief. According to Luke, Jesus
turned to the people following and told them not to weep for him but rather
to weep for themselves and their children.

In Jacopo Bassano's *The Way to Calvary* and Ridolfo Ghirlandaio's *The
Procession to Calvary* we see one of the women reach forward towards Christ,
holding a piece of cloth to him. This is St Veronica, who by tradition was said
to have been so moved by Christ's agony that she stretched out to wipe the
sweat from his forehead. According to fourteenth-century legends of the
saints, Veronica then found an impression of Christ's face left on the cloth.
The true image or 'Vera Ikon' bears a direct connection with this saint's
name.
[Jacopo Bassano (6490); Bergognone (1077B); attr. Boccaccino (806);
Ridolfo Ghirlandaio (1143); Giampietrino (3097); Niccolò di Liberatore (side
panel) (1107); North German School (2160); Ugolino di Nerio (1189);
Raphael (2919)]

Christ: Pentecost

Pentecost [Biblical: Acts of the Apostles 2. 1–13] The Christian church
celebrates Pentecost on the Sunday commonly known as Whit Sunday. Whit
Sunday marks the fiftieth day after Easter when, according to the Bible, the
apostles gathered together and received tongues of fire on their heads. The
Bible describes how the apostles were filled with the Holy Ghost and began to
speak in other tongues, or languages. Acts does not specify in detail the
names of the assembled company, but Peter was certainly there. We learn that
Peter stood up and preached to the multitude of foreigners who came
running to listen in amazement as they heard these simple men from Galilee
speaking in whatever language or dialect was appropriate for each individual
ear. The onlookers marvelled at the way the apostles could speak the
languages of the Parthians, Phrygians, Egyptians, Arabs and many others.
Some even mocked the babble of tongues, claiming that the apostles were
drunk.

Both the National Gallery paintings show a group of haloed figures
gathered together in a room. The painting of *Pentecost* ascribed to Giotto
clearly shows the tongues of fire as well as a few bemused onlookers. The

Pentecost Attr. Giotto (1266(?)–1337)

Barnaba da Modena and Jacopo di Cione paintings of *Pentecost* are curious for their inclusion of the Virgin Mary with the twelve apostles. Her central position gives her a special significance as the mother of the apostles and as a symbol of the Christian church itself. The dove hovering above the Virgin's head clearly indicates the descent of the Holy Ghost, but there is as yet no indication of a great babble of talk.

[Barnaba da Modena (1437); Giotto (5360); Jacopo di Cione (578)]

Christ presented to the People (also known as *Ecce Homo*) *see* Christ: Passion – 9

Christ: Resurrection – 1

Christ rising from the Tomb
Resurrection of Christ
Maries at the Sepulchre
[Biblical: Matthew 28. 1–6; Mark 16. 1–6; Luke 24. 1–6; John 20. 11–13]

All the Gospels describe how on the third day after Christ's death his tomb was found empty. Mark tells us that the three Maries came very early in the morning as the sun rose. Puzzling first about how they would be able to roll away the stone guarding the sepulchre, they found to their amazement that it had already been removed and that a young man in a long white cloth was sitting inside the tomb. The youth told the frightened women that Christ had already risen, and that he had gone ahead of them and his other followers into Galilee.

Matthew refers to the angel of the Lord sitting upon the stone of the tomb with a face which shone like lightning and clothes as white as snow. Luke and John refer to two angels inside the tomb. Each Gospel describes how the angels, regardless of their number, gave the same message, that Christ was risen, as he had foretold. Yet nowhere in the Bible do we find an actual description of this event.

Paintings depicting the scene of the Resurrection often portray the scene in two or more stages. We may first see Christ emerging from the tomb; we then witness his rising above the tomb; and finally we see Mary Magdalene and her companions coming to the tomb and finding it empty. Many artists depict the moment when Christ's Resurrection is announced to the three Maries. Jacopo di Cione's *The Maries at the Sepulchre* shows the three women standing with their precious pots of ointment, deep in conversation with one of two angels who guard the empty tomb. The painting attributed to an imitator of Mantegna, which is also known as *The Maries at the Sepulchre*, shows a very similar scene where one of the women converses with an angel while the other two hover in the foreground.

The Resurrection of Christ Ugolino di Nerio (active 1317–27)

In the second panel by an imitator of Mantegna in the National Gallery, *The Resurrection of Christ*, we see the tomb outside the cave, and guarded by sleeping soldiers with Christ standing triumphantly on the edge of the tomb. (Many depictions of the Resurrection include the sleeping soldiers, despite the fact that no such guardians are referred to in the Bible.) Christ holds a white banner with a red cross which symbolises his Passion and Resurrection. His body is erect, with one hand raised in blessing. Jacopo di Cione's depiction of the same scene shows Christ already risen above the tomb with triumphant banner fluttering in the air.

In some depictions of the Resurrection, such as Ugolino di Nerio's *Resurrection of Christ*, Christ climbs wearily out of the tomb, as if only recently risen from a deep sleep. Ugolino's Christ has yet to assume the triumphant pose of the Resurrection. Despite holding his banner of triumph, he shows a weary hesitance as he comes out into the morning light. By comparison Gaudenzio Ferrari's painting of *Christ rising from the Tomb* shows a very confident Christ, gesturing as if in welcome to us as he puts one foot up on to the side of the tomb.

[Jacopo di Cione (575); Jacopo di Cione (576); Gaudenzio (1465); imitator of Mantegna (1106); imitator of Mantegna (1381); Niccolò di Liberatore (side panel) (1107); attr. Pietro Orioli (predella) (1849); Ugolino di Nerio (4191)]

Christ: Resurrection – 2

Christ appearing to the Virgin
Christ appearing to the Virgin with the Redeemed of the Old Testament
[Biblical: Mark 16. 1–5; Pseudo-Bonaventura, *Meditations on the Life of Christ* LXXXVI]

Although the Bible describes how Christ appeared to Mary Magdalene after she had been to the tomb and found it empty [*see* Christ: Resurrection – 1], there is no reference to any appearance to his mother, the Virgin Mary. Yet the National Gallery painting of *Christ appearing to the Virgin* by a follower of Rogier van der Weyden clearly alludes to a time shortly after Christ's crucifixion. To the left and through the background door we see a tomb guarded by an angel and sleeping soldiers. It is almost as if Christ, recently risen from the tomb, has made his way up the path to the house of his mother so that she should be the first to realise that he has been victorious over death. Through the window we see the figures of three women on their way towards the tomb. Clearly these background scenes allude to the passage in the Gospel of Mark which describes how the three Maries – Mary Magdalene, Mary the mother of James, and Mary who was known as Salome – come to the tomb to anoint Christ's body with sweet spices only to find that their Lord has already risen from the dead [*see* Christ: Resurrection – 1]. In the Weyden painting we sense that the Virgin – risen early and already at her devotions – is actually interrupted by the entrance of her son. Her gesture of surprise and the shadows cast by his legs on the tiled floor suggest his physical presence. The *Meditations on the Life of Christ* does indeed describe how Christ appeared to his mother on the Sunday after his crucifixion. The Virgin had stayed at home to pray for her son's return while the three Maries went to the tomb. In the midst of her tears she saw Jesus dressed in white and

talking to her as if in the same room.

The studio of Juan de Flandes painting of *Christ appearing to the Virgin with the Redeemed of the Old Testament* also shows Christ appearing to his mother in her bedroom, but this time he does not come alone. The fact that Christ is surrounded by the redeemed souls of the Old Testament (who had to await Christ's descent into Limbo before they could be released) suggests that this painting is meant to be read as a vision rather than an actual appearance.

It is significant that the scrolls in the Juan de Flandes painting bear inscriptions from the Pseudo-Bonaventura (chapter 86) and the Book of Habakkuk (3. 18). Apocryphal texts, such as the *Meditations on the Life of Christ* (which was at one time thought to have been written by St Bonaventura), encouraged worshippers to experience the sufferings and miracles of their Lord through empathy. Specific mention was made of the Virgin's suffering as she witnessed the death of her son and appeared to die with him as she swooned at the foot of the Cross. Yet in the Juan de Flandes painting the Virgin seems calm, with an expression that is almost joyful. It is as if she speaks the words of Habakkuk: 'Yet will I rejoice in the Lord, I will joy in the God of my salvation.'

[Studio of Juan de Flandes (1280); workshop of Van der Weyden (1086)]
See also Virgin Mary: Death – 1

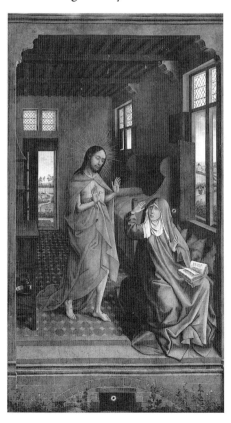

Christ appearing to the Virgin
Workshop of Rogier van der
Weyden (about 1399–1464)

Christ: Resurrection – 3

St Mary Magdalene approaching the Sepulchre
Christ appearing to the Magdalen (also known as *Noli me tangere*)
[Biblical: John 20. 1–18]

The Bible tells us that shortly after Christ's death Mary Magdalene went to his tomb and, finding it empty, ran to Peter and John to tell them that the body of their Lord had been stolen. After the disciples had been to see with their own eyes that the body had disappeared, Mary Magdalene remained behind, weeping and looking into the empty tomb. John tells us that Mary then saw two angels dressed in white sitting at either end of the tomb [*see* Christ: Resurrection – 1]. The angels asked Mary why she was weeping, and after telling them that she was mourning for her Lord she turned away to find herself facing Jesus. At first she did not recognise Jesus, thinking that he was the gardener. (Some depictions of Christ appearing to the Magdalen show him clothed as if a gardener and holding gardening tools.) When Jesus asked Mary Magdalene why she was weeping she begged him to tell her where the body of her Lord had been taken. Only when Jesus called her by name did she realise who he was, and turning towards him attempted to embrace him. But Jesus moved away from her telling her that she should not touch him – thus the Noli me tangere by which this scene is often known.

Christ appearing to the Magdalen (also known as *Noli me tangere*) Titian (active before 1511, died 1576)

Many depictions of the Mary Magdalene show her holding the pot of ointment which she used to anoint the body of Christ after the crucifixion. (It is sometimes argued that she was the woman referred to in the Gospel of Luke who washed Christ's feet with her tears and anointed them with precious ointment after drying them with her hair.) Gian Girolamo Savoldo's painting of *St Mary Magdalene approaching the Sepulchre* shows the saint standing in front of the entrance to the tomb. She has placed her ointment pot on the ledge behind, and turns to look at us as if startled out of her reverie by a sudden sound. Perhaps the artist wants us to imagine that Christ is at this moment approaching Mary Magdalene.

In Titian's painting of *Christ appearing to the Magdalen* our attention is drawn to the moment when Jesus turns away from Mary Magdalene's touch, telling her that he is not yet risen. By comparison, in the Byzantine School painting of *Christ appearing to the Magdalen* we find a number of scenes combined within the same composition. The pathos of the moment of rejection is thus somewhat eclipsed.

[Byzantine School (3961); imitator of Mantegna (639); Master of the Lehman Crucifixion (3894); Savoldo (1031); Titian (270)]

Christ: Resurrection – 4

Incredulity of St Thomas [Biblical: John 20. 19–29] The Gospel of John describes how, after Christ had appeared to Mary Magdalene [*see* Christ: Resurrection – 3], he went the same evening to visit his disciples. They were gathered together behind closed doors, frightened that the Jews might search them out and persecute them, as they had been followers of the 'King of the Jews'. John tells us how Jesus spread out his arms to the disciples, showing them the wounds in his hands and side, and blessing them.

When the disciples told Thomas Didymus (another member of the group who had not been with them when Christ first appeared), he professed doubt about the true identity of their visitor. For this reason Thomas Didymus is often referred to as Doubting Thomas. Thomas argued that he would only believe that their Lord had risen from the dead if he was able to place his own fingers into Christ's wounds.

Eight days later Jesus appeared again to the disciples, who were once more indoors. Christ invited Thomas to reach out and feel his wounds. He also commanded Thomas to believe, rather than to be without faith. Faced with the evidence of his own hands and eyes, Thomas was convinced, crying out, 'My Lord and my God!' But Christ reproached Thomas, saying that those who believed in him without seeing him were infinitely more worthy of his blessing.

This episode has become known as the Incredulity of Thomas, yet most depictions show Thomas Didymus touching Christ's body and therefore actually caught in the moment of believing. Except for the Giovanni Battista da Faenza painting of *The Incredulity of St Thomas* which shows Christ and Thomas in the open air, the National Gallery paintings of the Incredulity are comparatively faithful to the original text in their depiction of this moment of touch. The action takes place inside, and Christ is surrounded by disciples – all eleven in the Cima painting. The Guercino is particularly suggestive of a

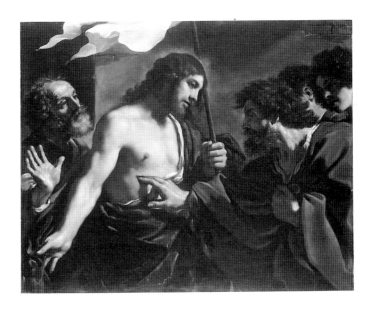

*The Incredulity of
St Thomas*
Guercino
(1591–1666)

closed atmosphere where the disciples huddle in fear of their lives. Only a few
figures are included in Guercino's work, suggesting a restricted space. There
is also a dramatic system of lighting, which suggests both the divine light of
Christ and the sparse illumination of a room barred against the outside
world and the evening light.

[Cima da Conegliano (816); Giovanni Battista da Faenza (1051); Guercino
(3216)]

Christ: Resurrection – 5

Supper at Emmaus
Walk to Emmaus
[Biblical: Luke 24. 13–31]

We are told in the Bible how on the Sunday after the Crucifixion [*see* Christ:
Crucifixion], two of Christ's followers walked to Emmaus, a village outside
Jerusalem, where they planned to have supper. On the way they discussed the
mystery of the empty tomb discovered by the three Maries [*see* Christ:
Resurrection – 1], and the strange message of the two men in shining
garments: 'Why seek ye the living among the dead?'

Luke describes how Jesus joined his erstwhile companions as they made
their way to Emmaus, but they did not recognise him. When Jesus asked
them what they were discussing and why they looked so sad, Cleopas (son of
one of the Maries who stood by the Cross) rounded on him in astonishment.
Surely this must be a complete stranger, not to have heard about the
crucifixion of Jesus of Nazareth? The two companions told the stranger of
their sorrow over the disappearance of the body of their lord, and their
disappointment that he had not fulfilled his promise to be the redeemer of
Israel. At this Jesus replied that it was necessary for Christ to suffer before
being gloried; he talked at length about the prophesies in the Old Testament,
explaining all those passages which foretold the coming of Christ.

When they drew near to Emmaus, Christ seemed about to leave and carry on up the road, but Cleopas and his companion urged him to stay with them. Luke describes how Christ went in and sat down with them to eat. Breaking the bread and blessing it, Christ revealed his true identity, and as his two followers realised that this stranger was indeed the living Christ, he vanished from their sight.

Altobello Melone's painting of *The Walk to Emmaus* shows the moment when Jesus greets Cleopas and his companion as they walk towards Emmaus. We note that the sky is still light as they turn to acknowledge the stranger dressed in pilgrim garb. In the painting of *The Walk to Emmaus* by Lelio Orsi we see the three companions deeply immersed in conversation as they walk along the road against a darkening sky. The central figure of Christ with his gesturing left hand suggests that he is imparting information whilst his two companions turn towards him in rapt attention.

The background details of the Melone painting show the three figures as they approach Emmaus. This was presumably the moment when Cleopas and his companion persuaded Christ to stay with them and continue into the village, since evening was approaching.

In Caravaggio's *The Supper at Emmaus* we see the two companions reacting in astonishment as the central figure of Christ stretches one arm over the laden table and draws the other across to bless a roll of bread. The standing figure at the side is probably an innkeeper, although Luke does not indicate whether the travellers were planning to eat with friends or at an inn.

[Caravaggio (172); Melone (753); Orsi (1466)]

The Supper at Emmaus Michelangelo Merisi da Caravaggio (1571–1610)

Christ: Resurrection – 6

Ascension of Christ [Biblical: Acts 1. 1–11] The scene of the Ascension of Christ is comparatively rare in Western art. Acts describes how for forty days after the Crucifixion [*see* Christ: Crucifixion] Christ appeared to his followers and talked with them. At the end of this period Christ joined them for the last time and told them to stay in Jerusalem until they received a sign from God. Christ told his followers that they would receive power from the Holy Ghost [*see* Christ: Pentecost], and that they would then spread his word in Jerusalem and throughout the whole world. The Bible tells us that Christ then rose up in the sky until he was hidden from sight by a cloud. As those below strained their eyes upwards to catch a last glimpse of Christ, two men dressed in white appeared and told them that Christ had ascended into heaven.

Jacopo di Cione's *The Ascension of Christ* shows a triumphant figure of Christ floating above a circle of figures which includes the Virgin and eleven disciples. At the side we see two haloed figures dressed in white. They seem to talk to each other as if deciding when they should come forward with their message.

[Jacopo di Cione (576)]

Christ rising from the Tomb *see* Christ: Resurrection – 1

Christ taking Leave of his Mother *see* Christ: Passion – 1

Christ teaching from St Peter's Boat on the Lake of Gennesaret *see* Christ: Ministry – 1

Christ washing his Disciples' Feet *see* Christ: Passion – 2

Cimon and Efigenia [Italian 14th-century literature: Boccaccio, *Decameron*, Day 5, 1st story] The story of Cimon and Efigenia (or Iphigenia) deals essentially with the refining power of love. Boccaccio relates how Cimon, one of a number of sons born to a wealthy family in Cyprus, although as handsome as his brothers, was completely uncultured. His family and friends thought he was mad, and all their efforts to educate him came to nothing.

Boccaccio tells us how one day Cimon came across Efigenia, a chaste and refined maiden. Efigenia was lying asleep and revealing her beautiful nakedness through flimsy clothing. Cimon was seized with a great love and determined to make himself worthy of Efigenia. He learnt to read, to dress in the latest fashion, to sing, and even mastered the arts of war. After many adventures, including the abduction of Efigenia on the open seas when she was on her way to marry the husband chosen for her by her father, Cimon finally won her for his wife.

The National Gallery painting of *Cimon and Efigenia*, ascribed to the Venetian School, shows the moment when Cimon comes across Efigenia sleeping in a meadow and guarded by another female figure, perhaps one of two female attendants mentioned in Boccaccio's story. Boccaccio also refers to a fountain close by the sleeping Efigenia. The female figure guarding Efigenia might therefore be identified as a water nymph.

[Venetian School (4037)]

Circumcision *see* Christ: Childhood – 5

Cleopatra

Banquet of Cleopatra
Cleopatra
[Roman literature: Pliny the Elder, *Natural History* IX, 119–21]
Cleopatra (queen of Egypt in the first century BC) had a long affair with Mark Antony, after the assassination of her first Roman lover Julius Caesar. Descriptions of Cleopatra refer both to her exceptional beauty and to her extraordinary personal extravagance. Cleopatra not only spent vast sums of money on dress and entertainment in order to dazzle such paramours as Mark Antony, but on one occasion – according to Pliny – gave practical demonstration of her prodigality by dissolving one of her pearl earrings in a goblet of vinegar and then drinking the liquid.

Giovanni Battista Tiepolo's painting of *The Banquet of Cleopatra* suggests Cleopatra's opulent way of life by depicting this bizarre episode in a grandiose architectural setting peopled by exotic courtiers and guests. The effect of Cleopatra's extravagant gesture is mirrored in the figure of Mark Antony who reels back in amazement as Cleopatra's hand hesitates momentarily above the goblet.

Antony and Cleopatra formed a power base in Alexandria against a background of almost constant hostility from Rome. But after the defeat of Cleopatra's fleet in the Battle of Actium in 31 BC, Alexandria was surrendered and Antony committed suicide. According to popular legend Cleopatra also committed suicide through the painless but venomous bite of an asp. The National Gallery School of Fontainebleau painting of *Cleopatra* draws attention to this painless death by showing Cleopatra reclining comfortably

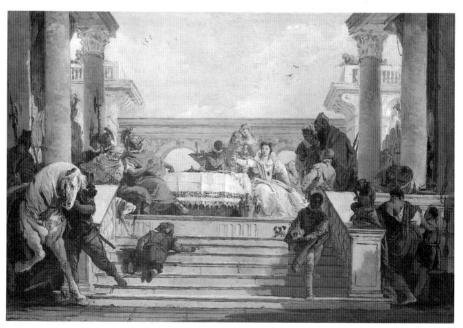

The Banquet of Cleopatra Giovanni Battista Tiepolo (1696–1770)

upon a couch and casually fondling a small snake which bites her nipple.
[School of Fontainebleau (5762); Giovanni Battista Tiepolo (6409)]

Close of the Silver Age [Greek and Roman literature: Ovid, *Metamorphoses* I, 89–150; Hesiod, *Works and Days*] Classical literature describes how the creation of the world evolved over a number of quite distinct periods of time. These were known as the four ages. Gold and Silver were the names given to the first two ages when, at the beginning of the world, men and women lived in harmony in pastoral settings, feeding off wild fruit, nuts and honey and then learning how to fashion tools and build themselves houses. The later Bronze and Iron Ages saw the breakup of this harmony and the growth of discord, through the creation of weapons and the outbreak of war.

The painting known as *The Close of the Silver Age* by Lucas Cranach the Elder is thought to show the end of the first peaceful period, since it shows the beginnings of discord. Male figures beat each other with great sticks while their women and children appear to gather together for safety. The tentative nature of this fight suggests that real chaos is only just beginning.
[Lucas Cranach the Elder (3922)]

Clotho [Greek mythology: Hesiod, *Theogony*, 211–22] Clotho was one of the Three Fates in Greek mythology involved in spinning the thread of life. Clotho held the distaff; Lachesis drew off the thread; and Atropos cut it. The Latin equivalents, known as Parcae, were associated with birth – premature, full-term and still.

The National Gallery *Clotho* after Pierre Paul Prud'hon appears to combine the activities of two of the fates, since she seems both to draw off the thread and to support the distaff against the crook of her arm. Perhaps we should identify her as Lachesis, measuring out the portions of life. The depiction of a youthful female figure rather than an old woman is unusual.
[After Prud'hon (3587)]

Consecration of St Nicolas *see* St Nicholas

Continence of Scipio [Roman literature: Livy, *History of Rome from its Foundation*, 26:50; Italian 14th-century literature: Petrarch, *Africa*, 4:375–88] Publius Cornelius Scipio Africanus Major, a Roman hero of the third century BC, was renowned for the great forebearance he showed when offered a beautiful virgin as booty of war in his campaign to recapture Spain from the Carthaginians. Hearing that the young woman was already betrothed, Scipio not only treated her with respect, but also called her lover to the camp to reclaim her. We learn that the parents of the girl (described by some as a princess) brought ransom for her in the form of golden vessels. But Scipio, in yet another gesture of chivalry, offered these back as a wedding gift.

The National Gallery Italian School painting of *The Continence of Scipio* shows all these incidents. In the centre we see the greeting between Scipio and the lover in the presence of the delighted hostage. To the left we see the elderly parents, who gesture in the direction of this happy group whilst at the same time giving directions to several men who are unloading heavy packages from a number of camels and uncovering them to reveal shining gold vessels.
[Italian School (643B)]

Conversion of the Magdalen *see* Christ: Conversion
Conversion of St Hubert *see* St Hubert – 1
Conversion of St Paul *see* St Paul
Coriolanus persuaded by his Family to spare Rome [Roman literature: Dionysius of Halicarnassus, *Antiquitatem sive originum romanarum*, 8, XLIV–LIV; Livy, *History of Rome*, 2:40; Plutarch, *Life of Coriolanus*, 12:34–6] [English 16th-century literature: Shakespeare, *Coriolanus*, act 5, scene 3] Coriolanus, a victorious Roman general in the fifth century BC, acquired his name from Corioli, one of the towns to the south of Rome belonging to the Volsci tribe. Exiled from Rome because of tyrannical tendencies, Coriolanus returned with the backing of his old enemies, the Volsci, intending to lay siege to the city. But he was met outside the city walls by his mother and his wife with their two small children. The names of these women vary, some texts calling the mother Volumnia and others giving this name instead to Coriolanus' wife. But all the sources agree that the women were successful in pleading for Rome to be spared.

Michele da Verona's painting of *Coriolanus persuaded by his Family to spare Rome* depicts Coriolanus on his knees in front of his young wife against the backdrop of a great city which sprawls both sides of a wider river. It is as if Coriolanus has arrived in haste together with a company of soldiers on horseback, and, in kneeling to his consort, already signals his acquiescence to

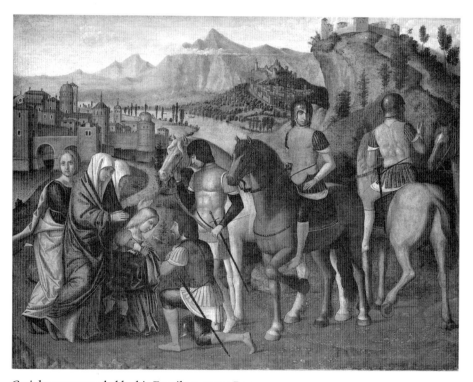

Coriolanus persuaded by his Family to spare Rome
Michele da Verona (about 1470–1536/44)

her request.

The background of Signorelli's *Coriolanus persuaded by his Family to spare Rome,* on the other hand, suggests a much more purposeful siege in the massed tents which are pitched aggressively across the river from Rome. Coriolanus in the right foreground seems surprised to find his womenfolk so far from town. His open armed gesture is suggestive of both welcome and enquiry. The women also appear to be rather diffident in their approach. Their body language suggests that they have not yet made their plea for clemency.

[Michele da Verona (1214); Signorelli (3929)]

Cornelia and her Sons [Roman literature: Valerius Maximus, *Facta et dicta memorabilia* IV. 4; Plutarch, *Lives,* 7] According to Plutarch when Cornelia, a Roman matron of great virtue, was asked to show a visitor her jewels, she brought forward instead her two sons Tiberius and Gaius Gracchus, known as the Gracchi.

In the National Gallery painting of *Cornelia and her Sons* by a follower of Padovanino the figure on the right, identifiable as Cornelia, does indeed caress two young boys. The scene is presumably set in Cornelia's own home since she has books on her lap with which to educate her young 'jewels'. It is not clear, however, whether the second female in the picture is playing with

Cornelia and her Sons
Follower of Padovanino (1588–1648)

her own jewels or admiring those belonging to Cornelia. The jewels have obviously been taken from the casket on the table, and according to Valerius Maximus Cornelia's visitor did indeed show off her own jewellery. But it is curious that she is not actually wearing the jewels. The artist of this picture clearly wants us to realise that Cornelia's visitor took her jewellery from house to house with the intention of boasting about it to her friends.
[After Padovanino (70)]

Coronation of the Virgin *see* Virgin Mary: Coronation

Coup de Lance *see* Christ: Crucifixion

Croesus and Solon [Greek and Roman literature: Herodotus 1. 29–33; Plutarch, *Lives*, 5:27] According to classical texts, Croesus, a fabulously rich king from Asia Minor in the sixth century BC, was visited by the wise Athenian Solon who suggested that riches were not the greatest asset in life, nor necessarily what brought greatest happiness. Indeed, according to Solon, even the poorest might be better off if blessed with good fortune. Some time later, Croesus appreciated the wisdom of Solon's warning. Despite his great wealth and power he was defeated by Persia and condemned to death by Cyrus the Persian king.

Hendrick van Steenwyck's painting of *Croesus and Solon* depicts Croesus in a turban and Eastern clothing, showing Solon around his richly decorated palace.
[Steenwyck (1132)]

Crowning with Thorns *see* Christ: Passion – 8

Crucified Christ with the Virgin Mary, Saints and Angels (also known as *The Mond Crucifixion*) *see* Christ: Crucifixion

Crucifixion *see* Christ: Crucifixion

Cupid complaining to Venus [Greek literature: Theocritus, *Idyll* XIX ('The Honeycomb Stealer')] Lucas Cranach the Elder's painting of *Cupid complaining to Venus* shows Cupid crying after being stung by bees from the honeycomb he has just stolen. The theme for this painting derives from the third-century BC Greek poet Theocritus who composed a poem called 'The Honeycomb Stealer'. The Latin inscription in the top right-hand corner points out that the pain of the bee sting after the sweet taste of honey is similar to the pain we feel after the brief satisfaction of love. Cranach's painting thus offers a warning about the wounds of love.
[Cranach (6344)]

Damon
Damon broods on his Unrequited Love
Damon takes his Life
Thyrsis asks Damon the Cause of his Sorrow
Thyrsis finds the Body of Damon
[Italian 16th-century literature: Tebaldeo, *2nd Eclogue*]
The Ferrarese court poet Tebaldeo's tale of the Arcadian shepherds Damon and Thyrsis charts a sad story of unrequited love. This elegiac story is depicted in four small scenes painted on two strips of wood which are attributed to Previtali. All four scenes have the same landscape background.

Damon loved Amaryllis, but was not loved in return, so he retreated into

the countryside to lament his fate and play upon his psaltery, a medieval stringed instrument. But because he had used this instrument to play sweet music to Amaryllis, its sounds only reminded him of her. In *Damon broods on his Unrequited Love* we see the dejected lover sitting alone in a landscape. He holds the psaltery on his knee but seems lost in thought. An urban scene in the background suggests the town from which Damon has fled to escape the pain of Amaryllis' rejection.

In the second scene, *Thyrsis asks Damon the Cause of his Sorrow,* we see Thyrsis trying to persuade Damon to give up his solitary life and return to his friends. Damon looks up as if about to respond to his friend's questions. But the lovelorn shepherd in fact refuses to return to the town. Instead, he breaks his instrument and stabs himself to death. In *Damon takes his Life* we witness Damon plunging a dagger into his breast, with the shattered psaltery at his feet.

When Thyrsis found Damon's body he scattered flowers over the corpse and composed an epitaph. In this last scene, *Thyrsis finds the Body of Damon,* we see a distant view of water with a boat sailing off into the distance, perhaps reflecting the liberation of Damon's soul through death.

[Attr. Previtali (4884)]

Damon broods on his Unrequited Love *see* Damon

Damon takes his Life *see* Damon

Dance of Miriam *see* Moses – 2

Daphnis and Chloë (recently retitled *A Pair of Lovers*) [Greek and Roman literature: Diodorus Siculus, *Bibliotheca Historica*, 4:84; Longus, *Daphnis and Chloë*] According to the Roman writer Longus, Daphnis and Chloë were married and lived thereafter in pastoral bliss. However, the first-century BC writer Diodorus Siculus also wrote a story about a pair of lovers called Daphnis and Chloë. Diodorus described a very different love between his nymph Chloë and her Sicilian herdsman. Although Diodorus tells us that Daphnis at first swore eternal love to Chloë we learn that he was later seduced by someone else. The story ends in tragedy when Chloë blinds Daphnis for this betrayal of their love. Thereafter Daphnis spent his time composing mournful laments on his pan pipes and writing pastoral, or bucolic poems.

Although the painting of *Daphnis and Chloë* by Paris Bordone (which has recently been retitled *A Pair of Lovers*) has traditionally been associated with the Diodorus story, it is possible that it refers to the later story of Daphnis and Chloë which was written by Longus in the third or fourth century AD, since it seems to show a couple who are blissfully in love. The flying cupid figure who gestures towards Daphnis, and at the same time holds a crowning wreath of foliage above the lovers' heads, certainly suggests a picture of domestic bliss.

It is however significant that Chloë holds a set of pan pipes. This would be appropriate if these were the fated lovers described by Diodorus. The wreath held by Cupid could also refer to the laurel bush under which Daphnis (according to Greek legend) was left as a child.

[Bordone (637)]

Daughter of Herodias *see* St John the Baptist – 3

David – 1

Story of David and Goliath
David and Jonathan
Triumph of David over Saul
[Biblical: I Samuel 17 and I Samuel 18. 1–7]

The Book of Samuel describes one of the great battles between the Philistines and the Israelites when Goliath, a man of gigantic stature and fighting on the Philistine side, challenged any Israelite to single combat in order to decide the outcome of the conflict. Goliath's great girth, combined with the blaze of his brass helmet, his coat of mail and the greaves of brass around his legs, reduced the Israelites to fear and trembling.

David, a young shepherd boy from near Bethlehem, had three older brothers who served in the army of Saul, king of the Israelites. David was sent by his father to take food to his brothers and to make sure that they were safe. Finding himself in the thick of the battle in search of his brothers, David saw Goliath and heard him taunting the Israelites and challenging them to single combat. When David saw how his own side shrank in fear from this towering opponent, he spoke out in youthful ardour, berating the Israelites for their cowardice, and attempting to whip up some aggressive reaction to Goliath. David's brothers and the other soldiers were not pleased to have this young boy tell them how to fight their battle. Thinking to teach David a lesson they informed Saul who commanded that the boy should be brought to him.

David pleaded with the king to be allowed to go out and fight Goliath, but Saul at first thought he was too young and inexperienced. However, inspired by the young man's sense of mission and his belief that God would watch over him, Saul finally gave his consent, offering David his own armour and giving him his blessing.

Samuel describes how Goliath scarcely glanced at David on the battlefield; indeed this great giant of a man made fun of the young boy, asking if he had come out with his stick to beat a dog, and offering to feed his flesh to the passing birds and beasts. But David, proclaiming the power of the Lord, defied Goliath and rushed towards him. Arming his sling with a stone from his bag, David aimed carefully at Goliath and felled him with one blow to the forehead.

Cima da Conegliano's painting of *David and Jonathan* is particularly faithful to this part of the story in showing Goliath with a single gash in the front of his head.

The Bible relates how David severed Goliath's head with his sword. This moment is shown in Pesellino's *Story of David and Goliath* (which is on loan to the National Gallery). David then took Goliath's head back to Jerusalem where he presented it to Saul. Saul was amazed by David's prowess, especially since the young Israelite had rejected the armour and weapons offered him, going into combat instead armed only with a sling and five smooth stones.

After enquiring about David's family, Saul insisted on taking the young boy into his own household. Samuel tells us that Saul's own son Jonathan felt an instant bonding with David and that a great affection sprang up between them. Samuel describes how Jonathan's love for David was so great that he

*David and
Jonathan*
Giovanni Battista
Cima da Conegliano
(1459/60(?)
–1517/18)

stripped himself of his garments even down to his sword, bow and girdle, insisting that his new friend should take them as gifts.

Cima da Conegliano's painting of *David and Jonathan* combines two main episodes from the life of David. He is shown walking in the company of Jonathan and yet still holding the head of Goliath and resting a sword on his shoulder, as if only recently returned from his triumph against the Philistines.

David's return from the battle with Goliath is often referred to as the Triumph of David. This moment is depicted in the second of the two Pesellino panels, *The Triumph of David over Saul* (which is also on loan to the National Gallery). The Book of Samuel describes how all over the land women came out into the streets with musical instruments to sing and dance in celebration at Saul's victory over the Philistines. But although they praised their king, they were even louder in their appreciation of the young hero David. This eventually brought jealousy and suspicion into Saul's heart, leading to an estrangement between him and David and finally to his suicide. [Cima (2505); Pesellino (L7); Pesellino (L8)]

David – 2

David at the Cave of Adullam [Biblical: II Samuel 23. 13–17] The legendary King David, who ruled over the whole of Israel a thousand years before the birth of Christ, is best known for his youthful victory over the Philistine giant, Goliath [*see* David – 1]. At the time of this miraculous feat King Saul ruled over the Israelites. Saul at first received David in triumph, lavishing love and favours on him. But gradually this affection turned sour as Saul

became aware of David's increasing popularity amongst the Israelites. After many trials and tribulations David was forced to flee, seeking help even from Goliath's old home town of Gath. Yet, despite the estrangement from Saul, David remained faithful to the Israelites in their continuing fight against the Philistines, the ancient foes of the children of Israel.

The cave of Adullam was one of the places where David rested during a great battle with the Philistines. It was here also that he gathered around him a large following of relatives and loyal supporters. Samuel tells us how David defied and finally triumphed over the Philistines, even though his own people (the Israelites) refused to help him. At one stage the remains of the Philistine army pitched in the valley of Rephaim whilst David returned to the safety of the cave of Adullam on the hill above. It was here that David received a special offering from three of his followers. Hearing that David longed for a drink of water from the well just outside the gates of Bethlehem, three men risked their lives by breaking through the Philistine lines to fetch some of the precious liquid for their master. But when they returned to the cave David, repenting of his capricious wish, would not drink the water, pouring it instead on the ground as a thanksgiving to God. How could he drink this when these three heroes might have shed their own blood in fetching it?

Claude's painting of *David at the Cave of Adullam* shows David, with arms raised, greeting the three men as they return from their hazardous journey across the valley. One of the three offers David his helmet which he has filled with water. Two more soldiers make their way up towards the cave – one of them looking over his shoulder towards the enemy on the plain below. Over the trees on the far side we see the tops of the buildings of Bethlehem.
[Claude (6)]

David at the Cave of Adullam *see* David – 2
David and Goliath, Story of *see* David – 1
David and Jonathan *see* David – 1
Dead Christ mourned (also known as *Three Maries*) *see* Christ: Death – 2
Dead Christ in the Tomb, with the Virgin Mary and Saints *see* Christ: Death – 3
Death of Actaeon [Mythological: Ovid, *Metamorphoses* III, 173–252] Actaeon, the son of Aristaeus [*see* Death of Eurydice] and grandson of Cadmus [see Cadmus], was turned into a stag by Diana and subsequently torn to death by his own hounds.

Ovid tells us how Actaeon, leaving his hunting companions, happened to wander into the sacred grove where Diana and her nymphs were bathing. All the nymphs clustered around the goddess hoping to hide her nakedness, but she, being taller than the rest, stood head and shoulders above them. Angered and embarrassed Diana cast around looking for her bow and arrows, but defenceless in her nudity, she had nothing but the water and her curse with which to fend off this unexpected intruder. Scooping up some water, Diana hurled it at Actaeon, daring him, if he were able, to boast about seeing her naked.

Actaeon darted away in fear, not realising that he was cursed with more

than Diana's anger and contempt. The youth was at first amazed at the speed with which he escaped from the enchanted glade, but coming upon a pool and seeing his reflection there, he realised that his form had changed into that of a stag, complete with horns, sharpened ears and spotted hide. His mind still alert, Actaeon considered the dilemma of returning home in this guise and the alternative which was to remain in hiding in the woods.

As Actaeon pondered his predicament his own pack of hounds came baying, in swift pursuit of the stag they had scented in the wind. Fleeing in despair, unable to call his hounds by their many names, he gradually lost ground. Three of the hounds cut across the mountain, inexorably gaining upon their hapless master. Two dug their fangs in his back; the third fastened on his shoulder. The others burst upon the scene and the whole pack set upon Actaeon who sank upon his knees as if in prayer, uttering wild and strange cries. At the same time his hunting companions urged on the hounds lamenting the absence of Actaeon at this exciting kill. Calling Actaeon's name in all directions, they remained unaware that the dying stag who turned towards them in agony was in fact him.

Titian's painting of *The Death of Actaeon* shows Actaeon in the moment of

The Death of Actaeon Titian (active before 1511, died 1576)

transformation. Only his head is changed into that of a stag, yet three of his hounds already claw and snarl at his body. Titian has embroidered Ovid's text to emphasise the poignant fate of the master pursued by his own hounds. At the same time we witness Diana (suitably tall), as if in like pursuit, albeit without a string to her bow. Now dressed in the garb of huntress, yet somewhat awkwardly placed in the composition, Diana seems physically removed from the scene of the kill, although she is apparently in full stride. It is as if she is an onlooker, perhaps only following the hunt in her mind.

Titian was perhaps aware of the original passage in Ovid where we learn that the wrath of the 'quiver-bearing goddess' was only appeased when Actaeon had died from countless wounds. Through the trees we dimly perceive one of Actaeon's friends on horseback, too far away to witness either the transformation or the savage revenge.

[Titian (6420)]

Death of Eurydice [Mythological: Virgil, *Georgics* 4.315] The death of Eurydice is closely linked with the story of Aristaeus. Aristaeus was the son of Apollo and a nymph Cyrene. As well as being a hunter, Aristaeus was a devoted keeper of bees. Although usually innocently involved in husbandry, Aristaeus made one fatal mistake which was to cost him the lives of all his

The Death of Eurydice Niccolò dell'Abate (about 1509/12–1571)

beloved bees. He fell in love with and pursued Eurydice, a dryad (or tree nymph), who was married to Orpheus.

In desperate flight from Aristaeus, Eurydice stepped upon and was bitten by a snake. She later died from the snake's poison and was carried away into the underworld. Eurydice's death was avenged by her sister dryads who killed all the beekeeper's bees. Aristaeus, in despair, went to his mother for advice. Cyrene sent him to Proteus (a sea god), who in his turn advised Aristaeus to make a sacrifice of bulls and cows by way of appeasement to the tree nymphs. Virgil tells us that Aristaeus's prayers were answered when swarms of bees emerged from the rotting carcasses.

Niccolò dell'Abate depicted the first part of this myth as if scene by scene in the painting entitled *The Death of Eurydice*, even showing us the figure of Orpheus in the background playing upon his lyre and charming the wild animals. This detail reminds us of the later part of the story when Orpheus, grief-stricken at the loss of Eurydice, follows her to the underworld and tries to lead her back to life – playing on his lyre, and charming the custodians of hell [*see* Orpheus].

[Niccolò dell'Abate (5283)]

Death of Procris, Landscape with the *see* Cephalus – 2

Death of St Benedict *see* St Benedict

Death of St Jerome *see* St Jerome

Death of St Peter Martyr *see* St Peter Martyr

Death of the Virgin *see* Virgin Mary: Death – 1

Decapitation of St Catherine *see* St Catherine

Departure of Abraham *see* Abraham

Deposition *see* Christ: Death – 1

Deposition from the Cross *see* Christ: Death – 1

Diana and Callisto [Mythological: Ovid, *Metamorphoses* II, 442–53; Ovid, *Fasti* 2, 155–92] Ovid describes how Zeus seduced Callisto, one of the chaste nymphs who followed Diana (the virgin huntress, goddess of the Moon). This was a particularly shameful seduction, since Zeus assumed the guise of Diana herself in order to catch Callisto off guard.

Some time after, Callisto – shamed by the loss of her virginity – found herself once again in the company of her mistress Diana. At first Callisto was frightened that this 'meeting' with the goddess might mark yet another terrifying encounter with Zeus. But seeing the other nymphs in train, Callisto – although reluctant and fearing Diana would guess her guilty secret – followed along with them. Ovid describes how nine months later Diana went to bathe after a tiring day's hunting in the hot sun. The goddess was delighted to find a cool grove and a softly murmuring stream. When Diana encouraged her nymphs to disrobe and join her, Callisto held back blushing, anxious not to reveal the pregnancy that had followed her union with Zeus. But the other nymphs who, according to Ovid, knew about her seduction, forced her to undress. Callisto vainly tried to cover her body and its incriminating evidence, but Diana saw all and banished the tainted nymph both from the pool and from their company.

The National Gallery painting of *Diana and Callisto*, attributed to Tassi,

shows Callisto's pregnant state revealed on one side of the stream, whilst Diana – already emerged from the water and resting under the shade of a tree on the farther bank – lifts an arm in the nymph's direction, as if issuing the command of exile.
[Attr. Tassi (4029)]

Diana and Callisto Attr. Agostino Tassi (about 1580–1644)

Diana bathing surprised by a Satyr(?) [Classical mythology] According to classical mythology the virgin huntress Artemis, whose Roman name was Diana, was the goddess of the Moon. She is often depicted with a crescent moon at her forehead. Diana was aggressively protective of her virginity, and so laid great store on privacy when bathing naked in the pools and streams she came upon whilst hunting. Those who blundered upon her nakedness, whether by intent or inadvertently, were greeted by spears and shields. On occasion, as for example, in the case of Actaeon, Diana's revenge was a particularly hideous death for the intruder [*see* Death of Actaeon].

Since Diana was the symbol of chastity and purity, she and her nymphs – who were likewise dedicated to virginity – were often subjected to the lascivious attentions of woodland satyrs, symbols in their turn of lust. Sometimes Diana bathed unaware of a nearby voyeur. However in many depictions, as in the National Gallery painting of *Diana bathing surprised by a Satyr(?)* attributed to a follower of Rembrandt, the goddess is suddenly alerted to an unwelcome presence.
[Follower of Rembrandt (2538)]

*Diana bathing
surprised by a
Satyr*(?)
Follower of
Rembrandt
(1606–69)

Dido – 1

Dido building Carthage (also known as *The Rise of the Carthaginian Empire*) [Roman mythology: Virgil, *The Aeneid* I] After the murder of her husband Sychaeus in Tyre, Dido fled across the sea towards Africa. She is said to have taken a number of her people with her as well as a substantial part of her husband's wealth. A great storm blew Dido's fleet westwards. On reaching North Africa, she is said to have bartered with the local inhabitants and come to an agreement whereby she was allowed as much land as could be covered by the hide of a bull. The wily queen cut the hide into thin strips, and was thus able to enclose a large area of land. This land became known as Carthage. According to Virgil, Carthage confronted Italy, 'opposite to the mouth of the Tiber but far away'. It was at Carthage that Dido built the citadel of Byrsa and dedicated a great temple to Aesculapius (the god of Healing).

In Turner's painting of *Dido building Carthage* we see the diminutive figure of Queen Dido discussing the plans of her city against a backdrop of monumental architecture. To the right is a vast tomb dedicated to Dido's

husband Sychaeus. According to Virgil, Dido's betrayal of her love for Sychaeus in favour of the Trojan Aeneas not only destroyed her standing with her own people but ultimately influenced her decision to take her own life [*see* Dido – 2, 3 and 4]. In the mist beyond Sychaeus' tomb we see the portico of a great temple – perhaps that dedicated to Aesculapius. Other monumental buildings rise to the left. The architectural style of these buildings conjures up the glory of classical Rome although Carthage is thought to have been founded in the ninth century BC, long before the foundation of Rome.

In Turner's painting we seem to be looking to the east and into the rising sun. Turner often uses the movement of the sun symbolically. Thus the rising sun marks optimistic beginnings, whereas the sunset is reserved for melancholic decline. In the foreground of *Dido building Carthage* young boys play with toy boats. Perhaps this alludes to the arrival of Aeneas with the Trojan fleet, as well as to their later embarkation for Italy [*see* Dido – 4]. [Turner [498]]

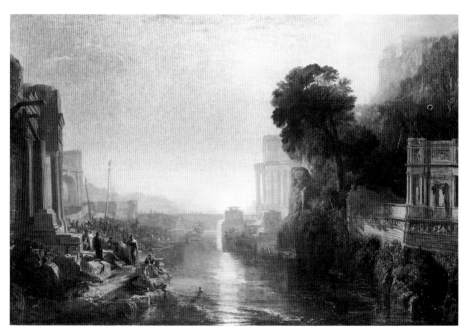

Dido building Carthage Joseph Mallord William Turner (1775–1851)

Dido – 2

Dido receiving Aeneas and Cupid disguised as Ascanius [Roman mythology: Virgil, *The Aeneid* I] Virgil tells us how when the young Trojan prince Aeneas first arrived in Carthage seven years after the fall of Troy [*see* Troy – 1 and 2], his mother Venus arranged that Dido, the queen of Carthage, should fall in love with him. Venus was anxious to effect a union between her son and the ruler of Carthage as she worried that her fellow goddess Juno might seek to

harm Aeneas. Juno was the sworn enemy of Troy. She was also the protectress of Carthage and knew that it was destined to fall to a race of Trojan descent. Aeneas was thus not only a natural enemy but also a threat to the city under Juno's protection.

Enlisting the help of Cupid, Venus ordered him to assume the form of Aeneas' son Ascanius. She then told him to go to Queen Dido with gifts. Venus planned that Dido should be so enraptured by Ascanius that she should fall in love with his father Aeneas. Virgil tells us how Cupid was much taken with this plan, and having discarded his wings, practised the walk of Ascanius.

Francesco Solimena's painting of *Dido receiving Aeneas and Cupid disguised as Ascanius* shows the moment when Cupid (clearly identifiable through his wings) moves towards Dido and lifts her limp hand to his lips. Virgil describes how only a moment before the queen had composed herself, 'proudly curtained on her golden seat'. Solimena's painting seems to refer to this. The queen sits in regal pose under a great swathe of curtain as if waiting to welcome the guests she has invited to a great banquet. Yet her attention is fixed on Cupid.

Virgil describes how Cupid at first clung to Aeneas and then walked winsomely towards the queen. When Dido saw him she was overcome with passion both for the boy and for his beautiful gifts. She wanted to clasp him in her arms. Cupid's embrace marked Dido's downfall, for in that moment he planted the seeds of passionate love in the queen's breast, draining from her all thoughts of Sychaeus [*see* Dido – 1] and filling her instead with a burning

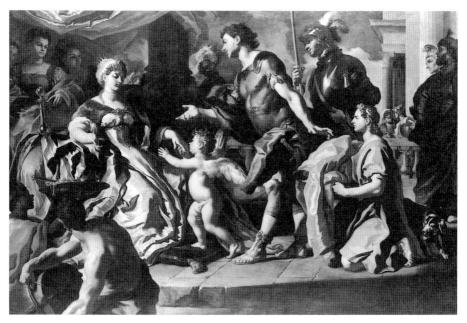

Dido receiving Aeneas and Cupid disguised as Ascanius Francesco Solimena (1657–1747)

desire for Aeneas.

In Solimena's painting Aeneas gestures towards Dido whilst at the same time pointing out the rich cloth he has brought as a present. In the background we catch glimpses of the Phoenician maids and Carthaginian guests invited to the feast. Yet our attention is fixed on the queen. We wait for her to raise her eyes and recognise this new love which will finally leave her in despair and drive her to suicide [see Dido – 3 and 4].

[Solimena (6397)]

Dido – 3

Union of Dido and Aeneas [Roman mythology: Virgil, *The Aeneid* IV] According to Virgil, Dido (queen of Carthage) fell desperately in love with Aeneas when he stopped in Carthage during his years of wandering after the Fall of Troy [see Dido – 2]. Aeneas, a young Trojan prince, was destined to found a Trojan community in Italy. But his movements were closely monitored, and at times directed by two warring goddesses, Juno and Venus.

Despite the fact that she was only recently widowed, Dido sought the help of the gods to win over Aeneas' love so that she might ensnare him in marriage. Juno, seeing that Dido was hopelessly in love with Aeneas and bereft of all sense of modesty or propriety, decided to play a part in the matchmaking begun by Venus [see Dido – 2]. Being the guardian of Carthage, and knowing the prophecy that this city would be destroyed by a race of Trojan descent, Juno had special reasons for keeping Aeneas there. Only in this way could she hope to thwart his plans to settle in Italy. Failing to get Venus' support Juno devised her own plot to bring about the seduction of the Trojan prince. Juno proposed to cast a great storm in the path of Dido and Aeneas as they went hunting. The two would set off separately, but Juno's storm of hail and rain would force their separate retinues to take flight and effect a private meeting between Dido and Aeneas when they both took refuge in the same cave.

The National Gallery painting of *The Union of Dido and Aeneas* by Gaspard Dughet shows a cupid tending a solitary horse whilst Dido and Aeneas hover at the entrance of a cave in the hillside. Aeneas seems to gesture Dido towards his horse, but she – perhaps feigning modesty – appears to hold back. Above the couple another cupid aims his arrow towards them. Perhaps they have yet to declare their love for each other. Aeneas' own bow and arrow lie discarded on the ground, as if he has only just discovered Dido. Perhaps he has only just found this refuge from the storm.

Virgil describes how the lightning flashed and the mountain nymphs shrieked with joy at the union of Dido and Aeneas, yet in this moment we are aware only of the gathering storm clouds and the lashing wind. Together with Juno, who sits in the lowering thunder clouds above, we wait for the lightning and Aeneas' declaration of love.

[Dughet (95)]

Dido – 4

Dido's Suicide [Roman mythology: Virgil, *The Aeneid* IV, 504ff] Although Juno was successful in her plan to bring Dido and Aeneas together [see Dido – 3], their joyful union was shortlived. Dido, elated and heedless of the

gossips around her, boasted of her conquest of Aeneas, claiming that she was now remarried, despite her recent widowhood.

Virgil describes how all the people of Africa discussed the shameful passion and self-indulgence of Dido and Aeneas, accusing the queen of forgetting her royal duties as she whiled away the long winter months with her Trojan lover. Finally, Iarbas (one of Dido's rejected suitors who was consumed with jealousy and anger), made sacrifices to Jupiter, calling upon him to look down and see how Aeneas 'this second Paris, wearing a Phrygian bonnet to tie up his chin and cover his oily hair', now ruled over Dido and Carthage.

Jupiter, calling on the services of his winged messenger Mercury, gave instructions that Aeneas should be reminded of his destiny. He was to be reminded that it was not his fate that he should tarry among enemies in a minor city in Africa, but rather that he should settle in Italy and found Rome. He owed this to his mother Venus who had saved him from the Greeks. He owed this to his son Ascanius. He must set sail. How could Aeneas withstand such stern orders? Virgil describes how he was struck dumb, his hair bristling with fear and he realised that his only recourse was to set sail.

Whilst Aeneas was trying to pluck up courage to tell Dido that he was leaving, she – with a woman's intuition – understood that all was lost, and ran through the streets of Carthage in a frenzy of despair. Coming upon Aeneas, she denounced him as a traitor, accusing him of wanting to leave without even bidding her farewell. Wildly lamenting her fate, Dido claimed that Aeneas wanted to leave her alone to face the hatred of neighbouring tribes, and perhaps even to undergo a forced union with Iarbas. Deaf to all his explanations, Dido cursed Aeneas and was carried, swooning, back to her bed chamber.

Virgil describes how the Carthaginian queen then watched the movements of the Trojans from her citadel. First she saw Aeneas' men gathering stores in the city and pillaging the countryside for barley and corn. And then, with bitter anguish, she saw them launching their ships along the beach.

Realising that Aeneas was indeed leaving and that her future was hopeless, Dido commanded her sister Anna to make a great funeral pyre. She ordered that the pyre should be built in the centre of the palace in a courtyard that was open to the sky but hidden from general view. Everything that reminded Dido of her lost love, from Aeneas' armour to the bridal bed, was to be destroyed. Anna had no idea that her sister was contemplating suicide, but Aeneas was warned by Mercury that Dido planned a shocking revenge. Mercury, knowing also that Dido would send soldiers in pursuit, urged Aeneas to leave before the whole coastline went up in flames.

As dawn broke Dido saw the Trojan fleet sailing away, the harbour empty and the oarsmen gone. Uttering terrible oaths and threatening horrible punishments for Aeneas, his son, his countrymen and his fleet, Dido called upon the Carthaginians to arm themselves and pursue the Trojans. At the same time she climbed on to the funeral pyre and plunged Aeneas' sword into her breast.

Virgil describes how rumour spread like wildfire through the town. Everyone converged on the palace as the flames licked the funeral pyre,

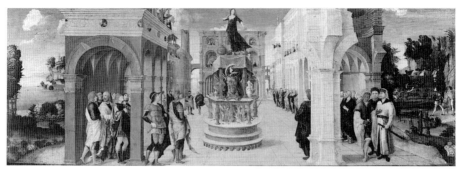

Dido's Suicide Liberale da Verona (1445–1526)

gradually taking hold and burning high to consume Dido, the surrounding altars and the palace itself.

Liberale da Verona's painting of *Dido's Suicide* shows a number of different episodes from this tragic story. Although there is much activity in the countryside to the right, the harbour itself is empty, suggesting that Aeneas has already fled. Inside the palace we see Dido standing high on the funeral pyre, her right hand raised to her breast as if about to kill herself. The weapon she holds is a small dagger, but the hilt of Aeneas' sword juts out between her feet. We note the flickering flames at the base. Yet some of the surrounding courtiers seem unconcerned by the queen's action, as if witnessing a dramatic gesture rather than a serious bid for suicide. Perhaps Liberale da Verona wants us to remember that Dido tricked her sister Anna into believing that the building of the pyre was on the advice of a distant priestess who had promised either to bring Aeneas back to Dido, or to release her from her love.

[Liberale da Verona (1336)]

Dido building Carthage (also known as *The Rise of the Carthaginian Empire*) *see* Dido – 1

Dido receiving Aeneas and Cupid disguised as Ascanius *see* Dido – 2

Dido's Suicide *see* Dido – 4

Dives

Dives and Lazarus

Rich Man being led to Hell

[Biblical: Luke 16. 19–31]

The Gospel of Luke describes how a certain rich man, Dives, used to dine sumptuously each day dressed in fine clothes, whilst Lazarus, a beggar covered with sores, lay at his gate in the hope that he might receive some of the crumbs from his table. Although the biblical text is not specific on this point, we have to assume that Dives was not moved to feed Lazarus. Indeed we read that it was the dogs instead who came out and licked at the beggar's sores, as if rather to feed off him. The Bible describes how both men died, and (as might be expected) Dives went to hell, whereas Lazarus was carried by angels to heaven and into the arms of Abraham.

The painting of *The Rich Man being led to Hell* by David Teniers suggests

Dives and Lazarus Follower of Bonifazio di Pitati (?) (1487–1553)

the fear and disgust Dives must have felt in encountering the fiends of hell. In torment Dives called out to Abraham, beseeching that Lazarus might be sent down to comfort him. This request rejected, Dives nevertheless persisted in his pleas, asking that Lazarus should at least be allowed to visit the house of Dives' father, so that other members of the family might be warned of the punishment meted out to those who were deaf to the miseries of the poor.

The National Gallery painting of *Dives and Lazarus* by a follower of Bonifazio is curious in that it shows Lazarus kneeling and gesticulating, rather than lying, at the gate. There are, moreover, a large number of people sitting around the table laid out in the loggia. Perhaps therefore the artist was anxious to draw out the moral of the story, and chose to show the return of Lazarus in answer to Dives' tormented plea that his relations should be warned of the dreadful fate awaiting them if they turned away from the beggar at their gate.

[After Bonifazio(?) (3106); Teniers (863)]

Dives and Lazarus *see* Dives

Don Quixote and Sancho Panza [Spanish 16th/17th-century literature: Cervantes, *Don Quixote*] Don Quixote, the ridiculous hero of Cervantes' tale, spent much of his life imagining false foes and engaging in ludicrous confrontations. Cervantes, who died in 1616, was intent on satirising the age of chivalry. He therefore depicted Don Quixote as an impoverished and confused gentleman who rode out looking for adventure on his horse Rosinante, with by his bibulous and simple-minded squire, Sancho Panza.

In the National Gallery painting of *Don Quixote and Sancho Panza* by Honoré Daumier Sancho Panza swigs from a gourd whilst his somewhat somnolent and blinkered mule pricks his ears in the direction of another figure on horseback. This is Don Quixote, caught in the moment of charging full speed into a flock of sheep.

[Daumier (3244)]

Dormition of the Virgin *see* Virgin Mary: Death – 1

Drunken Silenus supported by Satyrs *see* Bacchanalia

El Hechizado por Fuerza, Scene from (also known as *The Forcibly Bewitched*) [Spanish 18th-century literature: Antonio de Zamora, *El hechizado por fuerza*, act II] Goya's painting *Scene from 'El Hechizado por Fuerza'* develops a scene from Zamora's tale of witchcraft *El Hechizado por fuerza* in which one of the characters, Don Claudio, comes into a darkened room to find himself surrounded by terrifying images of asses and grotesque masks which he believes to be a fit company for the devil. Goya has actually depicted a devil in the painting, in the form of a lampstand. Behind the trembling Don who replenishes the lamp with oil we see a whole company of mules cavorting in the shadows.

The original text has Don Claudio referring to this scene as a dance of donkeys and lighting his lamp to give himself courage. But as he replenishes his lamp with oil from his jug, he fears he is using up his own life source. He foolishly believes the yarn spun to him that the length of his life is governed by the burning flame.

Goya has caught the Don's conflicting emotions of fear and reluctance as he leans forward to illuminate the scene in order to banish the hideous images lurking in the shadows, yet appears at the same time to hesitate and hold back, as if estimating the portion of life he is pouring away. The inscription in the lower right-hand corner LAM/DESCO derives from the words *lampara descomunal* (extraordinary lamp) in Zamora's text – 'O extraordinary lamp, whose civil light – after the way of lamps – is sucking up my vital oil.'

[Goya (1472)]

Elijah

Elijah and the Angel, Landscape with

Elijah fed by Ravens

[Biblical: I Kings 17; I Kings 19. 4–15]

The Bible describes how Elijah (a ninth-century BC Hebrew prophet) was driven into the desert in despair, after trying to fight the heathen cult which had been imported into Israel by King Ahab and his wicked wife Jezebel. It was the task of the Hebrew prophets to protect their own deity against many Baalim or false gods which infiltrated the religion of the Israelites.

In punishment for their false beliefs Elijah called down a great drought on Ahab and his land before going to hide in the Wilderness. We learn that God told Elijah to go and live near the Cherith brook, promising him that he would find water there and that he would be fed by ravens. The ravens brought bread and flesh to Elijah in the morning and again at evening time, and when he was thirsty he drank from the nearby brook. Guercino's painting of *Elijah fed by Ravens* (which is on loan to the National Gallery) shows a great raven swooping down with a package of food in its beak. Elijah holds up his cloak as if to gather in the food and in the foreground we notice the clear waters of the brook.

Later verses of the Book of Kings describe how Elijah returned to the land of Ahab and how Jezebel then threatened him with death after his triumph

over four hundred and fifty prophets of Baal. Once again Elijah fled into the Wilderness. But after a day's journey he sat down under a juniper tree and prayed to die, since he felt that he had failed his Lord. Exhausted by his flight he fell asleep.

Whilst Elijah slept an angel came and touched him, telling him to get up and eat. This Elijah did and, having refreshed himself, lay down once more to rest. But an angel came a second time, rousing him and encouraging him yet again to eat, telling him that he had a great journey in front of him.

The Bible describes how Elijah travelled for forty days and forty nights until he came to Mount Horeb, which was known as the mountain of the Lord. Here Elijah found a cave, where he heard a voice telling him to go and stand on the mountain before the Lord. When Elijah did this the Lord God passed him by, and there was first a great wind which 'rent the mountain and brake in pieces the rocks', and then there was an earthquake, and then a fire. And after all this there was a small voice which commanded Elijah to go back the way he had come.

Gaspar Dughet's *Landscape with Elijah and the Angel* seems to combine various parts of the story. We see Elijah in conversation with an angel, but no evidence of food or drink. Elijah himself seems just to have emerged from a cave to the left as if already encamped on Mount Horeb. We are also aware of a great wind which tears at the leaves and branches of the trees and agitates the surface of the water cascading over rocks and cliffs in the middle foreground. And at the same time we see the figure of God the Father seated in the clouds with arm raised, as if to point Elijah back along the way he has travelled. We thus seem to witness both the beginning and the end of Elijah's venture.

[Dughet (1159); Guercino (L273)]

Elijah and the Angel, Landscape with *see* Elijah

Elijah fed by Ravens *see* Elijah

Embarkation of the Queen of Sheba, Seaport with *see* Queen of Sheba

Embarkation of St Ursula, Seaport with *see* St Ursula

Emperor Theodosius is forbidden by St Ambrose to enter Milan Cathedral [Italian 13th-century literature: Jacopo da Voragine, *The Golden Legend*] St Ambrose (also known as St Ambrosius) was Bishop of Milan in the fourth century. He is traditionally referred to as one of the Four Latin Doctors of the Church, the other three saints being Gregory the Great, Augustine and Jerome. During Ambrose's bishopric Milan was the administrative centre of the Roman Empire in the West. Ambrose thus assumed a great civic responsibility as well as overseeing church matters.

In 390 the Roman governor at Thessalonica was killed by rioters, and in retribution the emperor of the day, Theodosius I (the 'Great',) ordered a brutal massacre of the city's inhabitants. St Ambrose wrote to Theodosius telling him that he should do penance in public for such an ungodly act. The saint is said to have commented, 'The emperor is within the church: he is not above it.'

Van Dyck's painting of *The Emperor Theodosius is forbidden by St Ambrose to enter Milan Cathedral* shows the bishop gesturing towards the laurel-

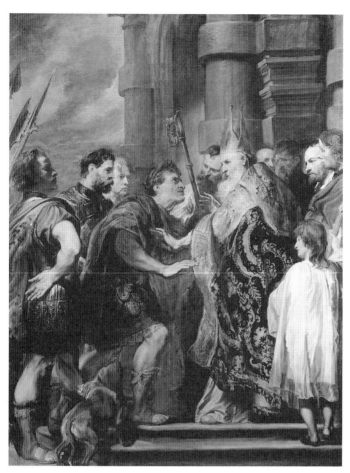

The Emperor Theodosius is forbidden by St Ambrose to enter Milan Cathedral Anthony van Dyck (1599–1641)

wreathed emperor as if barring his way into the church portico beyond. Theodosius appears to lower himself in front of the saint. His followers may stand as if in gestures of defiance, but Theodosius seems about to genuflect, thus humiliating himself in front of the bishop and the onlookers behind. [Van Dyck (50)]

Entombment *see* Christ: Death – 3

Entombment of Christ *see* Christ: Death – 3

Entombment of the Virgin *see* Virgin Mary: Death – 1

Erminia takes Refuge with the Shepherds [Italian 16th-century literature: Tasso, *Gerusalemme Liberata* 7:6ff] The meeting of Erminia, a Saracen princess, with an old shepherd was often used by painters to represent the differences between war and peace. In Tasso's epic poem *Gerusalemme Liberata* Erminia disguises herself by donning the armour of a female warrior Clorinda, and sets off in search of the Christian knight Tancred whom she loves. On her way she pauses to rest and contemplates the peaceful haven of the countryside.

The National Gallery painting of *Erminia takes Refuge with the Shepherds* by a follower of Annibale Carracci shows Erminia in armour deep in

conversation with an elderly figure who reclines against a rock where children relax and play musical instruments. The sheep in the background suggest that the man is a shepherd. Erminia's confrontation with this group reminds her of the joys of pastoral life in contrast with the ravages of war. [Circle of Annibale Carracci (88)]

Esther before Ahasuerus [Biblical: Esther 2. 5–23; 3, 4, 5, 6, 7 and 8. 1–4] Esther, a young Jewish virgin, was brought up by her cousin Mordecai who was a servant at the court of the Persian King Ahasuerus. Esther gained favour with Ahasuerus and used his love to gain protection for the Jews, after Vashti, his wife, had lost favour with him and had been banished from his sight. Vashti's great sin was disobedience. She refused the king's command to come before him so that he could show her beauty to all the people gathered around. Vashti's punishment was that she would never again be called into the presence of the king, and that her royal estate should be given to another woman.

The Bible tells us how Esther was taken into Ahasuerus' household along with a number of other beautiful young women, in an attempt to lighten the king's sense of loss. After twelve months of purification during which all the young virgins were bathed with the oil of myrrh and other sweet-smelling lotions, Esther was brought before the king. Ahasuerus was so taken with her that he placed a crown on her head and made her queen in Vashti's place.

Mordecai had warned Esther not to divulge her Hebrew origins, a deception which was to play a vital part in later events. Haman, a servant of Ahasuerus, developed a deep hatred for Mordecai and his race after Mordecai refused to show respect and bow before him. Haman complained to Ahasuerus, maintaining that the Jews refused to obey the king's laws. He persuaded Ahasuerus to issue a death decree for all the Jews in his kingdom. Only the king himself had the power to rescind this death sentence by touching the offender on the head with his golden sceptre.

When Mordecai learnt of this he appealed to Esther to intervene with the king. But one of the strictest laws of the Persian court was that no subject – under pain of death – should come before the king unless summoned. Esther told Mordecai that there was no way she could go before the king without being summoned, adding that she hadn't been called for thirty days – a human touch amounting almost to pique! Despite Esther's response Mordecai insisted that she should try to reach Ahasuerus, reminding her that as a Jewess she too was threatened by the king's decree. Mordecai also told Esther that it was perhaps her destiny to save her people. Esther finally relented and sent a message to Mordecai commanding him to gather all the Jews in the palace together and to fast for three days and nights. Esther promised that she and her attendants would do the same and that she would then go, uncalled, to the king, and if necessary die for such disobedience.

On the third day, Esther put on her royal apparel and went and stood in the inner court of the king's house facing the king enthroned upon the royal throne 'over against the gate of the house'. At the sight of his beautiful consort, Ahasuerus is said to have melted, offering her his golden sceptre and her heart's desire, even to half of his kingdom. We learn that Esther's request

was that Ahasuerus and Haman should come to a banquet that she had prepared for them. In a number of rather confusing episodes we subsequently learn how Ahasuerus honoured Mordecai for services rendered in protecting his life earlier in the story. However, during a second day of banqueting with Esther, Haman was dishonoured by being named as the villain whose desire was to see Esther and all her people killed. Later still we read how Esther fell down weeping in front of the king and begged him to rescind the death decree which Haman had elicited from him. And finally we learn that the king 'held out the golden sceptre toward Esther. So Esther arose, and stood before the king.'

Although Sebastiano Ricci's painting is merely entitled *Esther before Ahasuerus*, it seems likely that the artist was illustrating the later episode in the story of Esther when she begs for the protection of her people. This is borne out by the fact that Esther kneels in front of the king rather than confronting him across the expanse of the courtyard. It is also significant that

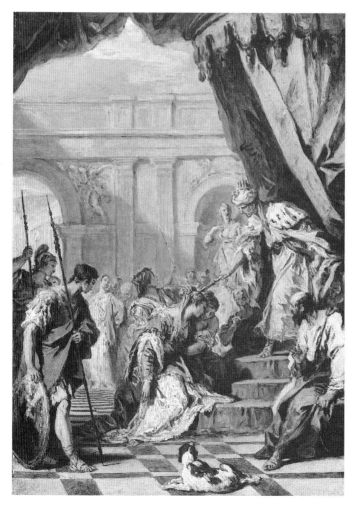

*Esther before
Ahasuerus*
Sebastiano Ricci
(1659–1734)

the king rises to touch her head with his sceptre, whilst Esther remains in humble pose before him. The figure sitting at the right in the foreground has been identified as Haman, although if this does indeed depict the moment of pardon for the Jews he would already have been hanged.

[Ricci (2101); Signorelli (3946)]

Execution of Lady Jane Grey [English history] Lady Jane Grey, the great granddaughter of Henry VII, was proclaimed queen of England on the death of the Protestant Edward VI in 1553 in an attempt to secure the Protestant succession and maintain the influence of her close family. However her reign lasted only nine days by which time her supporters in the country had melted away and Mary Tudor, committed to Catholicism, was proclaimed queen in her stead. Lady Jane was sent to the Tower of London and beheaded in a lower floor room there on 12 February 1554, at the age of seventeen.

Paul Delaroche's painting of *The Execution of Lady Jane Grey* shows the vulnerable and blindfolded figure of Lady Jane Grey clad only in her chemise, being guided towards the block by the Lieutenant of the Tower, Sir John Brydges. On one side the executioner stands by impassively, sporting a cockade strangely reminiscent of the French Revolution, whilst the deposed queen's ladies-in-waiting (who hold Lady Jane Grey's robes) abandon themselves to grief in the left background.

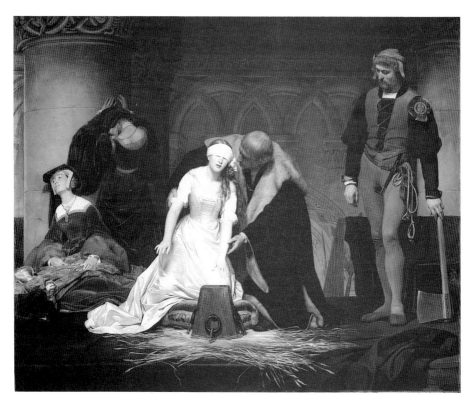

The Execution of Lady Jane Grey Paul Delaroche (1795–1856)

According to the catalogue of the 1834 Paris Salon at which Delaroche's painting was shown, the artist lifted information for his picture from a Protestant Martyrology of 1588. It was from this source that he learnt that the executioner used an axe to perform his grisly task. There is certainly a strong feel of authenticity to the scene, despite the somewhat theatrical composition. We sense that Lady Jane Grey has been escorted up the background steps to the place of execution. And the background architecture itself is very suggestive of the medieval architecture of the Tower of London. [Delaroche (1909)]

Execution of Maximilian [French and Mexican history] Emperor Maximilian of Mexico was executed by firing squad on 19 June 1867 by nationalist forces who resented the imposition (through the agency of France) of a Hapsburg archduke as head of state. Two of Maximilian's aides, General Miramon and General Mejia, were also shot. Napoleon III had withdrawn French support at a critical point in Maximilian's campaign, thus leaving the Mexican emperor helpless and vulnerable. This betrayal was regarded as a heinous crime by many of those Frenchmen (including Manet) who saw themselves as Republicans, and who – although having little sympathy for Napoleon III, or for his foreign policies – were sensitive to the Mexican emperor's dilemma.

The French press carried detailed descriptions of the execution, describing even the lone soldier who was responsible for firing the last shot to kill Maximilian. Manet produced a number of painted and printed versions of the event although their public showing in France was prohibited by government censorship.

The National Gallery painting of *The Execution of Maximilian* is incomplete (Manet having cut the work into a number of pieces, some of which subsequently disappeared); other versions show the emperor and his two aides holding hands and stalwartly confronting the rifle fire. It seems that Manet relied on contemporary prints and photographs for both Maximilian and his generals. The fact that Manet dressed his soldiers in uniforms resembling those of the French as opposed to those of the Mexicans was no doubt a direct reference to the French betrayal, and thus a political gesture on the artist's part. [Manet (3294)]

Execution of Savonarola and Two Companions *see* Savonarola

Exhumation of St Hubert *see* St Hubert

Family of Darius before Alexander [Greek and Roman literature: Plutarch, *Lives*, 33:21; Valerius Maximus, *Factorum et Dictorum memorabiliter*, Book IX; Quintus Curtius; Rufus, *History of Alexander* III, 13–25; Diodorus Siculus, *Bibliotheca historica* XVII] After a fierce battle with Alexander the Great at Issus in the fourth century BC, King Darius of Persia, conqueror of Belshazzar and lord over a luxurious and exotic court, fled the field leaving his womenfolk at the mercy of the victorious forces.

We learn that Alexander came upon the wailing Sisygambis (mother of Darius) and her daughter-in-law Stateira huddling in Darius' tent together with the two small princesses. Although Sisygambis at first mistakenly approached Hephaestion, Alexander's right-hand man, instead of Alexander

to beg for mercy, Alexander – with true grace and magnanimity – covered her confusion by maintaining that Hephaestion too was worthy of being a ruler, and that they were as twins. The early texts refer to Hephaestion's greater height, which perhaps gave him a greater presence than his master. According to Valerius Maximus Alexander said to Sisygambis, 'There is nothing amiss in your having taken him for me, for he too is Alexander.'

Depictions of the family of Darius in front of Alexander frequently show Sisygambis falling back in dismay, or changing the direction of her body in order to offer homage instead to the real Alexander. He in turn gestures towards her, as if to calm her emotions, or stretches out to help her rise to her feet.

Paolo Veronese's painting of *The Family of Darius before Alexander* presents us with the difficult choice of distinguishing between the two men. The colour and pose of the man in pink and red would suggest that this is the conquering hero. Yet his gesture and the imperious pose of the man in armour to his left might suggest also that he is only Hephaestion who gestures back to his master. The laurel leaf painted across the breastplate of the figure in armour must surely symbolise victory. Yet the likelihood is that this is the victorious general and that the figure who gestures forward with a reassuring hand movement is indeed Alexander. The directional thrust of the group of women suggests that they first directed their gaze and attention towards the figure in armour, Sisygambis changing only at the last moment and floundering slightly as her gaze flicks back towards the figure in pink. Plutarch mentions that Alexander had a strong body odour and so, as one might expect from a decorous leader, he went back to wash and change after the sweat of the battle, before presenting himself to the family of Darius. Veronese may have wished to allude to this by depicting Alexander in such finery.

Veronese chose to change the background from the battlefield to the elegant classical architecture of Darius' palace. No doubt the involvement of

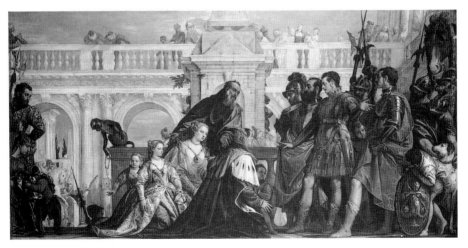

The Family of Darius before Alexander Paolo Veronese (1528(?)–88)

the sixteenth-century architect Palladio with the Pisani, Veronese's patrons in the painting of this picture, played some part in influencing this deviation from the text.

[Veronese (294)]

Fantastic Ruins with St Augustine and the Child *see* St Augustine – 1

Feast of Herod *see* St John the Baptist – 3

Fight between the Lapiths and the Centaurs [Mythological: Ovid, *Metamorphoses* XII, 210–535] According to classical mythology the Lapiths were a peaceful tribe who lived in the north of Thessaly. Their king was called Pirithous, son of Ixion. It was believed that Ixion had also sired the race of the centaurs (half horse and half man) through his union with the cloud, Nephele.

The centaurs were renowned for their crude and animal-like behaviour. When Pirithous held a great feast for his new bride Hippodamia, he invited these half relations to the celebrations. But the centaurs abused the hospitality of the Lapiths. One of them, Eurytus, overcome by drink and lustful feelings, tried to abduct the bride. Ovid describes how Hippodamia was caught by her hair and dragged violently away. Theseus, one of Pirithous' friends, caught up an antique mixing-vat and hurled it into Eurytus' face, crying out against the madness of the centaurs. Eurytus stumbled to the ground, blood, brains and wine spilling out of him. At this all the other centaurs joined in the fray, stealing chandeliers and using them as great battering rams. In the ensuing chaos the centaurs rampaged through the crowd, raping and pillaging.

Ovid's description of the battle lingers over such details as the gouging out of eyes, the smashing of bone and the burning of hair. Piero di Cosimo's *The Fight between the Lapiths and the Centaurs* seems to follow the original text closely. Apart from the many individual details of conflict and suffering, the artist gives centre stage to two centaurs, one male and apparently wounded, the other a female who fondles and comforts her companion. These must be Cyllarus and Hylonome, gentle lovers who wandered the mountainsides in peace. Ovid describes how Cyllarus was pierced by a javelin, and how Hylonome, after embracing and kissing his dying body, decided in her grief to take her own life.

[Piero di Cosimo (4890)]

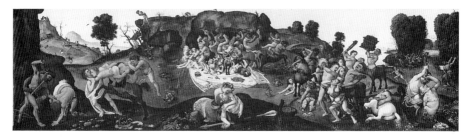

The Fight between the Lapiths and the Centaurs Piero di Cosimo (about 1462–after 1515)

Finding of the Infant Moses by Pharaoh's Daughter *see* Moses – 1
Finding of Moses *see* Moses – 1
Flaying of Marsyas *see* Marsyas – 2
Flight into Egypt *see* Christ: Childhood – 6
Four Scenes from the Early Life of St Zenobius *see* St Zenobius
Funeral of St Francis and the Verification of the Stigmata *see* St Francis
Good Samaritan [Biblical: Luke 10. 30–5] The Bible recounts the parable of a traveller who was attacked on his way down to Jerusalem from Jericho. Robbers tore the clothes from his back, beat him up and left him for dead on the roadside. Jesus, in telling this parable, sought to instil a new understanding of neighbourliness by describing how various people came upon the wounded man but for one reason or another did not stop to offer help. There was the priest who crossed over on to the other side of the road. There was the Levite (a descendant of Levi, the third of Jacob's twelve sons), who, despite the fact that he too belonged to a religious sect, also crossed over on to the other side, albeit after first having a good look at the bleeding body. But then a Samaritan – a member of a race which was by tradition considered hostile to the Judaic tribe of Israelites – not only stopped, but also cared for the wounded man.

We hear how the Samaritan bound up the traveller's wounds, after pouring in soothing wine and oil, and how he then placed the man on his own horse and took him to the comfort and security of a nearby inn. As a result of this caring act he became known as the Good Samaritan.

Jacopo Bassano's painting of *The Good Samaritan* shows the moment when the Good Samaritan struggles to lift the wounded traveller up on to his horse. A head and leg wound have already been bandaged, and there is a reference to the medication described in the Bible in the gleaming pitcher in the foreground. In the left background we see the scurrying figures of the priest and Levite as they pass on by. The nearer of the two, presumably the Levite, has his head buried in a book – no doubt a religious text. Both figures are unaware of the Samaritan's act of mercy.
[Jacopo Bassano (277)]

Hagar
Hagar and the Angel, Landscape with
Angel appearing to Hagar and Ishmael
Angel appears to Hagar and Ishmael in the Desert
[Biblical: Genesis 16. 1–4; 21. 1–19]
After many years of infertility, Sarah, the ageing wife of Abraham [*see* Abraham], persuaded her husband to lie with Hagar, an Egyptian slave girl, in an attempt to procure a son for the family. Hagar did indeed bear a son, Ishmael, but when Sarah in her turn conceived and gave birth in very old age to Isaac, a rift occurred between the two women.

Long before the birth of Isaac, Sarah had felt humiliated in the eyes of her slave, both by her own barrenness and the other's fertility, and she noticed that Hagar no longer deferred to her. When Sarah complained about Hagar's insolence, Abraham told her to punish the slave girl's bad behaviour. Sarah's treatment of Hagar must have been harsh since we learn that the slave girl

fled her mistress whilst pregnant, only to be turned back by an angel of the Lord. The angel not only promised Hagar the birth of Ishmael, but also the great multiplication of her own race through the birth of this child.

Ishmael seems to have inherited his mother's lack of respect. After mocking the elderly mother of his half-brother Isaac, he incurred the displeasure of both Sarah and Abraham, and was cast out into the Wilderness together with Hagar. Although Abraham had given them bread and water, the two fugitives were soon reduced to exhaustion and near death. Hagar, in despair, thrust Ishmael under a shrub and moved some distance away so that she should see neither the suffering nor the death of her son. Whilst Hagar wept alone, the young boy added his own cries which – the Bible tells us – were heard by God. Hagar then heard an angel calling her, telling her that her son's cries had been answered, and that she should lift him up and all would be well.

Assereto's and Guercino's paintings of *Hagar and the Angel* (which are on

An Angel appears to Hagar and Ishmael in the Desert
Follower of Salvator Rosa (1615–73)

loan to the National Gallery) depict the moment when the angel delivers his message. The Bible tells us that when Hagar opened her eyes she saw a well of water from which she filled her bottle in order to offer sustenance to her son. Although Claude in his *Landscape with Hagar and the Angel* and the imitator of Rosa in his painting of *An Angel appears to Hagar and Ishmael in the Desert* also show the moment of revelation between the angel and Hagar, our emotional response to each is quite different. In the painting ascribed to an imitator of Rosa we experience the pathos of the moment when the abandoned and, incidentally, very young child, reclines under an empty water bottle. The angel's gesture in this painting merely suggests that help is at hand. The frantic Hagar has yet to discover the well. But Claude offers us a shimmering expanse of water in the form of a lake as an ample and cogent symbol of regeneration for the exhausted travellers.

[Assereto (L596); Claude (61); Guercino (L612); after Rosa (2107)]

Hagar and the Angel, Landscape with *see* Hagar

Helsinus

Helsinus preaching in favour of the Celebration of the Conception
Helsinus saved from shipwreck

[Italian 13th-century literature: Jacopo da Voragine, *The Golden Legend*]

Helsinus, the Abbot of Ramsey in the time of William the Conqueror, was sent on a mission to see if Denmark was preparing to invade the British Isles. On his return, his ship was caught in a violent storm, but the figure of an angel dressed as a bishop came and stood on the churning waters in front of them. Helsinus heard the bishop tell him that they would all be saved if Helsinus agreed to celebrate the Immaculate Conception of the Virgin on a particular day, 8 December, and to persuade others to do likewise. These, and other incidents, are depicted in the side panels of the National Gallery Dalmatian School painting.

[Dalmatian School (side panels) (4250)]

Holy Family with Saints in a Landscape *see* Christ: Childhood – 1

Horses of Achilles [Greek mythology: Homer, *Iliad* I, XVI, XIX and XXII] The title of Homer's epic poem comes from the alternative name for Troy – Ilium. The poem deals with the disastrous events which followed a petty disagreement in the Greek camp during the final months of the Trojan War.

Agamemnon, the leader of the Greek army, appropriated a slave girl belonging to Achilles, after losing his own concubine Chryseis. Chryseis, the daughter of a priest of Apollo, had been captured by the Greeks when they stormed the Island of Chryse near Troy. A plague had subsequently ravaged the Greek camp, and Agamemnon – advised that this was Apollo's revenge for the rape of Chryseis – decided (albeit reluctantly) that his booty should be returned.

Achilles, enraged at the theft of his own bedwarmer, refused to engage any further against the Trojans, and retired sulking to his tent. As a result the Greek's suffered a number of devastating losses. Achilles' own friend Patroclus was slaughtered by Hector, the eldest son of King Priam of Troy.

Homer tells us that Patroclus used Achilles' chariot and horses to go into battle. This chariot was drawn by two foals, Xanthus and Balius – offspring of

Zephyrus (the West Wind) and the Storm Horse Podarge. These immortal horses had been given to Achilles' father Peleus as a wedding gift from the gods.

Grief-stricken at the loss of Patroclus, Achilles was reconciled with Agamemnon and returned to fight the Trojans. Homer describes how when Achilles urged Xanthus and Balius into the fray, charging them to bring him back alive to his friends, Xanthus lowered his head so that his great mane came tumbling down and swept the ground. Xanthus, who had the power of human speech, told Achilles that they would indeed bring him home that day safe and sound. But he warned his master that he would soon die and that not even the West Wind's speed would be powerful enough to save him. Just as Xanthus warned Achilles he was struck dumb by the Furies (the spirits of punishment).

Achilles, scorning Xanthus' warning, raised the battle cry and drove the horses forward. After a savage battle Achilles killed Hector, and – in retribution for the death of Patroclus – dragged the Trojan prince's body round the walls of Troy behind his chariot.

The National Gallery painting in the style of Van Dyck of *The Horses of Achilles* shows neither the death of Patroclus nor the engagement between

The Horses of Achilles
Style of Anthony van Dyck
(1599–1641)

Achilles and Hector. Yet we recognise Xanthus 'of the glancing feet' in the great prancing bay in the foreground. The horse's headlong flight seems suddenly checked, as he splays his front and back legs, tossing his long mane and tail. Caught in a burst of light the great bay swings his neck and head round as if heeding some fearsome command. In the background we see the more delicate dapple filly Balius, poised, almost spectre-like against the ground. In the troubled sky above the winged head of a wind god hovers, no doubt a reference to Zephyr, the father of the horses.

[Style of Van Dyck (156)]

Immaculate Conception *see* Virgin Mary: Conception

Immaculate Conception of the Virgin, with Two Donors *see* Virgin Mary: Conception

Incidents in the Life of St Benedict *see* St Benedict

Incredulity of St Thomas *see* Christ: Resurrection – 4

Infancy of Jupiter *see* Jupiter – 1

Institution of the Eucharist *see* Christ: Passion – 3

Introduction of the Cult of Cybele at Rome (also known as *The Triumph of Scipio*) [Mythological: Ovid, *Fasti*, 4, 291–348] The cult of Cybele, the Asia Minor earth mother goddess, was brought to Rome towards the end of the third century BC during the Second Punic War. According to the Sibylline books, the Romans would not be victorious until they lodged the image of Cybele in their own city.

The goddess was accompanied on her journey to Rome by male followers known as Corybantes. Descriptions of the arrival of Cybele in Italy relate how the ship carrying the goddess stuck fast in the mud of the Tiber. A Vestal Virgin Claudia Quinta (who had been accused of adultery) rushed forward and, calling upon the goddess to bear witness to her virginity, cast off her girdle, tied it around the ship's bow and hauled the vessel single-handed up river to Rome.

According to tradition, Publius Cornelius Scipio Nasica, the worthiest man in Rome, was chosen to welcome Cybele to the city. He is traditionally identified as the standing figure in profile gesturing with his right hand in Mantegna's painting of *The Introduction of the Cult of Cybele at Rome*. Once established in a temple on the Palatine, the goddess was served only by her oriental eunuch priests (who were known as Galli). It was believed that the Galli castrated themselves in memory of Attis, the one-time consort of Cybele.

Mantegna's painting of *The Introduction of the Cult of Cybele at Rome* shows Cybele (in the form of both a meteor and a female bust with turreted headdress), carried in triumph on a litter which is supported by attendants in Eastern garb. In front of the litter a figure throws itself forward as if in supplication or thanksgiving. It has often been argued that this is Scipio. We do indeed see the inscribed tombs of Scipio's father and uncle (both heroes of the war with Spain) in the background, and yet some doubt exists over this figure's identification. This is surely not the stance we would expect from the dignified Roman statesman Scipio.

The figure in the foreground of Mantegna's painting could well be Claudia.

The Introduction of the Cult of Cybele at Rome (also known as *The Triumph of Scipio*)
Andrea Mantegna (about 1430/1–1506)

Despite the masculine modelling of the neck, the pose and dishevelled clothing – including a loosely hanging sash – seem more appropriate for a gesture of supplication or thanksgiving from Claudia than the welcome of Scipio.

Perhaps the clue to the scene lies in the figure of the drummer-boy standing on the stairs at the right. This slight figure turns his head to look away from us towards an entrance in the wall. At the same time he raises a pipe to his lips as if to supplement the fanfare of his drum beat. We are thus encouraged to think that Cybele's litter will be taken up the steps and through the door at the right into the Palatine temple where she is to be housed. The fact that Scipio's tombs are shown in the left-hand background suggests that the goddess may already have been received in triumph. The figures in the centre and to the right may therefore represent the crowd lining the streets to see the goddess brought to the temple. It would be most fitting that Claudia, the thankful Vestal Virgin, should be present at this moment to offer her own devotions to Cybele.

[Mantegna (902)]

Isaac and Rebecca

Rebecca at the Well
Rebekah and Eliezer at the Well
Marriage of Isaac and Rebekah (also known as *The Mill*)
[Biblical: Genesis 24]

The Book of Genesis deals in great detail with Abraham's search for a wife for his son Isaac. We learn how Abraham, who was born in Ur on the lower Euphrates, commanded one of his servants Eliezer to go back to Ur to look for a suitable bride. Eliezer took with him a number of camels and set off on his journey. He prayed that when he stopped at a well outside the city of Nahor the girl who offered water to him and his camels should be the one destined to become Isaac's bride.

The Bible describes how a young woman called Rebekah (also known as Rebecca) came to the well and offered water to Eliezer. She then told him that she was one of Abraham's nieces. Gerbrand van den Eeckhout steps back a few paces in his *Rebekah and Eliezer at the Well* to offer us a general view of the meeting between Abraham's servant and Rebekah. Giovanni Antonio Pellegrini on the other hand takes a closer look at the meeting in his painting

of *Rebecca at the Well* and concentrates on the moment when Rebekah reveals to Eliezer that she is one of Abraham's relations. Rebecca's raised left hand suggests that she is talking to Eliezer. He, meanwhile, lifts his head to listen to her whilst opening his box of jewels as if to choose suitable gifts to give to her.

The Bible tells us that Eliezer was overjoyed to hear of the connection between Rebekah and Abraham and, having given her gifts of precious jewels, went back to her home to make arrangements for her marriage to Isaac.

We learn that towards the end of their journey back to Canaan Eliezer and Rebekah met Isaac wandering in the fields. Rebekah modestly covered herself with a veil, and was escorted by Isaac into the tent of his mother Sarah where, we are told, she became his wife.

Claude's painting of *The Marriage of Isaac and Rebekah* is so called after the artist's inscription on it. It makes no reference to Sarah's tent, although the groups of people seated on the ground and the dancing figures would be consistent with imagined marriage celebrations. These however form no part of the biblical account. Certainly the golden sky suggests an evening light which might symbolise the end of Rebekah's journey, and perhaps the distant vistas refer also to the land of Ur she has left. But the most prominent background detail (which also seems to have nothing to do with the Bible story) is the Mill, which gives the painting its alternative title.

[Claude (12); Gerbrand van den Eeckhout (6535); Pellegrini (6332)]

Israelites gathering Manna *see* Moses – 4

Jacob – 1

Jacob reproaching Laban for giving him Leah in place of Rachel (the painting by Saraceni has recently been retitled *Moses defending the Daughters of Jethro*) [Biblical: Genesis 29. 21–7] The Bible describes how Jacob was cruelly tricked by Laban when, after serving him faithfully for seven years in the belief that he would receive Laban's youngest daughter Rachel as a wife, Laban substituted Rachel's older sister Leah after the wedding feast. When Jacob discovered that he had consummated his marriage with Leah, he complained bitterly to Laban. Had he not served his master well? Had it not been agreed that Rachel should be his wife? Why should Laban play such a trick on him? Laban's unemotional response was that in his country it was customary for older sisters to be married first.

Hendrick ter Brugghen's enigmatic painting of *Jacob reproaching Laban for giving him Leah in place of Rachel* shows Jacob reproaching the old man Laban, whilst Leah peers from behind a curtain in the background and the younger Rachel stands demurely at her father's side. There is an air of resignation in the painting. None of the figures apart from Jacob reacts with any great emotion. And although Leah seems to lurk in the shadows of the bedchamber in a slightly conspiratorial fashion, her sister Rachel seems unaffected either by the remains of the wedding feast or by the fact that her position has been usurped. Perhaps Rachel knows already that she will have to wait a long time before becoming Jacob's wife [*see* Jacob – 2].

Carlo Saraceni's painting previously known as *Jacob reproaching Laban for giving him Leah in place of Rachel*, but recently recatalogued as *Moses defending the Daughters of Jethro*, shows a distinctly agitated male figure in

the foreground, in front of a woman who wrings her hands and casts her eyes heavenwards as if in despair. On all sides onlookers gesticulate and question. Here indeed is a depiction of sad confusion.

The fact that seven female figures are included in the scene has been seen as supporting the new interpretation that Saraceni was alluding to the seven daughters of Jethro who were barred by shepherds from watering their sheep at the well. According to the Biblical account Moses remonstrated with the shepherds and helped the women fill troughs with water so that their sheep could drink. This new interpretation would have greater force if the figures in the painting were positioned to dramatise Moses' intervention on behalf of the daughters. The shepherds, far from being shown beside the well and barring the way to it, are positioned on the other side of Moses while the female figures, still lamenting their circumstances, are scattered across the scene. Yet the sheep, whose access to the water Moses would be negotiating, are already browsing contentedly beside the well.

[Ter Brugghen (4164); Saraceni (6446)]

Jacob – 2

Jacob with the Flock of Laban [Biblical: Genesis 30. 25–43] The Bible describes how Jacob first met Rachel watering her father's sheep at their well. Jacob begged Laban to let him have Rachel as a wife and agreed to earn her by serving as Laban's herdsman for seven years. But although Jacob carried out his side of the bargain, Laban tricked him at the end of this time, and substituted his older daughter Leah at the wedding feast [*see* Jacob – 1]. Jacob had to labour another seven years with Laban's flocks before he was allowed to have Rachel as his wife.

Some time after marrying Rachel Jacob decided to return with his wives and children to his own country in the land of Canaan. Before leaving Jacob had to ask Laban's permission, but Laban was reluctant to let him go. The old man realised that this son-in-law had brought him great fortune. Not only had his two daughters found a husband, but many children had been borne; even Laban's animals had prospered. But Laban was finally persuaded when Jacob promised Laban that if he were allowed to leave, he would spend one last period of time tending Laban's flock, without asking for payment for all his years of hard work.

The Bible describes how Jacob suggested that he should go through all Laban's flock, dividing off the brown sheep and the speckled and spotted goats, and that he should take these for his own portion. It was agreed that the two flocks would be kept separate, and that in the meantime Jacob would also continue to feed and tend Laban's animals.

We learn how Jacob cunningly multiplied his own portion by encouraging his sheep and goats to mate with Laban's flock. Each time his sheep or goats gave birth Jacob separated the spotted or speckled young and added them to his own portion. Jacob saw to it that only the stronger of his animals conceived. Thus not only a large number of speckled, spotted and brown young were born and added to Jacob's portion, but each new animal was also strong and healthy.

Jusepe de Ribera's painting of *Jacob with the Flock of Laban* shows Jacob

Jacob with the
Flock of Laban
Jusepe de Ribera
(1591(?)–1652)

with one of his spotted flock straddling his knee. Beside him a number of sheep drink from the watering trough. Sticking out of the water at the left is a white rod. This probably refers to the rods of green poplar, hazel and chestnut which Jacob is said to have peeled and placed in the watering troughs in order to encourage his flocks to conceive.

[Ribera (244)]

Jacob reproaching Laban for giving him Leah in place of Rachel *see* Jacob – 1
Jacob with the Flock of Laban *see* Jacob – 2

Jason

Jason swearing Eternal Affection to Medea
Capture of the Golden Fleece
[Mythological: Ovid, *Metamorphoses* VII]

Ovid describes how Medea (the sorceress daughter of the king of Colchis) fell desperately in love with the stranger Jason when he arrived at her father's court in search of the Golden Fleece. The Golden Fleece had been stripped from a magical winged ram that had brought the refugee Phrixus in safety to Colchis, as he fled the hatred of his stepmother Ino. The fleece was guarded in a grove in Colchis by a dragon who never slept.

Jason came from Thessaly where his father Aeson had been usurped by a half-brother Pelias. Pelias agreed to return the throne to Jason in exchange for the Golden Fleece. Although Aeetes, the father of Medea, seemed willing

to surrender the fleece, he set Jason a number of impossible tasks – one being to yoke a pair of fire-breathing bulls to a plough. Medea, touched by Jason's youth, noble birth and heroism, dreamed already of marriage and travel to a foreign land. She longed to help him, but was conscious of the betrayal to her father if she offered her aid. Medea also feared that Jason, once having taken advantage of her magic powers, might abandon her for someone else.

Medea plotted to ensnare the young stranger, hoping to wring a promise of marriage from him. But whilst she dreamed of love she remembered her duties to her father and her position at Aeetes' court. Wandering deep into the forest she came upon an ancient altar dedicated to Hecate, a goddess often associated with sorcery, and frequently set up at crossroads where questions of direction had to be considered. Inspired by Hecate Medea decided to relinquish her love for Jason and her plans to leave her father's

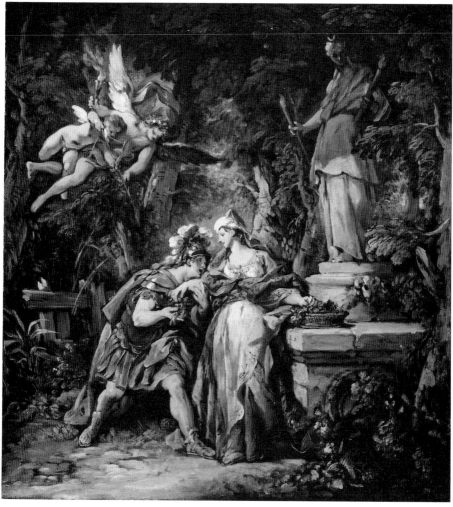

Jason swearing Eternal Affection to Medea Jean-François Detroy (1679–1752)

court and travel to distant lands. But suddenly Jason came into sight. Ovid describes how the son of Aeson appeared even more beautiful than usual on that day. We learn how Medea flushed and paled in turn, feeling great flames of passion engulf her. Jason grasped Medea's right hand and quietly begged for help, promising marriage in return. The young prince swore to be faithful to Medea, calling on Hecate and all the other divinities of the grove, as well as King Aeetes to witness his pledge.

Jean-François Detroy's painting of *Jason swearing Eternal Affection to Medea* shows Jason in supplication before Medea, embracing her right arm as she stands against the garlanded altar of Hecate. Medea looks down at Jason as if in illustration of Ovid's text. 'She gazed upon him and held her eyes fixed on his face as if she had never seen him before.' Two winged figures above aim arrows towards Jason, as if to transfix him with a similar passion. The torch-bearing Hecate on the other hand averts her gaze, as if contemplating the tragedies which will later drive Medea, when betrayed by Jason, to murder and infanticide. On Hecate's altar we notice a basket filled with foliage. Medea has already taken some sprigs of this and handed them to Jason. These are the herbs Jason uses to squeeze a magic potion on to the guardian of the Golden Fleece.

Detroy's painting of *The Capture of the Golden Fleece* shows the moment of triumph when Jason plucks the Golden Fleece from above the supine form of the dragon, drugged into deep sleep by the juice of the magic herbs. In the background we see the ships of the Argonauts, Jason's companions, preparing to set sail with Jason, Medea and the fleece and return to Greece.
[Detroy (6330); Detroy (6512)]

Jason swearing Eternal Affection to Medea *see* Jason
Jesus opens the Eyes of a Man born Blind *see* Christ: Ministry – 8
Joseph – 1
Joseph sold to Potiphar [Biblical: Genesis 39. 1] The Book of Genesis tells us that when Joseph was brought down into Egypt by the Ishmaelites he was sold to Potiphar, one of the Pharaoh's officers. Jacopo Pontormo's painting of *Joseph sold to Potiphar* shows a somewhat bedraggled Joseph looking up timidly into the face of his new master, whilst various other figures in the crowd casually go about their business as if unaware of Joseph's predicament. Although the Bible describes the Ishmaelites as travelling by camel the figures in Pontormo's painting are shown on horseback.

It is curious that Joseph is depicted as such a young boy. Earlier in the Bible we learn that Joseph was already seventeen years old when he received the brightly coloured coat (a gift from his father Jacob) which sparked off so much jealousy and hatred amongst his half-brothers.

Pontormo was clearly not so interested in textual accuracy in depicting this scene. He preferred instead to concentrate on the anatomical distortions of the people around Joseph. The foreshortened figure bending down behind Joseph to pick up money serves not only to illustrate the artist's skill in the depiction of figures in curious poses, but also acts as an energetic foil to the limp hero as he timidly encounters the imposing gaze of his new master.
[Pontormo (6451)]

Joseph sold to Potiphar
Jacopo Pontormo
(1494–1557)

Joseph – 2

Pharaoh with his Butler and Baker [Biblical: Genesis 40] Joseph's period of employment in Potiphar's household came to an abrupt halt when Potiphar's wife accused the young Hebrew of attempted rape. Joseph was immediately thrown into prison. Whilst in prison he was joined by two disgraced servants of the Pharaoh's household. These two, the Pharaoh's butler and baker, experienced strange dreams which they could not understand. The butler dreamed of a three-branched vine that blossomed and bore great clusters of fruit which he then crushed into a cup and gave to the Pharaoh. The baker dreamed that he had three white baskets on his head but that birds came down and ate all the pastries in the top basket which he had baked for his master. Joseph interpreted these images for them, telling the butler that his dream meant good fortune and that he would be reinstated after three days. He asked the butler to remember him when he was released and put in a good word for him with the Pharaoh. Joseph then warned the baker that his dream was a bad omen and that he would soon die. He told him that he would be hung from a tree and that his flesh would be devoured by birds. Several years after his release from prison the butler (although at first forgetting his promise to Joseph) did talk to the Pharaoh about Joseph's powers of interpretation. As a result Joseph also was released and given a position of great power in Egypt.

Jacopo Pontormo's painting of *Pharaoh with his Butler and Baker* relates to several parts of this story. Pharaoh in the foreground seems neither to heed nor care for the predicament of the figures in the background who are being seized and bound before being led away. Yet one of these may be the butler who is about to be released. The prisoner on the stairs is similar to the foreground figure who kneels and serves at Pharaoh's table.
[Pontormo (6452)]

Joseph – 3

Joseph receives his Brothers on their Second Visit to Egypt [Biblical: Genesis 43. 11–29; 44. 1–3] Joseph, the son of Rachel born to Jacob in his old age, was hated and feared by his stepbrothers, the sons of Jacob's first wife Leah [*see* Jacob – 1]. The brothers decided to lay hold of Joseph when he came to see them as they tended their flocks in the fields. After catching Joseph they stripped off the coat of many colours given to him by Jacob and cast him into a deep pit. Then they sat down to eat and consider how they might kill him.

Seeing a passing band of Ishmaelite travellers on their way to sell goods in Egypt, one of the brothers suggested that they could sell Joseph rather than slay him. But while they considered this option, another band of merchants found Joseph in the pit, pulled him out and sold him to the Ishmaelites themselves. When the brothers found the pit empty they decided to dip Joseph's coat in the blood of a kid goat and take it back to Jacob so that the old man would think his son was dead.

Meanwhile Joseph, who had first been sold as a slave to Potiphar [*see* Joseph – 1] and then found favour with the Pharaoh himself [*see* Joseph – 2], was raised to a position of great power in Egypt. Many years later, at the time of a great famine, people came from far and wide to buy corn which Joseph had carefully laid up in Egyptian storehouses during the previous years of plenty. Joseph was by that time governor of Egypt and in charge of selling the corn. Jacob, hearing about the stores of Egyptian corn, sent his sons down into Egypt to buy provisions from the governor. But when Joseph's brothers came before him they no longer recognised him. Joseph however knew immediately who they were and, thinking of vengeance, accused his brothers of being spies. At the same time he made enquiries about Jacob and his younger brother Benjamin (Rachel's second son).

Although Joseph finally provided his brothers with corn, he insisted on holding one of them hostage until the others came back again with Benjamin. The brothers agreed to this and were much relieved that they could return home with food. But on the way back they were very puzzled to find that their money had been returned, hidden in the mouth of each sack of corn. When Jacob heard of his sons' agreement with the governor and the mysterious return of payment, he was afraid, and refused to let Benjamin go to Egypt, fearing that he would never return.

But the famine continued and when the first supply of corn was finished Jacob urged his sons once again to go down into Egypt. Fearing the Egyptian governor's rage if they returned empty handed, the brothers refused to go unless they could take Benjamin with them. Jacob finally agreed, but he also arranged that fruit, balm, honey, spices, myrrh, nuts and almonds and a great

Joseph receives his Brothers on their Second Visit to Egypt Bacchiacca (1495–1557)

deal of money should be taken along as offerings to this powerful governor, in the hope that it might soften his feelings towards Benjamin.

Bacchiacca's painting of *Joseph receives his Brothers on their Second Visit to Egypt* depicts three separate events which took place during this second visit to Egypt. To the left we see the brothers arriving at Joseph's house, where their asses are fed and where they are offered water to wash their feet. In the centre we see Joseph coming out to receive them and accept their gifts. The Bible tells us that Joseph prepared a great feast for his visitors, and that he was moved to tears when he saw his brother, Benjamin. The following morning Joseph commanded his steward to fill the brothers' sacks with corn and once more to return their money to them. Joseph also ordered that a silver cup should be hidden in Benjamin's sack. He planned to incriminate his brothers in order to recall them and finally make himself known to them.

To the right of Bacchiacca's painting we see the young Benjamin astride an ass with a bulging sack hanging over its flanks. His brothers surround him protectively as they move off on their journey north, little suspecting that they will shortly be pursued and brought back to Joseph, under a charge of theft.

[Bacchiacca (1218)]

Joseph – 4

Joseph's Brothers beg for Help
Joseph pardons his Brothers
[Biblical: Genesis 44. 14–34; 45. 1–5]

After the silver cup hidden by Joseph was found [*see* Joseph – 3], Benjamin and his brothers were brought back to Joseph for questioning. Arriving at Joseph's house, the brothers fell on the ground before him protesting their innocence. The Bible suggests that the brothers understood in this moment that their past sins, including their treatment of the young Joseph, were catching up on them. They offered to place themselves in bondage to Joseph, but he rejected their offer, insisting that only Benjamin should be left behind.

Judah, one of the ten, begged Joseph to take him instead, crying that his aged father Jacob would die of grief if this second beloved son were lost. At this Joseph could restrain himself no longer and, sending his servants and retainers away, revealed his true identity. The Bible describes how Joseph wept with emotion as he declared himself to his brothers. His cries were so violent that they were even heard in the Pharaoh's household.

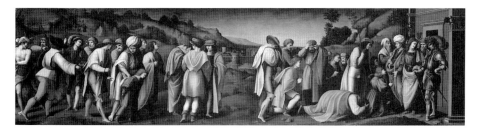

Joseph pardons his Brothers Bacchiacca (1495–1557)

Bacchiacca's painting of *Joseph pardons his Brothers* shows the disconsolate brothers together with the small figure of Benjamin being hustled along on the left. The same small figure kneels at the right in front of Joseph, who gestures towards him whilst at the same time turning to an armed figure standing beside him. Benjamin's brothers register their horror at Joseph's suggestion that Benjamin should be left behind by hanging their heads, prostrating themselves on the ground, or tearing their hair. This must surely be the moment before the pardon as Joseph's retainers are still standing close to him. The figure prostrating himself on the ground behind Benjamin is no doubt Judah, the brother who comes forward and offers himself in Benjamin's stead.

In Jacopo Pontormo's painting of *Joseph's Brothers beg for Help* we seem to witness the same moment of despair, although the figure of Benjamin is not immediately recognisable. Individual figures react with shock and horror as Joseph, regally enthroned, stretches out an arm and appears to pass judgement. Meanwhile in the background, as if in ironic contrast to the brothers' hideous predicament, the commerce of buying and selling corn continues.

[Bacchiacca (1219); Pontormo (6453)]

Joseph – 5

Joseph with Jacob in Egypt [Biblical: Genesis 45. 16–28; 46. 1–7 and 30–4; 47. 1–10 and 27–31; 48. 1–14] Jacopo Pontormo's painting of *Joseph with Jacob in Egypt* shows a number of episodes which deal with the period of time after Joseph's reconciliation with his brothers in Egypt [*see* Joseph – 4].

The Bible tells us how the Pharaoh commanded Joseph to invite his father and all his family to come and live in Egypt. Jacob duly arrived with some seventy or so men, women and children, together with their assorted sheep, goats and cows.

The Bible describes how Joseph presented his father Jacob to the Pharaoh and how the family settled and prospered as shepherds. We are also told that after nearly two decades, when Jacob had reached the advanced age of one hundred and forty-seven years and was nearing death, Joseph took his two sons Manasseh and Ephraim to be blessed by their grandfather.

Pontormo shows the presentation of Jacob to the Pharaoh in the left foreground of his painting, whilst to the right we see Joseph escorting his sons up the steps to his aged father's bedchamber. The deathbed scene

displays close attention to the Bible text as Joseph, who is seated at the side of the bed, seems to bring his children 'out from between his knees'. We also sense the old man's failing eyesight, as he lifts his head somewhat hesitantly towards Joseph, and (as the Bible tells us) closely questions his son about the identity of the two boys.

Stretched diagonally across the painting is a disconsolate group of men who are making their way towards a seated figure, who subjects the pieces of paper they hold to close scrutiny. This part of the painting no doubt refers to the business matters with which Joseph was involved during the intervening twenty years.

We read in Genesis how yet another famine afflicted the peoples of Egypt and Canaan during this period and how at first people came to Joseph and offered their cattle in exchange for bread. But at the end of another year they were reduced to selling their land. As a result Joseph accrued vast stretches of land for the Pharaoh and finally the whole of Egypt became part of the Pharaoh's domain. Joseph encouraged many people to come and live in the cities; others were given seed with which to cultivate the land which now belonged to the Pharaoh.

Joseph with Jacob in Egypt Jacopo Pontormo (1494–1557)

Although the famine reduced many people to the status of bonded landworkers, they only had to yield a fifth of their produce. Pontormo's painting catches this mixture of bondage and good business in the procession of people who wait so patiently, and yet seem to present their individual cases with such purpose.

[Pontormo (1131)]

Joseph with Jacob in Egypt *see* Joseph – 5

Joseph pardons his Brothers *see* Joseph – 4

Joseph receives his Brothers on their Second Visit to Egypt *see* Joseph – 3

Joseph sold to Potiphar *see* Joseph – 1

Joseph's Brothers beg for Help *see* Joseph – 4

Judgement of Midas [Mythological: Ovid, *Metamorphoses* XI] Midas, the somewhat foolish king of Phrygia, was renowned for two things: his ability to turn all he touched to gold and his ass's ears. Ovid describes how Midas, after finally releasing himself from the curse of the touch of gold (which affected even the food he ate), retired to the woods and fields, shunning his wealth and worshipping only the god Pan to whom he was particularly devoted. Hearing strains of music, Midas came upon the reed-playing god himself, and found himself caught up in a contest of musical talent.

Pan had boasted that his music was superior to that of the Sun god Apollo. When Midas stumbled upon the scene the old mountain god Tmolus had just been appointed judge in a competition between the two musicians. Midas was charmed by Pan's music, but Tmolus decided in favour of Apollo. The looks of the latter were all in his favour. Ovid describes how Apollo was not only majestically clothed and equipped – with his golden head wreathed with laurel, a long sweeping mantle and a lyre inlaid with gems and Indian ivory – but how he also managed to arrange himself so that even his pose was suggestive of artistry.

Despite the fact that all the other onlookers were in agreement with Tmolus, Midas challenged the decision, calling it unjust. Had Midas been aware of the punishment meted out by Apollo to the satyr Marsyas in a similar musical confrontation [*see* Marsyas – 2], he might well have checked his tongue or questioned the reliability of his own ears more closely. Apollo's revenge was swift. Ovid tells us that as Midas confronted the indignant Sun god, he felt his ears lengthen and fill with shaggy, grey hair. Furthermore, an instability at their base made these unwelcome appendages twitch like those of some slow-moving ass.

In the painting of *The Judgement of Midas* by Domenichino and assistants Apollo gestures casually towards Midas who in turn points to Pan. One of the onlookers behind Pan gazes in amazement at the protruding ears which have sprung up on either side of the king's crown. As yet Midas seems unaware of his transformation. But Ovid describes how the wretched monarch subsequently covered his temples with a purple turban, revealing his shameful secret only to his barber.

[Domenichino and assistants (6285)]

Judgement of Paris, Landscape with *see* Paris – 1

Judith

Judith

Judith in the Tent of Holofernes [Apocryphal: Book of Judith 8. 8–10] Although Judith is often depicted as a young winsome heroine, she was in fact a comfortable, well-off widow living in Judah. When the Babylonian King Nebuchadnezzar waged war against those states (including Judah) which had refused aid in his conflict with the Medes, Judith decided to take drastic action to save her homeland. She went to the camp of the besieging army pretending to be a deserter. At first she held herself aloof from the Babylonians and refused to meet in private with Holofernes, the general in charge of Nebuchadnezzar's army. But after three days she agreed to dine with him. Changing out of her widows' weeds into more seductive clothes, Judith presented herself at the general's tent. As the evening wore on Holofernes became more inebriated and somnolent. Seizing the right moment, Judith snatched up Holofernes' scimitar and hacked off his head. Dumping the head unceremoniously into her maid's bag, she then left the camp.

Neither the figure nor the body language in the National Gallery painting of *Judith in the Tent of Holfernes* by Johann Liss is suggestive of modesty or grace. This is a buxom woman with well developed muscles and forceful

Judith in the Tent of Holofernes
Johann Liss
(about 1595–
1629/30)

determination. We just catch a glimpse of the frightened and horrified eyes of the maid looking up at her mistress as she holds open a sack to take the gruesome trophy. Judith, still gripping the scimitar, glances back at us over her shoulder, as if to gauge our own reaction to the spurting blood which gushes out of the severed neck towards us.

[Liss (4597); Eglon van der Neer (2535)]

Juno discovering Jupiter with Io [Mythological: Ovid, *Metamorphoses* I] In the course of his amorous pursuits Jupiter, the king of the gods, assumed various forms ranging from a shower of gold [*see* Jupiter – 2] to a bull [*see* Rape of Europa]. However, in the case of Io, it was the female partner who was transformed. Io's fate was to be turned into a cow, forced to lie on the ground and drink from muddy streams.

According to Ovid, Jupiter came across Io as she wandered in the shady woods close to her father's stream. Although Io fled from Jupiter he caught up with her by covering the land with a thick dark cloud. Meanwhile Juno, who was constantly on the look-out to discover her husband's peccadilloes, looked down with some bewilderment at the unnatural night-time effects below. Suspecting betrayal, Juno glided down to earth and commanded the clouds to disperse. But Jupiter was too quick for his spouse. As the clouds cleared Juno did indeed discover her husband, but apparently in innocent dalliance with a beautiful white heifer.

In Pieter Lastman's painting of *Juno discovering Jupiter with Io* we see Juno, accompanied by her majestic peacock – symbol of her power and of her riches – swooping down upon Jupiter and Io. Jupiter seems to swerve away, as

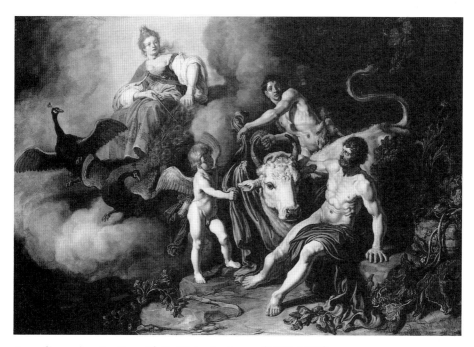

Juno discovering Jupiter with Io Pieter Lastman (1583–1633)

if aware of his wife's unpredictable reactions in situations such as this. At the same time two figures identifiable as Cupid and Deceit attempt to cover the cow's body.

But Jupiter did not succeed in this subterfuge. Ovid describes how Juno demanded the cow as a gift from her husband. The luckless Io was then handed over to the jealous wife. We read subsequently of Io's countless miseries. Guarded by the many-eyed Argus at Juno's command, Io was forced to feed on the leaves of trees and bitter herbs during the day and was ignominiously haltered during the night. Encountering her father Inachus, the wretched Io could only lick his hand, bringing him to the edge of despair by tracing her sad history in the dust with her hoof. It took many days before Jupiter brought himself to beg forgiveness from Juno and Io was returned to her former self [*see* Mercury – 2].

[Lastman (6272)]

Jupiter – 1

Infancy of Jupiter [Mythologyical: Ovid, *Fasti*, 5, 121–4] Jupiter was protected at his birth by the Curetes, attendants of his mother, the goddess Rhea. Jupiter's father Saturn had sworn to destroy his offspring since he knew that one day one of them would rise up against him. Rhea fled from Saturn and gave birth to Jupiter in a cave in Crete. She subsequently handed Saturn a stone in swaddling clothes, which he, in an attempt to devour his offspring, immediately swallowed.

Jupiter was brought up on the slopes of Mount Ida in Crete, hence the name of his attendants, the Curetes. The Curetes prevented the discovery of the young baby by dancing around him and clashing their weapons to drown the sound of his cries. The Curetes were often confused with the Corybantes, male companions of the Asia Minor goddess Cybele [*see* Introduction of the

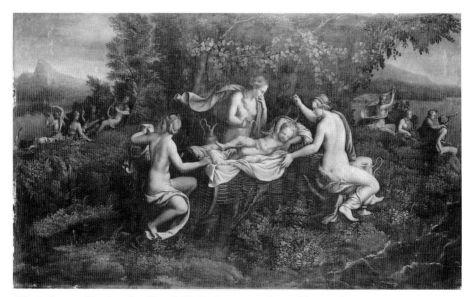

The Infancy of Jupiter Studio of Giulio Romano (1499(?)–1546)

Cult of Cybele at Rome]. The confusion no doubt arose because Cybele was sometimes identified as Rhea. Corybantes were renowned for their wild dances and music.

The National Gallery painting of *The Infancy of Jupiter* from the Studio of Giulio Romano shows male and female figures in the background, suggesting a possible mixture of Corybantes and Curetes. Yet although there is both dancing and music making, there is no evidence of the clashing of armour. The young Jupiter lies asleep in his wicker cradle, attended by three females who gently rock him whilst remaining alert to possible dangers around. These must surely be the other attendants of Rhea, mountain nymphs, who reared their young charge on honey and goat's milk.
[Studio of Giulio Romano (624)]

Jupiter – 2

Jupiter and Semele [Mythological: Ovid, *Metamorphoses* III] Semele, the daughter of Cadmus of Thebes, was loved by Jupiter. Juno, inflamed with jealousy that Jupiter was engaged with yet another rival, persuaded the pregnant Semele to induce her lover to make love to her for once in his most glorious and godly state. Juno knew full well that as a mortal Semele would be unable to survive such an ordeal.

As was often the case Jupiter was unable to match his wife's machinations. Acceding to Semele's request, the great god descended upon her in a flash of lightning, thus setting her alight and finally reducing her to ashes.

The National Gallery painting of *Jupiter and Semele* attributed to Tintoretto shows Jupiter thundering down towards the waiting Semele, who lies with slightly protruding belly on a soft couch with curtains. The bright aureole of light and lowering clouds which surround Jupiter give some indication of the tragedy which will follow.
[Attr. Tintoretto (1476)]

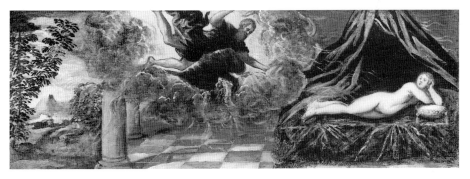

Jupiter and Semele Attr. Jacopo Tintoretto (1518–94)

Jupiter and Semele *see* Jupiter – 2
Kitchen Scene with Christ in the House of Martha and Mary *see* Christ: Ministry – 11
Lamentation *see* Christ: Death – 2
Lamentation over the Body of Christ *see* Christ: Death – 2
Lamentation over the Dead Christ *see* Christ: Death – 2

Leda and the Swan [Mythological: Ovid, *Metamorphoses* VI; Apollodorus, *Bibliotheca* I] According to classical mythology Zeus in the guise of a great swan ravished Leda, the wife of Tyndareus (king of Sparta). This episode is thus often referred to as Leda and the Swan. Leda is said to have hatched an egg or two eggs from this union. It was believed that the beautiful Helen – whose subsequent elopement with Paris [*see* Paris – 2] led to the Siege of Troy – was hatched from one of these.

Michelangelo's depiction of *Leda and the Swan* concentrates on the physical union of bird and woman. The swan lovingly lays his neck against Leda's breast, and traces the embrace of his wing and tail feathers against her thigh and buttock. Leda herself reclines in pleasurable acceptance. The painting in the style of Mola of *Leda and the Swan* suggests a more intellectual approach. Leda assumes a more imperious pose, sitting up as if to debate the swan's proposal. This is not so much a union as an opening talk. We are also offered more information about the physical surroundings in which the union took place. Although the rich bedcoverings and Leda's own drapery would suggest an interior, the background makes it quite clear that the swan has emerged from the more likely habitat of fields and marshland. [After Michelangelo (1868); style of Mola (151A)]

Legend of the Wolf of Gubbio *see* St Francis

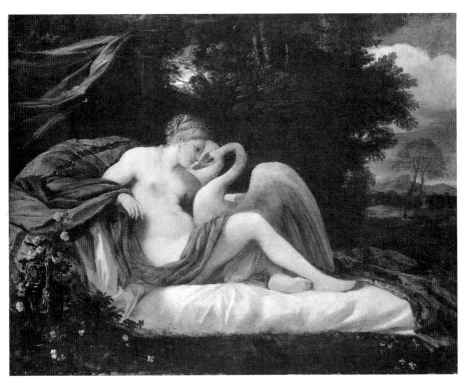

Leda and the Swan Style of Pier Francesco Mola (1612–66)

Lot

Lot and his Daughters leaving Sodom
Lot's Daughters make their Father drink Wine
[Biblical: Genesis 19. 1–36]

Although Guido Reni's painting is traditionally described as *Lot and his Daughters leaving Sodom*, it probably refers rather to the later flight of these three from Zoar, a nearby town. The Book of Genesis describes how Lot was visited by two angels when he was living in Sodom. When news of the arrival of these two males reached the men of Sodom, they came beating at Lot's door demanding that the strangers should be brought out to them so that they could have sexual intercourse with them. We learn how Lot refused to deliver the angels, but offered instead his own two daughters who were still virgins. This offer of heterosexual intercourse was rejected by the Sodomites.

Later we read how the angels persuaded Lot to leave with his wife and daughters before they destroyed the city of Sodom. Their one instruction was that the family should not look back as they left. Lot's wife weakened, and as a result she was turned into a pillar of salt. The painting of *Lot's Daughters make their Father drink Wine* in the style of Lucas van Leyden includes the figure of Lot's wife and the burning town of Sodom in the background.

The Bible describes how Lot left the city of Zoar and went with his two daughters to live in a mountain cave. It was here that the daughters plied

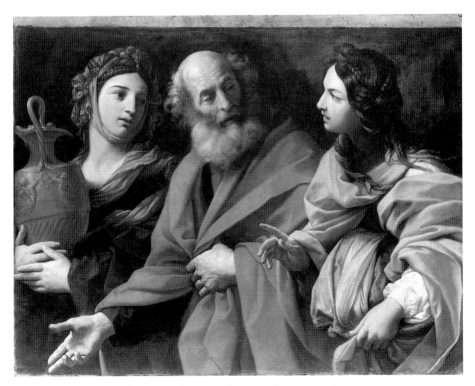

Lot and his Daughters leaving Sodom Guido Reni (1575–1642)

their father with drink so that they could make love to him without his knowledge. The daughters' argument was that, given their isolated living conditions far from any other willing male partners, they could not ensure the continuation of their father's line in any other way.

Guido Reni's painting depicts the aged Lot and his purposeful daughters, deep in discussion. To our left we notice that the slightly more mature-looking daughter carries a large wine flagon. This is in keeping with the biblical text which makes clear that it was the firstborn who organised the incestuous union with Lot.

[Reni (193); style of Lucas van Leyden (3459)]

Lot and his Daughters leaving Sodom *see* Lot

Lot's Daughters make their Father drink Wine *see* Lot

Marcia [Roman history: Plutarch, *Life of Cato*] Although there is little action in the National Gallery painting of *Marcia* by Domenico Beccafumi, Marcia's gesture towards an inscribed tablet draws our attention to the unusual pattern of her marital status. We learn from this that Marcia (who lived in the first century BC) was first married to M. Porcius Cato, and then, at Cato's own instigation, married to his friend Hortensius. When Hortensius died Marcia returned to her first husband Cato.

Like Patient Griselda [*see* Patient Griselda], Marcia therefore epitomised the obedient wife.

[Beccafumi (6369)]

Marcus Curtius [Roman history: Livy, *History of Rome* VII, 6] There are a number of versions of the legend which deals with the hero Curtius and an area in the Roman Forum known as Curtius' pond. Two of the versions describe how the hero (in one instance the Sabine Mettius Curtius and in the other the Roman soldier Marcus Curtius) leapt on horseback into a swamp or chasm.

According to Livy the fourth-century BC Marcus Curtius knew of the prophecy that the chasm in the Forum could only be filled by one of Rome's great strengths or treasures. Thinking that he might fit the bill, Marcus Curtius rode fully armed into the pit which immediately closed over his head.

None of the versions of the legend describes flames in the pit, although reference was made to the consul Curtius closing the area in the fifth century BC because it had been struck by lightning. Perhaps therefore the fire depicted in the National Gallery's painting of *Marcus Curtius*, attributed to Bacchiacca refers to that earlier event, thus combining two of the known versions of the legend.

[Attr. Bacchiacca (1304)]

Maries at the Sepulchre *see* Christ: Resurrection – 1

Marriage at Cana *see* Christ: Ministry – 3

Marriage of Frederick Barbarossa and Beatrice of Burgundy [Imperial history] The National Gallery painting of *The Marriage of Frederick Barbarossa and Beatrice of Burgundy* shows the moment when the Bishop of Wurzburg raises his hand to bless the union between the Holy Roman Emperor Frederick and his bride Beatrice of Burgundy in 1156. To the left is Beatrice's father, Rainaldus of Burgundy.

Frederick was crowned Holy Roman Emperor in 1155, and harboured fierce ambitions to rule in Italy. His reign witnessed an increasing conflict between imperial power and the Church of Rome, culminating in the defeat of Frederick's German forces, and his public act of humility in kneeling to Pope Alexander III in the porch of St Mark's cathedral in Venice in 1177.

Giovanni Domenico Tiepolo's painting, probably a copy of a large-scale fresco of the same scene by his father Giovanni Battista, emphasises the moment of benediction of the couple. In the original composition, painted on the wall of the Residenz building in Wurzburg, the bishop's gesture has a wider significance. Not only does the bishop bless Frederick and Beatrice, but his raised hand offers a blessing also to the bold impresa of the eagle painted on the imperial banner, which is held by the crowd. The scene thus constitutes both the blessing of the emperor's marriage and the Holy Roman Empire.

[Giovanni Domenico Tiepolo (2100)]

Marriage of Isaac and Rebekah (also known as *The Mill*) *see* Isaac and Rebecca

Marriage of St Catherine of Siena [Legends of the Saints: Raymond of Capua, *Legenda Maior*; Thomas Caffarini, *Legenda Minor*] The fourteenth-century Sienese St Catherine, who joined the Dominicans much against her parents' will, is said to have experienced visions from the age of seven. According to her biographers Catherine also experienced a mystic marriage with Christ, following the example of her namesake, St Catherine of Alexandria.

The National Gallery painting of *The Marriage of St Catherine of Siena* by Lorenzo d'Allessandro da Sanseverino shows Catherine clothed in the Dominican habit and in the company of St Dominic and another figure dressed in Dominican robes who has been identified as the Blessed Costanzio da Fabriano. Costanzio died in 1481 and was later beatified by Pope Pius VII. These two Dominicans appear to witness the marriage as Catherine receives the ring from the Christ child. The mitred St Augustine, who holds a book in one hand, seems to protect, or be on the point of presenting, Costanzio with the other. St Augustine's posture perhaps indicates some connection between his reflections on evil and the imperfections of humanity, and Catherine's own Dialogue which discussed man's religious and moral responsibilities. It may also be that St Augustine is presenting Costanzio as a new member of the Dominican ranks.

[Lorenzo d'Allessandro da Sanseverino (249)]

Marriage of the Virgin *see* Virgin Mary: Marriage

Mars and Venus *see* Venus – 3

Marsyas – 1

Marsyas(?) and Olympus [Greek mythology: Apollodorus, *Bibliotheca* I] Annibale Carracci's painting of *Marsyas(?) and Olympus* reputedly shows Marsyas and his follower, the composer Olympus. Marsyas, a satyr and also a proficient flute player, is frequently shown holding or playing the double flute. A number of musical instruments are depicted in Carracci's painting: a set of pan pipes being played by the younger figure on the left, another set

hanging above the bulky figure to the right, and yet another slightly simpler, divided set of pipes hanging from the trunk of the tree to the left.

The musical theme is entirely appropriate for the harpsichord or similar instrument for which this panel was probably made. But the identification of the two figures is less clear. Neither of the figures is represented as a satyr, and the rather cumbersome figure to the right is more suggestive of the drunken Silenus than the sprightly Marsyas depicted in Domenichino's painting of *The Flaying of Marsyas* [*see* Marsyas – 2]. Yet Carracci's figure certainly leans forward as if in rapt attention to the music of the pan pipes, and there is no suggestion of surrounding vines.

[Annibale Carracci (94)]

Marsyas – 2

Flaying of Marsyas [Mythological: Ovid, *Metamorphoses* VI, 382–400] The satyr Marsyas made the mistake of picking up a reed pipe which had been discarded in pique by Minerva (goddess of War). Ovid tells us that the other gods ridiculed Minerva when she played on her flute, because the effort of blowing on the instrument distorted her features. Minerva flung the pipe aside, and cast a curse upon it.

Unaware of the awful destiny awaiting the person who perfected the art of playing the pipe, Marsyas took the instrument and taught himself to make music on it. This angered Apollo (the god of Music), and he challenged Marsyas to a contest. They agreed that Apollo should play his lyre and Marsyas his flute. According to some sources it was Marsyas himself who arrogantly challenged Apollo and called upon the Muses to be the judges of their skills. It was agreed that the winner could deal with the other in whatever way he chose.

The Muses [*see* Pegasus and the Muses] were traditionally the companions of Apollo. They were the goddesses of the Arts, particularly of Literature, Music and Dance. No wonder therefore that they decided in favour of Apollo who was traditionally associated with poetry and music as well as the sun. Yet Apollo's brutal decision as winner to flay Marsyas alive appears to contradict those qualities of rational and civilised behaviour for which he was revered. His action seems more in keeping with the orgiastic revels of the Bacchante with which Marsyas, as a satyr, was traditionally associated.

Ovid describes how when Apollo applied his knife, Marsyas screamed and repented of his boasting. Fauns, satyrs, nymphs and shepherds wept and lamented, as Marsyas' blood flowed on to the ground and his exposed sinews, veins and vital organs quivered and pulsated in the air. Ovid tells us that the earth soaked up their tears, turning them into a great river which was known as the Marsyas and ran with clear waters all the way to the sea.

The painting of *The Flaying of Marsyas* by Domenichino and assistants shows Apollo slicing the bound satyr's skin. Marsyas writhes in agony as surrounding figures react in horror. It seems as if the artist has chosen representatives from all those people described by Ovid as witnessing the scene. A satyr kneeling in the foreground holds out his arms towards Marsyas as if unable to believe this gross punishment; female figures – probably nymphs – to left and right shield their eyes or gesture in remonstration to

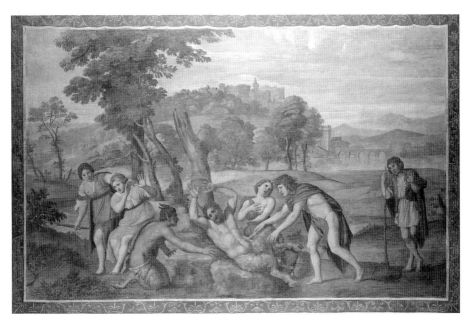

The Flaying of Marsyas Domenichino (1581–1641) and assistants

Apollo who seems not to heed them, so absorbed is he in his grisly task; to the right a muse-like figure of a shepherd looks on meditatively, yet also with his hand raised in apparent disbelief. And in the background we see a broad expanse of water spanned by a bridge with many arches. No doubt this is the River Marsyas which sprang from the tears of those lamenting Marsyas' sad fate.
[Domenichino and assistants (6288)]

Marsyas(?) and Olympus *see* Marsyas – 1

Martyrdom of St Januarius [Legends of the Saints: H. Delehaye, *Hagiographie napolitaine*] Januarius (also known as Gennaro) was a bishop of Benevento who was beheaded (together with six of his companions) near Pozzuoli at the beginning of the fourth century. Some versions of the Januarius legend describe how the saint's index finger was accidentally cut off along with his head. Two phials preserved at Naples Cathedral are said to contain the blood from this finger which was caught and preserved, and miraculously liquifies each year.

Luca Giordano's painting of *The Martyrdom of St Januarius* shows the saint kneeling on a stone slab, presumably just before his martyrdom. An angel swoops down from the left bearing a martyr's palm, while to the right we see Januarius' executioner silhouetted against a fiery background. The flames behind this figure remind us of the invocations made in the name of St Januarius against eruptions on Mount Vesuvius (which is in the vicinity of Naples).
[Giordano (6327)]

Martyrdom of St Sebastian *see* St Sebastian

Martyrdom of St Stephen [Biblical: Acts 7. 54–60] The Bible describes how Stephen, the first martyr, was stoned to death after members of the synagogue in Jerusalem brought forward witnesses to his blasphemy. An angry crowd gathered when Stephen accused the people of betraying and murdering Jesus. The turning point was when he looked up into the sky and claimed to see the figure of Christ standing beside God the Father. The Bible tells us that the people covered their ears in horror, rushing upon Stephen and casting him outside the city walls. We learn how the witnesses against the saint came and laid their clothes down at the feet of a young man named Saul before picking up stones to hurl at Stephen.

The National Gallery painting of *The Martyrdom of St Stephen* attributed to Antonio Carracci shows Stephen surrounded by partially clothed figures wielding stones. Other figures stand and watch against the background of the city walls. To the left a seated figure gestures towards the scene. This is possibly Saul (who later converted to Christianity and took a new name, Paul [*see* Conversion of Saint Paul]), guarding the clothes of Stephen's persecutors.

[Attr. Antonio Carracci (77)]

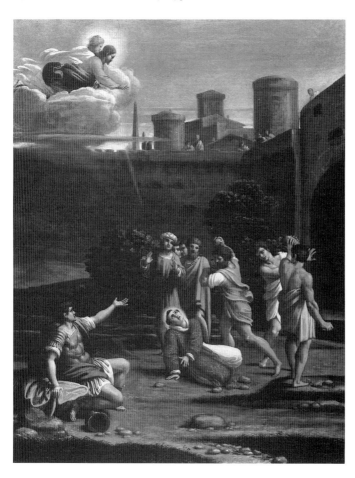

The Martyrdom of St Stephen
Attr. Antonio Carracci (1589(?) – 1618)

Mass of St Giles *see* St Giles – 2
Mass of St Hubert *see* St Hubert – 1
Massacre of the Innocents *see* Christ: Childhood – 7
Meeting at the Golden Gate *see* Virgin Mary: Conception
Mercury – 1

Mercury and the Dishonest Woodman [Aesop's *Fables*] According to legend Mercury rewarded an honest woodman who had lost his axe by replacing it with a tool made of gold. Since the woodman had made no special claims for his lost tool Mercury felt his honesty deserved a special reward. But when another woodman attempted to profit from this by claiming that he also had lost a golden axe, Mercury recovered an iron axe – whether that of the honest or dishonest woodman is uncertain – thereby rendering just deserts to false claims.

Salvator Rosa's painting of *Mercury and the Dishonest Woodman* shows Mercury holding up an object he has retrieved from the marshy land in front of the woods. On the bank another figure, presumably that of the dishonest woodman, peers across to discover what the god has found.
[Salvator Rosa (84)]

Mercury – 2

Mercury piping to Argus [Mythological: Ovid, *Metamorphoses* I] When Juno discovered Jupiter cavorting with a beautiful white cow she was suspicious and forced him to let her have the heifer as a present. Juno was right to mistrust Jupiter. The cow was in fact Jupiter's lover, the nymph Io [*see* Juno discovering Jupiter with Io].

Juno subsequently made Io's life miserable, placing her under the strict guardianship of Argus, the many-eyed herdsman. Any direction Io wandered, Argus was able to swivel one of the eyes that covered his body to keep watch on her. Juno then sent a vicious fly to bite and irritate Io so that she could not stand still long enough for Jupiter to make love to her. But Jupiter could no longer bear to see Io's distress, and sent his winged messenger Mercury to lull Argus to sleep and then kill him.

Ovid describes how Mercury put on his winged sandals, took his sleep-producing wand, and donned his magic cap. He then leapt down to earth, where he removed his cap and wings keeping only his wand by his side. Then, disguised as a shepherd, he drove a flock of goats along the country paths, playing upon a reed pipe.

Argus was greatly taken with the sound of the reed pipe and asked Mercury to sit down beside him so that he could hear some more. Mercury sat and talked and played, hoping that Argus would fall asleep, but although Argus allowed many of his eyes to droop, there were always others that remained open and alert. Argus then asked Mercury about the invention of the reed pipe. The winged messenger spun a long story about Syrinx, how she was pursued by Pan and how she was transformed into reeds in order to escape his embraces [*see* Pan]. Argus finally dozed off and Mercury immediately waved his wand over him to deepen his sleep. Then, taking out his sword, he slashed the nodding head from its neck.

Johann Carl Loth's painting of *Mercury piping to Argus* probably depicts

Mercury piping to Argus
Johann Carl Loth
(1632–98)

the moment when Argus first meets Mercury. Mercury seems hardly aware of Argus, who somewhat strangely is shown as a normal human being with only one pair of eyes. To the left we glimpse the head of the beautiful Io transformed into a white cow.

[Loth (3571)]

Mercury – 3

Mercury stealing the Herds of Admetus guarded by Apollo [Mythological: Ovid, *Metamorphoses* II] According to classical mythology Apollo was forced by Zeus to serve Admetus for a year as punishment for his slaughter of the Cyclops [*see* Apollo killing the Cyclops]. Ovid describes how Apollo (having slain his lover Coronis for her infidelity [*see* Apollo slaying Coronis]) spent his days wrapped in a shepherd's cloak and piping on a reed pipe. Whilst Apollo's thoughts were on his lost love, his cattle strayed into the nearby fields. Ovid describes how Mercury saw the straying cattle, and used his native craft to drive them into the woods where he hid them.

The painting by Domenichino and assistants of *Mercury stealing the Herds of Admetus guarded by Apollo* shows Apollo in the foreground, playing on one pipe rather than the seven-reeded pipe described by Ovid. In the background we see the stealthy figure of Mercury guiding the straying cattle towards the woods.

[Domenichino and assistants (6291)]

Mercury and the Dishonest Woodman *see* Mercury – 1
Mercury piping to Argus *see* Mercury – 2
Mercury stealing the Herds of Admetus guarded by Apollo *see* Mercury – 3
Miracle of St Mark [Italian 13th-century literature: Jacopo da Voragine, *The Golden Legend*] It was traditionally believed that St Mark the Evangelist was buried in Alexandria after a cruel martyrdom in which he was dragged through the streets of that city. In the ninth century the supposed remains of the saint were secreted out of Alexandria by Italian merchants and brought to a new resting place in Venice. Mark subsequently became the patron saint of Venice.

The National Gallery painting of *The Miracle of St Mark* after Tintoretto depicts an incident after the death of St Mark when the saint intervened to save the life of a servant. We learn from *The Golden Legend* that the servant of a nobleman living in Provence decided to make a pilgrimage to Venice to visit the shrine of St Mark. On his return he was threatened with punishment by his master who had not given him leave of absence. The master first ordered that his servant should have his eyes torn from their sockets; then that his legs should be broken and his feet cut into pieces; and finally that his face and teeth should be smashed. But at each attempt the servant invoked the name of St Mark, and the iron instruments of torture broke or melted. At this the master relented and begged his servant to forgive him. Later on he travelled to Venice with his servant to visit the shrine of St Mark himself.

The National Gallery painting shows the supine figure of the servant stretched naked and vulnerable upon the ground whilst his torturers gaze in astonishment at his unblemished body and their broken tools. The master,

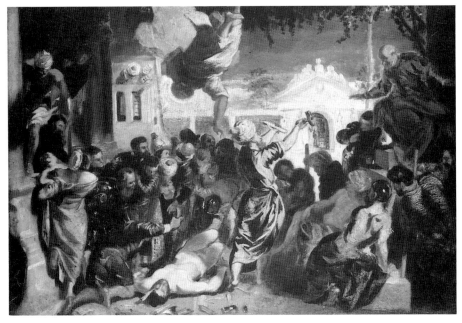

The Miracle of St Mark After Jacopo Tintoretto (1518–94)

seated to the right, seems equally amazed. It is curious to note the Eastern turbans in what was reputed to be a Provençal setting. None of the figures appears to notice St Mark swooping down to protect the servant in the middle foreground.

[After Tintoretto (2900)]

Miracle of St Nicholas *see* St Nicholas

Miraculous Draught of Fishes *see* Christ: Ministry – 2

Miraculous Translation of the Holy House of Loreto [Legends of the Saints] Giovanni Battista Tiepolo's painting of *The Miraculous Translation of the Holy House of Loreto* (which is on loan to the National Gallery) refers to a popular legend of the fifteenth century which claimed that the house in which the Virgin Mary received the Annunciation from the Angel Gabriel and where the Virgin and Joseph lived and cared for the young child Jesus was transported from Nazareth and set down at Loreto (near Ancona) on the eastern coast of Italy. St Francis of Assisi is said to have predicted this event when he visited a Franciscan convent just outside Ancona in 1215.

It was believed that angels carried the Holy House away to safety when the Holy Land was being attacked by the Saracens in 1291. Most depictions of this scene show the Virgin Mary (often holding her child) hovering above the roof of the house and protecting it as it floats over the sea. Sometimes, as in Tiepolo's painting, the house passes over groups of armed Saracens. The National Gallery painting shows these figures falling back in amazement as the house surges across the sky.

The town of Loreto subsequently became a great pilgrim site, and the Virgin herself acquired a new title, 'Our Lady of Loreto'.

[Giovanni Battista Tiepolo (L41)]

Moses – 1

Finding of the Infant Moses by Pharaoh's Daughter

Finding of Moses

[Biblical: Exodus 2. 1–6]

The final chapters of Genesis describe how Jacob (father of Joseph) and many of his brethren left Israel and joined Joseph in Egypt [*see* Joseph – 5]. We learn from the Book of Exodus how the children of Israel prospered in Egypt; indeed their numbers multiplied to such an extent that the indigenous Egyptians began to feel threatened by them.

After the death of Joseph and many of the first generation immigrants, the Pharaoh of the day decided to take radical measures both to curb the power of the Israelites and to restrict their numbers. He decreed that the Israelites should be reduced to semi-slave status, enrolling them under strict task masters to help build the great cities of Egypt, and subjecting them to bonded service in the fields. When it became apparent that the Hebrew population continued to increase despite these restrictions, the Egyptian king ordered the Hebrew midwives to ensure that only the female babies survived when they attended Hebrew women in childbirth.

The midwives were reluctant to carry out the Pharaoh's order, and when questioned why they were failing in their task replied that the Hebrew women were quicker in childbirth than the Egyptians, and because of this

they never arrived early enough to catch and despatch the male children. At this the Pharaoh decreed that every son born to a Hebrew woman should be thrown into the river.

Moses was thus not the only Hebrew child to float upon the waters. His mother had hidden him until he was three months old. Then, fearing that he would be discovered, she made a little ark or basket of bulrushes for him and laid it at the edge of the river. Moses' sister hid a little way off to keep watch and see what would happen. The Bible describes how Pharaoh's daughter came down to the river to bathe and found the ark amongst the reeds. Sending one of her maids to fetch the basket she opened it and found the child crying inside. Pharaoh's daughter took pity on the baby and when the sister approached and cunningly offered to find a Hebrew nurse to look after it she unwittingly entrusted Moses to the care of his own mother.

All the National Gallery paintings of the Finding of Moses show the princess and her attendants walking by the river and the moment of discovery of the abandoned child. In *The Finding of Moses* attributed to Antonio de Bellis our attention is drawn also to the crouching figure of the sister, who peers out from behind a tree. But the Bartholomeus Breenbergh painting of *The Finding of the Infant Moses by Pharaoh's Daughter* adheres most closely to the biblical text in its depiction of the ark as a basket that can be opened. Moses has in fact already been removed from his bulrush home, and is being shown to the princess who is shaded from the sun by a high, flat

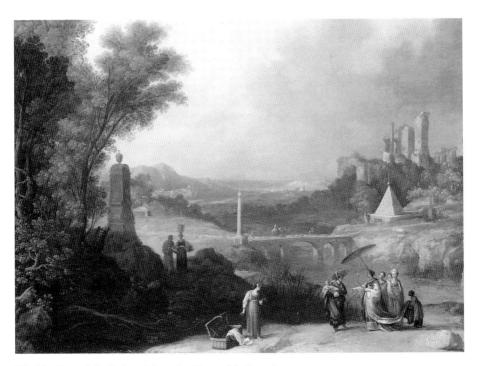

The Finding of the Infant Moses by Pharaoh's Daughter
Bartholomeus Breenbergh (1598–1657)

parasol. In the background we see many fantastic buildings ranging from pyramids to high towers. Perhaps this is one of the great cities of Pithom or Raamses which the Israelites were forced to build.

[Breenbergh (208); attr. Antonio de Bellis (6297); Nicolas Poussin (6519); attr. Zugno (542)]

Moses – 2

Dance of Miriam [Biblical: Exodus 15. 20–1] The Bible describes how after the Children of Israel had crossed the Red Sea Miriam, the prophetess (and also sister of the chief priest Aaron), caught up a timbrel (or tambourine) and started to make music. All the other women also snatched up timbrels and followed Miriam around dancing. Miriam told them to sing praises to the Lord for this triumph over their enemies.

In the National Gallery painting of *The Dance of Miriam* by a follower of Lorenzo Costa we see a number of women dancing in the middle foreground,

The Dance of Miriam
Follower of
Lorenzo Costa
(1459/60–1535)

while the somewhat austere figures of Moses and some of his male followers confront us in the right foreground at the edge of the water. There are many other figures of women in the background who are as yet unaware of the festivities. This painting emphasises the scale of the Exodus. The company stretches far back into the mountainous distance.

[Follower of Costa (3104)]

Moses – 3

Brazen Serpent [Biblical: Numbers 21. 4–9] According to the Bible the Children of Israel were punished by a plague of poisonous snakes after complaining to Moses about their arduous journey out of Egypt. Many of the Israelites died from snake bites, whilst others turned to Moses begging for help. Moses was advised by God to make a fiery serpent and set it up on a pole. God promised Moses that all those who had died would come alive again if they looked at this brazen image.

Rubens' painting of *The Brazen Serpent* shows the tortured bodies of the Children of Israel as they turn towards the beckoning figure of Moses. The figure of Eleazar, standing beside Moses, draws their attention to the bronze serpent on the pole behind.

[Giaquinto (6515); Rubens (59)]

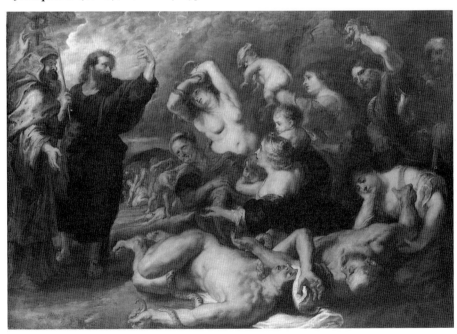

The Brazen Serpent Peter Paul Rubens (1577–1640)

Moses – 4

Israelites gathering Manna [Biblical: Exodus 16. 14–36] After the crossing of the Red Sea in their flight from Egypt, the Children of Israel came into a great desert or wilderness called Sin. In this wasteland there was no food or shelter. The Israelites began to complain, lamenting the fact that they had left the

The Israelites gathering Manna Ercole de' Roberti (active 1479, died 1496)

comfort of their homes and, above all, that Moses and Aaron had brought them to a place where they would all die of hunger.

The Book of Exodus describes how the Lord spoke to Moses, telling him that bread would rain down from heaven. For six days the Children of Israel would be able to go out and gather a certain amount of this, and on the seventh day (having gathered double quantities the previous day) they should rest. Moses commanded Aaron to call the Israelites together and tell them that God had listened to their complaints. When the people were all congregated together they looked out into the Wilderness and saw a vision of God in a cloud.

The next morning, after a heavy dew, the Israelites saw what appeared to be a hoar frost covering the ground. Moses told them to collect these small round white seeds, since this was the bread that the Lord had promised them. They called the coriander-like seed Manna, and went out each morning to collect it, finding that it rotted if left on the ground during the day. For forty years the Children of Israel were nourished in this way, on miraculous desert bread which, we are told, tasted like wafers made with honey.

Both National Gallery depictions of the gathering of Manna show Moses and Aaron watching whilst the Israelites collect basins, buckets and apronfuls of the seed. Some collect so much that they fill great sacks. This was in accordance with Moses' command that each should gather according to his needs. In the background we see the Israelites taking the bread back to their homes and tents. Some versions of the Bible in fact refer only to tents. It is curious therefore to find semi-permanent wooden structures in both paintings. But at least Ercole de' Roberti is faithful to the text in depicting the barren background in his painting of *The Israelites gathering Manna*. The craggy rock to the right perhaps suggests the lower slopes of Mount Sinai which rose from the plain of the Wilderness of Sin.

[Follower of Costa (3103); Roberti (1217)]

Moses – 5

Moses brings forth Water out of the Rock

Moses striking Water from the Rock
[Biblical: Exodus 17. 1–7]
After their years in the Wilderness of Sin [*see* Moses – 4], the Children of Israel travelled on and pitched their tents in Rephidim. But here another trial awaited them. In Rephidim there was no water. Once again the Israelites complained to Moses. Why had he brought them out of Egypt if they and their cattle were to die of thirst? Appealing to God, Moses was told by the Lord to take some of the elders of the company and to go to the rock in Horeb. God commanded Moses to smite the rock with his rod. The Bible describes how God promised Moses that water for the Children of Israel would come spurting from the rock.

Both Giaquinto's *Moses striking Water from the Rock* and the painting of *Moses brings forth Water out of the Rock* by a follower of Filippino Lippi depict the moment of this miracle. Filippino Lippi's painting shows Moses kneeling in front of a rock with his rod raised in the air as if to tap upon it. To his left stand two figures with their arms raised as if in amazement, whilst on the other side of the painting we see many figures of men, women, children and animals drinking thirstily from the freely flowing water. In the left background we notice the pitched tents of the Israelites whilst to the right we see a great procession of people and camels winding their way through the landscape. Perhaps this refers to the weary journey from the Wilderness of Sin to the arid wasteland of Rephidim, although the luxuriant foliage of Lippi's painting is hardly redolent of a parched land.
[Giaquinto (6516); follower of Filippino Lippi (4904)]

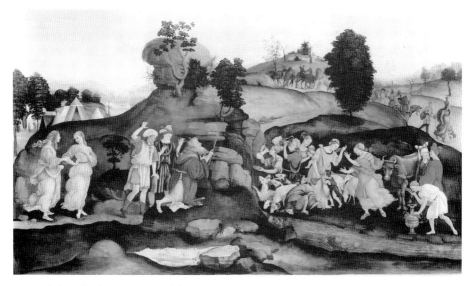

Moses brings forth Water out of the Rock Follower of Filippino Lippi (1457(?)–1504)

Moses – 6
Adoration of the Golden Calf
Worship of the Egyptian Bull God, Apis

[Biblical: Exodus 32. 1–25]

The Bible describes how Moses led the Children of Israel out of Egypt in search of a new and promised land. This journey involved them in many adventures [*see* Moses – 2, 3, 4 and 5]. For many months Moses (who came from the tribe of Levi) guided his people through battles and starvation until they finally reached the Wilderness of Sin and the foothills of Mount Sinai. It was on this mountain that Moses spoke with the Lord and received the Tablets of the Law, or Ten Commandments, with which he was expected to rule his people.

Whilst Moses was receiving the Ten Commandments, the Israelites lost heart, believing he would never return to them. Restless and impatient, they demanded another god to worship from Aaron, the brother of Moses. Aaron demanded all the gold from their earrings so that he could form a golden calf for them to worship.

It is traditionally believed that the calf was made in the form of the Egyptian Bull god Apis, a deity which emerged from a river and pranced up into the sky as its worshippers surrounded it with music and singing. Although the painting of *The Worship of the Egyptian Bull God, Apis* by a follower of Filippino Lippi has not been clearly identified as an Adoration of the Golden Calf, the central figure of the bull with a crescent moon at its shoulder is clearly identifiable as Apis. Lippi's composition also includes an encampment of tents and the frenetic figures of worshippers who dance, sing and make music.

The Adoration of the Golden Calf Nicolas Poussin (1594(?)–1665)

The Bible tells us that the Israelites danced naked and in frenzied joy around this new god. 'And they rose up early on the morrow, and offered burnt offerings, and brought peace offerings; and the people sat down to eat and drink, and rose up to play.'

Poussin's painting of *The Adoration of the Golden Calf* suggests both the carefree atmosphere of a feast in the open air with its dancing figures and its crowd of people seated on the ground, as well as the almost hysterical worship of this new idol. He chose not, however, to show the Children of Israel nude. Yet their dishevelled dress and frantic gestures are strongly suggestive of the impropriety which so shocked Moses on his return. Raucous sounds indicated that all was not well long before Moses reached the camp. His companion Joshua thought he heard the sound of war. But Moses replied: 'It is not the voice of them that shout for mastery, neither is it the voice of them that cry for being overcome; but the voice of them that sing.'

Casting the great tablets of stone inscribed with the new law on the ground, Moses descended into the camp swearing vengeance. By the end of the day three thousand Levites lay dead, slaughtered by their own kind and on the express command of Moses, the leader of the tribe.
[Follower of Filippino Lippi (4905); Poussin (5597)]

Moses brings forth Water out of the Rock *see* Moses – 5
Moses striking Water from the Rock *see* Moses – 5
Moses defending the Daughters of Jethro *see* Jacob – 1
Mourning over the Dead Christ *see* Christ: Death – 3
Mystic Marriage of St Catherine of Alexandria *see* St Catherine
Mystic Nativity *see* Christ: Childhood – 1
Naming of St John the Baptist *see* St John the Baptist – 1
Narcissus
Narcissus
Landscape with Narcissus
[Mythological: Ovid, *Metamorphoses III*]
According to classical mythology Narcissus was a youth of great beauty who fell in love with his own image, reflected in the smooth water of a pool. Narcissus had been cursed for rejecting all those who offered him their love.

Ovid describes how when Narcissus reached his sixteenth year he attracted the love of both youths and maidens. But Narcissus was full of pride and cold disdain. Once, whilst he was out hunting deer, the nymph Echo saw him and fell desperately in love with him. But Echo was cursed with a strange speech disability. She could never keep quiet whilst others spoke, and could only begin to speak if first addressed by someone else. Even then she was only able to repeat the last words she had heard. Echo had been reduced to this state by Juno for the many times she shielded Jupiter whilst he dallied with the nymphs of the mountainside. Echo used to engage Juno in long conversations whilst the nymphs made their getaway. Juno's revenge was that Echo's tongue should be severely restricted so that she could only have very short conversations.

Echo confronted Narcissus but was rejected. Grief-stricken, she retreated to the woods where she spent countless days lamenting her fate. After many

sleepless nights Echo began to wither away until only her voice remained: a cruel fate merely for having loved. But many others suffered from Narcissus' egocentric disdain. Finally, one of his rejected lovers burst out in pain and anger: 'May he himself love, and not gain the thing he loves.' Nemesis (the goddess of Retribution) heard the youth's cry. She drew Narcissus to a clear pool with a silvery bright, smooth surface. Slaking his thirst, Narcissus was caught by the reflection of his own beautiful form in the water.

Jacob Pynas concentrates on the end of the story by showing Narcissus peering into a trough of water in his *Landscape with Narcissus*. But Claude's painting of a *Landscape with Narcissus* depicts both the revenge of Nemesis and Echo's earlier demise. On the left we see Echo reclining as if in death, whilst two other nymphs peer over a bush to see Narcissus transfixed by his own image at the water's edge.

Ovid describes how Narcissus looks at himself in speechless wonder, caught by his exquisite reflection but unaware that it is his own. In vain Narcissus tries to kiss the smooth cheeks, caress the twisting locks of hair, touch the twin stars of his eyes. In vain he reaches through the surface of the water to clasp his own ivory neck. But each time the form shimmers away.

Unable to tear himself away from his beautiful reflection, and never able to reach it and thus satisfy his passion, Narcissus gradually weakens and dies. When his naiad-sisters and the dryads come to take his body to the funeral pyre they find only a fragile and lovely yellow and white flower growing in the spot where Narcissus has whiled away his hours.

The National Gallery painting of *Narcissus* attributed to a follower of Leonardo catches the mesmerised glance of the youth as he engages with his own image in the mirror-like surface of the water. And at the same time the

Narcissus
Follower of
Leonardo
(1452–1519)

pallor of his flesh reminds us of Ovid's description of the fading ruddy colour mingling with white, and of the failing of strength and vigour. We sense that Narcissus is slowly pining away, consumed by a hidden fire.
[Claude (19); follower of Leonardo (2673); Pynas (6460)]

Nativity *see* Christ: Childhood – 1
Nativity with God the Father and the Holy Ghost *see* Christ: Childhood – 1
Nativity at Night *see* Christ: Childhood – 1
Nativity with Saints *see* Christ: Childhood – 1
Nessus and Dejanira [Mythological: Ovid, *Metamorphoses* IX] Dejanira, the daughter of the River god Oeneus was loved by Achelous, another River god, and Hercules, the son of Jupiter. Ovid describes how Achelous and Hercules fight a great battle for Dejanira's hand during which Achelous, after transforming himself in various ways in an attempt to overcome his rival, is mutilated and beaten.

Hercules then claims Dejanira and sets off home with her. On the way they come to her father's river which is swollen by winter rains, making it difficult to cross. Although Hercules is unperturbed by this, he is anxious about his bride. So when Nessus, a centaur who fords people across the river, offers to carry Dejanira to the other side Hercules immediately agrees.

Ovid describes how Hercules himself swims across the swirling waters of the River Oeneus after first throwing his club and bow across to the other side. As he reaches dry ground and is on the point of picking up his bow, he hears screams from Dejanira, whom Nessus is trying to rape. Furious at the centaur's betrayal of trust Hercules shoots an arrow at him as he tries to escape. Nessus tears at the arrow which has passed through his body and is protruding from his breast. Great spurts of blood mixed with deadly poison pour down on to his tunic. Nessus gathers this up and offers it to Dejanira, promising her that it has the power to revive love that has waned. This is in fact a deadly revenge. Much later, Dejanira sends the tunic to Hercules, believing that he has fallen in love with Iole. Ovid describes in hideous detail how the tunic sticks to Hercules' skin and causes him horrible agony as he tries to pull it off, and in doing so tears away his own muscles and lays bare his bones. In desperation, Hercules rampages over the mountainsides like a wounded bull, and finally throws himself into the flames of a funeral pyre.

Louis de Boullongne's painting of *Nessus and Dejanira* shows Dejanira seated quite comfortably on the centaur's back, yet Hercules has already emerged from the waters and is gesticulating towards them. An arrow lies in the foreground as if already discarded by the centaur, whilst on the right Nessus himself seems to tell Dejanira about the power of his blood-stained tunic.
[Boullongne (6506)]

Niccolò Mauruzi da Tolentino at the Battle of San Romano *see* Battle of San Romano

Noli me tangere *see* Christ: Resurrection – 3

Odyssey – 1

Ulysses deriding Polyphemus [Greek mythology: Homer, *The Odyssey* IX] *The Odyssey* describes the adventures of Ulysses (known to the Romans as

Odysseus) on his way back from Troy at the end of the ten year war. In one episode Odysseus discovers the land of the Cyclops (one-eyed giants). After mooring the boats, he takes twelve of his best men with him to discover what the Cyclops are like. Odysseus and his men come to a point on the mainland where there is a cave with a high entrance which is the den of a lonely giant, Polyphemus. According to Homer Polyphemus, who lived apart from the other Cyclops, looked like some great wooded peak rearing up in solitary state against the sky.

Odysseus and his men go into the giant's cave to explore, only to find themselves trapped inside when Polyphemus comes back to the cave to milk his ewes, rams and goats, and closes the entrance with a great stone. Lighting a fire the giant sees Odysseus and his men huddling in the shadows, and demands to know who they are. Brushing aside Odysseus' plea for hospitality and protection in the name of the great god Zeus, Polyphemus stretches out and seizes two of the men. He then devours them after beating their heads against the floor and tearing them limb from limb. Paralysed with fear and unable to escape because of the great rock at the cave's entrance, Odysseus can only watch in horror as Polyphemus finishes his ghastly repast and swills down a great pitcher of milk before falling asleep beside his animals.

At dawn Polyphemus milks his sheep and snatches another two men for breakfast, before taking his flock to graze in the high pastures. While he is away Odysseus and his men fashion a pointed stake from a huge staff of olive wood which they find lying near the sheep's pen in the cave. Odysseus plans to blind the Cyclops with this and asks four of his men to volunteer to help him lift it on the giant's return.

When Polyphemus returns he brings all his animals into the cave and follows the previous routine of milking the sheep and goats before seizing two more victims for his meal. But this time Odysseus approaches and offers Polyphemus some of the wine he has brought with him. Finding the wine to his taste, Polyphemus demands more. Engaging Odysseus in conversation, the Cyclops asks his name and promises to give him a gift in return for the wine. When Odysseus replies 'Nobody' Polyphemus reveals that his special gift will be to eat him last.

As Polyphemus collapses on the floor in a drunken stupor Odysseus heats the end of the olive stake in the fire and, with the help of his four volunteers, lifts it up and twists the red hot point into the Cyclops' eye. Screaming with rage and pain Polyphemus tears the stake from his bloody eye socket and shouts to the giants living in the other caves to come to his aid. Hearing Polyphemus cry out they call to him, demanding to know what is wrong. But Polyphemus only replies that it is Nobody's treachery rather than any violence that is killing him. Thinking that Polyphemus must be delirious with some kind of fever, the other Cyclops leave him alone.

Meanwhile inside the cave Odysseus is rejoicing in the choice of name that has, for the moment, saved their lives. Polyphemus heaves the great stone away from the mouth of the cave and tries to catch his victims escaping along with the sheep. But Odysseus has a more cunning plan. Realising that it is hopeless to try and dodge past the giant, he lashes some of the remaining

rams together in threes, and places one man against the belly of each middle animal. Although Polyphemus runs his hands across the backs of each of the rams as they pass by, he does not think to check their undersides, and Odysseus and his men escape to freedom.

Disentangling themselves from the rams, Odysseus and his men drive the flock down to the waiting ship and quickly set out to sea. But before they are out of earshot Odysseus hurls back a curse at Polyphemus. In response, Polyphemus tears off a great pinnacle of rock and dashes it down into the sea engulfing the ship in a tidal wave which carries it back towards the shore. When the ship is turned about again Odysseus rages back at the giant, revealing his true name and origin. At this Polyphemus groans, remembering the prophecy that he would be blinded by one named Odysseus.

Turner's painting of *Ulysses deriding Polyphemus* shows Odysseus' ship sailing to freedom against a dawn sky. Polyphemus emerges from the clouds like some great mountain in the sky, his head bowed as if lamenting his fate. [Turner (508)]

Odyssey – 2

Penelope with the Suitors [Greek mythology: Homer, *Odyssey* XVII] Penelope, left alone for many years by her husband Odysseus [*see* Odyssey – 1], finally sends her son Telemachus in search of his father. Homer describes how Penelope is sorely tested during Odysseus' absence, the greatest problem being a number of suitors who wish to marry her and seek to persuade her that her husband is dead.

At first Penelope buys time by insisting that she can give no answer to her suitors' requests until she has finished weaving a shroud for Laertes, the father of Odysseus. This is a cunning ruse for, although the mistress of the house works avidly at her loom during the day, by night she carefully unravels all that she has woven during the previous hours.

But Penelope's trickery is discovered, and the suitors (who have moved into the house, feasting upon Penelope's food, consorting with her women servants and generally usurping her powers as mistress) demand a final answer. On the advice of the goddess Athene Penelope challenges the suitors to an archery contest using the great bow left behind by Odysseus. In the meantime Telemachus has returned home after finding his father alive. Odysseus accompanies his son disguised as a beggar.

Although Homer describes the great archery contest in which Odysseus overcomes and slaughters his rivals, Pintoricchio's painting of *Penelope with the Suitors* refers to the earlier part of the story when Telemachus returns to Penelope with news that his father is still alive. Odysseus' bow hanging on the wall at the left suggests that the archery contest has not yet begun. And although we notice a figure looking through the doorway at the right, who may well be the disguised Odysseus, it seems more likely that this is a swineherd called Eumaeus.

According to Homer Eumaeus was sent directly by Telemachus to give the news of his return to Penelope privately, but another messenger (who was sent by the ship's crew to warn Penelope that Telemachus would be delayed whilst he attempted to outwit the suitors who were conspiring to kill him)

blurted out the news to the women servants before Eumaeus could intervene. When Eumaeus returned to Odysseus and Telemachus he related how the ship's messenger had got to Penelope first. Eumaeus also described how he had seen a great armed ship sailing into the harbour, which probably held supporters of Penelope's suitors.

The National Gallery painting appears to depict this part of the story with great accuracy. Through the open window we see a great ship at anchor in the harbour. Penelope, meanwhile, is seated quietly at her box loom. Although the central figure has often been identified as Telemachus, it is possible that this is the ship's messenger who arrives first and blurts out the news for all to hear. His gestures suggest that he is imparting news of some importance. With one hand outstretched towards Penelope he lifts the index finger of the other as if to enumerate a number of points.

According to Homer, when Telemachus finally returned, Penelope came out of her room and burst into tears as she threw her arms around her son's neck. The Pintoricchio Penelope is surely too impassive for this to be the first meeting between mother and son after a long period of absence. Yet it may be that we witness a further episode in the story. Another passage in the Odyssey describes how after the return of Telemachus Penelope sits spinning the delicate thread on her distaff whilst her suitors devour a feast laid out in front

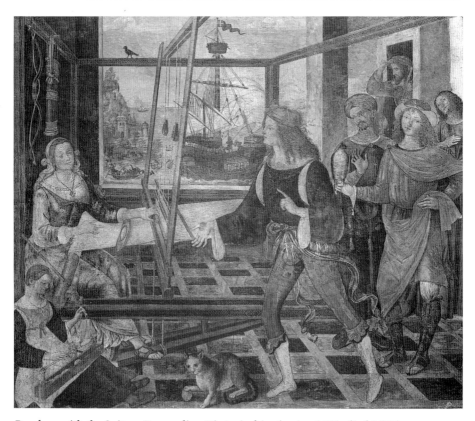

Penelope with the Suitors Bernardino Pintoricchio (active 1481, died 1513)

of them. At the end of the meal Penelope turns somewhat frostily to her son and enquires whether he intends that she should retire to her bedchamber without his deigning to give her any news about his travels and his attempts to find Odysseus.

Perhaps then the National Gallery painting is a distillation of several parts of the Odyssey. If the central figure is indeed Telemachus, he has clearly already begun describing his adventures. Two of the background figures gesture in amazement and possibly even thanksgiving. Perhaps they are reacting to that point in the story where Telemachus tells Penelope that Odysseus is indeed alive, but kept captive and in deep distress in the cave of a nymph called Calypso.

[Pintoricchio (911)]

Oedipus and the Sphinx [Greek mythology: Apollodorus, *Bibliotheca* III] Because of a prophecy that he would kill his father Laius (king of Thebes), Oedipus was taken away at birth and given to a servant who was told to expose him on Mount Cithaeron – the child's feet first being pierced with a spike so that he could not wander away to freedom. But the servant, instead of exposing Oedipus, gave him to a shepherd who delivered him to the childless king and queen of Corinth. The child was named Oedipus because of his deformed feet.

When Oedipus grew up he travelled to Delphi to seek information about his real parents, after being told that he was not a true son of the royal house of Corinth. The Delphic Oracle told Oedipus that he would murder his father and marry his mother. Deciding that the risks were too great to consider returning to his adoptive parents, Oedipus set his back on Corinth and wandered towards Thebes. On the way he met Laius, whom he did not recognise, and killed him after a quarrel, thus unwittingly fulfilling the first part of the prophecy.

Arriving at Thebes Oedipus encountered the Sphinx who posed an impossible riddle and killed all those who could not answer it. Oedipus' uncle, the brother of his natural mother Jocasta, had offered the kingdom and his sister to anyone who could rid the country of the Sphinx. Oedipus guessed the answer to the riddle, and the mortified Sphinx killed herself. Oedipus then married Jocasta and only later discovered that she was in fact his own mother.

Ingres' painting of *Oedipus and the Sphinx* shows the perfect nude body of Oedipus, no ugly gashes in his feet. He is deep in conversation with the Sphinx. She looks displeased, with her uptilted breasts and clenched paw suggesting affront and perhaps the growing realisation that her riddling days are over. Oedipus' answer to the riddle 'What moves on four feet, on two feet and finally on three, but becomes weaker as the feet increase in number?' was 'Man who crawls as a child and falters along with a stick in old age'.

Oedipus' pose in the National Gallery painting suggests that he has just arrived at the two feet response, since he both gestures to the Sphinx and back to himself, as if indicating an appropriate example for that part of the answer to the riddle.

[Ingres (3290)]

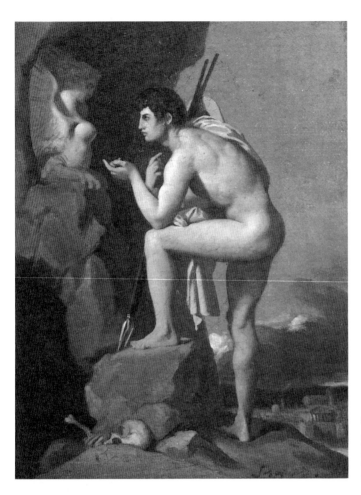

Oedipus and the Sphinx
Jean-Auguste-Dominique Ingres
(1780–1867)

Ophelia among the Flowers [English 16th-century literature: Shakespeare, *Hamlet*, act IV, scene 5; act V, scene 1] In Shakespeare's play Hamlet is loved by Ophelia, daughter of Polonius. Hamlet, although attracted to Ophelia, subjects her to cruel taunting as he attempts to persuade those around that he is insane. Ophelia, driven to real insanity by Hamlet's rejection and his accidental murder of her father, wanders the castle of Elsinore muttering disjointedly and bursting into wild fragments of song. Meeting her brother Laertes she lists flowers and herbs, describing their particular qualities: rosemary for remembrance; pansies for thoughts. Driven at last to suicide, Ophelia is brought to the churchyard to be buried. Laertes prays that violets should grow from her unpolluted flesh, while Hamlet's mother scatters flowers over the corpse, lamenting that she had hoped rather to decorate Ophelia's marriage bed.

Redon's painting of *Ophelia among the Flowers* began life as a study of flowers in a vase. At a later stage the artist turned the painting on its side and included the head of Ophelia in the lower right-hand corner. She seems to

float against a dimly perceived landscape. This combination of hazy background with detailed rendering of flowers and leaves is curiously suggestive of Ophelia's creeping insanity in Shakespeare's tale.
[Redon (6438)]

Origin of the Milky Way

[Greek mythology: Diodorus Siculus, *Bibliotheca Historica*, 4:9; Byzantine: *Geoponica* XX, 11, 19; *Historia del Giglio* XI, 20] There are a number of variations to the story concerning the origin of the Milky Way, but the basic elements remain the same. Jupiter sires Hercules through his union with the mortal Alcmene. Hercules is suckled at the breast of Juno, and some of the flowing milk spurts up into the sky to form stars whilst other droplets fall down to earth to form lilies.

According to Diodorus Siculus, Alcmene took her son and abandoned him outside the city walls of Thebes because she feared Juno's revenge for her liaison with Jupiter. But one of the other goddesses, Minerva, intervened to save Hercules. Minerva arranged for Juno to discover the abandoned child. She then persuaded Juno to suckle the child, thus not only saving Hercules'

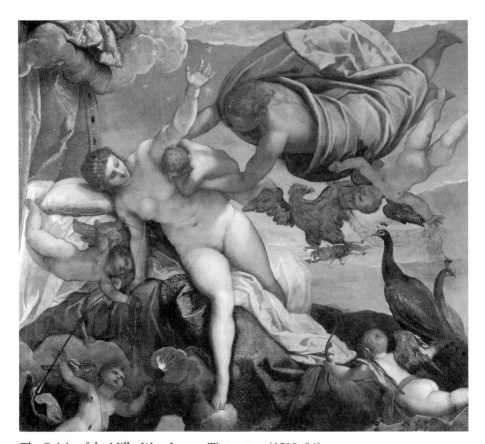

The Origin of the Milky Way Jacopo Tintoretto (1518–94)

life but also giving him the gift of immortality. We learn that the baby sucked so violently that a great flow of milk escaped to cover the heavens. Other versions of the legend say that it was Jupiter himself who brought his love child to suckle at Juno's breast.

The Tintoretto painting of *The Origin of the Milky Way* shows a distinctly agitated queen lurching away from Hercules, as if reluctant to quench his urgent thirst. Great jets of milk gush down towards the earth and up into the clouds, where we see the stars of the Milky Way forming. The queen's celestial couch is attended by peacocks (symbolic of her riches and all-seeing eyes) and cherubs. Jupiter, who brings the child to his wife's breast, is identifiable by his thunderbolt-bearing eagle.

[Tintoretto (1313)]

Orpheus [Mythological: Ovid, *Metamorphoses* x] When Eurydice was bitten by a snake and taken to the underworld [*see* Death of Eurydice], Orpheus determined to win her back. Journeying to the gates of Hades Orpheus pleaded with Persephone and Pluto (rulers of the underworld) to return his wife to him. He asked only that she might be given the normal span of years allotted to humanity. Orpheus argued that Persephone and Pluto had the advantage over humans since their reign over souls in the underworld lasted for ever whilst humans had a finite number of years to live in the world above.

Ovid tells us that Orpheus was playing so sweetly on his lyre while he pleaded with the gods of the underworld that all the spirits wept and even the rulers themselves relented. Orpheus was allowed to take Eurydice back to the world above but only on condition that he did not look back to see if she were following until after he had left the valley of Avernus (the point from which he had descended into the underworld).

For a long time Orpheus controlled his desire to see Eurydice but at the last moment he weakened and looked back. Eurydice immediately vanished from his sight. Anguished and in despair, he tried to cross back over the River Styx to search for Eurydice again, but the wild-eyed Charon turned him away.

Ovid describes how after many years of wandering Orpheus came to a hill where he sat down and started to play his lyre. He played so sweetly and with such emotion that great trees of oak, linden, beech, laurel and many other species grew up and bent their branches towards him, and all kinds of wild beasts and birds gathered around to listen.

The Roelandt Savery painting of *Orpheus* is very suggestive of Ovid's text with its luxuriant foliage and the large crowd of domestic and wild animals who crowd round Orpheus to listen to his music. The only unexpected detail is that Orpheus plays upon a violin rather than a lyre.

[Savery (920)]

Ovid among the Scythians [Roman history] The Roman poet Ovid (author of *The Metamorphoses*, a text which influenced so many of the narrative paintings now hanging in the National Gallery) was banished from Rome for writing the somewhat salacious text *Ars amatoria* (*The Art of Love*). Ovid was exiled to Tomis, a bleak place on the Black Sea which was often invaded by

Ovid among the Scythians Ferdinand-Victor-Eugène Delacroix (1798–1863)

fierce Scythian tribes who lived to the north.

Whilst in exile Ovid learnt the local language and used it to write a poem in honour of Augustus and Tiberius. Perhaps this is what we witness in Delacroix's painting of *Ovid among the Scythians*. Ovid reclines in the middle foreground against a wild and mountainous landscape and a stretch of water which no doubt represents the Black Sea. The bleak setting suggests that Delacroix was aware of Ovid's description of the treeless landscape and the constant threat of invasion by Scythian warriors. A number of other figures in the middle foreground seem in awe of the poet, despite their armour. They kneel in front of Ovid, offering him gifts and inclining their heads in deference. Their respectful attitude might stem from the fact that they witness a poem being written in their own language. The detail of the horse being milked in the foreground quite clearly alludes to a piece of information (that Scythians drank the milk of mares) included in one of a number of elegiac poems describing life in Tomis. Ovid sent these back to his wife and friends hoping that they would remind the people of Rome of his continuing existence. The poems were subsequently published as *The Tristia*, but the ban on Ovid was never lifted, and he died in lonely exile.

[Delacroix (6262)]

Pair of Lovers *see* Daphnis and Chloë

Pan

Pan and Syrinx
Pan pursuing Syrinx
[Mythological: Ovid, *Metamorphoses* I]

The story of Pan and Syrinx was told to Argus by Mercury. Mercury hoped to lull the all-seeing herdsman to sleep so that he might free Io who had been transformed into a beautiful white cow [*see* Mercury – 2].

Syrinx was a nymph who spent much of her time avoiding the lascivious advances of satyrs and gods who lived in the woods and fields around her home on the slopes of Mount Arcadia. One of these was Pan (god of shepherds and the symbol of fertility). Pursuing Syrinx to the banks of the River Ladon, Pan thrust forward to catch the nymph but found himself clutching a bunch of marsh reeds instead of her soft flesh. Ovid describes how when Syrinx called for help on reaching the water, the river goddess clasped the nymph in her own embrace before turning her into a thicket of sighing reeds.

Sighing in disappointment, Pan heard a low complaining from the bundle in his arms. Realising that he could yet stay close to Syrinx, Pan cut the reeds and fashioned them into a pipe. He then took this instrument with him wherever he wandered, making sweet music on it and even pitting it against the musical skill of such great gods as Apollo [*see* Judgement of Midas].

The National Gallery paintings catch both the voluptuousness of Syrinx and the eager pursuit of Pan. In *Pan pursuing Syrinx* by Hendrick van Balen the Elder and a follower of Jan Brueghel Syrinx twists violently away from Pan, seeming almost to overbalance in her anxiety to escape. In the Boucher painting of *Pan and Syrinx* however it is the satyr who seems about to tumble

Pan and Syrinx François Boucher (1703–70)

through the reeds into the water as the anguished Syrinx cowers against the body of the river nymph.

[Van Balen the Elder and a follower of Jan Brueghel (659); Boucher (1090)]

Pan and Syrinx *see* Pan

Pan pursuing Syrinx *see* Pan

Paris – 1

Judgment of Paris, Landscape with

Paris awards the Golden Apple to Venus (also known as *The Judgement of Paris*)

[Mythological: Lucian, *Dialogue of the Gods*, 20]

Most myths have elaborate codas and just as complicated beginnings, but depictions of the Judgement of Paris normally concentrate on the moment when the young Trojan prince Paris (disguised as a shepherd) ends the dispute between Juno, Minerva and Venus as to which of them is the most beautiful by handing the golden apple to Venus. All the goddesses offered bribes to Paris to sway his judgement. Juno offered riches and the possession of land, Minerva prowess in battle. But Paris found the offer of the third goddess Venus – that he would be loved by the most beautiful woman in the world – the most persuasive and decided she should receive the prize. He subsequently met and fell in love with Helen, wife of King Menelaus of Greece [*see* Paris – 2], and, by eloping with her, sparked off the ten year siege of Troy.

All the paintings in the National Gallery show Paris reaching out towards

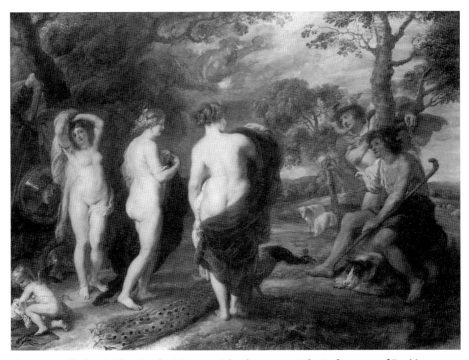

Paris awards the Golden Apple to Venus (also known as *The Judgement of Paris*)
Peter Paul Rubens (1577–1640)

Venus, but Joachim Wtewael's *The Judgement of Paris* includes a number of other significant details. Wtewael wants us to know something about the beginning of the story as well. Thus in the right background of his work we find a reference to the incident which led the goddesses to quarrel in the first place.

Mercury was sent by Jupiter with a golden apple which had been tossed by Eris (the personification of strife) into the middle of a wedding feast to celebrate the union between Peleus (the Mountain god) and Thetis (a sea-nymph). The apple was inscribed with the message 'To the Fairest'. Eris wanted to cause trouble among the wedding guests after being left off the invitation list. Her wedding gift of the golden apple had an immediate and catastrophic effect. All the goddesses rushed for the golden prize, claiming their individual rights of possession, and there was general uproar at the feast. Rubens refers to Eris's troublemaking in one of his two paintings of *Paris awards the Golden Apple to Venus* by including a figure of the Fury, Alecto, who sweeps across the thundery sky and brandishes a twisting snake in his outstretched hand. But it is Wtewael who refers directly to the earlier part of the story by revealing a scene of the wedding feast in chaos.
[Both and Poelenberg (209); Rubens (194); Rubens (6379); Wtewael (6334)]

Paris – 2

Abduction of Helen by Paris [Greek mythology: Homer, *Odyssey* IV] The beautiful Helen of Troy emerges in a variety of guises from different classical texts. Her elopement with Paris undoubtedly led to the ten year war between the Greeks and Trojans, causing great anguish, slaughter and despair. Yet some classical texts see Helen as a tragic victim, and others describe how she overcame her love for Paris and finally returned to live happily with her husband Menelaus.

Many depictions of the Rape of Helen show her dragged unwillingly from the bosom of her family and transported roughly across the sea of Troy. The National Gallery painting of *The Abduction of Helen by Paris* by a follower of Fra Angelico is curious in that it shows a somewhat cocky female figure apparently perfectly happy to take a ride on her lover's back, despite the fact that at least one of her courtiers is in hot pursuit. The foreground figure of a prancing child seems to ape the adult behaviour. Looking into the painting we see that at least one other lady is being abducted and bundled off to the boat lying at anchor in the harbour – again apparently without protest.

The attitude of Helen and her women may puzzle us, yet as she herself relates in Homer's *Odyssey*, her infatuation with Paris was brought about by Aphrodite (the goddess of Love known to the Romans as Venus). The building on the right is perhaps significant in this context. A figure of a female deity set up on a column in the back of the building reveals that it is a temple. Yet even here we see a number of women who appear to raise little objection to the threat of abduction. Perhaps this is the temple of Aphrodite. Her powerful presence would certainly explain why Helen and her companions are carried away in such ecstasy.

And Helen's own claim that she was powerless in the face of this love is supported by earlier events. It was after all Venus who promised Paris the

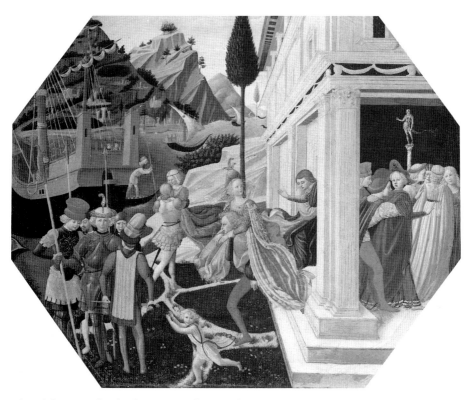

The Abduction of Helen by Paris Follower of Fra Angelico (active 1417, died 1455)

love of the most beautiful woman in the world [*see* Paris – 1]. Helen was thus doomed to fall in love with Paris, to be lured away from her country, her daughter, her bridal chamber and a husband 'who had all one could wish for in the way of brains and good looks'.
[Follower of Fra Angelico (591)]

Paris awards the Golden Apple to Venus (also known as *The Judgement of Paris*) *see* Paris – 1

Parting of Hero and Leander – from the Greek of Musaeus [Mythological: Ovid, *Heroides and Amores*, 18, 19; Musaeus, *The Loves of Hero and Leander*, 281–494] Leander used to swim the Hellespont each night to visit the beautiful Hero. Leander came from Abydus on the Asiatic side of the water which is now known as the Dardanelles straits. Hero was a priestess in the temple of Aphrodite at Sestos which was on the Greek side of the water. Some sources maintain that Leander was guided only by the lantern Hero held aloft to show the way. Others refer to the light beaming from a tower at Sestos. One night a great storm blew up and Leander was left to struggle and drown in the swirling waters when his guiding light was extinguished. When Leander's body was washed up on the shore Hero threw herself in despair into the sea.

Although Turner chose to depict Aphrodite's temple and other buildings at Sestos with some care in his painting of *The Parting of Hero and Leander –*

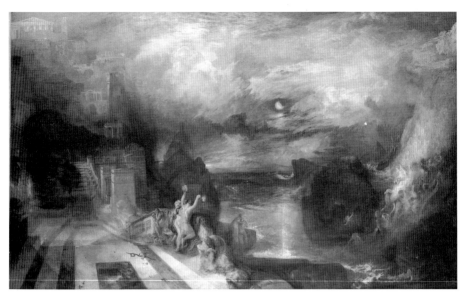

The Parting of Hero and Leander – from the Greek of Musaeus
Joseph Mallord William Turner (1775–1851)

from the Greek of Musaeus, he clearly favoured the idea that it was Hero's own light which was extinguished as she looked out in eager anticipation over the churning waters. Turner in fact shows Hero holding two blazing torches. Although the flames are still flickering in the painting, the background details unfold the tragedy of Leander's death. Great clouds swirl across the sky whilst ghostly figures cascade down towards the water. Perhaps these are the Nereids who will carry Leander's body away. To the left Hero searches the water front for her lover, whilst in the right foreground the struggling figure of a lone swimmer suggests Leander's panic and confusion when suddenly cast into darkness.

[Turner (521)]

Patient Griselda [Italian 14th-century literature: Boccaccio, *Decameron*, Day 10, 10th story] Boccaccio's bizzare story of Griselda relates the history of a peasant girl chosen as a bride by Gualtieri, Marquis of Saluzzo. Griselda was subjected to a series of humiliations and cruel hoaxes by Gualtieri in order to prove that she was worthy of her new position.

Concentrating on the three main events in the life of this patient and long-suffering creature, the National Gallery paintings of *Patient Griselda* depict Griselda's initial joy at being raised to the ranks of the nobility as Gualtieri's bride; her public disgrace when banished from court; and finally the moment when she is recognised as the rightful Marchioness of the land.

Boccaccio describes how the Marquis Gualtieri (a pleasure-seeking young man who enjoyed hunting) was reluctant to marry, despite the fact that his subjects were anxious to see him settled. Gualtieri finally agreed to get married but only if he was allowed to choose his own wife. Boccaccio tells us that Gualtieri already had his eye on a beautiful young peasant girl called Griselda. Gualtieri first went to visit Griselda's father to ask permission to

marry his daughter, and then prepared a great wedding feast in her honour.

Gualtieri then rode out to collect his bride, but before leaving her family home Griselda was subjected to her first test. Gualtieri, who had been assured by the girl's father that she would be obedient and acquiescent to all his demands, ordered Griselda to strip in public before putting on the rich clothes he had brought as wedding gifts.

Other tests followed. Not long after the marriage Griselda gave birth to a daughter. Instead of showing joy Gualtieri subjected Griselda to cruel taunts, telling her that she was despised by their servants because of her lowly birth, and because she had only given birth to a female.

Despite the fact that he secretly rejoiced in the birth of his daughter, Gualtieri arranged for a servant to take the child away as if to kill her. Griselda accepted all her husband's taunts about her lowly station in life and even accepted that her child should be taken away from her. But when the servant came to take the child Griselda begged him to show compassion and save her daughter from death by exposure or attack by wild beasts. Boccaccio describes how this was all a cruel hoax. In fact Gualtieri had arranged for the child to be taken in safety to Bologna to be cared for by relatives.

In due course a second child, a boy, was born and the same cruel charade repeated. Once again Griselda calmly agreed that the child should be taken away from her, despite being inwardly in turmoil.

Gualtieri dealt Griselda a final blow by telling her that he no longer wished to live with her and that he had decided to find another wife. He then arranged for fake divorce papers, and with an accompanying sadistic twist sent for their own daughter – by then twelve years old – to play the part of the new wife.

Griselda was sent back to her father in disgrace, after a public humiliation at court. Boccaccio describes how she bit back her tears, handed her wedding ring to Gualtieri and left dressed in an undergarment and without shoes.

All this time, the courtiers – who might otherwise really have complained about Griselda being raised to a position of wealth and power – were filled with admiration and compassion for her.

Griselda was subjected to a final test of endurance when she was brought back to court and ordered to sweep and prepare the chambers for Gualtieri's new bride. In front of the assembled company Gualtieri then asked Griselda what she thought of this marriage. Griselda's reply was that if this was what her lord wished, it could only be good. She asked only that he should not torment his second wife as he had his first, fearing that his new bride was too young and delicate to withstand such cruel treatment. At this Gualtieri turned to Griselda and told her that the moment had come to reward her for her long patience. He explained that he had deliberately tested her in order to teach her how to be a good wife. He had hoped in this way also to demonstrate Griselda's admirable qualities to his courtiers so that they would be willing to accept her as their Marchioness. This had truly been an endurance test demanding much patience.

[Master of the Story of Griselda (912); Master of the Story of Griselda (913); Master of the Story of Griselda (914)]

Pegasus and the Muses [Mythological: Antoninus Liberalis, *Metamorphoses*, 9; Hesiod, *Theogony*, 280–94, 315–25, and *Catalogue of Women and Eoiae*, 7] Pegasus (a great winged horse who sprang together with his brother Chrysaor from the blood of Medusa [*see* Perseus – 2]) was said to have created the fountain of Hippocrene on Mount Helicon with a stamp of his hoof. Helicon was one of the sacred areas where the Muses (goddesses responsible for, and inspiring Art and Learning, Literature, Music and Dance) gathered. They had originally been the nymphs who guarded the Hippocrene spring.

Although one of the earliest Greek poets Hesiod refers to only nine Muses, the National Gallery painting of *Pegasus and the Muses* attributed to Romanino includes over a dozen male and female figures. They seem unaware of the prancing horse in the middle foreground. Yet one group of four figures in the foreground seems very definitely to be singing, whilst another group of five women in the background is dancing around in a circle. These may well be the nine daughters of Pierus whose singing, we are told, made Mount Helicon swell towards the heavens with delight. Pegasus was advised by Poseidon to stop the swelling of the mountain by kicking it with his hoof, whereupon water ran freely from the ground forming the Hippocrene spring, and the mountain settled back into its original shape. [Attr. Romanino (3093)]

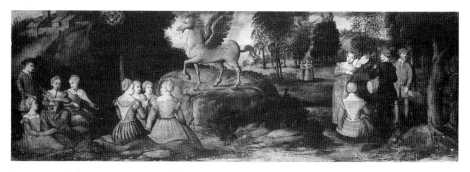

Pegasus and the Muses Attr. Gerolamo Romanino (about 1484/7–1559(?))

Penelope with the Suitors *see* Odyssey – 2
Pentecost *see* Christ: Pentecost
Perseus – 1

Perseus and Andromeda [Mythological: Ovid, *Metamorphoses* IV] Andromeda, the daughter of Cepheus, king of the Ethiopians, was fastened to a rock on the sea shore to be devoured by a savage sea monster that threatened her father's kingdom. Andromeda's mother Cassiopeia had boasted of her daughter's beauty, claiming that she was even more beautiful than the Nereids, the nymphs of the sea. The Nereids complained to the Sea god Poseidon, who duly punished the Ethiopians by sending a monster to ravage the land and finally to threaten Andromeda herself.

Perseus (son of Zeus and Danae) came upon Andromeda and, according to Ovid, would have thought her a statue were it not for the tears that were

trickling down her cheeks, and her hair that was gently stirring in the breeze. He was immediately struck by her beauty and, declaring his love for her, begged her to tell him who she was and why she was chained to the rock.

Ovid describes how Andromeda's natural modesty and shame at being displayed naked and vulnerable in front of Perseus made her at first reluctant to answer. But as Perseus continued to question her, she told him of her mother's boast. At that moment the monstrous sea creature came lurching across the sea towards them. Andromeda and her parents (who were lurking nearby) let out great shrieks, the king and queen beating their breasts in despair over their daughter's fate. But Perseus, listing some of his many virtues and exploits, asked for Andromeda's hand if he could destroy the beast. The despairing parents agreed despite the fact that Andromeda had already been promised to her uncle Phineus, and Perseus prepared to confront the monster.

The National Gallery painting of *Perseus and Andromeda* by a follower of Guido Reni shows Perseus charging towards Andromeda on his winged horse

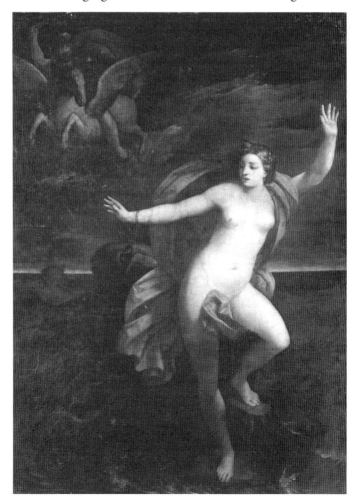

*Perseus and
Andromeda*
After Guido Reni
(1575–1642)

Pegasus [*see* Pegasus and the Muses]. At the same time a huge sea monster rears up from the waters and turns his gaping mouth towards Andromeda. Ovid describes the battle that ensued between Perseus and the sea monster as both bloody and ferocious. Perseus flew high up above the sea so that his shadow was cast on the surface of the water. Then, as the monster attacked the shadow, Perseus came swooping down and buried his sword deep into its shoulder. Ovid describes how Perseus rained down blows on the beast until it belched out water mixed with purple blood. As Perseus finally plunged his sword into the creature's vital parts, great cries of celebration rang out. Andromeda's parents saluted Perseus as their new son-in-law, and Andromeda, freed from her chains, came forward to greet her new love.
[After Reni (87)]

Perseus – 2

Perseus turning Phineas and his Followers to Stone
Phineas and his Followers turned to Stone
[Mythological: Ovid, *Metamorphoses* v]

When Perseus came upon Andromeda chained to a sea rock and left to the mercies of a monstrous sea creature, he was quick to realise the advantages of the situation [*see* Perseus – 1]. Pledging to rescue her if she would subsequently be offered to him in marriage, Perseus swept down into bloody conflict with the monster.

After his victorious conquest Perseus was taken back to the palace for the marriage feast. Ovid describes how a rich banquet was laid out in the great golden palace hall. After the feast there was much talk amongst the guests, Perseus asking about the customs and traditions of their land, and relating in turn some of his own adventures. Perseus described how he had crept up on Medusa by looking into his own shield, thereby avoiding the fate of so many others who had turned to stone after meeting the Gorgon's glance. Perseus told his new friends also how he had beheaded Medusa and how his great winged horse Pegasus had sprung from her blood.

In the midst of the celebrations a great uproar was heard in the royal halls and the wedding feast was suddenly turned into a tumultuous sea of chaos as Phineus, the king's brother, burst in with raised spear. Claiming that Andromeda had been promised to him, Phineus went to hurl his spear at Perseus, but King Cepheus intervened, reminding his brother that he too could have claimed Andromeda when she was chained to the rock. But Phineus was in no mood for discussion. Uncertain whether to aim at Cepheus or Perseus, he hurled his spear in the air missing both but catching one of the assembled company full in the face before it stuck fast in a bench. Then a furious battle broke out. Ovid describes how the floor was wet with blood and bodies in their death throes writhed in agony.

In the end Perseus found himself alone facing Phineus and a thousand followers who were closing in on all sides. Pinning himself against a great column for cover Perseus fought bravely, but was heavily outnumbered. With a great cry of warning to those of his friends who were near to turn their faces away, Perseus raised Medusa's head against his assailants. Thescelus, one of Phineus' men, made mock of this and raised his javelin to aim at Perseus,

but was immediately turned to stone. Another opponent, Ampyx, thrust his sword at Perseus' breast, but as he lunged forward he found his right hand stiffening. Another sprang forward defended by his great shield and hurling abuse, but he too was caught in his tracks, turning into a statue with his mouth still open.

Finally Phineus, seeing his men turned to stone and unable to help, regretted his intervention at the wedding feast. With arms stretched out sideways and head averted, Phineus begged for pardon from Perseus. But Perseus twisted the Gorgon's head so that her gaze should reach Phineus and even as he turned his eyes away he felt his neck stiffening and the tears on his face turning to stone.

In the painting of *Phineas and his Followers turned to Stone* attributed to an anonymous French artist the scene is particularly suggestive of the confused battle at the wedding feast. Although we readily recognise Minerva flying above her half-brother Perseus and Perseus himself brandishing the head of Medusa (and, as the original text relates, standing against a great column in the palace hall), the raging figures all around are less easily distinguishable.

Luca Giordano's painting of *Perseus turning Phineas and his Followers to Stone* is much easier to read. We quite clearly witness the moment when Perseus first lifts Medusa's head since we see Thescelus turned to stone in the act of reaching out to push the Gorgon's head aside. Nileus, with his shield, is

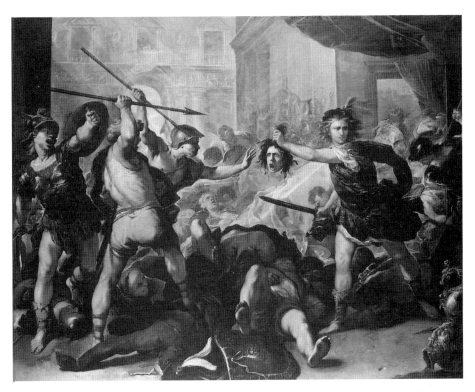

Perseus turning Phineas and his Followers to Stone Luca Giordano (1634–1705)

caught in full flow of abuse as he seeks to charge around the side of Ampyx (shown holding a spear or javelin rather than the sword described by Ovid). All around there is the chaos of the battle. The painting screams with the piteous moans of the wounded and the hysterical shrieking of King Cepheus and Queen Cassiopeia as they hover in the background, uncertain whether to flee, or to stand in more heroic mode as Ovid describes them: 'On his side his father-in-law with useless loyalty and his bride and her mother range themselves, and fill all the hall with their shrieks.'

[French School (83); Giordano (6487)]

Perseus and Andromeda *see* Perseus – 1
Perseus turning Phineas and his Followers to Stone *see* Perseus – 2
Pharaoh with his Butler and Baker *see* Joseph – 2
Phineas and his Followers turned to Stone *see* Perseus – 2
Pietà *see* Christ: Death – 3
Pietà with Two Angels *see* Christ: Death – 3
Plague at Ashdod *see* Ark of the Covenant – 1
Pope accords Recognition to the Franciscan Order *see* St Francis
Preaching of St John the Baptist *see* St John the Baptist – 2
Presentation of Jesus in the Temple *see* Christ: Childhod – 4
Presentation in the Temple *see* Christ: Childhood – 4
Presentation of the Virgin *see* Virgin Mary: Birth
Procession to Calvary *see* Christ: Passion – 10
Procession of the Trojan Horse into Troy *see* Troy – 2
Psyche – 1

Psyche outside the Palace of Cupid (also known as *The Enchanted Castle*) [Mythological: Apuleius, *The Golden Ass*, Cupid and Psyche i] The Roman writer Apuleius tells the story of Psyche who was so beautiful that people began worshipping her instead of Venus. Venus, affronted by this, plotted an unpleasant punishment for Psyche. She called her mischievous son Cupid to her, and 'implored him to use his dear little arrows and sweet torch of flames' against Psyche to make her fall in love with a most unsuitable man. Psyche did indeed form a curious alliance – with Venus' own son. Although Cupid agreed to carry out his mother's orders, he fell in love with Psyche himself and took her to live with him in his enchanted castle.

Apuleius relates how the ancient oracle of Apollo prophesied that Psyche would marry a 'dire mischief, viperous and fierce' and her parents, hoping to save her from such a fate, took her up to the top of a high mountain crag and abandoned her there. But when Psyche was alone a wind blew up, lifted her off her feet, and transported her gently down into the valley below where she fell asleep on a soft bed of turf. When she woke she began to explore her new surroundings, first walking towards some tall trees and then along beside a clear stream until she came across a magnificent royal palace in the middle of the wood.

Claude's painting of *Psyche outside the Palace of Cupid* shows Psyche coming out of a clearing in the woods and resting on the ground as she contemplates a magical building rearing up against the evening sky. Apuleius describes how Psyche thinks the palace is so magnificent it must have been

built by a god. It was indeed the work of a god. This was the palace of Cupid. We learn later how Psyche meets Cupid and goes to live with him in his enchanted castle [see Psyche – 2].

[Claude (6471)]

Psyche – 2

Psyche showing her Sisters her Gifts from Cupid [Mythological: Apuleius, *The Golden Ass*, Cupid and Psyche I; Cupid and Psyche II] According to Apuleius, when Venus enlisted the aid of Cupid to plot the downfall of Psyche, her mischievous son fell in love with Psyche himself [see Psyche – 1].

Psyche's delight in her husband (whom she knew only by touch and hearing) was marred only by a longing to see and talk with her sisters. When Cupid told her how her family were grieving for her, believing that she was dead, Psyche wept and pleaded with her husband, swearing that she would die unless she could see and comfort her sisters. Apuleius describes how Cupid finally gave in, delighted by the way in which Psyche whispered loving words into his ears and twined her arms and legs around him. He even suggested that she should give her sisters some of his jewellery as welcome presents.

Cupid agreed that Psyche's sisters should be transported to the enchanted castle by the same wind that brought Psyche to him. But he warned her that her sisters were evil women, and that they would try to force her to discover what he looked like. Cupid told Psyche that if she listened to her sisters she would never lie in his arms again. In Apuleius' tale of *The Golden Ass* we read how the sisters did indeed persuade Psyche to discover what her husband looked like, and how the lovers were parted but finally reunited through the intervention of Venus.

When the sisters first met, they were filled with rapturous joy. Psyche showed them round the palace, ordered a wonderful bath for them and treated them to a magnificent feast. When questioned about her mysterious husband by her sisters (who by now had become somewhat envious), Psyche tried to conceal the fact that she did not actually know who her husband was or what he looked like. Under persistent questioning Psyche became confused and worried and after loading her sisters with jewelled pins, rings and necklaces, she called up the West Wind and ordered him to take them away as soon as possible.

Fragonard's painting of *Psyche showing her Sisters her Gifts from Cupid* shows a relaxed Psyche demonstrating her wealth and good fortune to her sisters. As yet the sisters seem not to have been offered their going-away presents. Indeed, they seem delighted at this stage to survey Psyche's richly clothed attendants, and to review her gifts. But in the background we notice a figure emerging from the clouds and although it is tempting to identify this as the distressed figure of Cupid, wary of his young wife's tongue, it seems more likely that it represents one of the Furies intent on whipping up discord. Even as we watch the seeds of envy are being planted in the sisters' minds.

[Fragonard (6445)]

Psyche showing her Sisters her Gifts from Cupid Jean-Honoré Fragonard (1732–1806)

Psyche outside the Palace of Cupid (also known as *The Enchanted Castle*) *see* Psyche – 1

Psyche showing her Sisters her Gifts from Cupid *see* Psyche – 2

Purification of the Temple *see* Christ: Ministry – 10

Queen of Sheba

Embarkation of the Queen of Sheba, Seaport with Solomon and the Queen of Sheba

[Biblical: I Kings 10. 1–2]

The Book of Kings tells us that the Queen of Sheba went to Jerusalem with a great train of camels, spices, gold and precious stones to visit King Solomon. The queen had heard of Solomon's fame 'concerning the name of the Lord', and went, we are told, to test Solomon with difficult questions.

Claude's *Seaport with Embarkation of the Queen of Sheba* shows Sheba about to embark, although whether on her way to visit Solomon, or homeward bound, is not entirely clear. The Book of Kings tells us that Solomon gave Sheba 'all her desire' as well as a portion of his royal bounty. We learn that Sheba, having received these gifts, 'turned and went to her own country, she and her servants'.

The Bible does not tell us whether the queen travelled by land or sea; nor is it specific about the origins of this royal person. However, as early as the first

century AD it was argued that Sheba came from Africa. More recently she has
been traced to Arabia (now the Yemen).

Claude presumably adhered to the notion, popular right through to the
Middle Ages, that Sheba was an African queen. The position of the sun,
which appears to be rising, would suggest that the queen is bound eastward.
(Claude certainly favoured the rising sun for beginnings.) The baggage being
loaded into boats and the gold vessels waiting on the quayside also make it
more likely that the queen has yet to meet Solomon. There is an air of
preparation and bustle suggestive of the beginning of an important journey,
rather than the more formal ceremony which would attend the departure of
the queen after her meeting with Solomon. People crane forward from
windows and congregate along the quayside, as if anticipating the moment of
departure with rising excitement, rather than being officially gathered
together to bid farewell to an eminent guest.

It is significant, yet entirely characteristic of Claude, that the buildings
depicted – whether suggesting Old Testament Jerusalem, the exotic Yemen to
the south, or the even less familiar Africa to the west – are constructed in the
style of classical Rome. Claude may well have considered compass directions
when depicting the sun casting its first rays over the seaport, but when it
came to architectural details, he adopted a fixed style irrespective of context.

For Claude, the classical style was the only one worthy of consideration. It
is interesting to note the connections between Claude's architecture and that

Seaport with Embarkation of the Queen of Sheba Claude Lorraine (1604/5(?)–82)

depicted in the sixteenth-century Venetian School painting of *Solomon and the Queen of Sheba*. In the background we see Sheba's boats drawn up against the classical porticoes and courtyards of a complex palace structure. There are echoes of this (although seen from an opposite viewpoint) in the painting produced by Claude a century later.

[Claude (14); Venetian School (3107)]

Raising of Lazarus *see* Christ: Ministry – 12

Rape of Europa [Mythological: Ovid, *Metamorphoses* II] When Europa (daughter of the king of Tyre) came across a beautiful bull amongst a herd of cows, she was so enchanted by his mild manner and skittish games that she climbed on his back for a ride. Little did she suspect that this mild mannered beast was the god Jupiter in disguise.

Ovid describes how Europa was at first frightened of this beautiful beast, but gradually plucked up courage to come near and hold out some flowers to his snow-white lips. Jupiter in turn kissed her hands and frisked around on the grass before lying down on the yellow sand. He then offered his chest to be stroked, and his horns to be garlanded with flowers. With the princess finally upon his back Jupiter gradually edged his way down towards the water's edge. Before Europa could escape the bull swam out into the deep water of the open sea.

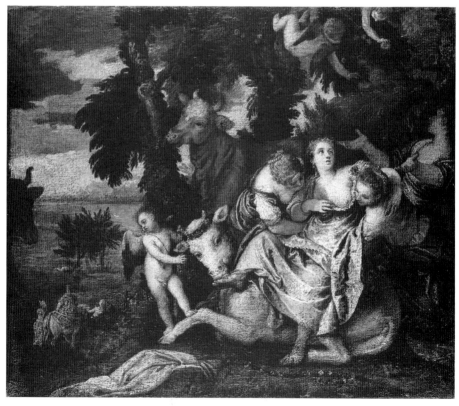

The Rape of Europa After Paolo Veronese (1528(?)–88)

Ovid describes how the princess clung with one hand to a horn and with the other to Jupiter's flanks, looking back in fear to the sea shore, her garments streaming out behind her. Jupiter carried Europa away across the sea to Crete and there, assuming his normal form, raped her. Europa subsequently gave birth to Minos, who became king of Crete.

The National Gallery painting of *The Rape of Europa* by a follower of Veronese shows Europa being helped on to the bull's back. He, garlanded and mild, licks her foot, whilst a little cupid figure standing by his head seems to gesture down towards the sea shore. In the lower left-hand corner we see Europa on the bull's back whilst two female companions walk along beside them. The same little cupid is heading them towards the edge of the water over which Europa will be transported with such fear.

[After Veronese (97)]

Rape of Ganymede [Mythological: Ovid, *Metamorphoses* x; Hesiod, *The Homeric Hymns and Homerica* v, To Aphrodite, 199–226] The great god Jupiter did not only transform himself in the pursuit of female flesh. Both Ovid and Homer describe how Jupiter was so taken with the beautiful Trojan boy Ganymede that he changed himself into a great eagle, swooped down upon the unsuspecting shepherd boy and carried him away to the Olympic heights where he lavished love on him and made him his chief cup-bearer.

Ovid gives this particular peccadillo short coverage, describing the rape of Ganymede in only a few lines. There is no lingering over the physical attractions of Ganymede or the youth's emotional reaction to the god's attentions. This coupling was nevertheless regarded both in ancient Greek times and at later periods as an ideal and respectable image of homosexual love.

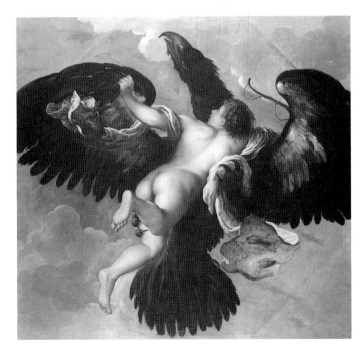

The Rape of Ganymede
Attr. Damiano Mazza (active 1573)

The painting of *The Rape of Ganymede* ascribed to Mazza shows a startled Ganymede straddled across the belly of a great eagle who rears his neck and beak awkwardly as if to transport his burden ever higher into the heavens. One great talon twists round to clutch the youth's thigh, whilst another clasps the drapery fluttering from his shoulders, as if to suggest a human embrace. [Attr. Mazza (32)]

Rape of the Sabines (After the Signal) *see* Sabines
Rape of the Sabines (Before the Signal) *see* Sabines
Rape of the Sabine Women *see* Sabines
Rape of Tamar by Amnon [Biblical: II Samuel 13. 1–14] The story of Tamar and Amnon concerns the incestuous relationship between a brother and a sister. According to the Bible Amnon loved his sister Tamar, but was frightened to take any action because Tamar was still a virgin. We learn how Amnon's cousin Jonadab suggested that he should make himself sick and beg his father, King David, to let Tamar look after him.

When David came to visit his sick son, Amnon asked that Tamar should be allowed to come and cook for him. The Bible describes how David agreed and how Tamar, having baked some cakes, was lured by Amnon into his bedchamber where he begged her to make love to him. Tamar rejected her brother's advances, protesting that he should not force her and that this was

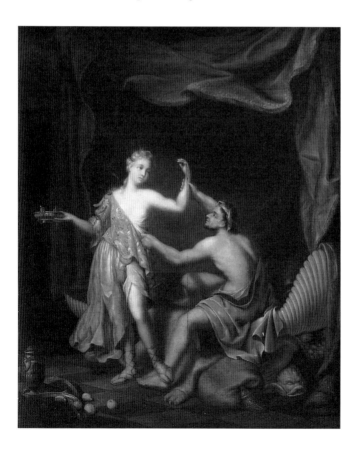

The Rape of Tamar by Amnon
Philip van Santvoort
(active from about 1718)

not the way to go about things. She suggested that Amnon should talk with their father, adding that she was sure David would not keep them apart. But Amnon was impatient and forced himself upon his reluctant sister.

Tamar's resistance no doubt contributed to the great hatred and contempt Amnon subsequently felt for her. We read how Amnon called his servant and gave him instructions to eject Tamar and bolt the door after her. Tamar, who had arrived dressed as was the custom in the multicoloured garment of a virginal princess, covered her head with ashes and tore her dress in despair.

Philip van Santvoort's *The Rape of Tamar by Amnon* draws attention both to Tamar's cooking and to her brother's lust. The Bible suggests that Tamar would have been quite happy to love Amnon, so long as the appropriate procedures were observed. In Santvoort's painting Amnon reaches forward to grasp his sister's unresisting arm with one hand, whilst attempting to disrobe her with the other. We are aware that Tamar is not entirely negative in her own feelings towards her brother. She neither drops the plate of cakes she is holding, nor kicks her brother away with the foot which is so strategically positioned behind his left ankle. Instead, she seems to pause with a slight smile on her face, and assume the graceful and pliant pose of a dancer. [Santvoort (3403)]

Rebecca at the Well *see* Isaac and Rebecca

Rebekah and Eliezer at the Well *see* Isaac and Rebecca

Reconciliation of Romans and Sabines *see* Sabines

Rest on the Flight into Egypt *see* Christ: Childhood – 6

Resurrection of Christ *see* Christ: Resurrection – 1

Return of the Ark *see* Ark of the Covenant – 2

Rich Man being led to Hell *see* Dives

Rinaldo

Carlo and Ubaldo see Rinaldo conquered by Love for Armida
Rinaldo turning in Shame from the Magic Shield
[Italian 16th-century literature: Tasso, *Gerusalemme Liberata*, 1574, canto XVI, stanzas 17–23 and 30]

Surrounded by the cupids of love Rinaldo lies enamoured in the lap of Armida, the beautiful and wily young witch enlisted by the Saracens in their fight against the Christians. In Tasso's *Gerusalemme Liberata* we learn how the Saracens ask Satan for help when threatened by the armies of the West at the time of the First Crusade. Satan's advice is that Armida should ensnare and slay the young Christian leader Rinaldo. But Satan's plan is thwarted when Armida falls in love with Rinaldo. Armida, charmed by Rinaldo's beauty, whisks him away to her enchanted palace where they while away the hours in each others' arms. Tasso describes how Rinaldo gazes deeply into Armida's eyes whilst at the same time holding up a mirror so that she can in turn see her own image transformed by her love for him.

In Van Dyck's painting of *Carlo and Ubaldo see Rinaldo conquered by Love for Armida* we see Carlo and Ubaldo (two knights who come in search of Rinaldo) peering over a background tree at the two lovers. Armida seems preoccupied by the frolicking cupids, one of whom holds up a mirror. Rinaldo on the other hand is totally enthralled with his lover.

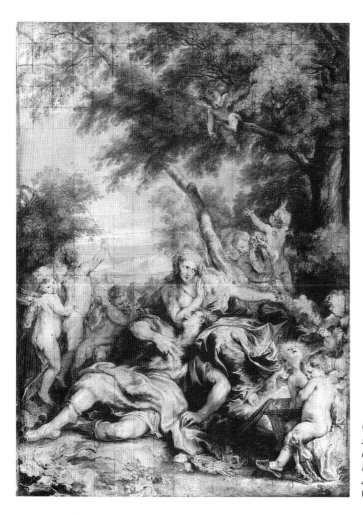

*Carlo and Ubaldo
see Rinaldo
conquered
by Love for Armida*
Antony van Dyck
(1599–1641)

Rinaldo's moment of shame is depicted in the Giovanni Battista Tiepolo painting of *Rinaldo turning in Shame from the Magic Shield,* where we see him casting aside the garland of flowers he accepted so carelessly under the magic seduction of Armida. In the clear light of the day Rinaldo realises that the reflection in the gleaming and magic shield held up to him by Ubaldo reveals his betrayal of the Christian cause. At this moment Rinaldo understands that Armida has bewitched him. Rinaldo's backward glance and raised arm suggest that he does not like what he sees in the mirror. Yet the limp right arm and languid positioning of the lower part of his body suggest also that he is reluctant to give up his love. Tasso resolves this conflict by having Rinaldo return to Armida, swearing eternal love. Armida for her part swears undying affection for Rinaldo and converts to Christianity.

[Van Dyck (877B); Giovanni Battista Tiepolo (6303)]

Rinaldo turning in Shame from the Magic Shield *see* Rinaldo
Sabines
Rape of the Sabine Women

Rape of the Sabines (Before the Signal)
Rape of the Sabines (After the Signal)
Reconciliation of Romans and Sabines
[Ancient history: Livy, *History of Rome*, 1:9; Plutarch, *Lives*, 2:14]
When Romulus established Rome, probably some time during the eighth century BC, he went to great lengths to promote the growth of the city by inviting all and sundry to come and settle there. When he realised there was a disparity in numbers between the male and female settlers he set about acquiring some more women by inviting the neighbouring tribe of the Sabines to come and watch the chariot races in honour of Consus, god of the Harvest and Autumn Sowing. Romulus expressly invited the Sabines to bring their women and children with them. Whilst they were watching the games Romulus ordered the Romans to carry off all the Sabine women. Domenico Morone's paintings of *The Rape of the Sabines (Before the Signal)* and *The Rape of the Sabines (After the Signal)* show the Sabine women watching the games before Romulus' signal and their abduction immediately after.

According to Plutarch only unmarried Sabine maidens were plucked from the crowd, but both the Italian School painting of *The Rape of the Sabine Women* and Rubens' painting of the same scene suggest that little discrimination was made by the rapacious Romans. Romulus watches impassively as mothers and maidens alike are torn from their children and family embraces, before being dragged away against the festive background of the Consualia games. This treachery led to war between the Sabines and Romans, a conflict which was finally only resolved by the original victims.

The Italian School painting of *The Reconciliation of Romans and Sabines* shows how the enslaved Sabine women brought about a reconciliation between both sides. The two tribes are said thereafter to have buried their differences and to have lived happily together. This tradition fits well with Plutarch's explanation of the motives behind the original rape. Plutarch, a moral philosopher of the first century AD, maintained that the Romans

Top: *The Rape of the Sabine Women*
Bottom: *The Reconciliation of Romans and Sabines* Italian School (16th century)

wanted only to bind themselves to the Sabines by the surest possible means in order to form a strong alliance.

[Italian School (644A); Italian School (644B); Domenico Morone (1211); Domenico Morone (1212); Rubens (38)]

Sacrifice of Isaac *see* Abraham

St Anthony Abbot

Christ appearing to St Anthony Abbot during his Temptation
Temptation of St Anthony
[Christian writings: St Athanasius, *Life of St Anthony*]

According to his fourth-century friend and biographer St Athanasius, the hermit saint Anthony spent the last part of his life in a cave near the Red Sea. He was visited there both by the faithful and by those who were curious to see how he lived. According to tradition St Anthony was also visited by demons in the form of wild beasts who were intent on tempting him to break his austere and chaste existence.

Christ appearing to St Anthony Abbot during his Temptation
Annibale Carracci (1560–1609)

Annibale Carracci's painting of *Christ appearing to St Anthony Abbot during his Temptation* shows St Anthony surrounded by all manner of beast, animal, human and hybrid. Yet the saint seems unaware of these threatening creatures, and, lifting his eyes from his sacred text, contemplates a vision of Christ being transported by angels across the sky. His tormentors fall back in anguish and fear. It is significant that St Anthony is shown witnessing Christ as opposed to God the Father. Both St Anthony and St Athanasius campaigned strongly against the Arian heresy which maintained that Christ was an instrument created by the Father, having dignity and godliness bestowed on him by God the Father, rather than having divine equality as an essential part of the Trinity.

[Annibale Carracci (198); Savery (L130)]

St Anthony of Padua

St Anthony of Padua(?) distributing Bread
St Anthony of Padua miraculously restores the Foot of a Self-Mutilated Man
St Anthony of Padua with the Infant Christ

[Legends of the Saints: P.Y. Marti, *De Fontibus vitae S. Antonii Patavani*]

St Anthony of Padua was born in Portugal at the end of the twelfth century, and died near Padua in 1231. His desire for missionary work led him to join the Franciscan order. But although he spent some time trying to convert Moslems in Morocco, illness forced him to return to Europe, and he spent the last years of his life in Italy. St Anthony was renowned for his eloquent and learned sermons. But he was also said to have performed many miracles. Certainly his shrine at Padua became a major pilgrimage site.

Willem van Herp the Elder's *St Anthony of Padua(?) distributing Bread* shows a Franciscan friar (whose head and face radiate light) standing with other members of the same order on the steps of a church or monastery. The friars are handing out loaves of bread to a group of men, women and children which has gathered in front of the building. Some of the figures in the lower right-hand corner are identifiable as pilgrims. They are being guided towards the saint by a small child.

Luca Giordano's painting of *St Anthony of Padua miraculously restores the Foot of a Self-Mutilated Man* depicts the miracle wrought by the saint on the leg of a son who had kicked his mother, and cut off his own foot in remorse. St Anthony had ordered the amputation, suggesting that it was a fitting punishment for the son's disrespect. He subsequently made the man whole again.

Giuseppe Bazzani's painting of *St Anthony of Padua with the Infant Christ* on the other hand reflects the legend that St Anthony had a vision of the Christ child when preaching about the Incarnation. The saint stands with outstretched arms, as if in the middle of some discussion. Unsupported by the saint, a nude child reaches forward across his chest to embrace him, one hand resting on the saint's shoulder and the other stretching out as if to hold on to his arm. St Anthony seems barely aware of the Christ child, yet the gesture of his hands and body suggest that he is about to turn and clasp the child to him.

[Bazzani (3663); Giordano (1844); van Herp the Elder (203)]

St Anthony of Padua(?) distributing Bread *see* St Anthony
St Anthony of Padua with the Infant Christ *see* St Anthony
St Anthony of Padua miraculously restores the Foot of a Self-Mutilated Man *see* St Anthony
St Augustine – 1
Fantastic Ruins with St Augustine and the Child
St Augustine with the Holy Family and St Catherine of Alexandria (also known as *The Vision of St Augustine*)
Appearance of St Jerome with St John the Baptist to St Augustine
[Italian 13th-century literature: Jacopo da Voragine, *The Golden Legend*; Christian writings: Petrus de Natalibus, *Catalogus Sanctorum*]
The fourth-century St Augustine of Hippo spent the early part of his life womanising and following radical sects such as the Mani (also often referred to as Manichaeists), much to the despair of his Christian mother, Monica. However, when he was in his early thirties, he went to Milan and came under the influence of St Ambrose. A short while later he converted to Christianity.

According to fifteenth-century legends of the lives of the saints, Augustine was once walking along the seashore when he came upon a child who was trying to fill a hole in the sand with sea water scooped up in a small shell. Seeing the futility of this, he told the child that he would never succeed in his task. The infant's response – which revealed that he was none other than the Christ child, since he could look into the other's mind – was that his task was

Fantastic Ruins with St Augustine and the Child François de Nomé (1593–after 1644(?))

no less futile than St Augustine's own meditations on the infinite mysteries of the Trinity.

De Nomé's *Fantastic Ruins with St Augustine and the Child* shows the saint walking along a sea shore with a bizarre architectural backdrop. His body seems small and vulnerable against the huge buildings, contributing to our sense of his isolation.

Garofalo's painting of *St Augustine with the Holy Family and St Catherine of Alexandria* by comparison shows the saint comfortably seated at his studies, and looking up, as if only momentarily distracted by the child to the left. The painting has a curious timeless quality almost as if it were a vision rather than an actual happening. This sensation is heightened by the accompanying figures of St Catherine of Alexandria and St Stephen and the Virgin and Child group surrounded by an angelic host. St Augustine did in fact have a number of visions. In one St Jerome and St John the Baptist appeared to him simultaneously. But in Botticini's predella panel of *The Appearance of St Jerome with St John the Baptist to St Augustine* the figure of St Augustine is only momentarily distracted by the crowded aureole of light in the sky.

[Botticini (predella) (227); Garofalo (81); de Nomé (3811)]

*Sts Augustine
and Monica*
Ary Scheffer
(1795–1858)

St Augustine – 2

Sts Augustine and Monica [Christian writings: St Augustine, *Confessions* IX, chapter 10] According to St Augustine's *Confessions*, he discussed the Kingdom of Heaven with his mother shortly before her death at Ostia in 387. St Monica played a great part in the religious education of her son. She even followed him from Africa to Italy, where she witnessed his conversion.

After St Augustine's baptism, they decided to return to Africa. Augustine recalls in his *Confessions* how it was at the port of Ostia on the Tiber that he discussed the concept of everlasting life for the blessed. Several days later Monica fell ill and died in Italy without seeing her homeland again.

Ary Scheffer's painting of *Sts Augustine and Monica* suggests a close mother and son relationship, although we know that this was sorely tested as a result of their very different attitudes to faith. Even after his conversion Augustine continued to question and wrestle with the problems of the Christian faith. Monica's faith on the other hand was based on a firm and unquestioning conviction. This essential difference between the two is suggested in the National Gallery painting where St Augustine's pose of active consideration is set against that of radiant acceptance on the part of his mother.
[Scheffer (1170)]

St Augustine with the Holy Family and St Catherine of Alexandria (also known as *The Vision of St Augustine*) *see* St Augustine – 1

St Bavo about to receive the Monastic Habit at Ghent [Legends of the Saints: J. Molanus, *Indiculus Sanctorium Belgii*, Louvain 1573] The National Gallery painting of *St Bavo about to receive the Monastic Habit at Ghent* by Rubens depicts a number of people and scenes associated with the life of the seventh-century St Bavo against the background of a church structure which has been identified as St Peter's at Ghent. Bavo is shown in the central panel presenting himself in splendid armour and cloak to two bishop figures identifiable as the saints Amand and Floribert.

Bavo was a wealthy Flemish landowner who decided to join the Benedictine order after the death of his wife. Bavo distributed his wealth among the poor and presented himself to Bishop Amand for instruction in the faith. At the bottom of the steps in Rubens' painting and curling round to the left we see the poor, lame and sick receiving Bavo's money.

Bavo's daughter Agletrude also converted to a saintly life and is probably one of the three female figures depicted on the left wing. The other two have been identified as the sisters Gertrude and Begga who became involved in missionary work in the monastery founded by their mother at Itta. Gertrude was particularly impressed by Bavo's conversion and actions. Gertrude is traditionally identified by a shepherd's staff with a mouse running up it. Although this is lacking in Rubens' painting, it seems likely that the figure on the far left is Gertrude, since she seems transported into a higher dimension of faith in witnessing the moment of Bavo's rejection of his worldly life.

In the right-hand wing of the painting we see a herald who brings a command from the Emperor Mauritius to the kings Clothar and Dagobert that Bavo should not enter the religious order. The fact that Bavo is shown in the garb of a soldier of some distinction suggests that the imperial reluctance

St Bavo about to receive the Monastic Habit at Ghent Peter Paul Rubens (1577–1640)

to see him change into a monk stems from the realisation that the emperor will thereby lose a good fighting man. There may also be a reflection here of St Amand's own clashes with King Dagobert over the use of force in converting the people of Flanders. St Bavo's exchange of armour for the Benedictine habit held by a cleric at Amand's side would thus have been particularly gratifying.
[Rubens (57)]

St Benedict
Incidents in the Life of St Benedict
St Benedict admitting Sts Maurus and Placidus into the Benedictine Order
St Benedict in the Sacro Speco at Subiaco
St Benedict tempted in the Sacro Speco at Subiaco
Death of St Benedict
[Legends of the Saints; Italian 13th-century literature: Jacopo da Voragine, *The Golden Legend;* Christian writings: St Gregory the Great, *Dialogues*]
After rejecting the licentious lifestyle of late fifth-century Rome Benedict retired from the world to live in a cave at Subiaco. Margarito's scene of *St Benedict tempted in the Sacro Speco at Subiaco* shows the saint casting himself on thorns in order to mortify his flesh whilst the painting of *St Benedict in the Sacro Speco at Subiaco* by Lorenzo Monaco shows a fellow hermit St Romulus lowering a basket of food down to the cave in which St Benedict lived. Two Roman youths, Maurus and Placidus, were sent to be instructed in religious matters in the community which grew up round Benedict at Subiaco. This episode is shown in Lorenzo Monaco's *St Benedict admitting Sts Maurus and Placidus into the Benedictine Order.*

Incidents in the Life of St Benedict Lorenzo Monaco (before 1372–1422 or later)

Benedict subsequently founded the great Benedictine order at Monte Cassino and devised his Rule for a new reformed monastic order. As well as advocating poverty, chastity and obedience, the Rule required that monks should involve themselves in manual labour, although, in Benedict's own words, 'nothing too harsh or rigorous'. According to tradition Benedict performed many miracles in which he saved lives and cured those possessed of evil spirits. The painting of *Incidents in the Life of St Benedict* by Lorenzo Monaco shows Benedict warning Maurus that Placidus is in danger of drowning. Maurus is shown saving his friend by walking on the water and pulling him out by his tonsured hair, whilst to the right Benedict is shown visiting his saintly sister Scholastica.

The Legends of the Saints describe how when St Benedict was dying he was carried into the community's chapel, where he took communion and then died, standing up in the arms of his disciples. However, Lorenzo Monaco's predella panel representing *The Death of St Benedict* shows the saint already dead and laid out on a bier.

[Margarito (side scene) (564); Lorenzo Monaco (2862); Lorenzo Monaco (4062); attr. Lorenzo Monaco (5224); Lorenzo Monaco (L2)]

St Benedict admitting Sts Maurus and Placidus into the Benedictine Order *see* St Benedict

St Benedict in the Sacro Speco at Subiaco *see* St Benedict

St Benedict tempted in the Sacro Speco at Subiaco *see* St Benedict

St Bernard's Vision of the Virgin [Legends of the Saints; *Liber de Passione Christi et doloribus et planctibus matris ejus*] The twelfth-century St Bernard of Clairvaux was the founder of the Cistercian order. Bernard argued for simplicity and poverty in monastic life. As Filippo Lippi's painting *St Bernard's Vision of the Virgin* suggests the saint was a prolific writer.

According to tradition his faith was also tinged with mysticism. St Bernard

St Bernard's Vision of the Virgin Fra Filippo Lippi (about 1406(?)–69)

is said to have had a vision of the Virgin (to whom he was particularly devoted) in which she offered him milk from her breast, thus revealing herself as the mother of mankind as well as of the Christ child. Lippi's Virgin holds up her hand towards Bernard as if engaged in conversation with him, whilst the surrounding angels gather up her robes as if physically transporting her to this earthly place. The Christ child is not included in the composition, suggesting that Mary is in this instance presented to the saint in the guise of uncorrupted virgin mother.

[Filippo Lippi (248)]

St Catherine

Decapitation of St Catherine
Mystic Marriage of St Catherine of Alexandria
Virgin and Child with Saints Catherine of Alexandria and Siena

[Legends of the Saints; Italian 13th-century literature: Jacopo da Voragine, *The Golden Legend*]

St Catherine of Alexandria is thought to have lived in the fourth century, although very little is known about her life. According to the thirteenth-century *Golden Legend*, Catherine was of royal birth, and converted to Christianity during the age of the Emperor Maxentius. We are told that

Maxentius desired Catherine, but that she spurned his advances. He therefore ordered that she should be martyred on a wheel studded with spikes. For this reason the saint (as in the Parmigianino painting of *The Mystic Marriage of St Catherine of Alexandria*) is often shown attached to, or holding, a wheel. According to legend a miraculous bolt of thunder destroyed the wheel before Catherine was torn to shreds on it. The emperor subsequently ordered that she should be beheaded. This episode is shown in Margarito's painting of *The Decapitation of St Catherine*.

Some texts describe how Catherine was given an image of the Virgin and Child in front of which to make her devotions. We learn that the Christ child first turned towards Catherine, and finally placed a ring on her finger, symbolising their union in faith. In Parmigianino's painting we witness the mystic marriage between Christ and Catherine which takes place in the Virgin Mary's chamber. The two figures in the background are possibly the Virgin's own parents, Joachim and Anna. The elderly man looking back at the scene from the lower left-hand corner may be Joseph.

We see the whole figure of Joseph in the left background of the Portuguese

The Mystic Marriage of St Catherine
Francesco Parmigianino (1503–40)

School depiction of *The Mystic Marriage of St Catherine of Alexandria*. In this painting we also see a number of angels floating behind the trellis of the *hortus conclusus* (enclosed garden), as well as an extra female figure to the right who has been identified as Mary Magdalene. Although we sense that these are real people involved in specific actions in particular places, it seems clear that the original union took place between Catherine and a painted image of the Christ child.

[Bergognone (298); Margarito (side scene) (564); Parmigianino (6427); Portuguese School (5594)]

St Christopher carrying the Infant Christ [Legends of the Saints; Italian 13th-century literature: Jacopo da Voragine, *The Golden Legend*] By tradition the third-century St Christopher was a man of huge stature who retired from the world to live by a ford where he earned money by carrying travellers across the waters. The name Christophoros in Greek means 'one who carries Christ'.

According to *The Golden Legend* Christopher first served a mighty king who claimed to be the strongest king in the land. But Christopher left the king's service in search of a more powerful master, when he discovered that he cringed at the mention of the devil. Meeting the devil (disguised as a soldier and with a band of ferocious followers), Christopher embarked on a new period of service. But when they came upon a cross set up by the roadside, the devil insisted on making a diversion so that he should not have to confront the holy sign, showing that he also had his weaknesses.

When the devil admitted that he was frightened of crosses because they reminded him of the man named Christ, Christopher decided to go in search of this person who was more powerful than both the devil and the king. Christopher searched in vain, until one day he came across a hermit who advised him to serve Christ by helping travellers across the wide waters of a river.

Christopher settled at the edge of the river and made a great stave to help him wade across from side to side. One day when he was resting he heard a voice calling for help. Finding a child outside, Christopher lifted his small passenger on to his shoulders, took up his stave and started to cross the river. But he found the child so heavy that he began to give way at the knees, and feared that he would drown in the rising waters. Reaching the other side, and exhausted by his efforts, Christopher turned to the child saying that he felt as if he had been carrying the weight of the world on his shoulders. At this the child revealed himself as Christ and explained to Christopher that he should not be surprised by his apparent weakness, since he had not only been carrying the world upon his shoulders but also its creator. The child told Christopher that he should dig his stave into the ground on reaching the other side of the river, and that on the following morning he would find that it had flowered, thus proving the truth of his words.

The German School painting of *St Christopher carrying the Infant Christ* shows Christopher about to lift the Christ child upon his shoulders against a background of the river and a number of scenes associated with the saint's life.

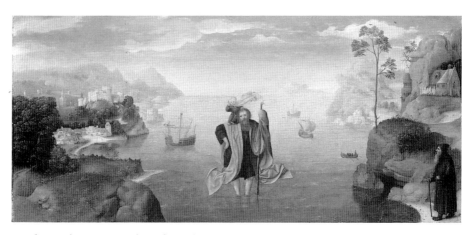

St Christopher carrying the Infant Christ Attr. studio of the Master of the Female Half-Lengths (active second quarter of 16th century)

The painting in the style of the studio of the Master of the Female Half-Lengths, on the other hand, shows the saint half-way across the river carrying his precious burden. On the right-hand bank we note the diminutive figure of the hermit. This reminds us not only of St Christopher's huge stature, but also of his search for the most powerful prince in the world. In neither painting is there any sense of the agonies Christopher suffered when he carried the child across the river.

[German School(?) (2156); attr. studio of the Master of the Female Half-Lengths (716)]

St Dorothy and the Infant Christ [Legends of the Saints; Italian 13th-century literature: Jacopo da Voragine, *The Golden Legend*] The virgin martyr Dorothy is sometimes also referred to as Dorothea. The martyrdom of St Dorothy (who is thought to have been one of the many Christians persecuted in the reign of the fourth-century Emperor Diocletian) is described in *The Golden Legend.* On her way to execution, one of the onlookers in the crowd (a lawyer named Theophilus) mocked her, asking her to send him some flowers and fruit from the garden in heaven. The same Theophilus is said to have been converted when a child (in fact the infant Christ) visited him afterwards with a basket of roses and apples.

There is no reference to the crowd scene in Francesco di Giorgio's painting of *St Dorothy and the Infant Christ,* but the saint is shown holding the hand of a haloed child who in turn holds a basket of roses. These flowers were often used by artists to identify St Dorothy, and according to some versions of the legend, the Christ child did indeed appear to St Dorothy shortly after her encounter with Theophilus. The saint is said to have told the child to take the basket of roses and apples to the unbeliever.

[Francesco di Giorgio (1682)]

St Francis

St Francis giving away his Clothes and St Francis dreaming
St Francis renounces his Earthly Father

St Francis bears Witness to the Christian Faith before the Sultan
Funeral of St Francis and the Verification of the Stigmata
Legend of the Wolf of Gubbio
Pope accords Recognition to the Franciscan Order
Stigmatisation of St Francis and the Verification of the Stigmata
[Legends of the Saints: *Little Flowers of St Francis*; *Life of St Francis*; St
Bonaventura, *Legenda Maior*; Italian 13th-century literature: Jacopo da
Voragine, *The Golden Legend*]
St Francis of Assisi founded the Order of the Frati Minori (Friars Minor) in
the early years of the thirteenth century. Francis, who was baptised as
Giovanni Bernadone, was born into a wealthy Assisi family, and as a youth
helped his father with his wool and cloth trade. Jacopo da Voragine claimed a
number of reasons for the changing of the young Giovanni's name to
Francesco, one of them being the miraculous gift from God of being able to
speak French. This was perhaps not so surprising since Francis' mother was a
Frenchwoman.

Images of the young saint often bear witness to the family business in the
depiction of a costly piece of cloth being offered by Francis to a poverty
stricken knight, as in Sassetta's *St Francis giving away his Clothes and St
Francis dreaming*, or cast off in front of his father before Francis himself was
enfolded naked in the protective robes of church officials, as in Sassetta's *St
Francis renounces his Earthly Father*.

As a young man Francis received a number of confusing messages about
his life's mission. Dreaming of a castle emblazoned with victorious flags, after
offering his clothes to the impoverished knight, Francis mistakenly believed
that his mission in life was to be a soldier. The angel who visited Francis in
his sleep had in fact intended that he should establish an army of friars who
would fight for the Church Militant on earth. On another occasion, the
painted crucifixion in the small church of S Damiano just outside Assisi
seemed to command Francis to repair the crumbling fabric of the church.
Not at first understanding the metaphors embedded in the crucifix's message,
Francis' immediate response was to sell the bales of cloth entrusted to him by
his father so that he could donate money for the physical restoration of the
church. This action so enraged Francis' father that he sought legal action
against his son. When his father threatened to disinherit and disown him, St
Francis tore off his clothes, and throwing them at his father's feet, claimed
that from that moment onwards he would recognise no other father than
God. Depictions of this episode – sometimes described as the Renunciation
by Francis of his Worldly Goods, and elsewhere (as with the Sassetta
painting) as *St Francis renounces his Earthly Father* – frequently include the
enraged figure of the father who has to be physically restrained from striking
his son. This anger was no doubt prompted as much by the rejection of all
that the family and its business stood for as by the appropriation of the
family goods. The National Gallery painting suggests the father's agitated
state in the rippling folds of his cloak, and his unstable pose. The emotional
distance between father and son is emphasised by the architectural loggia
which divides them, and the unnaturally still form of St Francis who stands

in an attitude of pious devotion inside the loggia, whilst casting a humble and untroubled glance in the direction of the townspeople outside. The seated figure of Bishop Guido of Assisi, symbolically enfolding the nude body of Francis within his robes, underlines his acceptance into the body of the Church.

Dedicating himself to Christ Francis gathered twelve disciples around him and travelled to Rome in 1210 to gain papal recognition for the Franciscan Order from Pope Innocent III – an episode depicted in Sassetta's *The Pope accords Recognition to the Franciscan Order.* The new Order of friars established itself in the Porziuncola Chapel at S Maria degli Angeli near Assisi and they clothed themselves in local undyed cloth. These grey or brown habits were secured with belts containing three knots symbolising the friars' vows of poverty, chastity and obedience.

The Franciscan Order was from the beginning a missionary movement and attracted numerous converts. Francis even looked to the East to convert the Moslems. In 1219 he travelled with the crusaders of Gautier de Brienne to Egypt, and tried (unsuccessfully) to convert the Sultan Malek al-Kamel. Francis' offer to walk through fire in order to prove the power of his faith was not accepted, although Sassetta's painting of *St Francis bears Witness to the Christian Faith before the Sultan* shows the saint broaching the flames.

Sassetta's saint emerges as a slightly frail figure, lacking in stature and

St Francis renounces his Earthly Father (left)
Sassetta (1392(?)–1450)

sporting a thin tonsure of hair and a straggling beard. This tallies with the physical descriptions of Francis included in a first biography written by Tommaso da Celano, one of Francis' followers. Texts such as *The Golden Legend* describe the many tribulations Francis suffered while tempted by devils, as well as the extraordinary understanding and sensitivity he felt for his fellow creatures.

Scenes such as *The Legend of the Wolf of Gubbio* by Sassetta, although apparently illustrating the special understanding Francis had with wild beasts, also reflect his role as peacemaker in a period of social unease. Although by tradition St Francis tamed the wild wolf who was ravaging the countryside around Gubbio and devouring many unfortunate individuals, it seems likely that this was in fact an armed mercenary rather than a member of the lupine species. In Sassetta's painting the saint is actually shaking the wolf's paw whilst a notary makes note of their agreement that from that time onwards the beast should be fed at public expense.

St Francis' empathy with Christ was such that, in the last years of his life, he received the marks of Christ's crucifixion (the stigmata) on his body whilst praying in a mountain retreat at La Verna. Sassetta's depiction of *The Stigmatisation of St Francis and the Verification of the Stigmata* fits well with Tommaso da Celano's description of a fiery vision of a man with six wings, with limbs stretched in the shape of a cross.

The Funeral of St Francis and the Verification of the Stigmata (right) Sassetta (1392(?)–1450)

Descriptions of the life of St Francis reveal parallels with Christ even after death. We learn that when St Francis died in 1226, one of the bystanders, variously described as a knight and nobleman, bent forward to touch his body, in order to verify that he had indeed received the marks of the stigmata. Sassetta's painting of *The Funeral of St Francis and the Verification of the Stigmata* shows this figure (distinguishable as a layman through his dress) examining the wound in his side.

Francis' example led to the founding of a female mendicant order, the Poor Clares. These women first established themselves at S Damiano (the church where Francis had received his first vision) and later congregated in a church inside the town. Francis was in fact first laid to rest in a small church on the site of the present church of S Chiara and only later transferred to the sumptuous double church of S Francesco. Sassetta's painting of *The Funeral of St Francis and the Verification of the Stigmata* seems to depict the simpler setting of the first resting place.

[Sassetta (4757); Sassetta (4758); Sassetta (4759); Sassetta (4760); Sassetta (4761); Sassetta (4762); Sassetta (4763)]

St Francis bears Witness to the Christian Faith before the Sultan *see* St Francis

St Francis giving away his Clothes and St Francis dreaming *see* St Francis

St Francis renounces his Earthly Father *see* St Francis

St George

St George and the Dragon

St George killing the Dragon

[Legends of the Saints; Italian 13th-century literature: Jacopo da Voragine, *The Golden Legend*]

According to traditional belief St George was an Eastern saint who was born in Cappodocia in the third century. Jacopo da Voragine describes how the saint saved the life of a princess who was threatened by a dragon. We learn how the dragon lived in a lake close to a city, and menaced the citizens with its fiery breath. Indeed its breath was so foul that the wretched people who came into contact with it actually died. In an attempt to keep the dragon at bay the citizens offered it two sheep each day, but when their livestock became seriously reduced, threatening them with starvation, the king ordered that a human being should be substituted. The victims were chosen by lot and by decree no exceptions were allowed. When the lot fell to the king's own daughter, his offer of gold, money, even half of his kingdom, was greeted with fury by his people. Why should they make exceptions for the princess, when their own children had already been devoured as a result of his decree? With great sorrow the king ordered his daughter to be taken to the dragon's territory.

St George came upon the princess by the side of the lake and, seeing that she was crying, tried to comfort her. Fearing that he too would perish, the princess begged him to leave before the dragon destroyed them both. But St George promised that he would help her in the name of Jesus Christ and when the dragon appeared he sprang on his horse, made the sign of the cross and ferociously attacked the beast.

The National Gallery painting of *St George and the Dragon* by Paolo Uccello shows neither the city nor the lake. Indeed we assume that the dragon has bounded out from the cavernous rocks in the background. Yet, in one respect, Uccello's painting follows Voragine's text closely. *The Golden Legend* describes how St George told the princess to take her girdle, or belt, from her dress and put it round the beast's neck. He then told her to lead the dragon back to the city like a pet dog. It was not until the whole town was baptised in the name of Christ that St George actually killed the dragon. Uccello clearly understood the sequence of Voragine's narrative, suggesting a mere wounding of the beast at this stage (albeit in somewhat gruesome fashion through one of his great staring eyes).

[Crivelli (predella) (724); Domenichino (75); Moreau (6436); Tintoretto (16); Uccello (6294)]

St Giles – 1

St Giles and the Hind [Legends of the Saints; Italian 13th-century literature: Jacopo da Voragine, *The Golden Legend*] According to Jacopo da Voragine St Giles was born in Greece and was transported across the sea to Arles by some sailors who were grateful for his intervention in calming a great storm.

Jacopo da Voragine describes how St Giles went into various retreats, and how on one occasion he came upon a hind who (as if miraculously sent by God) regularly visited him and offered him her milk as nourishment. One day the hind came to the saint for protection, after being chased by a royal hunting party. Jacopo da Voragine describes how St Giles asked God to help the hind, and how the hunting dogs then fell back in disarray. Although the hunters came back the next day, they were forced once again to return to the palace without their prey. The king then decided to join in the chase, together with his bishop and a large hunting party. When the dogs turned back yet again, one of the archers shot an arrow, hoping to flush the hind out, but instead wounded St Giles who was praying at her side.

When soldiers hacked their way through the undergrowth, they came across the hermit with the hind lying at his knees. After turning the rest of the company back the bishop and king came to talk with St Giles alone. They questioned the white-haired old man, asking him who he was and how he came to be so badly wounded. St Giles refused all offers to help him and, believing that he would achieve a greater state of grace through suffering, prayed that his wound would not heal so long as he lived. But after many visits from the king, St Giles gave up his life as a hermit and agreed to take charge of a religious house (which was to follow the strictest discipline) which the king promised to build for him. This became the Benedictine monastery of Saint-Gilles near Arles.

The National Gallery painting of *St Giles and the Hind* by the Master of St Giles depicts the moment when the king and his bishop first discover St Giles. The arrow is shown piercing the hand of the saint as he protects the deer. The Master of St Giles has accurately positioned the main part of the hunting party some distance away; indeed the figure on horseback seems to be moving in the opposite direction as if to join the rest of the company. But the artist has assumed a certain amount of artistic licence in the depiction of

St Giles and the Hind
Master of
St Giles (active
about 1500)

the dense undergrowth. St Giles's visitors would certainly not have had to hack their way through this foliage to reach him.

[Master of St Giles (1419)]

St Giles – 2

Mass of St Giles [Legends of the Saints; Italian 13th-century literature: Jacopo da Voragine, *The Golden Legend*] According to *The Golden Legend* the king (traditionally said to be the Emperor Charlemagne) who persuaded St Giles to leave his retreat and live in a monastery confessed to the saint that he had committed a great crime. The king asked St Giles to intervene on his behalf, although he could not bring himself to confess what his sin had been.

Jacopo da Voragine describes how St Giles was visited by an angel as he was celebrating Mass. The angel laid a piece of paper on the altar, describing the king's crimes and containing a pardon for him so long as he repented his sin.

Other versions of the story maintain that the king only admitted to a grievous sin (thought to be an incestuous relationship with his sister) when the angel arrived bearing this incriminating evidence.

The Mass of St Giles
Master of St Giles (active about 1500)

The king in the National Gallery painting of *The Mass of St Giles* by the Master of St Giles certainly seems to raise his hands in apprehension on noticing the arrival of the winged messenger. And the quiet order reigning at the ceremony, combined with the tranquil expressions on the faces of the bystanders, suggests that all has yet to be revealed.

[Master of St Giles (4681)]

St Giles and the Hind *see* St Giles – 1

St Hubert – 1

Conversion of St Hubert
Mass of St Hubert

[Legends of the Saints: T. Rejalot, *Le culte et les reliques de S Hubert*]

The legend of the eighth-century St Hubert is often confused with that of the Roman general Eustace, since both were said to have been converted to Christianity as a result of the magical appearance of a stag bearing a crucifix between its antlers. On each occasion they were out hunting, and in each case it seemed as if the animal talked to them.

Hubert is said to have seen a white stag whilst out hunting on Good Friday.

This apparition persuaded him to give up a way of life devoted to such wordly pleasures as lavish clothing and the excitement of the hunt. Hubert later became a bishop and devoted a great deal of time to missionary work in the forest of Ardenne. Because of this he became the patron saint of hunters and trappers in that area, and is often depicted with a hunter's horn. The conversion of St Hubert was particularly favoured by northern European artists.

The National Gallery painting of *The Conversion of St Hubert* by the Master of the Life of the Virgin depicts the saint in rich and courtly costume, kneeling in front of a stag which is brown rather than white. His halo suggests however that he has already heeded the mysterious voice telling him to take up the holy life. A companion painting, *The Mass of St Hubert* also by the Master of the Life of the Virgin and originally forming part of the same altarpiece, shows the saint being visited by an angel as he celebrates mass. His

The Conversion of St Hubert
Master of the Life of the Virgin
(active second half of 15th century)

bishop's mitre and pastoral staff are held by a kneeling figure behind. A small crouching dog in the foreground, similar in colouring and breed to one of the dogs in the scene of *The Conversion of St Hubert*, is perhaps a reminder of his previous delight in the hunt.

[Master of the Life of the Virgin (252); Master of the Life of the Virgin (253)]

St Hubert – 2

Exhumation of St Hubert [Legends of the Saints: T. Rejalot, *Le culte et les reliques de S Hubert*] Illustrations of the legend of St Hubert appear only in northern European art, probably because he had a specifically local significance [*see* St Hubert – 1], first becoming Bishop of Maastricht and then Bishop of Liège.

After Hubert's death his body was twice exhumed. On each occasion his

The Exhumation of St Hubert Workshop of Rogier van der Weyden (about 1399–1464)

flesh was found to be miraculously uncorrupted. The National Gallery painting of *The Exhumation of St Hubert* by the workshop of Van der Weyden shows the second exhumation in 825, nearly one hundred years after the saint's death. Clerics and lay people alike cluster around to witness the perfect state of the saint's body, still clothed in bishop's robes. The onlookers show no reaction to the exhumation, other than quiet reverence. Clearly (unlike depictions of a similar miracle – the raising of Lazarus from his tomb) there is no stench of death. Indeed, as was often the case with saints, descriptions of the exhumation refer to the peculiarly sweet odour that rose from the tomb.

[Workshop of Van der Weyden (783)]

St James

St James being visited by the Virgin with a Statue of the Madonna of the Pillar
Beheading of St James
[Legends of the Saints: J.S. Stone, *The Cult of Santiago*]

Although there is evidence to suggest that James, the brother of John the Evangelist, was tried and executed under Herod Agrippa in Jerusalem in 44 AD (as depicted in Pesellino's predella panel of *The Beheading of St James*), the general consensus of opinion, at least from the tenth century onwards, was that James travelled to Spain and was buried at Compostela. According to legend, the Virgin Mary appeared to James in Saragossa seated on a pillar, and ordered him to build a church there.

Bayeu's painting of *St James being visited by the Virgin with a Statue of the Madonna of the Pillar* shows the saint disturbed in his devotions as he kneels on the ground. Above him in a swirling mass of cherubs and angels, the Virgin Mary appears seated on clouds instead of a pillar. But she gestures towards a statuette of the Virgin and Child carried separately by a trio of cherubs, and an angel at her side appears to support the end of a massive column. According to some versions of this legend, the Virgin ordered James to set the statuette up on a pillar of jasper.

[Bayeu (6501); Pesellino (predella) (4868)]

St Jerome

St Jerome
St Jerome before a Crucifix
St Jerome in the Desert
St Jerome in a Landscape
St Jerome in Penitence
St Jerome in a Rocky Landscape
St Jerome in his Study
St Jerome reading in a Landscape
St Jerome taking a Thorn from the Lion's Paw
St Jerome's Vision when Ill that he was beaten at God's Command
Appearance of St Jerome with St John the Baptist to St Augustine
Death of St Jerome
Vision of St Jerome
[Legends of the Saints; Italian 13th-century literature: Jacopo da Voragine, *The Golden Legend*; Christian writings: *Letters of St Jerome*]

Although St Jerome is commonly depicted as a hermit saint, beating his breast with a stone and contemplating an image of the crucifix to ward off lustful and evil thoughts, his main contribution to Christianity was to translate the Old and New Testaments into Latin. Images of the saint thus frequently emphasise his scholarly nature, even when depicting him in the desert.

When Jerome was about thirty, he did in fact retire into the Syrian desert for a number of years and studied Hebrew. In his own *Letters* Jerome relates how he was surrounded by venomous insects and wild beasts. Jerome also describes how he beat himself whilst at his devotions. Some painters chose to emphasise the saint's mortification of the flesh both in the desert and in his own home. In Botticini's predella panel of *Jerome's Vision when Ill that he was beaten at God's Command* we see the saint peacefully asleep whilst his flagellation for preferring Cicero to the Bible is shown in the sky outside his bedchamber.

Jacopo da Voragine describes how St Jerome left his native Dalmatia as a young man and travelled to Rome where he studied Greek, Latin and Hebrew. Voragine also tells us that Jerome was made a cardinal at the age of twenty-nine (this would have been in about 361). The office of cardinal did not in fact exist in the fourth century, but Jerome was certainly employed as secretary by the pope of the day (Damasus I) between 382 and 385, and one of the saint's more common attributes in paintings is his cardinal's hat. At times St Jerome is depicted fully robed in cardinal red, and holding a model of the Church, often resting on two volumes which signify his main work of translation.

Although St Jerome retreated into a monastery in Bethlehem during the last part of his life, he continued to write and study. Antonello da Messina makes clear reference to this later life as a scholar in his painting of *St Jerome in his Study*. We understand that this quiet corner forms part of the monastery at Bethlehem when we note the figure of the lion approaching in the right background. According to *The Golden Legend* this wild beast appeared suddenly in the grounds of the monastery, putting the monks into fearful flight. But St Jerome approached the lion and found that his foot was wounded by a thorn. Jerome removed the thorn, ordered his monks to wash the lion's foot, and allowed the beast to remain in the monastery almost as a domestic pet.

We learn from *The Golden Legend* that the lion was entrusted with the safekeeping of the monastery's ass, and how it followed the beast of burden like a shepherd when it went out into the fields. But one day the lion was overcome by a profound drowsiness and dropped off to sleep. Whilst he slept some merchants passing by with their camels stole the ass. Greatly distressed to find the ass gone, the lion slunk back to the monastery, hardly daring to enter the building, so great was his shame at losing the ass. The quiet approach of the animal in Antonello's painting suggests that this is indeed the moment of the lion's shameful return, rather than his first fear-inducing arrival.

Jacopo da Voragine describes how the monks assume that the lion has

devoured the ass, and how St Jerome orders that he should take over the ass's labour, carrying great loads of wood on his back.

Many depictions of St Jerome in the wilderness incorrectly show the saint already accompanied by the lion. It is interesting though to note those examples where the animal is depicted in a semi-comatose state. Bono da

St Jerome in his Study Antonello da Messina (active 1456, died 1479)

Ferrara's beast in the painting of *St Jerome in a Landscape* seems particularly somnolent.

Jerome died in the monastery at Bethlehem and subsequently appeared in a vision with St John the Baptist to St Augustine [*see* St Augustine – 1].

[Antonello da Messina (1418); follower of Giovanni Bellini (281); Bono da Ferrara (771); Botticini (predella panels) (227); Catena (694); Cima da Conegliano (1120); Crespi (6345); Cretan School (3543); Crivelli (predella) (724); studio of David (2596); Domenichino (85); attr. Patenier (4826); Pesellino (predella) (4868D); Savoldo (3092); Sodoma (3947); Tura (773)]

St Jerome before a Crucifix *see* St Jerome

St Jerome in the Desert *see* St Jerome

St Jerome in a Landscape *see* St Jerome

St Jerome in Penitence *see* St Jerome

St Jerome in a Rocky Landscape *see* St Jerome

St Jerome in his Study *see* St Jerome

St Jerome reading in a Landscape *see* St Jerome

St Jerome taking a Thorn from the Lion's Paw *see* St Jerome

St Jerome's Vision when Ill that he was beaten at God's Command *see* St Jerome

St Joachim's Offering rejected *see* Virgin Mary: Conception

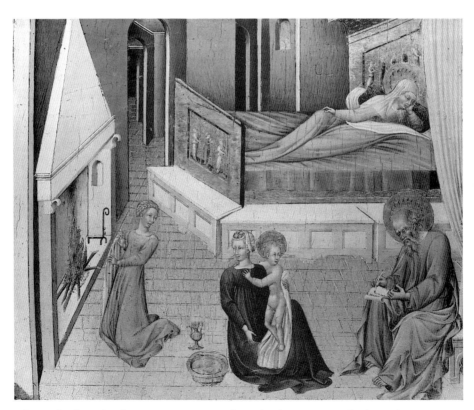

The Birth of St John the Baptist Giovanni di Paolo (active 1420, died 1482)

St John the Baptist – 1

Angel appearing to St Zacharias
Birth of St John the Baptist
Naming of St John the Baptist
[Biblical: Luke 1. 5–22 and 57–64]

According to the Bible, Zacharias (the father of St John the Baptist) was struck dumb in punishment for not believing the angel's message that his aged wife Elizabeth would bear a child. Niccolò di Pietro Gerini's *Angel appearing to St Zacharias* appears to show this moment of disbelief as Zacharias seems suddenly to stop in the middle of his censing. Elizabeth did indeed conceive and, when her child was born, insisted that the boy should be called John rather than Zacharias after his father.

Depictions of the birth scene often include the figure of Zacharias who signals his agreement to the naming of their child by writing 'His name is John' on a tablet or scroll. Barent Fabritius's painting of *The Naming of St John the Baptist* shows the aged Zacharias seated at the side of the cradle writing on a slate. Giovanni di Paolo's *The Birth of St John the Baptist* shows Zacharias using a scroll instead.

[Dalmation School (side panel) (4250); Fabritius (1339); Giovanni di Paolo (5453); attr. Niccolò di Pietro Gerini (predella) (579)]

St John the Baptist – 2

St John the Baptist retiring to the Desert
St John the Baptist in the Desert
St John the Baptist seated in the Wilderness
St John the Baptist preaching
Preaching of St John the Baptist
[Biblical: Matthew 3. 1–12; Mark 1. 1–8; Luke 3. 1–18; John 1. 15–28]

The Gospels describe how John the Baptist went into the Wilderness to baptise and preach repentance. We are not told when John left home, but the painting by Giovanni di Paolo of *St John the Baptist retiring to the Desert* shows a very young boy leaving the city gates and journeying into the mountains. We learn how John clothed himself in camel hair and fed off locusts and honey. The National Gallery paintings of *St John the Baptist seated in the Wilderness* by Murillo and by a follower of Annibale Carracci and *St John the Baptist in the Desert* which is attributed to Piazza show the partially clothed saint filling his bowl from a mountain stream.

The Gospels also tell us that people came not only from Jerusalem, but from all over Judaea and all the region around Jordan to listen to John and to be baptised by him with water. Although all the Gospels describe how John baptised in the Wilderness, Matthew and Luke are the most detailed in their descriptions of the crowds who gathered to listen to the saint, and of the sermons he preached. We learn how all kinds of people came to be baptised and to question the saint. Pharisees, Sadducees and even soldiers, as well as ordinary people, asked what they should do to gain remission for their sins. John told each one something slightly different. To those without any trade or profession he advised the sharing of clothing and food. To publicans he

The Preaching of St John the Baptist Cornelis van Haarlem (1562–1638)

advised fair prices. To the soldiers he advised a cessation of violence and false accusations and that they should be content with their wages. With the Pharisees and Sadducees he was less specific. Curse them he certainly did: 'O Generation of vipers, who hath warned you to flee from the wrath to come?' But for advice, John fell back on the rather vague suggestion that they should 'bring forth therefore fruits meet for repentance'.

Cornelis van Haarlem's *The Preaching of St John the Baptist* seems to show some of the saint's advice being practised by his converts. Groups of people sit picnicking and sharing their food whilst a publican appears to ply his wares from a great barrel brought to the scene. Meanwhile armed soldiers press forward on their horses and priestly figures lurk in the shadows at the side. St John himself seems vulnerable and small amongst this huge crowd. Perhaps this is a deliberate reflection on the artist's part of the Bible text: 'he that cometh after me is mightier than I'.

[Circle of Annibale Carracci (25); Cornelis van Haarlem (6443); Giovanni di Paolo (5454); attr. Murillo (3938); attr. Piazza (1152); Raphael (6480)]

St John the Baptist – 3

St John the Baptist decapitated
Beheading of St John the Baptist
Feast of Herod
Salome
Salome receives the Head of St John the Baptist
Daughter of Herodias
Salome bringing the Baptist's Head to Herodias
[Biblical: Matthew 14. 1–11; Mark 6. 17–28]
The story of the beheading of St John the Baptist is treated most fully in the Gospels of Matthew and Mark. In each of these texts we learn how John

incurs the dislike of Herodias by criticising her marriage with her brother-in-law Herod. Acting on the advice of her vengeful mother, Salome (who is the daughter of Herodias from a previous marriage) beguiles Herod into offering her the gift of her choice by dancing for him at his birthday feast. Salome demands the head of St John the Baptist on a charger, or dish. Although the Bible describes how Herod is exceedingly saddened by this request, he feels honour bound to carry out his promise. He therefore orders an executioner to bring him the head of St John the Baptist.

According to the Bible text John is beheaded in prison. But Puvis de Chavannes, in his painting of *The Beheading of St John the Baptist*, depicts the scene in a wooded clearing in front of a building. The executioner is poised to strike with his sword, whilst two figures – one of them thought to be Salome – look on. A crouching figure in the background appears to lament the saint's execution.

Both Matthew and Luke describe how John's head is brought to Salome and how she subsequently takes it to her mother. Caravaggio's *Salome receives the Head of St John the Baptist* shows Salome averting her gaze as if reluctant to look at this gruesome offering. But perhaps she is already anticipating her next action. Most paintings depicting the moments immediately after the execution of the saint show the head being presented to Herod in the banqueting hall. Frequently it is Salome herself who offers the charger to her stepfather. But in Giovanni di Paolo's painting of *The Feast of Herod* and Niccolò di Pietro Gerini's predella panel of *The Feast of Herod* it is a soldier who kneels in front of the horrified king. Other guests at the feast rear away from the head, covering their eyes in disgust.

Niccolò di Pietro Gerini also depicts the final episode of the story in his predella panel of *Salome bringing the Baptist's Head to Herodias*. Here we see Salome kneeling in front of her mother who, unlike Herod, readily accepts John's head.

[Caravaggio (6389); studio of Cesare da Sesto (2485); Giampetrino (3930); Giovanni di Paolo (5452); attr. Niccolô di Pietro Gerini (predella) (579); Puvis de Chavannes (3266); Sebastiano del Piombo (2493)]

St John the Baptist in the Desert *see* St John the Baptist – 2
St John the Baptist retiring to the Desert *see* St John the Baptist – 2
St John the Baptist seated in the Wilderness *see* St John the Baptist – 2
St John the Evangelist
St John the Evangelist baptising
St John saved from a Cauldron of Boiling Oil
St John resuscitating Drusiana
St John on Patmos
Vision in Patmos
St John the Evangelist on the Island of Patmos
Ascension of St John the Evangelist
[Biblical: Mark, 1. 19–20; Revelation 12. 1–4 and 14; Italian 13th-century literature: Jacopo da Voragine, *The Golden Legend*]
According to the Bible St John the Evangelist was the son of Zebedee and the brother of James. He was often described as the disciple best loved by Jesus,

and is frequently depicted leaning against Christ in scenes of the Last Supper [*see* Christ: Passion – 3].

It was believed that John was the author of the Apocalypse as well as the fourth Gospel. He is said to have had a vision on the Island of Patmos of the Woman of the Apocalypse (a creature clothed with the sun, and standing on the moon, and with a great crown of stars around her head). The National Gallery painting by Velázquez of *St John the Evangelist on the Island of Patmos* depicts the moment of revelation with particular drama, showing the saint bathed in the supernatural light of his own vision. However the Master of the Female Half-Lengths' *St John on Patmos* is perhaps more faithful to the text in the depiction of the dragon who waits to devour the child the pregnant

The Ascension of St John the Evangelist Giovanni del Ponte (active 1385–1437/42(?))

woman is about to bring into the world. The National Gallery's Northern European paintings also include John the Evangelist's emblem – the eagle – in reference both to that creature's soaring flight, and to St John's own searing vision.

Secondary texts such as *The Golden Legend* describe many of the adventures of John, including his raising of the woman called Drusiana, and his martyrdom in a cauldron of boiling oil. Both of these events are depicted in the predella of Giovanni del Ponte's *The Ascension of St John the Evangelist*. The predella of this altarpiece also includes a scene in which St John is shown baptising.

John is thought to have died at a very old age, tradition having it that he dug his own grave and then walked down into it. His death is often referred to as an ascension. The term ascension means the taking up into heaven. Giovanni del Ponte emphasises this point in his painting of *The Ascension of St John the Evangelist* by showing the figure of Christ (in the guise of God the Father) hovering over the saint and grasping his wrists as if physically to elevate him heavenwards on his bank of clouds.

[Giovanni del Ponte (580); Giovanni del Ponte (predella) (580A); Margarito (side scene) (564); Master of the Female Half-Lengths (717); South German School (4901); Velázquez (6264)]

St John the Evangelist baptising *see* St John the Evangelist
St John saved from a Cauldron of Boiling Oil *see* St John the Evangelist
St John resuscitating Drusiana *see* St John the Evangelist
St John on Patmos *see* St John the Evangelist
St John the Evangelist on the Island of Patmos *see* St John the Evangelist
St Justus and St Clement of Volterra

Legend of Sts Justus and Clement of Volterra [Legends of the Saints] According to local folklore St Justus and St Clement intervened to save the city of Volterra during a siege in the Middle Ages. The saints advised the citizens to place loaves of bread on the ground outside the city walls, so that the enemy would believe that they were paving the area with food. The vandals besieging the town, persuaded that there must be a surplus of food if the citizens were using bread instead of paving stones, decided to lift their siege.

The National Gallery painting by Domenico Ghirlandaio of *The Legend of Sts Justus and Clement of Volterra* shows a group of slightly bemused figures receiving bread from St Justus. It is not clear whether these are local lads or part of the besieging army. The elegance of their clothing suggests the former, yet the movement away from the city walls of two of the figures, who are clearly shown holding bread and casting somewhat doleful glances backwards, suggests that these are indeed the departing vandals.

[Domenico Ghirlandaio (2902)]

St Lawrence

St Lawrence showing the Prefect the Treasures of the Church
St Lawrence prepared for Martyrdom

[Legends of the Saints; Italian 13th-century literature: Jacopo da Voragine, *The Golden Legend*]

The third-century St Lawrence was martyred on the gridiron after causing offence to the Prefect of Rome, Decius. Although the details of his life are not entirely clear, it is generally believed that Lawrence was ordained deacon by Pope Sixtus II, and that he was ordered by Sixtus to give away the treasures of the church to the poor people of Rome. When challenged by the Prefect of Rome to present those treasures over which he, as deacon, had jurisdiction, Lawrence gathered up the poor people from the street and offered them instead.

The painting attributed to the Master of the St Ursula Legend of *St Lawrence showing the Prefect the Treasure of the Church* shows that Decius was not amused by such semantics. Indeed we sense that he is catching his breath in irritation as he brings his hand up to his chest. St Lawrence's gentle expression and outstretched arms appear again in Elsheimer's *St Lawrence prepared for Martyrdom*. But in this painting he is being disrobed in preparation for the gruesome roasting on the gridiron. The angel holding a martyr's palm gestures heavenwards as if to draw the saint's attention away from the fierce flames which are being fanned in the background. Meanwhile the figure on his left, who gestures up at an imperial statue in the right-hand foreground, seems to remind him that he can avoid this punishment if he renders the treasures of the church to the authority of Rome. The sculpture and architecture to the side and in the background give a strong sense of place to the narrative.

[Elsheimer (1014); circle of the Master of the St Ursula Legend (3665)]

St Lawrence prepared for Martyrdom *see* St Lawrence

St Lawrence showing the Prefect the Treasures of the Church *see* St Lawrence

St Mammas with the Lions [Legends of the Saints, *Bibliotheca Hagiographica Latina Antiquitatis et Mediae Aetatis*] Mammas was a third-century knight who died when he was disembowelled with a trident. Mammas is often shown in the company of lions and with a shepherd's staff in reference to that period of his life when he was exiled into the Wilderness. Whilst there he gathered a flock of lions about him and milked them as if they were cattle. He is said to have made cheese out of this milk, and to have used it to feed the poor.

After being disembowelled the saint is said to have walked away holding his entrails in his hands before finally giving up the ghost. He in fact suffered many tortures, including being placed in a lion's den, being beaten, being stoned, being drowned, having torches applied slowly over his whole body and three times being thrown into a fiery furnace.

Despite all the lurid and colourful details known about the saint's life, the predella panel of *St Mammas with the Lions* by Pesellino shows a comparatively peaceful scene. A number of lions bound in from the left, one of them licking the saint's foot as if in anticipation of the larger feast to come. But Mammas has clearly already subdued the beast on our right. We sense that this lion has considered attacking the saint but has retreated in the face of Mammas' faith.

[Pesellino (predella) (4868A)]

St Margaret swallowed by a Dragon [Legends of the Saints; H. Delahaye, *Les Légendes hagiographiques*]

According to legend Margaret of Antioch was swallowed by the devil in the form of a dragon, after refusing the advances of Olybrius, prefect in the reign of the Emperor Diocletian. By chance Margaret was holding her Christian's cross, and so was able to cut her way out of the dragon's stomach. She was finally beheaded, but her dying wish was that women in childbirth should call upon her and so be delivered safely.

The scene of *St Margaret swallowed by a Dragon* by Margarito shows a particularly menacing dragon with two heads. St Margaret is being swallowed in a conventional manner but after cutting herself free faces a new threat from the second gaping head on the tail which is turned towards her. The grille in the foreground reminds us that the saint underwent this martyrdom whilst in prison.

[Margarito (side scene) (564)]

St Mary Magdalene approaching the Sepulchre *see* Christ: Resurrection – 3

St Nicholas

St Nicholas by Miracle saves Three Innocent Men from Decapitation
Consecration of St Nicholas
Miracle of St Nicholas

[Legends of the Saints; Italian 13th-century literature: Jacopo da Voragine, *The Golden Legend*]

The Consecration of St Nicholas
Paolo Veronese (1528(?)–88)

Despite the folklore surrounding the fourth-century bishop saint Nicholas of Myra, we have little precise information about his life and works. The first descriptions of his life date from five centuries after his death. His bodily remains were stolen in 1087 by Italian merchants who took the precious relics from his first resting place in Myra and placed them in a new shrine at Bari in Apulia. For this reason he is often referred to as St Nicholas of Bari.

According to legend St Nicholas intervened to save the life of a group of pilgrims travelling on the sea who had been offered poisoned drink by the devil – a scene depicted in Margarito's *Miracle of St Nicholas*. The same artist also painted another scene from the saint's life, *St Nicholas by Miracle saves Three Innocent Men from Decapitation*, where St Nicholas stays the hand of the executioner as he raises his sword to behead three kneeling figures in front of him. But the best known act of mercy performed by St Nicholas was the saving of three young girls from a life of prostitution. Realising that one of his neighbours was reduced to sending his daughters out to work as prostitutes, he threw money through their window, thus giving rise to the legend of St Nicholas and the giving of gifts.

There is little reference in Veronese's painting of *The Consecration of St Nicholas* to the saint's Eastern origins or to the many people ranging from pawnbrokers to children for whom he had a particular significance. Veronese's painting does however depict a particular moment in the saint's life which is described in some detail in *The Golden Legend*. Jacopo da Voragine describes how a number of bishops gathered together to elect a new archbishop of Myra, and how one who had a particular authority over the others was charged with making the final choice. This individual heard a voice during the night telling him to stand watch at the entrance of the church the following morning. He was told that the one who came in first (who, incidentally, would be called Nicholas) was the one who should be chosen. The following morning St Nicholas was indeed the first to present himself at the church. On being asked who he was, he answered 'Nicholas, the servant of your Holiness'.

Veronese's painting of *The Consecration of St Nicholas* shows Nicholas kneeling in devotion before the imposing figure of a cleric whose long white beard and elaborate bishop's garb marks him out as the individual entrusted with the election of the new archbishop. Nicholas looks up in humility towards the outstretched hand of blessing. Voragine tells us that Nicholas had the simplicity of a dove, and was in fact reluctant to accept the high office offered to him. But although his pose suggests a reluctance to be plucked for high office from the crowd of dignitaries who surround him the arms crossed against his breast indicate acceptance. The foreshortened figure of an angel holding an archbishop's mitre, crozier and stole indicates by his downward glance that the choice of Nicholas as the next archbishop of Myra is in accordance with God's divine will.

[Margarito (side scene) (564); Margarito (side scene) (564); Veronese (26)]

St Nicholas by Miracle saves Three Innocent Men from Decapitation *see* St Nicholas

St Paul

Conversion of St Paul
St Paul Preaching at Ephesus
St Paul on Malta

[Biblical: Acts of the Apostles 9. 1–20; 19. 18–20; 27. 41–4; 28. 1–6]

We learn from the Acts of the Apostles that Saul, a great persecutor of Christians, was himself converted by a vision he received on the road to Damascus. The Bible describes how Saul, who later changed his name to Paul, was travelling to Damascus with letters from the High Priest which gave him authority to bring back any Christian converts he found to Jerusalem in chains. But a great light suddenly dazzled him and he fell to the ground. Saul then heard a voice asking, 'Saul, Why are you persecuting me?' When Saul enquired who it was who was talking to him, the voice said, 'I am Jesus'. The Bible describes how Saul, trembling and astonished, begged for guidance, and was told to get up and travel on into Damascus. But when Saul tried to rise from the ground he found that he was blind and his travelling companions had to lead him into Damascus.

After several days without food or drink, Saul was visited by a disciple of Christ, Ananias. Ananias had been warned by God of Saul's loss of sight. He had been entrusted to make contact with Saul, to cure his blindness and to receive him into the brotherhood of Christ. When Saul felt Ananias' hands upon him he instantly regained his sight, and after being baptised and initiated in the Christian faith by other disciples living in Damascus, began preaching in the synagogue, claiming that Christ was indeed the Son of God.

Karel Dujardin's painting of *The Conversion of St Paul* shows a number of horsemen in disarray, with cloaks flapping dramatically in the wind. In the background figures lie on the ground, cower over their horses' necks or scramble away from the flailing hooves. Only one figure, the armoured soldier in the left foreground, seems as yet untouched by the event. Contextually it would be appropriate for Saul to be shown wearing armour – indeed the sword became his symbol. It is also appropriate that Saul should be given a prominent position within the composition. We may thus at first identify this figure on horseback (who still holds his great furling banner despite the fact that his horse jerks round in frenetic movement) as Saul. Yet such a depiction reverses the Bible text; Saul would in this case be the only one to remain on horseback in the face of the blinding light.

A turbaned figure in the foreground whose dappled horse has crumpled under him with nostrils erect in terror seems more likely to be Saul. This horseman, who is bathed in light, raises both arms in astonishment and seems to look up towards a figure which emerges from the mass of clouds in the sky. Two of the other horsemen look towards him as if illustrating that part of the Bible where we are told that those who were travelling with Saul remained motionless in astonishment, hearing a voice, but seeing no man.

Close examination of the picture surface reveals a shaft of light which beams directly towards the turbaned figure in blue. Moreover, a cherub with a scourge and torch emerging from the sky above directs his attention towards the same figure. Behind the cherub is another figure, partially hidden

by a bank of cloud – presumably Jesus who will emerge to question Saul.

The Ferrarese School painting of *The Conversion of St Paul* offers a more orthodox rendering of the subject. The clearly recognisable figure of Saul, encumbered by heavy armour, has been thrown from his horse and is shown trying to stumble to his feet. Meanwhile, a forceful Christ figure is moving rapidly towards Saul in a burst of cloud. Perhaps Dujardin deliberately chose to confuse the moment of conversion, depicting the moment of the blinding light, rather than the receiving of the divine message.

Although this event is called the Conversion of St Paul, Saul in fact kept his name for a considerable period of time after the vision of the blinding light. It is not until the time of his mission to the Gentiles together with Barnabus that the Bible refers to him as Paul.

The later chapters of the Acts of the Apostles describe how Paul went to Asia and performed many miracles of healing there. We learn how 'certain vagabond Jews' or 'exorcists' sought to copy Paul by performing their own miracles, but with disastrous results. Not only did those possessed by evil

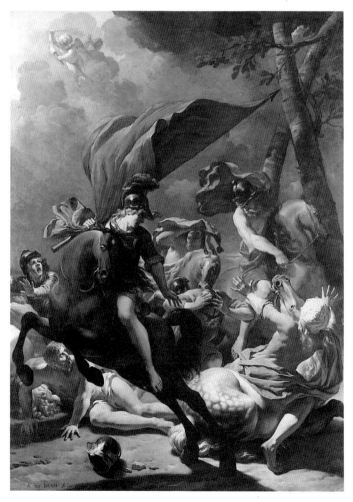

*The Conversion of
St Paul*
Karel Dujardin
(about 1622–78)

spirits refuse to acknowledge the 'healers' but they actually attacked them, tearing their clothes from their backs and sending them fleeing in fear. Word spread quickly around Ephesus and many were strengthened and renewed in their faith by this example of moral discrimination even among those possessed by the devil. Other sorcerors brought all their books of black magic to Paul and burned them in a public show of repentance. Eustache Le Sueur's painting of *St Paul preaching at Ephesus,* in common with many other depictions of this incident, suggests that St Paul played an active part in the burning of these texts.

More miraculous was the incident at Malta. The Acts of the Apostles describe how Paul was shipwrecked during a long journey to Italy, and how all those aboard managed to get safely to land, either through swimming or through floating on the ship's broken pieces. The people on the island made a great fire to warm them, but when Paul gathered up some sticks to add to the fire, a viper – escaping from its resting place and from the sudden heat – sunk its fangs into Paul's hand. The superstitious locals thought this was an omen and assumed that Paul must have committed a great crime for which he was being punished. But when Paul shook the snake off and appeared to suffer no ill effects from its bite, the islanders changed their minds and decided he must instead be a god.

Adam Elsheimer's painting of *St Paul on Malta* shows Paul's shipwrecked companions hanging up their clothes to dry whilst others gather wood and tend the fire. In the glow of the flames we notice the figure of Paul dangling a snake above the flames. As suggested in the biblical text, there is an atmosphere of apprehension and hesitation in the faces and figures of those gathered around him.

[Dujardin (6296); Elsheimer (3535); Ferrarese School (73); Le Sueur (6299)]

St Paul on Malta *see* St Paul

St Paul preaching at Ephesus *see* St Paul

St Peter Martyr

Assassination of St Peter Martyr

Death of St Peter Martyr

[Italian history]

St Peter Martyr was a thirteenth-century Dominican friar in Italy, who was murdered by a bunch of assassins in the pay of a couple of noblemen from Venice. Peter, an ardent persecutor of heretics, roused the hatred of these men by accusing them of heresy and confiscating their property.

Giovanni Bellini's *The Assassination of St Peter Martyr* shows Peter being hacked to death, whilst the other friar Brother Dominic vainly tries to escape the blows of another assailant. This scene of carnage takes place against the background of a forest and a distant town. The painting of *The Death of St Peter Martyr* ascribed to Bernardino da Asola has a particularly brutal feel to it, perhaps because the saint is pinned to the ground by his assailant and yet tries vainly to resist. Peter's violent end is often referred to in images of the saint by the addition of a livid slash of blood across his skull and a sword or knife which protrudes from his wound.

[Giovanni Bellini (812); attr. Bernardino da Asola (41)]

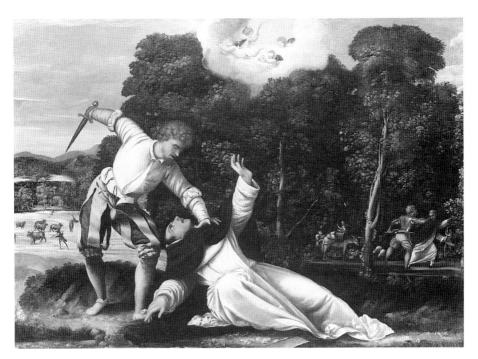

The Death of St Peter Martyr Attr. Bernardino da Asola (recorded 1526)

St Sabinus before the Governor of Tuscany(?) [Legends of the Saints] The painting of *St Sabinus before the Governor of Tuscany(?)* attributed to Pietro Lorenzetti shows a bishop saint together with two deacons who stand in front of a seated figure of Justice with whom they appear to converse. Little attention is paid by any of the figures to the statue held out by the group to the left. The National Gallery painting possibly refers to the incident in the life of the Tuscan St Sabinus when he and his two followers, Sts Marcellus and Exuperantius refused to worship a pagan image of Jupiter. Indeed Sabinus is said to have thrown the statue on the ground and to have had his hands cut off in punishment.

Since this predella painting is thought to form part of an altarpiece made for the chapel of S Savino (St Sabinus) in the Cathedral at Siena, there is some justification for the identification of the figures in the scene. However, if this is an incident in the life of St Sabinus, we witness neither the precise moment of his refusal to worship a pagan god, nor his punishment for such a refusal. It is a strangely indecisive piece of narrative, made even more enigmatic by the back view of the Governor Venustianus who, we are told, was later converted to Christianity.
[Attr. Pietro Lorenzetti (1113)]
St Sebastian
Martyrdom of St Sebastian
St Sebastian
[Legends of the Saints; Italian 13th-century literature: Jacopo da Voragine,

The Golden Legend]

Little is known about the origins of St Sebastian, but he was already venerated as early as the fourth century. He was said to be an officer in the Emperor Diocletian's Praetorian Guard. When Diocletian heard that Sebastian had converted to Christianity, he commanded that Sebastian's own company should subject him to martyrdom by arrows. Although Sebastian suffered great agonies it was traditionally believed that none of his vital organs was pierced, and that he survived his ordeal. Indeed, according to some versions of his life, he presented himself a second time to the emperor claiming that he could serve two masters at the same time – in other words, his heavenly lord as well as his terrestrial emperor. But Diocletian remained unconvinced and ordered that Sebastian should be clubbed to death. His body was then dumped unceremoniously into one of Rome's main sewers, the Cloaca Maxima.

The Martyrdom of St Sebastian Attr. Antonio (about 1432–98) and Piero (born about 1441, died before 1496) del Pollaiuolo

The Pollaiuolo painting of *The Martyrdom of St Sebastian* shows him tied to a tree on a plateau beyond which is a valley dotted with cyprus trees and fringed by mountains. Bernardino Zaganelli's painting of *St Sebastian* on the other hand shows the saint standing against a column. Yet once again we see a distant valley view in the background. The landscape in the Pollaiuolo painting is often seen as a reference to the Tuscan landscape around Florence, but the raised foreground site may also reflect the belief that Sebastian was martyred on the Palatine hill outside Rome. Certainly the ruined triumphal arch to the left appears to link the place of martyrdom with classical Rome.
[Crivelli (predella) (724); Gerrit von Honthorst (4503); attr. Antonio and Piero del Pollaiuolo (292); Bernardino Zaganelli (1092)]

St Ursula

Seaport with the Embarkation of St Ursula
St Ursula taking Leave of her Father(?)
[Italian 13th-century literature: Jacopo da Voragine, *The Golden Legend*]
The cult of St Ursula and her legendary eleven thousand virgins developed during the ninth century, when a number of texts emerged describing how Ursula left her father's royal court in Brittany, and went on a pilgrimage to Rome with ten female companions.

Ursula's hand had been sought by the pagan king of England. Her answer was that she would marry the king's son if he agreed not only to wait three years before consummating their marriage, but also to convert to Christianity and go with Ursula on a pilgrimage to Rome.

Ursula demanded that the English king should provide her with ten virgin companions and that she and each of her companions should be accompanied by one thousand other virgins. To her surprise, Conon (the king's son) agreed to her request, and travelled with Ursula and all the other virgins to the Holy City. On their way back Ursula and Conon (baptised Etherius at Rome), were waylaid by Huns near Cologne and massacred. Etherius was the first to be killed, followed in quick succession by the eleven thousand virgins. Ursula alone witnessed it all, and finally – having refused to marry the barbarian chief – was put to death with a single arrow. An early text of about the fourth or fifth century AD, describing the place of martyrdom of a number of young virgins near Cologne, possibly gave rise to the later legend of St Ursula.

According to the thirteenth-century text of *The Golden Legend* by Jacopo da Voragine, Ursula's father ordered that a group of men should join the pilgrimage in order to defend them on the journey. However, Claude's *Seaport with the Embarkation of St Ursula* makes no reference either to the many virgins or to male members in Ursula's retinue. A comparatively small group of women walk down towards the quay and the rowing boats which wait to accompany them to one of the great ships in the harbour. Even fewer women surround the kneeling figure of Ursula in Vittore Carpaccio's *St Ursula taking Leave of her Father*(?) but in the distance we see that a large crowd of people has already gathered on the quayside to wave farewell to the pilgrims.
[Carpaccio (3085); Claude (30)]

St Ursula taking Leave of her Father *see* St Ursula
St Vincent Ferrer
Scenes from the Life of St Vincent Ferrer [Legends of the Saints: *Les bases de l'étude historique de Saint Vincent Ferrer*]
The Dominican missionary, St Vincent Ferrer, died in 1416 shortly after withdrawing his support from the Avignon claimant to the papal throne, Pope Benedict XIII. St Vincent lived for many years in Avignon and whilst there acted as the papal confessor. But he was also actively involved in missionary work in other parts of Europe. St Vincent's fire and brimstone preaching attracted vast groups of penitents long before Savonarola's similar warnings in Florence at the end of the fifteenth century. Converts followed Vincent from one city to another, creating instant crowds to hear his stirring sermons.

The predella panel of *Scenes from the Life of St Vincent Ferrer* by a follower of Francesco del Cossa, with its views of miraculous intervention in the face of fire and busy figures clustering around in earnest adulation, is very suggestive of St Vincent's intense life as a preacher.
[After Cossa (predella) (597A)]

St Zeno exorcising the Daughter of the Emperor Gallienus [Legends of the Saints: B. Perci, 'De Christianarum Antiquitatem Institutionibus in S. Zenonis Veronensis episcopi sermonibus', *Antonianum* XXIII (1948)] Many of the sermons of the fourth-century bishop saint Zeno of Verona still exist. Yet little is known of his personal life except for the fact that he was born in Africa and was fond of fishing. The National Gallery predella painting by Pesellino of *St Zeno exorcising the Daughter of the Emperor Gallienus* depicts the saint in conventional mode – banishing an evil spirit. The daughter of Gallienus lies on the ground whilst the crowned figure of the emperor crouches over her in anxiety. St Zeno, shown with pale skin despite his African origins, also leans forward, with one arm raised, as if physically lifting the little figure of a demon out of the girl's mouth.
[Pesellino (predella) (4868C)]

St Zenobius
St Zenobius revives a Dead Boy
Four Scenes from the Early Life of St Zenobius
Three Miracles of St Zenobius
[Legends of the Saints]
The fifth-century bishop saint of Florence St Zenobius was renowned for his powers of healing. Both Botticelli's painting of *Three Miracles of St Zenobius* and Giovanni Bilivert's *St Zenobius revives a Dead Boy* illustrate the saint's curative powers.

Botticelli's *Three Miracles of St Zenobius* shows how Zenobius had the power to bring corpses back to life, restore to health those afflicted with physical defects such as blindness, and cure those who were mentally afflicted. (According to legend he exorcised two young men possessed by devils who had been driven to gnaw their own flesh.) As was the custom in the depiction of the curing of souls, Botticelli shows devilish beasts fleeing from the bodies in horror in the face of the saint's intervention.

*St Zenobius revives
a Dead Boy*
Giovanni Bilivert
(1576–1644)

St Zenobius is usually depicted as an elderly and bearded figure dressed in bishop's robes. Botticelli's *Four Scenes from the Early Life of St Zenobius* trace his rejection of worldly pleasures as a young man, leaving the woman he was to marry and turning instead to the Church. He and his mother are baptised by Theodosius, the bishop of Florence, and Zenobius then follows Theodosius by being made bishop in his stead. All the National Gallery paintings suggest an architectural background appropriate to Florence, although the buildings in the background of Botticelli's paintings are more suggestive of the High Renaissance than the fifth century when St Zenobius was alive.

[Bilivert (1282); Botticelli (3918); Botticelli (3919)]

St Zenobius revives a Dead Boy *see* St Zenobius

Sts Augustine and Monica *see* St Augustine – 2

Salome *see* St John Baptist – 3

Salome bringing the Baptist's Head to Herodias *see* St John the Baptist – 3

Salome receives the Head of St John the Baptist *see* St John the Baptist – 3

Samson and Delilah [Biblical: Judges 15 and 16. 4–20] There is a certain element of sado-masochism to the story of Samson (an Israelite of great

strength who became involved in the conflict between Israel and the Philistines). The Bible describes how the Philistines came to Delilah when they realised that she and Samson were lovers and asked her to discover the secret of his strength. They had good reason to fear the Israelite. Samson's past exploits included the killing of a lion with his bare hands and setting fire to Philistine cornfields by knotting three hundred foxes together, attaching blazing torches to their tails, and letting them run loose on Philistine land.

Although it is generally well known that Delilah betrayed Samson after learning that his strength lay in his hair, a number of other incidents described in the Bible suggest that Samson was not averse to being bound and tested.

The first mention of bondage occurs when Samson was seized by his own people and bound with two new cords before being handed over to the Philistines, who at that time controlled the area around Jerusalem which was known as Judah. The Bible tells us how Samson's cords loosened like burning flax and how he subsequently laid hold of an ass's jaw and slaughtered a thousand Philistines before sinking down to the ground to slake his thirst and rest. Small wonder that the Philistines were anxious to know the secret of his strength.

Yet Samson seems to have enjoyed tricking the Philistines. When Delilah first enquired after his secret, he told her that he would have to be bound with seven sapling branches before anyone could take him. Samson allowed himself to be bound by Delilah and then he lay down in her chamber. Delilah had already hidden the Philistines there but when they leapt out to take Samson he confounded them all by bursting free of his bonds, as if they were mere threads. The Bible describes how Delilah was somewhat piqued, claiming that Samson was making fun of her.

Samson then proposed a second bondage using new ropes that had never been tried elsewhere. Once again the Philistines hid in Delilah's chamber, hoping to overpower her lover. But the ropes burst as before, leaving Samson free to mock his enemies. After a third attempt (during which Samson encouraged Delilah to bind his hair into an intricate pattern and fasten it with a pin, but even so he was able to walk away unharmed) the enraged Delilah accused Samson of having no love for her, as he treated her enquiries about his strength with such obvious flippancy. At this Samson revealed the truth, that his strength lay in his hair which had never been cut. Finally mistress of the secret, Delilah lulled Samson to sleep, called a man to shave seven locks from his head and then delivered him up to the Philistines. Delilah was duly rewarded with eleven hundred pieces of silver – many more than those paid so many years later to the traitor Judas for his betrayal of Christ.

Both National Gallery paintings depict the moment when Samson's hair is cut as he lies in the lap of his beloved Delilah. But Rubens' *Samson and Delilah* seems to catch the spirit of the moment most accurately. The Philistines, so many times thwarted by Samson's artful tricks, hesitate on the threshold of the dimly lit chamber. Samson, beguiled into vulnerable sleep through trust and love, sprawls across the wakeful Delilah, whose nerves are

on tenterhooks as she caresses her lover, whilst at the same time offering him up to the razor. Here indeed is a scene of watchful treachery.
[Mantegna (1145); Rubens (6461)]

Savonarola

Savonarola

Execution of Savonarola and Two Companions

[Italian history]

Savonarola, a Dominican monk, was hanged and burnt in the Piazza della Signoria in Florence in May 1498, after a few brief years of power. After the exile of the Medici from Florence in 1494 Savonarola held sway over the Florentine populace with powerful and frightening sermons about the wickedness of mankind and the imminence of the Day of Judgement. The profile portrait of *Savonarola* (a panel painted on both sides) emphasises his stern and purposeful mission. He was finally overcome by the Florentines (with backing from the papacy in Rome) and dragged from his convent of S Marco to be questioned, tried and sentenced. Two companions, Domenico da Pescia and Silvestro Maruffi, were executed at the same time.

The National Gallery Florentine School painting of *The Execution of Savonarola and Two Companions* shows the funeral pyre on the reverse side of the monk's portrait. The citizens gather around to watch and add bales of firewood to the flames which illuminate the corpses hanging above. Beyond we see part of the Palazzo della Signoria and other buildings lining the square. The site of the fire is still marked by an inscribed roundel set into the paving stones of the Piazza.
[Florentine School (1301 and reverse)]

Scenes from the Life of St Vincent Ferrer *see* St Vincent Ferrer

Scenes from the Passion *see* Christ: Crucifixion

Schoolmaster of Falerii [Roman literature: Plutarch, *Life of Camillus*] Plutarch's *Life of Camillus* describes how Camillus (a hero of the Roman republic, d. 365 BC) and his forces marched into the territory of the Faliscans and laid siege to the fortified city of Falerii. Not only was this city well protected by its walls, but its citizens were also well provided with food and drink. The people of Falerii were so confident about their ability to withstand the siege that they used to walk freely in the streets and even allow their children out beyond the walls for exercise. The schoolmaster in charge of the children on such walks was however intent on treachery. Drawing the children farther away from the city each day until they no longer feared the open spaces or the besieging army beyond, he finally led them right up to the Roman lines and demanded to be taken to Camillus. When brought in front of the Roman leader, the schoolmaster explained that he had come to deliver up the children of Falerii (and thus the town itself) to the enemy. He claimed that he wished for no other recompense than Camillus' favour.

Camillus was so outraged by this action that he ordered the schoolmaster to be stripped and driven back into the city by his young charges, giving the children rods and scourges to beat him along the way. Camillus claimed that although war led to injustice and violence, certain laws must still be observed, the most important one being man's sense of right and wrong.

When the children returned to the city they sang Camillus' praises, calling him god and telling their parents and friends (who had been in despair at their disappearance) that he had acted like a father to them. The people of Falerii were so impressed by this act of justice that they decided to offer the city to Camillus' authority.

The painted panel of *The Schoolmaster of Falerii* by the Master of Marradi depicts the moment when the schoolmaster offers to hand over the children of Falerii. He kneels in front of Camillus who is seated on a white horse. Camillus appears again on the left, apparently discussing the surrender of Falerii with the ambassadors who were sent out to him after the children's return. In his hand he holds a great key, symbol of his triumph over the city. In the background we see various stages of the schoolmaster's treachery as he lulls his young charges into a false sense of security, weaving paths in and out of the countryside surrounding the city.

[Master of Marradi (3826)]

Silenus gathering Grapes *see* Bacchanalia

Solomon and the Queen of Sheba *see* Queen of Sheba

Sons of Boreas pursuing the Harpies [Mythological: Apollonius of Rhodes, *Argonautica* II; Virgil, *Aeneid* III] The myth of the blind Phineus tormented by Harpies is connected with that of Jason and his search for the Golden Fleece [*see* Jason].

Jason and his Argonauts met Phineus when they landed in Thrace in their good ship Argo. When the Argonauts arrived Phineus agreed to foretell their future if they rid him of the Harpies. Phineus was in despair at the scourge of Harpies or wind creatures – half bird, half women – who either snatched away his food or defiled it with their filthy touch, making it unfit for human consumption.

In *The Legend of the Golden Fleece*, we read how two sons of Boreas (the North Wind) were among the group of men accompanying Jason on his quest. These sons, Zetes and Calais (born as a result of Boreas' union with the nymph Oreithyia) had human bodies and great wings which enabled them to fly through the air. When Phineus asked for the Argonauts' help Zetes and Calais surged up into the sky and drove the Harpies away over the sea to the island of Strophades. Then they turned back to rejoin their companions. Thus the island became known as the Strophades (*strophe*, a turning).

Pozzoserrato's painting of *The Sons of Boreas pursuing the Harpies* depicts the great battle in the sky high above the exquisite landscape and buildings of Thrace, although somewhat confusingly we find three winged figures involved in the conflict. The figures on the ground are not immediately identifiable, although it is probable that the lower left-hand group depicts Phineus' first wife Cleopatra and their two sons. Cleopatra was the daughter of Boreas and thus the sister of the avenging Zetes and Calais. After Cleopatra's death Phineus remarried. In the right-hand middle ground we see an elderly figure with a crown who seems to reject the clinging embrace and whispered words of a female figure at his side. This figure is probably Phineus' second wife who so hated her step-children that she conspired to defame them in their father's eyes and have them blinded. Phineus'

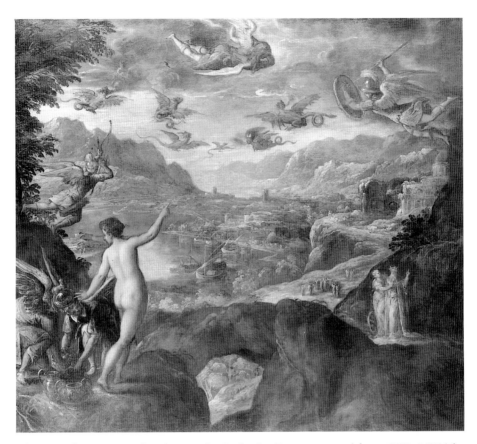

The Sons of Boreas pursuing the Harpies Ludovico Pozzoserrato (about 1550–1603/5)

punishment for agreeing to this dreadful deed was to be blinded himself. We learn how Zeus offered Phineus death or blindness and how he chose the latter, but Helios (the Sun god), feeling that blindness was too light a punishment, sent the Harpies to add to his suffering.

The Harpies were one of the most revolting creations of Greek mythology. In Virgil's *Aeneid* we find a hideous description of harpies at work. Aeneas relates how he and his men landed on the Island of Strophades which was the home of the Harpies after their eviction from Thrace. 'No monster is more grim than the Harpies ... birds with girls' countenances, and a disgusting outflow from their bellies. Their hands have talons and their faces are always pallid with hunger.' Aeneas describes how the Harpies swooped down on him and his men as they sat eating, with a great flapping of their wings and a foul stench, and how they tore at the men's food with horrible screams and made everything unclean with their filthy lips.

[Attr. Pozzoserrato (5467)]

Sophonisba see *Woman Drinking Poison*

Soul of St Bertin carried up to God [Legends of the Saints: L. van der Essen, *Etude sur les vitae des saints mérovingiens de l'ancienne Belgique*] Simon

Marmion's painting of *The Soul of St Bertin carried up to God* shows a nude
figure representing the soul of the seventh-century French missionary St
Bertin being carried up towards the enthroned figure of God the Father by
two angels above the very realistically depicted tiled roof of a church. This
may well represent the monastery church which was founded by the saint
who endured great physical hardship in missionary work around the Pas-de-
Calais.

The National Gallery painting is a fragment from the high altarpiece of the
church of Saint-Bertin at Saint-Omer which developed from St Bertin's
monastery.

[Marmion (1302)]

Stigmatisation of St Francis and the Verification of the Stigmata *see* St
Francis

Supper at Emmaus *see* Christ: Resurrection – 5

Susannah and the Elders [Biblical: *The Apocrypha*: Story of Susannah]
Although it is generally well known that Susannah rejected the advances of
two elderly men who lusted after her, it is not such common knowledge that
they threatened Susannah with public disgrace if she would not agree to sat-
isfy them.

Coming upon the decorous and modest Susannah at the end of a day dur-
ing which they had been invited with other guests into her husband Joakim's

Susannah and the Elders Guido Reni (1575–1642)

garden, the elders offered an impossible choice: either Susannah would satisfy them, or they would denounce her for behaving improperly with an imaginary younger lover. We learn how Susannah rejected their advances and was in consequence denounced by them. She was subsequently condemned to death but was saved when the elders offered conflicting evidence under cross-examination.

Guido Reni's *Susannah and the Elders* is perhaps the more arresting of the two National Gallery depictions of this story, since it suggests that the elders are confident that Susannah will accept their lascivious advances. As the older of the two peers intently at her youthful flesh as if already enjoying its touch, the other figure gently eases away Susannah's robe, whilst lifting a finger to his mouth, as if to warn her against making any sound. Susannah's expression shows that she is considering their proposals and has not yet decided to reject them. Ludovico Carracci's painting on the other hand suggests that Susannah is desperately trying to cover her body as she cowers away from these unwelcome intruders.

[Ludovico Carracci (28); Reni (196)]

Symbolic Representation of the Crucifixion *see* Christ: Crucifixion

Tanaquil [Roman history] Tanaquil, as the inscription *'Binos feci que provida Reges'* (*'With foresight I made two kings'*) in Beccafumi's *Tanaquil* suggests, was a king maker. According to legendary Roman history Tanaquil was first married to Tarquinius Priscus, who was probably Etruscan in origin. After moving to Rome on Tanaquil's advice, Tarquinius was elected king on the death of Ancus Marcius. But several decades later the heirs of Ancus Marcius conspired against Tarquinius, murdered him, and attempted to seize what they considered was their rightful inheritance. Tanaquil contrived however to place Servius Tullius, a slave in the Tarquin household, upon the throne. She thus not only protected her own interests, but also those of her children. Her two sons in fact married the daughters of Servius Tullius – alliances that were doomed to wreak havoc and carnage. One of the daughters not only persuaded her brother-in-law to kill his wife (her sister), his brother (her husband) and his father-in-law Servius (her father), but also arranged that the two of them should then marry and become the next king and queen.

None of this treachery is suggested in Beccafumi's portrait of Tanaquil. Indeed her youthful looks and untroubled brow suggest that she has only recently effected the smooth transference of power from her husband to her slave.

[Beccafumi (6368)]

Temptation of St Anthony *see* St Anthony Abbot

Three Miracles of St Zenobius *see* St Zenobius

Thyrsis asks Damon the Cause of his Sorrow *see* Damon

Thyrsis finds the Body of Damon *see* Damon

Tobias and Tobit
Tobias and the Angel
Landscape with Tobias
Tobias and the Archangel Raphael returning with the Fish
Anna and the Blind Tobit

Tobit and Anna
[Biblical: *The Apocrypha*, Book of Tobit 2. 11]
According to *The Apocrypha* which was written about two centuries before the birth of Christ, Tobit (a Jewish captive in Nineveh) became blind after lying down in the street to sleep and being spattered with the droppings of sparrows. After eight years this blindness was cured by Tobit's son, Tobias. *The Apocrypha* describes how Tobit sent his son on a mission to retrieve money owed to him, and how after a long journey Tobias, in the company of the Archangel Raphael, encountered and killed a monstrous fish. The angel told Tobias to catch the fish, cut up and eat its flesh, and keep back its heart, liver and gall. Returning to his father, Tobias then healed the old man's sight with the fish's gall.

In Domenichino's *Landscape with Tobias* we see the angel issuing directions to Tobias as he kneels beside the river to catch the fish. Tobias holds the box into which he will place the fish's vital parts.

All those paintings showing Tobias still holding the entire fish on his return journey are guilty of artistic licence, since by this time the fish, according to the story, has already been eaten. The painting of *Tobias and the Archangel Raphael returning with the Fish* by a follower of Adam Elsheimer shows a fish of such huge dimensions that Tobias has to drag it along the ground. By comparison, the tiny creature depicted by the follower of Verrocchio in his *Tobias and the Angel* suggests that the artist did not attend closely to descriptions of the fish's size in the original text.

Although there is some uncertainty about the identification of the figures in Abraham de Pape's painting of *Tobit and Anna* the spinning wheel and the apparent poverty of the couple fit well with descriptions of their life during Tobias' absence.

Rembrandt's painting of *Anna and the Blind Tobit* appears on the other hand to show Tobit and his wife Anna waiting for their son's return. There is an atmosphere of quiet expectation, but the woman's alert pose suggests that as well as looking through the window for signs of a traveller on the road, she is also keeping watch over her disabled spouse.
[Domenichino (48); after Elsheimer (1424); Lievens (72); de Pape (1221); Rembrandt (4189); Rosa (6298); style of Rosa (811); follower of Verrocchio (781)]

Tobias and the Angel *see* Tobias and Tobit
Tobias and the Archangel Raphael returning with the Fish *see* Tobias and Tobit
Tobias, Landscape with *see* Tobias and Tobit
Tobit and Anna *see* Tobias and Tobit
Toilet of Bathsheba [Biblical: II Samuel 11. 2–17] The story of Bathsheba casts the normally respectable figure of King David in a slightly unpleasant light. Walking upon the roof of the royal palace in Jerusalem one evening at dusk, David happened to see the beautiful Bathsheba washing herself. He was inflamed with passion at the sight of her nudity, and despite discovering that she was already married to Uriah the Hittite, sent messengers to bring her to him so that he could satisfy his desire.

The Bible describes how Bathsheba came to David, and after making love with him, returned to her own home, only to find some time later that she was pregnant. When she told David about the child, he conspired to get rid of Uriah so that he could marry Bathsheba himself. The hapless Uriah was sent into the thick of battle on David's express command, and was subsequently slain. After a modest period of mourning Bathsheba was called back to David, married him, and later bore him a son. This is clearly not a very edifying story. Even the Book of Samuel could not resist adding that the Lord was not pleased with David's behaviour.

The National Gallery painting of *The Toilet of Bathsheba* in the style of Giordano appears to depict the moment when David first spies upon Bathsheba as she washes in the cool of the evening. We even see the figure of the king leaning forward from the roof of the palace. Yet Bathsheba seems not only to be washing but also to be receiving gifts from a casket held out to her by one of her attendants. Perhaps David has already sent a message to Bathsheba, summoning her to him; she seems already to consider how she might best prepare herself for her meeting with the king, arranging the locks of her hair and seeking advice on which jewels to wear.

[Style of Giordano (4035)]

Tower of Babel [Biblical: Genesis 11. 1–9] The story of the building of the Tower of Babel is a curious mixture of honest human endeavour and slightly devious godly intervention. The Bible describes how many children were born to the sons of Noah, and how a great multitude of people speaking the same language travelled westwards until they came to a plain in the land of Shinar. With great presence of mind they decided to make bricks and mortar and build a city with a great tower that would stretch up into the heavens.

To build a city was a sensible, even practical measure. To try to reach the sky was perhaps somewhat presumptuous. We read how God looked down at the children of the earth as they worked, and was displeased. He decided to confound their corporate efforts by confusing their means of communication with each other. Genesis describes how the Lord first broke up the people's communal language so that they all began to speak in different tongues. And then scattered the people to many different parts of the world. In this way the great building project came to an abrupt halt.

Leandro Bassano's painting of *The Tower of Babel* catches well the spirit of a large number of different people, both men and women, working together to serve a common cause. In the foreground we see the beginnings of the great tower doomed never to rise amongst the clouds.

[Leandro Bassano (60)]

Trajan and the Widow [Italian 13th-century literature: Dante, *The Divine Comedy*, Purgatory, canto X, 76ff] We read in *The Divine Comedy* how, after entering through the gate of Purgatory, Dante climbs up through walls of moving rock to an open terrace above. On one side of the terrace he finds a marble wall cut vertically out of the side of the mountain, which contains carved images from sacred and pagan history. Among these Dante discovers the story of the Roman Emperor Trajan and the Widow.

This story relates how a grief-stricken mother grabbed hold of Trajan's

bridle as he journeyed out one day on horseback, and pleaded with him to avenge the death of her son. One of Trajan's own soldiers had trampled her child under foot. Trajan asked the woman to wait until he returned, but she insisted that he attend to the matter, rather than rely on a successor's sense of duty, if Trajan himself were not to return.

The two National Gallery Veronese School paintings depicting the story of *Trajan and the Widow* show the confrontation between the mother and Trajan in the midst of a throng of trampling horsemen, and the subsequent meting out of justice, when Trajan postpones his journey from the city, and the rider responsible for killing the child is brought to justice.

This scene on Purgatory's mountain wall revealed to Dante that even a pagan leader like Trajan could have a keen sense of duty, and an awareness that individual troubles were as important as high matters of state. But the artist who painted these images based on the Dantean text was clearly not over-familiar with the original verses. Dante's canto contains a description of the golden eagles – symbols of imperial power – fluttering above the emperor in the wind. Yet the figure in the National Gallery paintings is barely distinguishable as a soldier, let alone an emperor, and his followers carry very simple staves, with little suggestion of the panoply of power.

[Veronese School (1135); Veronese School (1136)]

Transfiguration *see* Christ: Ministry – 5

Transformation of Cyparissus [Mythological: Ovid, *Metamorphoses* x] Cyparissus, a beautiful youth who was much loved by Apollo, edges into the story of Orpheus since he too was doomed to a life of lamentation.

Ovid describes how after losing Eurydice for ever Orpheus came to the top of a bare hill and started to play on his lyre [*see* Orpheus]. His melancholic music so enchanted the animals that they gathered around in thralled silence to listen to him. And at the same time a large number of trees began to grow and bend their branches towards him as if also listening. Amongst these was the cypress, the tree into which Cyparissus was changed after mistakenly killing a sacred stag.

Ovid describes how Cyparissus used to take a stag, which had gleaming golden antlers and a jewelled collar, to graze in the pastures and drink from clear spring waters. The stag was so tame that Cyparissus could garland his horns and ride on his back. But one hot, shadeless day, when the stag sought refuge in the cool of the forest, he was pierced by a javelin unwittingly thrown in his direction by Cyparissus.

Cyparissus was heartbroken by the stag's death and despite Apollo's protests and attempts to calm his grief, begged that he might be able to mourn for ever. Apollo granted his request and as he neared death, exhausted by endless weeping, his limbs began to turn green and he was transformed into a cypress tree.

Apollo also promised that he would always mourn for the youth and that Cyparissus himself would always mourn for others. Apollo decreed that the cypress tree should always grow in those places where people grieved for their lost loved ones.

The Transformation of Cyparissus by Domenichino and assistants shows the

grief-stricken Cyparissus changing into a tree as he laments the death of the stag lying on the ground beside him. The painting differs in some details, however, from the original story. The stag appears to be lying in the open rather than in the shade of the forest. There are no signs either of his wearing the jewelled collar and pearl ear pendants described by Ovid. The painting originally included in an upper portion the seated figure of Apollo in the clouds. This detail presumably reflected that part in the story where Apollo promised his friend an immortal place amongst the world's mourners. [Domenichino and assistants (6286)]

Tribute Money *see* Christ: Ministry – 6
Triumph of David over Saul *see* David – 1
Triumph of Pan *see* Bacchanalia
Troy – 1

Building of the Trojan Horse [Mythological: Homer, *Odyssey* IV; Virgil, *Aeneid* II] The Trojan horse was the artful weapon constructed by the Greeks during the Siege of Troy. Of massive dimensions, and made of wood, its belly was left hollow to conceal a number of heavily armed Greek soldiers.

Virgil describes how the Trojan horse (also known as the Wooden Horse) was made by the Greeks in a last attempt to breach the walls of Troy. The flanks of the horse were made from a trellis of sawn firwood under the directions of Epeius. This may well be the figure who stands gesticulating in front of the horse in Giovanni Domenico Tiepolo's *The Building of the Trojan Horse*. Although the two figures at the left have been identified as Agamemnon and Odysseus, the figure skulking in the background seems hardly fitting for one of the Greek heroes.

Both Menelaus (the husband of Helen, whose elopement with Paris laid the ground for the Trojan War [*see* Paris – 2]) and Odysseus [*see* Odyssey – 1

The Building of the Trojan Horse Giovanni Domenico Tiepolo (1727–1804)

and Odyssey – 2] were among the men picked to be concealed in the great horse's belly. The Greeks then left it outside the city walls, counting on the curiosity of the Trojans to come and investigate after their departure. But in order to ensure that the Trojans would take the horse back into the city with them, the Greeks left one of their band (Sinon) behind to persuade the Trojans that it had been made as an offering to Athena. Sinon told the Trojans that if they set the horse up inside Troy it would bring them good luck, as well as the protection of the goddess of War.
[Giovanni Domenico Tiepolo (3318)]

Troy – 2

Procession of the Trojan Horse into Troy [Mythological: Virgil, *Aeneid* II] Virgil describes how the people of Troy, deceived into believing that the Greeks had retreated – leaving the Wooden Horse behind as an offering to secure a peaceful homeward journey [*see* Troy – 1] – trundled the monster into the city amidst celebrations of dancing and singing.

Giovanni Domenico Tiepolo's painting of *The Procession of the Trojan Horse into Troy* is faithful to the original text in showing the joyful citizens encouraging the movement of the horse as it is hauled along on its rollers by a great rope attached to its foreleg. Virgil describes how the priest Laocoon tried to prevent the horse's entry into Troy and how when the citizens made a gaping hole in the walls to ease its passage – thus making themselves acutely vulnerable to attack – Cassandra (the prophetic daughter of King Priam of Troy) screamed out more warnings, but was still unable to dampen their enthusiasm. Tiepolo's painting in fact shows Cassandra being dragged away by her own people, as the great beast launches forward on its triumphal procession into the city.
[Giovanni Domenico Tiepolo (3319)]

The Procession of the Trojan Horse into Troy
Giovanni Domenico Tiepolo (1727–1804)

Two Followers of Cadmus devoured by a Dragon *see* Cadmus
Ulysses deriding Polyphemus *see* Odyssey – 1
Union of Dido and Aeneas *see* Dido – 3
Venus – 1

Birth of Venus [Mythological: Hesiod, *Theogony*, 188–200] According to Greek mythology Venus (in Hesiod Aphrodite) was born out of the foam which spewed from the castrated genitals of her father Uranus. Venus is often shown floating over the sea on an upturned scallop shell, long golden tresses fluttering in the breeze as she wafts gently towards land. By tradition it was believed that Venus first set foot on the island of Cyprus.

In Rubens' painting of *The Birth of Venus* the Sea goddess is shown stepping out of her shell on to a rocky shore. But although she is accompanied by a number of sea nymphs in reference to her origin, there is little to indicate that the land she has reached is Cyprus.

[Rubens (1195)]

Venus – 2

Venus and Adonis [Mythological: Ovid, *Metamorphoses* x] Adonis sprang fully formed from the myrrh tree into which his mother Myrrha was transformed after an incestuous relationship with her father Cinyras. Ovid describes how Myrrha, bitterly ashamed and wanting neither to live nor die, begged that she might be spurned by both the living and the dead. We learn how she continued to lament even when transformed into a tree, and how the liquid from her tears trickled down the bark of the tree-trunk as myrrh. When Adonis grew up Venus was so taken by his beauty that she fell passionately in love with him, following him everywhere, clinging to him, even going hunting with him and his hounds.

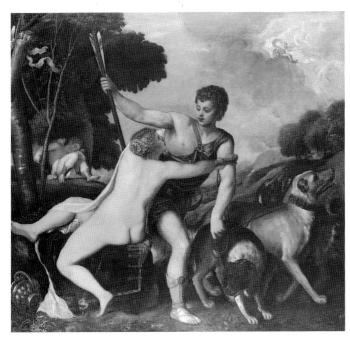

Venus and Adonis
Studio of Titian
(active before
1511, died 1576)

The National Gallery painting of *Venus and Adonis* from the studio of Titian depicts Venus in the sky, as if in full pursuit of the hunt, but in the foreground she clutches Adonis as if to hold him back from danger. Adonis hesitates, as if listening to some kind of warning.

Ovid tells us that Venus warned her young lover to beware of wild boars, wolves, bears and lions. The National Gallery painting suggests that this is the moment when Venus attempts to hold Adonis back from the dangers of the hunt. But Adonis' ardour has cooled (a fact no doubt reflected in the dozing figure of Cupid in the left background) and he is eager to leave. He seems barely even to consider his lover's anxiety. With one hand he clutches his hunting spear, and with the other he holds the leads of his hounds, reluctant to let go of either in order to return her embrace. Cupid's quiver hangs from the trunk of a tree in the foreground, reminding us that Venus was once grazed by one of her son's arrows as she clasped him in a passionate embrace and as a result was filled with an undying love for Adonis. But Adonis' larger version of Cupid's weapon symbolises death. This is the end of their love and he himself will be gored by a wild boar whilst out hunting. Venus, who hears his cries as she surges across the heavens in her chariot, arrives too late to save him.

[Studio of Titian (34)]

Venus – 3

Venus and Mars

Mars and Venus

[Mythological: Homer, *Odyssey* VIII; Ovid, *Metamorphoses* IV]

According to classical mythology Mars (the god of War) fell in love with Venus (the goddess of Love). Their passion for each other was frequently used by artists to illustrate the harmony which could come from such a union, despite the fact that Venus was in fact already married to Vulcan (the god of Fire).

Classical texts describe how Vulcan was consumed with jealousy and anger at the friendship between Mars and Venus and how he tried to catch them in the act of love and ensnare them in a great net of chains which he forged in his fire. Vulcan's figure, distorted through rage and jealousy, is often included in the background of paintings depicting the two lovers.

Botticelli's painting of *Venus and Mars* depicts the two lovers in attitudes of repose, their desire apparently sated. Venus and Mars have only the hard ground to lie on, but the activities of the little satyrs who cavort in Mars' armour and mock his prowess in battle present us with the clear message that their passion is satisfied and the brute force of the god of War is tamed.

In Palma Giovane's *Mars and Venus* Venus presses her mouth to her lover's lips whilst heaving him up on to the softly cushioned bed. A winged cupid appears to aid and abet Venus by adding his own shoulder to the task. At the same time he divests Mars of his boots. Other parts of Mars' clothing, including an elaborately plumed helmet, are scattered around the boudoir, which – according to Homer – formed part of Vulcan's palace. In this painting Venus' campaign of love has clearly only just begun.

[Botticelli (915); Palma Giovane (1866)]

Venus and Mars Sandro Botticelli (about 1445–1510)

Venus and Adonis *see* Venus – 2
Venus and Mars *see* Venus – 3
Vestal Virgin Tuccia with a Sieve [Roman literature: Pliny, *Natural History*, 28:12] Accusations of unchastity are rarely regarded as complimentary. For a Vestal Virgin, guarding the fire of the Temple of Vesta in ancient Rome, such an accusation was not only unwelcome, but could also lead to a hideous death. If found guilty of such a charge, she was entombed alive. No wonder then that the Vestal Virgin Tuccia felt she had to perform some extraordinary task to prove her innocence when branded by such an accusation.

According to Pliny, Tuccia filled a sieve with water and carried it all the way from the River Tiber back to the Forum where the Vestal Virgins lived, without spilling a drop.

The National Gallery painting by Mantegna of *The Vestal Virgin Tuccia with a Sieve* shows an intrepid Tuccia, who even turns her face away from the sieve she is carrying. She is so certain of her innocence that she does not need to watch the tilt of the sieve or look for water escaping from its fine mesh.
[Mantegna (1125A); Moroni (3123)]

Virgil reading the Aeneid to Augustus and Octavia [Roman literature: Donatus, *Life of Virgil*] Marcellus was the much loved son of Gaius Claudius Marcellus and Octavia (the sister of the Emperor Augustus). He appeared to have everything to live for: he was favoured by Augustus, successful in battle, and blessed also in his own personal life. When he died at the tender age of nineteen his parents and friends were therefore devastated. Donatus relates how Virgil paid tribute to Marcellus in the sixth book of the *Aeneid*, describing him as a conqueror towering above all other warriors. When this passage was read out in front of the emperor and his sister, Octavia fainted with grief.

Jean-Joseph Taillasson's painting of *Virgil reading the Aeneid to Augustus and Octavia* shows Virgil declaiming his verses to an enraptured audience. Onlookers watch, spellbound, and bend forward to hear the sad eulogy for Marcellus. The emperor's pose suggests that he would hear more yet can scarcely bear the pain of reliving his nephew's untimely death. At his side

Octavia, with hand hovering over her heart, has already abandoned herself to grief.

[Taillasson (6426)]

Virgin Mary: Annunciation

Annunciation

Annunciation with St Emidius

[Biblical: Luke I, 26–38; Apocrypha: *The Book of James*; Italian 13th-century literature: Jacopo da Voragine, *The Golden Legend*]

The Bible tells us that after Mary had been officially espoused to Joseph (a carpenter living in her home town of Nazareth) she was visited by the archangel Gabriel. Secondary texts tell us that the Virgin was not so much troubled by the angelic visitation – she was quite used to such visitors – as by the message he brought. According to Luke the angel Gabriel told Mary that she had found particular favour with the Lord and that of all women she was especially blessed. Seeing the Virgin somewhat puzzled by these words, he

The Annunciation Nicolas Poussin (1594(?)–1665)

told her that she was to have a son and that his name would be Jesus. Jesus would be a great man and people would call him Son of the Highest. Not only would he be a king, but his reign would go on for ever. Mary's first response to this concerned the practical point that she was still a virgin. But the angel told her that she would conceive as a result of being 'touched by the Holy Ghost and overshadowed by God the Father'.

Paintings of the Annunciation show the Virgin Mary at various stages during her conversation with the angel Gabriel. She is frequently shown virtuously at her studies or prayers and often shows concern or surprise at being interrupted. Comparatively few images show the Virgin in apparent acquiescence with head bent and hands crossed reverently in front of her.

Nicolas Poussin's painting of *The Annunication* seems to depict the precise moment of conception as described in Gabriel's message. The Virgin sits as if in a trance beneath a hovering dove, simultaneously 'touched' by the Holy Ghost and cast in shadow in the central part of her body, as if receiving the power of God the Father in her womb.

[Follower of Angelico (1406); Crivelli (739); Duccio (1139); Gaudenzio (3068); attr. Giannicola di Paolo (1104); Giovanni del Ponte (inset panel) (580A); Giusto de' Menabuoi (inset panel) (701); Filippo Lippi (666); Master of Liesborn (256); attr. Pietro Orioli (side panels) (1849); Nicolas Poussin (5472); Tura (905); Tuscan School (inset panel) (584)]

Virgin Mary: Birth

Birth of the Virgin
Presentation of the Virgin
[Apocrypha: *The Book of James*; Italian 13th-century literature: Jacopo da Voragine, *The Golden Legend*]
According to the Apocryphal *Book of James* and other texts dealing with the lives of the saints such as the thirteenth-century *Golden Legend*, the Virgin Mary was the child miraculously born to Joachim and Anna in their old age. Joachim and Anna vowed that if they were blessed with a child they would offer it in thanksgiving to the temple [*see* Virgin Mary: Conception]. Thus, at the tender age of four Mary was presented to the temple where she dedicated her life to purity and religious instruction.

Depictions of the Birth of the Virgin often include in the background the meeting of Joachim and Anna at the Golden Gate of Jerusalem, since it was here that the elderly couple embraced with joy, gladdened by the knowledge that after years of infertility Anna was to give birth to a very special child. Their kiss was thought to mark the moment of Mary's conception [*see* Virgin Mary: Conception].

The birth scene frequently shows Anna in bed after childbirth and turning over on her side to talk to one of her maidservants. At other times, as in Giusto de' Menabuoi's *The Birth of the Virgin*, Anna sits up to wash her hands and receive food, whilst the midwives wash the newborn baby in the foreground. *The Presentation of the Virgin* by the same artist shows Anna helping her child up the temple steps where the priest waits to welcome her and take her into a life of seclusion.

[Giusto de' Menabuoi (outer inset panel) (701); Master of the Osservanza

The Birth of the Virgin and *The Presentation of the Virgin*
Giusto de' Menabuoi (active 1363/4, died 1387/91)

(5144); after Murillo (1257); Netherlandish(?) (3650); Dalmatian School (side panel) (4250)]

Virgin Mary: Conception

Immaculate Conception
Immaculate Conception of the Virgin, with Two Donors
St Joachim's Offering rejected
Angel appearing to St Joachim
Meeting at the Golden Gate
Charlemagne, and the Meeting of Sts Joachim and Anne at the Golden Gate
[Biblical: Ecclesiastes, Revelations 12. 1, Song of Solomon; Apocrypha: *The Book of James*; Italian 13th-century literature: Jacopo da Voragine, *The Golden Legend*] The Immaculate Conception is one of the four declared Roman Catholic dogmas concerning the Virgin Mary, the other three being her Divine Motherhood, her Virginity and her Assumption into heaven.

Although the doctrine of the Immaculate Conception was already in circulation during the early Christian period, it was not mentioned in the Bible, and it was only declared a mandatory belief in the mid nineteenth century. During the Middle Ages, the doctrine was constantly questioned, with doubt reaching a climax during the sixteenth century and the period of the Reformation and Counter-Reformation. Those in dispute with the doctrine argued that Mary was human and that she had been born as a result of human intercourse and pregnancy. Her flesh was thus both tainted and corruptible. Those in support of the doctrine of the Immaculate Conception maintained that the Virgin Mary was spotless and untainted by original sin from the moment of her conception, and throughout her life.

The Bible makes no mention of Mary's parents Joachim and Anna (often referred to as St Anne) but stories about her family emerged at a comparatively early stage. In the late thirteenth century Jacopo da Voragine described in great detail the circumstances leading up to the Virgin's birth. We learn how Joachim of Nazareth married Anna of Bethlehem and how the couple lived a righteous life, giving a third of their money to the temple and its servants, a third to pilgrims and the poor, and keeping the last third for themselves, as commanded by the Lord. But they remained childless during twenty years of marriage. Desperate for a child, they vowed that if their marriage were blessed in this way, he or she would be dedicated to the service of God. Each year Joachim and Anna travelled to Jerusalem to make offerings at the three main festivals. On one occasion – the Feast of the Dedication – Joachim was brusquely turned away by the officiating priest, and, to his great shame, cast out of the temple. His sterility was seen as a stain which made him unworthy of making sacrifices to the Lord.

The Dalmation School painting of *St Joachim's Offering rejected* shows the priest physically ejecting Joachim watched by a number of bystanders. Withdrawing in shame amongst his shepherds, Joachim spent many days in fear of returning home in case he might be subjected to similar taunts from the friends and neighbours who had witnessed his public humiliation in the temple.

Jacopo da Voragine describes how Joachim was then visited by an angel who brought miraculous news. This scene is depicted in both the Dalmation School and Giusto de' Menabuoi's *Angel appearing to St Joachim*. The angel told Joachim that his prayers had been heard, and that far from seeming unworthy in the eyes of the Lord, he and Anna had been chosen to receive a miraculous gift, a child born from an infertile womb late in life. This would be a gift from God rather than the fruit of passion. The angel told Joachim that he should return home, and that, on arriving at Jerusalem, he would meet his wife Anna at the Golden Gate.

It was commonly believed that the moment of conception of the Virgin took place during the meeting at the Golden Gate. The angel told Joachim that Anna would be overcome with joy at seeing her long absent husband. Most depictions of this scene (such as the Dalmatian School *Meeting at the Golden Gate*) dwell on the intimate affection existing between the ageing couple. But the National Gallery painting attributed to the studio of the

Master of Moulins of *Charlemagne, and the Meeting of Sts Joachim and Anne at the Golden Gate* offers an extra dimension in the way in which Joachim places his left hand on Anna's stomach. It is as if Joachim already feels the quickening of the embryonic Mary within his wife's womb.

The inscription held by angels in the Crivelli painting of *The Immaculate Conception* affirms the purity of Mary's conception. 'As from the beginning I was conceived in the mind of God, so have I been made'. The lily and roses at either side are particularly appropriate in this context. The white lily, symbol of purity, was often presented to the Virgin Mary at the moment of the Annunciation of the immaculate birth of her own child Jesus [*see* Virgin Mary: Annunication]. And, according to an early legend mentioned by St Ambrose, the other flowers – the roses – grew without thorns (in other words without the power to inflict pain) before the Fall of Man and the expulsion of Adam and Eve from Paradise [*see* Adam and Eve]. The rose was thus also used as a symbol for the Virgin since she was considered to be the second Eve, brought into the world to redeem the sins of the first.

For believers, Mary symbolised the most perfect being after her son Jesus Christ, and furthermore, like her son, triumphed over the iniquities of the devil. For this reason depictions of the Immaculate Conception sometimes show the Virgin trampling on a dragon or serpent, both symbols of Satan. The Virgin is also frequently depicted standing on the moon.

The moon also appears in apocalyptical writings. The Book of Revelation refers to a 'great wonder in heaven; a woman clothed with the sun, and the moon under her feet, and upon her head a crown of twelve stars'. This image was adopted in many depictions of the Immaculate Conception. In *The Immaculate Conception* attributed to Murillo the Virgin is shown silhouetted

The Immaculate Conception of the Virgin, with Two Donors
Juan de Valdés Leal (1622–90)

against the sky in an aureole of light, the moon at her feet, and hands raised to her breast in an attitude of devotion. The Virgin is also sometimes accompanied by flying angels or cherubim who hold lilies, an olive branch or a cornsheaf – symbols of Mary's purity, wisdom and fruitfulness.

The image of the Immaculate Conception was particularly popular in seventeenth-century Spain amongst such artists as Murillo, Valdés Leal and Velázquez. In fact, Velázquez's father-in-law, Francisco Pacheco, suggested an iconographical scheme for the Immaculate Conception in his *Arte de la Pintura* (a textbook of painting). Pacheco based his ideas on the visions of a fifteenth-century Portuguese mystic, Beatrice de Silva.

Juan de Valdés Leal's painting of *The Immaculate Conception of the Virgin, with Two Donors* includes the victor's palm, the rose and the iris. In this painting we also see a mirror, no doubt symbolising the unspotted mirror of God which is described in the Song of Solomon. The throne in the background of the Valdés Leal painting also probably refers to King Solomon.
[Crivelli (906); Dalmatian School (side panels) (4250); Giusto de' Menabuoi (outer inset panel) (701); studio of the Master of Moulins (4092); attr.

The Coronation of the Virgin Giusto de' Menabuoi (active 1363/4, died 1387/91)

Murillo (3910); Valdés Leal (1291); Velázquez (6424)]
See also Helsinus
Virgin Mary: Coronation
Coronation of the Virgin Despite the fact that the Coronation of the Virgin is not described in the Bible, Mary as queen forms part of the Christian tradition from at least the fourth century onwards.

Most of the National Gallery depictions of the Coronation of the Virgin show the traditional format of the Virgin kneeling or seated beside Christ, and being crowned by him in the company of saints and angels. The paintings by the Master of Cappenberg, Johann Rottenhammer and Guido Reni are, however, somewhat different. Two of them, the Guido Reni and the Master of Cappenberg, show the Virgin being crowned by the Trinity in the form of God the Father, God the Son and God the Holy Ghost. And in Johann Rottenhammer's *The Coronation of the Virgin* the coronation group hovers in the heavens amidst a great company of angels and holy men and women. In the Reni painting the Virgin is crowned instead by angels, and seems wafted heavenwards by both angels and saints. It thus assumes something of the character of an Assumption [*see* Virgin Mary: Assumption] or Glorification of the Virgin.

[Barnaba da Modena (side panel) (2927); attr. Agnolo Gaddi (568); Giusto de' Menabuoi (701); Lorenzo Monaco (1897); Master of Cappenberg (263); Jacopo di Cione(?) (569); Reni (214); Rottenhammer (6481)]
Virgin Mary: Death – 1
Death of the Virgin
Dormition of the Virgin
Entombment of the Virgin
[Apocrypha: *The Book of John concerning the Falling Asleep of Mary*, and *The Passing of Mary*; Apocalyptic and hermetic literature, 2nd and 3rd centuries AD; Obsequies of the Holy Virgin] Although the death of the Virgin is not mentioned in the Bible, she is traditionally thought to have died at Ephesus. People still visit the Virgin's house at Ephesus, although according to some texts she died in Bethlehem, and yet others maintain that her last resting place was Jerusalem. The Gospel of John tells us that Christ looked down from the cross and entrusted his mother to the care of his favourite disciple John [*see* Christ: Crucifixion]. We learn how John then accepted the Virgin Mary, taking her home to live with him. It is significant therefore that John is also said to have died at Ephesus.

The death scene is sometimes described as the Dormition of the Virgin, since many believed that Mary did not die, but only fell asleep. Other titles include the Obsequies of the Virgin, in reference to the prayers, meditations and blessing that the apostles administered after her death. Depictions of the Virgin's death traditionally show her in bed surrounded by the figures of the apostles who cluster about in prayer and mourning.

Some of the early texts describe how the Virgin prayed on her death bed that she might see Jesus, the apostles and disciples before she died. From all over the world, and from beyond the grave these individuals then came to embrace the Virgin, to comfort her in her last hour, and to talk together and

The Death of the Virgin Imitator of Robert Campin (1378/9–1444)

perform miracles.

The National Gallery painting of *The Death of the Virgin* attributed to an imitator of Campin shows the Virgin's bedchamber filled with figures in attitudes of prayer, devotion and tender loving care. A half-length figure of God the Father hovers over her head as if waiting to receive her.

[Byzantine (4030); imitator of Campin (658); Gerolamo da Vicenza (3077); Tyrolese School (4190)]

Virgin Mary: Death – 2

Assumption of the Virgin [Apocrypha: *The Book of John concerning the Falling Asleep of Mary,* and *The Passing of Mary;* Italian 13th-century literature: Jacopo da Voragine, *The Golden Legend*] According to tradition, although

the Virgin died the normal death of a human [*see* Virgin Mary: Death – 1], Peter urged Jesus to raise her up body and soul to join him in heaven. The raising of the Virgin's body and soul after death is known as the Assumption. The cult of the Assumption of the Virgin stemmed from the belief that because the Virgin was so pure during her life her flesh could not be corrupted in death. Although not described in the Bible, the Assumption of the Virgin was included in Marian literature as early as the third century AD. These texts describe how three days after her death her body and soul were taken up together into heaven.

Many depictions of the death of the Virgin are in fact Assumptions since they show the figure of the Virgin being transported upwards by angels, or already in the arms of a God the Father figure. Gerolamo da Vicenza's *Death of the Virgin* gives a particular prominence to the ascending figure of Mary, raised in glory above her death bed.

The National Gallery depictions of the Assumption show the Virgin's tomb, and the figure of the Virgin herself in the company of angels. However, in *The Assumption of the Virgin* ascribed to Botticini we see in addition the figures of the apostles gathered around the tomb which has sprouted flowers symbolic of the Virgin's purity. We also see that the Virgin is kneeling in front of Christ in a celestial hierarchy of angels and saints arranged in nine circles.

Matteo di Giovanni chose in his *Assumption of the Virgin* to depict the moment when the Virgin was lifted up to heaven by a band of angels. She has not yet been received by her Son, who hovers above her in the company of saints and prophets. Matteo di Giovanni also chose to show one apostle figure only at the side of the Virgin's tomb. This is Thomas who doubted that the body of the Virgin had indeed been transported to heaven. According to apocryphal sources the Virgin had to let down her girdle so that Thomas would realise that both her soul and fully clothed body had ascended to her maker.

[Attr. Botticini (1126); Gerolamo da Vicenza (3077); Matteo di Giovanni (1155)]

Virgin Mary: Marriage

Marriage of the Virgin [Apocryphal writing; Italian 13th-century literature: Jacopo da Voragine, *The Golden Legend*] Although not described in the Bible, the iconography of the Marriage of the Virgin was well established by the Middle Ages. Most depictions of the scene show the elderly figure of Joseph holding his flowering branch and placing a ring upon the Virgin's finger. The marriage is celebrated by the High Priest, usually against the background of a temple – no doubt in reference to the childhood years spent by Mary in the seclusion of the temple precincts [*see* Virgin Mary: Birth]. We very often also see the rejected suitors standing at the side. They express rage and disappointment as they break their flowerless wands over their knees. The prophesy was that only the person whose wand flowered was worthy of marrying the Virgin.

The National Gallery depictions conform to the established conventions, although Niccolò di Buonaccorso's *The Marriage of the Virgin* includes the haloed figures of Joachim and Anna (the Virgin's parents) in a prominent

The Marriage of the Virgin
Niccolò di Buonaccorso
(active 1372, died 1388)

position behind the figure of Joseph. In the Sienese School painting we catch only a partial glimpse of a haloed female figure (presumably Anna) behind the Virgin.

[Ludovico Carracci (L413); Daddi (L13); Giusto de' Menabuoi (outer inset panel) (701); Niccolò di Buonaccorso (1109); Sienese School (1317)]

Virgin Mary: Visitation

Visitation [Biblical: Luke 1. 39–56; Apocrypha: *The Book of James*; Christian writings: Pseudo-Bonaventura, *Meditations on the Life of Christ* v] Luke's Gospel describes how, shortly after the annunciation from the angel Gabriel [*see* Virgin Mary: Annunciation], Mary left Nazareth and travelled over the hills to visit her cousin Elizabeth who lived in Judaea. Luke tells us how Mary learnt from the angel that her cousin (who had been barren for many years)

was already six months pregnant.

Arriving at Elizabeth's house, Mary went in and greeted her cousin. The Bible describes how Elizabeth felt her child leap in her womb at Mary's greeting. Filled with wonder, Elizabeth blessed Mary and the child.

There is no reference in the Bible text to Joseph, nor to Elizabeth's husband Zachariah being present at this meeting. But the *Meditations on the Life of Christ* does refer to the two men and includes an illustration of Joseph and Zachariah embracing. Both National Gallery depictions of the scene include male figures. Indeed in the (?)Italian School painting of *The Visitation* it seems that both husbands witness the greeting between Mary and Elizabeth.

However, in *The Visitation* attributed to the studio of the Master of 1518 it seems as if the artist has paid closer attention to the text, since Mary arrives on foot and alone. But the two cousins do not meet inside the city; instead Elizabeth has gone out to meet Mary and seems about to kneel in front of her, as if acknowledging the special nature of her cousin's pregnancy. The scurrying figure of an old man in the background adds a human touch to this awesome scene. Perhaps this is Zachariah who has reacted somewhat more slowly to the arrival of their kinswoman and now hurries out to greet her.

[(?)Italian School (5448); studio of the Master of 1518 (1082)]

Virgin and Child with Saints Catherine of Alexandria and Siena *see* St Catherine

Vision of the Blessed Clare of Rimini [Legends of the Saints: G. Garampi, *Life of the Blessed Clare of Rimini* (*Memorie ecclesiastiche appartenenti all'Istoria e al culto della Beata Chiara di Rimini*), Rome 1755] Garampi's *Life of the Blessed Clare of Rimini* describes how the fourteenth-century St Clare of Rimini had a vision of Christ, in which Christ showed her the marks of his suffering on the cross and offered her his peace. As a result Clare, who until the time of her vision had led a somewhat raucous and licentious life, developed a particular interest in the Passion of Christ.

The National Gallery painting of *The Vision of the Blessed Clare of Rimini* by the Master of the Blessed Clare shows St John the Evangelist standing between the kneeling Clare and a much larger figure of Christ who is accompanied by his twelve disciples. With one hand St John offers an open book to Clare upon which is written Christ's promise of peace; with the other he gestures towards Christ who is revealing the wounds of the crucifixion in his side and hands. The foremost of the disciples seem to present Christ to Clare, touching his clothes and pushing him towards the kneeling saint. Clare is shown in the chequered habit traditionally worn by penitents. Although her knotted belt suggests a connection with the Franciscan Order of the Poor Clares who followed St Francis [*see* St Francis], there is no evidence that she was in fact attached to any particular Order.

[Master of the Blessed Clare (6503)]

Vision of the Blessed Gabriele [Legends of the Saints: Mekhiorri, *Leggenda del Beato Gabriele Ferretti di Ancona, Sacerdote dei Francescani Osservanti*] According to tradition, the fifteenth-century superior of the Franciscan covent of S Francesco ad Alto, the Blessed Gabriele, had a vision of the Virgin Mary one night whilst he was praying in a wood near his friary.

Several decades after his death in 1456 his body, which was found to be miraculously uncorrupted, was transferred to a tomb inside S Francesco.

Crivelli's painting of *The Vision of the Blessed Gabriele* quite clearly depicts the vision in the sky as well as the prayer book upon the ground. The artist has, however, taken a number of liberties with the original story. Although a few sparsely foliaged trees are shown, the surroundings hardly suggest a wood. Moreover, the sky is clear, as if the vision were taking place by day rather than by night.

Italian artists of the fifteenth century were quite capable of painting night scenes, whether for the adoration of the newly born Christ child, or for the moment of ecstasy of a saint. Perhaps Crivelli deliberately chose day-time lighting to help us distinguish Gabriele from the more famous St Francis who founded the Franciscan order. In this light we are able to see that the Blessed Gabriele does not carry the marks of the stigmata, unlike his illustrious predecessor. Crivelli may even have deliberately removed the sandals from Gabriele's feet in order to emphasise the fact that his flesh is unmarked. The day-time lighting also allows us to see the conventual buildings of S Francesco ad Alto in the background. These architectural details confirm the identification of Gabriele since we know that the church of S Francesco at Assisi was only erected after Francis' death [*see* St Francis]. The background details of the winding path descending past a town towards a patch of water in the distance remind us also that S Francesco ad Alto was associated with the town of Ancona, and therefore close to the Adriatic sea.

[Crivelli (668)]

Vision of the Dominican Habit [Legends of the Saints] According to tradition the Blessed Reginald of Orléans and St Dominic both received visits from the Virgin Mary in the company of two angels. In each case the Virgin held up a black and white habit to indicate how she wished the Dominican friars to dress. The Dominican order was finally approved in 1216. Its members were known as the Black Friars.

The National Gallery painting of *The Vision of the Dominican Habit* by a follower of Fra Angelico shows the Virgin Mary appearing to the Blessed Reginald in his bedchamber, flanked on either side by standing angels. We sense that she is physically present in his room as she reveals the black and white robes to him. One of the angels even reaches out to touch Reginald on his shoulder. In the other scene where the Virgin appears to St Dominic we are more conscious of the fact that Dominic is receiving a vision since she hovers in the air in front of him.

[Follower of Fra Angelico (3417)]

Vision of Father Simón [Spanish history] Like many earlier visionaries, the Spanish priest Father Simón (1578–1612) was miraculously visited by Christ. However, unlike the Blessed Clare of Rimini [*see* Vision of the Blessed Clare of Rimini] or the earlier St Francis of Assisi [*see* St Francis], Father Simón saw Christ before the moment of his crucifixion as he toiled up towards Golgotha.

Accounts of the life of Father Simón (who was never in fact beatified) contain grisly descriptions of his mortification of the flesh, including the eating

of bodily wastes (both vomit and excreta). This was in fact a hallowed practice dating back to the time of the anchorite monks when devotees would consume the contents of baskets handed down each day after the holy men's ablutions. But Francisco Ribalta's painting of *The Vision of Father Simón* draws our attention to the visionary aspects of his life rather than his gastronomical habits.

According to contemporary accounts Father Simón saw Christ on a number of occasions, each time in the same place – the Calle de Caballeros in Valencia. This was the road up which convicted criminals of the day were led to execution. Small wonder then that Father Simón's vision should be of Christ on his way to his execution.

Ribalta's painting shows the priest kneeling in the deserted Calle de Caballeros, and reaching up towards a world-weary figure of Christ who is bowed down by the weight of the great cross on his back. On the other side, behind Christ, we distinguish the figures of trumpeters and those who follow to mock and jeer. The banner with its initials SPQR (Senatus Populusque Romanus, the Senate and people of Rome) reminds us that these figures are contemporaries of Christ. Behind Father Simón we catch a glimpse of a group of people who also follow the procession. These are probably the three Maries or St John and the Maries, who follow some distance behind the cross.

[Ribalta (2930)]

Vision on Patmos *see* St John the Evangelist

Vision of St Augustine *see* St Augustine

Vision of St Bernard *see* St Bernard

Vision of St Eustace [Legends of the Saints; Italian 13th-century literature: Jacopo da Voragine, *The Golden Legend*] Since Pisanello, the painter of *The Vision of St Eustace,* was an Italian artist it seems more likely that the saint depicted in this work is St Eustace rather than the northern European St Hubert of the Ardennes [*see* St Hubert – 1] Yet, according to tradition, both Eustace and Hubert were converted after receiving a vision of a stag with a crucifix between its antlers.

Pisanello's saint is dressed neither as a bishop (as should be the case with St Hubert), nor as a general (as would be the case with the legendary St Eustace who served in the Emperor Trajan's army). Comparison with the painting by the Master of the Life of the Virgin which is thought to depict the conversion of St Hubert [*see* St Hubert – 1] suggests that Pisanello's saint has yet to grasp the significance of the vision (involving in both cases a brown rather than a white stag). Pisanello's figure pauses on his horse, yet does not appear unduly surprised by the apparition. Nor do we feel that he is suddenly converted. Indeed – unlike the saint in the painting by the Master of the Life of the Virgin – Pisanello's figure lacks the customary aureole of light, or halo. Yet the religious symbolism is clear. The stag with its crucifix confronts him and his horse and dogs stop in their tracks as if unsure how to proceed.

[Pisanello (1436)]

Vision of St Helena [Legends of the Saints; Italian 13th-century literature: Jacopo da Voragine, *The Golden Legend*] Although Helena is said to have

received divine guidance in finding the place where the True Cross was buried, Jacopo da Voragine describes how a Jew named Judas helped Helena in her search. According to *The Golden Legend* Judas (not Iscariot) at first refused to lead Helena to the site of Golgotha where Christ had been crucified. But when Helena threw Judas into a dried-up well to starve to death, he decided to reveal where the True Cross was buried.

Veronese's painting of *The Vision of St Helena* appears to gloss over the more unpleasant details surrounding the finding of the cross. Indeed, his St Helena seems too gentle and refined to resort to such cruel methods in eliciting information. The fact that two cherubs are shown supporting a cross in the sky beyond suggests also that Veronese is reflecting the traditional belief that Helena's discovery of the cross was due to divine inspiration.

[Veronese (1041)]

Vision of St Jerome *see* St Jerome

Vision of St Joseph [Biblical: Matthew 1. 18–23] The Gospel text describes how Joseph was visited in a dream by an angel of the Lord after discovering

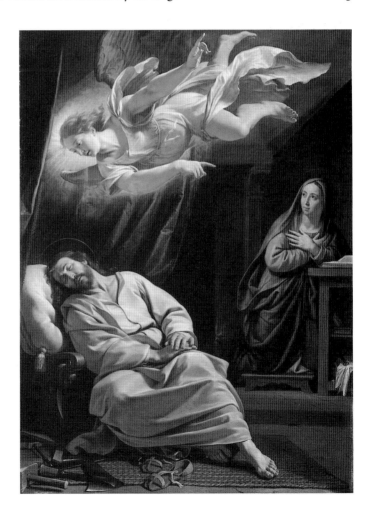

*The Vision of
St Joseph*
Philippe de
Champaigne
(1602–74)

that Mary was pregnant. Although Joseph expected Mary to be his wife, he had not at that time had sexual relations with her, and – according to Matthew – was embarrassed that there might be a public scandal. Mary had, after all, spent all her life up to that time engaged in virginal pursuits in the safe precincts of the temple [*see* Virgin Mary: Birth].

Matthew tells us that Joseph decided to hide Mary away, but as he was considering how to do this, the angel came and explained to him that Mary had conceived from the Holy Ghost, and that the child she was bearing would fulfil the prophecy of a virgin birth [*see* Virgin Mary: Annunciation].

Philippe de Champaigne's painting of *The Vision of St Joseph* illustrates both the moment of the angel's greeting, and Mary's seclusion. It seems as if Joseph has hidden his betrothed in this back room, and hung a great swathe of curtain between the two spaces so that, if necessary, he can hide her from prying eyes. The Virgin herself, intent on her prayers, seems to pause in her devotions, as if dazed by the radiant light emanating from the angel, and perhaps also aware in this moment that the nature of her pregnancy is being explained to Joseph.

[Champaigne (6276)]

Visitation *see* Virgin Mary: Visitation

Walk to Emmaus *see* Christ: Resurrection – 5

Way to Calvary *see* Christ: Passion – 10

Wolf of Gubbio, Legend of *see* St Francis

Woman drinking Poison [Roman literature: Livy 30:15] The woman in this painting has in the past been identified as Sophonisba. Sophonisba lived in Carthage during the last years of the third century BC at the time of the Second Punic War. It was her misfortune to become involved in the conflict between Rome and Carthage, and finally to lose her life.

Sophonisba's first marriage was to Syphax, a Numidian (African nomad) prince who was an ally of Rome. Sophonisba, being of Carthaginian stock, was the sworn enemy of Rome and managed to persuade her first husband to break off his alliance. Syphax was subsequently attacked and defeated by another nomadic leader Masinissa, who was in charge of the Roman army.

Masinissa fell in love with Sophonisba and made her his wife, but the Roman general Scipio, anxious not to lose another ally through Sophonisba's machinations, demanded that she should be sent in captivity to Rome. Masinissa, unable to deny Scipio's request, yet unwilling to yield Sophonisba, sent her a poisoned drink, which she dutifully quaffed.

Although the identity of the figure in Mantegna's painting of *A Woman drinking Poison* is not entirely certain, she seems happy to drain the liquid from her chalice, and the leaves of the laurel or olive tree behind her suggest a certain valour in her action, which would fit well with Sophonisba's bravery in the face of defeat.

[Mantegna (1125B)]

Woman taken in Adultery *see* Christ: Conversion

Worship of the Egyptian Bull God, Apis *see* Moses – 6

Select Bibliography

Alberti, L.B., *Leon Battista Alberti on Painting*, trans. J.R. Spencer, New Haven, 1956.

Allport, G.W., and Vernon, P.E., *Studies in Expressive Movement*, New York, 1933.

Ancona, A. d', *La leggenda d'Adamo ed Evo, testo inedito del secolo XIV*, Curiosità letterarie 106, Bologna, 1870.

Anderson, J., 'Pittura e devozione: la tradizione narrativa quattrocentesca', *La Pittura nel Veneto*, I, 1989–90.

Apocryphal Gospels, Acts and Revelations, trans. A. Walker, Edinburgh, 1870.

Apuleius, Lucius, *The Golden Ass*, trans. R. Graves, 1st published Penguin Classics, 1950.

Ariosto, L., *Orlando furioso*, ed. R. Cesevani, 2 vols., Turin, 1962–6.

Attwater, D., *The Penguin Dictionary of Saints*, Penguin Books, 1965.

Barasch, M., *Gestures of Despair in Medieval and Early Renaissance Art*, New York, 1976.

—— *Giotto and the Language of Gesture*, 1st published 1987; 1st paperback edition Cambridge, 1990.

Baxandall, M., *Giotto and the Orators: Humanist observers of painting in Italy and the discovery of pictorial composition 1350–1450*, 1st published Oxford, 1971; 1st published in paperback, 1986.

—— *Painting and Experience in Fifteenth-Century Italy*, 1st published 1972; 1st published as paperback, 1974.

Bennett, V., and Winch, R., *The Assumption of our Lady and Catholic Theology*, London, 1950.

Breckenridge, J.D., 'Et Prima Vidit': The Iconography of the Appearance of Christ to his Mother', *Art Bulletin*, 39 (1957), pp. 9–32.

Brilliant, R., 'Gesture and Rank in Roman Art', *Memoirs of the Connecticut Academy of Arts and Sciences*, XIV (1963), New Haven.

—— *Visual Narratives: Storytelling in Etruscan and Roman Art*, Ithaca, NY, 1984.

—— 'The Bayeux Tapestry: a stripped narrative for their eyes and ears', *Word and Image*, 7, n. 2 (Apr.–Jun. 1991), pp. 98–126.

Brown, P.F., *Venetian Narrative Painting in the Age of Carpaccio*, New Haven, 1988.

Brown, R., *Our Lady and St. Francis: All the Earliest Texts*, Chicago, 1954.

Bulwer, J., *Chirologia: or the Naturall Language of the Hand, Composed of the Speaking motions, and Discoursing Gestures thereof. Whereunto is added Chironomia: or the Art of Manuall Rhetoricke, by, J.B. Gent Philochirosophus*, London, 1644.

Calvocoressi, P., *Who's Who in the Bible*, 1st published in Great Britain by Viking, 1987; published in Penguin Books, 1988.

Carmichael, M., *Francia's Masterpiece: an essay on the beginnings of the Immaculate Conception in Art*, London, 1909.

Chastel, A., *Fables, formes, figures*, Paris, 1978.

Cornell, H., *The Iconography of the Nativity of Christ*, Uppsala, 1924.

Cothenet, E., 'Gestes et actes symboliques du Christ dans le IVe Evangile', *Gestes et Paroles dans les diverses familles liturgiques*, Conférences Saint-Serge SSIVe semaine d'études liturgiques, Paris, 28 juin–1 juillet 1978, Rome (Centro Liturgico Vincenziano), pp. 95–116.

Cotterell, A., *A Dictionary of World Mythology*, 1st published Oxford University Press, 1979; 1st published in paperback, 1986.

Decorum in Renaissance Narrative Art, eds. F. Ames-Lewis and A. Bednarek, Papers delivered at the Annual Conference of the Association of Art Historians, London, April 1991; published by Birkbeck College, University of London.

Elkins, J., 'On the impossibility of stories: the anti-narrative and non-narrative impulse in modern painting', *Word and Image*, 7, n. 4 (Oct.–Dec. 1991), pp. 348–64.

Eusebius, *History of the Church from Christ to Constantine*, trans. G.A. Williamson, 1st published England, 1965.

Ferguson, S., 'Spots of time': representations of narrative in modern poems and paintings', *Word and Image*, 4, n. 1 (Jan.–Mar. 1988), pp. 186–94.

Garnier, F., *Le Langage de l'image au moyen age. Signification et symbolique*, Paris, 1982.

Genette, G., *Narrative Discourse*, Oxford, 1972.

Gombrich, E.H., 'Ritualized Gesture and Expression in Art', *Philosophical Transactions of the Royal Society of London*, series B, Biological Sciences, no. 772, CCLI (1965), pp. 391–401.

—— 'Action and Expression in Western Art', ed. R.A. Hinde, *Non-Verbal Communication*, pp. 373–93, Cambridge, 1972.

—— *Symbolic Images: Studies in the art of the Renaissance II*, 1st published Phaidon Press, 1972.

Graves, R., *The Greek Myths*, 2 vols., Penguin, 1960.

Greenstein, J.M., *Mantegna and painting as historical narrative*, Chicago and London, 1992.

Gregory, Pope, *Epistulae* XI, 13 (Patrologia Latina, LXXVII, 1128).

Groenewegen-Frankfort, H.A., *Arrest and Movement: An Essay on Space and Time in the Representational Art of the Ancient Near East*, Chicago, 1951.

Gutberlet, H. *Die Himmelfahrt, Christi in der bildenen Kunst*, Strasbourg, 1934.

Habig, M.A. (ed.), *St. Francis of Assisi, Writings and Early Biographies: English Omnibus of the Sources for the Life of St. Francis*, Chicago, 1983.

Hahn, C., *Narrative and Liturgy in the Earliest Illustrated Lives of the Saints*, Ph. D. diss., Johns Hopkins University, 1982.

—— 'Purification, sacred action, and the vision of God: viewing medieval narratives', *Word and Image*, 5, n. 1 (Jan.–Mar. 1989), pp. 71–84.

—— 'Picturing the text: narrative in the "Life" of the saints', *Art History*, 13, no. 1 (Mar. 1990), pp. 1–33.

Hall, J., *Hall's Dictionary of Subjects and Symbols in Art*, 1st published John Murray, 1974; 1st paperback edition, 1984.

—— *A History of Ideas and Images in Italian Art*, London, 1983.

Hanfmann, G.M.A., 'Narration in Greek Art', *Narration in Ancient Art: A Symposium*, ed. C.H. Kraeling *et al.* (1957); reprinted in *American Journal of Archaeology*, 61 (1961), pp. 43–91.

Hesiod, *Theogony*, trans. H.G. Evelyn-White, London and New York, Loeb Classical Library, 1926.

Homer, *The Iliad*, trans. E.V. Rieu, 1st published Penguin Classics, 1950; new translation M. Hammond, 1987.

Homer, *The Odyssey*, trans. E.V. Rieu, 1st published Penguin Classics, 1946; revised edition, 1991.

Hope, C., 'Religious Narrative in Renaissance Art', *Royal Society for the Encouragement of Arts, Manufactures and Commerce Journal*, 134 (1986), pp. 804–18.

Howatson, M.C. (ed.), *The Oxford Companion to Classical Literature*, Oxford University Press, 1989 (1st published 1937).

Ingenhoff-Danhäuser, M., *Maria Magdalena. Heilige und Sünderin in der italienischen Renaissance*, Tübingen, 1984.

Jacobus de Voragine, *Legenda aurea: Vulgo historia lombardica dicta*, ed. Th. Graesse, 1st edn., Leipzig, 1850; translated and adapted as *The Golden Legend of Jacobus de Voragine*, eds. Granger Ryan and H. Ripperger, 1941; 2nd edn. New York, 1969; French edn. H. Savon of translation by J.B.M. Roze, 2 vols., Paris, 1967.

James, M.R., *The Apocryphal New Testament*, Oxford, 1926.

Jameson, Mrs. A.B., *Sacred and Legendary Art*, London, 1848.

—— *Legends of the Monastic Orders as represented in the fine arts*, London, 1850.

—— *Legends of the Madonna*, London, 1852.

—— *The History of Our Lord* (completed by Lady Eastlake), London, 1864.

Kaftal, G., *The Iconography of the Saints in Tuscan Painting*, Florence, 1952.

—— *Iconography of the Saints in Central and South Italian Schools of Painting*, Florence, 1965.

—— *Iconography of the Saints in the Painting of North East Italy*, Florence, 1978.

Kehrer, H., *Die Heiligen Drei Könige in Literatur und Kunst*, 1908–1909, reprint Hildesheim and New York, 1976.

Kessler, H.L., 'The Meeting of Peter and Paul in Rome: The Emblematic Narrative of Spiritual Brotherhood', *Studies in Art and Archaeology in Honor of Ernst Kitzinger on His Seventy-fifth Birthday. Dumbarton Oaks Papers*, 41 (1987), pp. 265–75.

—— 'Pictorial Narrative and Church Mission in Sixth-Century Gaul', *Pictorial Narrative*, pp. 75–91.

Knowlson, J.R., 'The Idea of Gesture as a Universal Language in the XVIIth and XVIIIth Centuries', *Journal of the History of Ideas*, XXVI (1965), pp. 495–508.

Kraeling, C.H., *et al.* (eds.), 'Narration in Ancient Art: A Symposium', *American Journal of Archaeology*, 61 (1961), pp. 43–91.

Ladner, G., 'The Gestures of Prayer in Papal Iconography of the Thirteenth and Early Fourteenth Centuries', *Didascaliae: Studies in Honour of Anselm M. Albareda*, ed. S. Prete, pp. 247–5, Rome, 1961.

Lafontaine-Dosogne, J., *Iconographie de l'enfance de la Vièrge dans l'empire byzantin et en occident*, Mémoires de l'Académie Royale de Belgique, Classe des Beaux-Arts 11, Brussels, 1964.

Lavin, I., 'Cephalus and Procris: transformations of an Ovidian myth', *Journal of the Warburg and Courtauld Institutes*, 17 (1954), pp. 260–87.

Lavin, M. Aronberg, *The Place of Narrative*, Chicago and London, 1990.

Leonardo da Vinci: *Treatise on Painting*, trans. P. McMahon, Princeton, 1956.

Levi d'Ancona, M., *The Iconography of the Immaculate Conception in the Middle Ages and the Early Renaissance*, College Art Association of America in conjunction with *The Art Bulletin*, 1957.

Livingstone, E.A. (ed.), *The Concise Oxford Dictionary of the Christian Church*, 1st published Oxford, 1977.

Marle, R. van, 'Giotto narrateur', *Revue de l'art ancien et moderne*, L (1926), pp. 154–66 and 229–40.

Marrow, J., *Passion Iconography in Northern European Art in the Late Middle Ages and Early Renaissance*, Kortrijk, 1979.

Meditations on the Life of Christ, trans. I. Ragusa and R. Green, Princeton, 1961.

Fra Michele da Carcano, *Sermones quadragesimales fratris Michaelis de Mediolano de decem preceptis*, Venice, 1492.

Nichols, S.G. Jr., *Romanesque Signs: Early Medieval Narrative and Iconography*, New Haven, 1983.

Os, H.W. van, *Marias Demut und Verherrlichung in der Sieneschen Malerei, 1300–1450*, The Hague, 1969.

—— 'St. Francis of Assisi as a Second Christ in Early Italian painting', *Simiolus*, vii 3 (1974), pp. 115–32.

Ovid, *Metamorphoses*, trans. F.J. Miller, 2 vols., 1966 (1st published, Cambridge, Mass., Harvard University Press, 1916); revised edition 1977, Loeb Classical Library.

Ovid, *Metamorphoses*, trans. M.M. Innes, Penguin Classics, 1st published 1955.

Pächt, O., *The Rise of Pictorial Narrative in Twelfth-Century England*, Oxford, 1962.

Panofsky, E., *Renaissance and Renascences in Western Art*, Uppsala, 1960.

Pictorial Narrative in Antiquity and the Middle Ages, ed. H.L. Kessler and M. Shreve Simpson, Vol. 14 of *Studies in the History of Art*, Center for Advanced Study in the Visual Arts, Symposium Series 4, Washington, DC, 1985.

Pietro da Lucca, *Arte del ben pensare e contemplare la Passione del nostro Signor Jesu Christo*, Venice, 1527.

Pliny, *Natural History*, trans. H. Rackam, 10 vols., Cambridge, Mass., Loeb Classical Library, 1969.

Plutarch, *Lives*, The Dryden Plutarch, revised by A.H. Clough, 3 vols., 1st published London, 1910.

Pseudo-Bonaventura, *Meditations on the Life of Christ*, eds. I. Ragusa and R. Green, Princeton, 1961.

Radice, B., *Who's Who in the Ancient World: A Handbook to the Survivors of the Greek and Roman Classics*, Penguin books, 1st published Great Britain, 1971; 1st published USA, 1971.

Rijnberk, G. van, *Le Langage par Signes chez les Moines*, Amsterdam, 1954.

Robb, D.M., 'The Iconography of the Annunciation in the fourteenth and fifteenth centuries', *Art Bulletin*, 18 (1936), pp. 480–526.

Robert, C., 'Die Entwicklung des griechischen Mythos in Kunst und Poesie', *Bild und Lied: Archaeologische Beitrage zur Geschichte der griechischen Heldensage*, Berlin, 1881.

Ringbom, R., *From Icon to Narrative: The rise of the Dramatic Close-up in Fifteenth Century Devotional Painting*, 2nd edn., Doornspijk, 1983.

Schapiro, M., *Words and Pictures. On the literal and the symbolic in the illustration of a text*, The Hague, 1973.

Schiller, G., *Iconography of Christian Art*, 2 vols., trans. Janet Seligman, London, 1972.

Schmidt, C., 'A space of time: continuous narrative and linear perspective in Quattrocento Tuscan art', *La Pittura nel Veneto*, I, 1989–90.

Schorr, D.C., 'The Iconographic Development of the Presentation in the Temple', *Art Bulletin*, 28 (1946), pp. 17–32.

Seznec, J., *The Survival of the Pagan Gods: The Mythological Tradition and its Place in Renaissance Humanism and Art*, Princeton, 1953.

Verdier, P., *Le Couronnement de la Vierge: Les origines et les premiers développements d'un thème iconographique*, Montreal, 1980.

Virgil, *The Aeneid*, trans. W.F. Jackson Knight, 1st published Penguin Classics, 1956; new translation D. West, 1990.

Wald, E.T. De, 'The Iconography of the Ascension', *American Journal of Archaeology*, XIX (1915), pp. 277–319.

Weiss, R., *The Renaissance Discovery of Classical Antiquity*, Oxford, 1969.

Weitzmann, K., 'The Narrative and Liturgical Gospel Illustrations' and 'Byzantine Miniature and Icon Painting in the Eleventh Century', *Studies in Classical and*

Byzantine Manuscript Illumination, ed. H.L. Kessler, introd. H. Buchthal, pp. 247–313, Chicago, 1971.

Wiebenson, D., 'Subjects from Homer's *Iliad* in Neoclassical Art', *Art Bulletin,* 46 (1964), pp. 23–37.

Wind, E., *Pagan Mysteries in the Renaissance,* London, 1958.

Wolff, C., *A Psychology of Gesture* (1st edn. 1945), London, 1948.

Index

[All cross-references in the Index refer to entries in the Index and not the Dictionary itself. Individual National Gallery accession numbers of paintings appear under the entries in the main dictionary]

Abbot see Saints: Anthony Abbot
Abduction of Helen by Paris [follower of Fra Angelico] *164–5*
Abraham and Isaac [Olivier] *3–4*
Abraham and Isaac approaching the Place of Sacrifice, Landscape with [Dughet] *3–4*
 see also *Departure of Abraham, Sacrifice of Isaac*
Achilles see *Horses of Achilles*
Actaeon see *Death of Actaeon*
Adam and Eve [Gossaert] *5*
Admetus see *Mercury stealing the Herds of Admetus*
Adonis see *Venus and Adonis*
Adoration of the Golden Calf [Nicolas Poussin] *149–51*
Adoration of the Kings [follower of Angelico; attr. Bonfigli; Botticelli; Botticelli; Bramantino; Pieter Bruegel the Elder; Jan Bruegel the Elder; attr. Carpaccio; David; Dolci; Dosso Dossi; Foppa; Giorgione; attr. Girolamo da Treviso; Gossaert; Jacopo di Cione; Filippino Lippi; after Master of the Death of the Virgin; Master of Liesborn; Spranger; Veronese] *33–5*
 see also *Adoration of the Magi*
Adoration of the Magi [North Italian School; Peruzzi] *33–5*
Adoration of the Shepherds [follower of the Bassano; attr. Bernardino; Butinone; Fabritius; Louis(?) Le Nain; North Italian School; attr. Pietro Orioli; Nicolas Poussin; Rembrandt; Reni; attr. Roberti; Signorelli; Signorelli; anon. Spanish; Titian] *31–3*
Adullam see *David at the Cave of Adullam*
Adultery see Christ: Adultery – *Woman taken in Adultery*
Aeneas at Delos, Landscape with [Claude] *5–7*
Aeneas descends into the Underworld see *Barque of Charon*
 see also *Dido receiving Aeneas and Cupid disguised as Ascanius, Union of Dido and Aeneas, Landscape with*
Aeneid see *Virgil reading the Aeneid to Augustus and Octavia*
Age see Silver Age
Agony in the Garden [Giovanni Bellini;

Bergognone; after Correggio; Garofalo; Mantegna; after Mantegna; Niccolò di Liberatore (side panel); attr. Pietro Orioli (predella); Lo Spagna] *66–8*
Agony in the Garden of Gethsemane [studio of El Greco] *66–8*
 see also Christ: Gethsemane
Ahasuerus see *Esther before Ahasuerus*
Alexander see *Family of Darius before Alexander*
Alexandria, Duke of see Christ: Baptising
Amnon see *Rape of Tamar by Amnon*
Andromeda see *Perseus and Andromeda*
Angel see *Annunciation to the Virgin, Elijah and the Angel, Hagar and the Angel, Sacrifice of Isaac, Tobias and the Angel, Tobias and the Archangel returning with the Fish, Tobias laying hold of the Fish, Vision of St Joseph*
Angel appearing to Hagar and Ishmael [Assereto] *113–15*
 see also *Angel appears to Hagar and Ishmael*
Angel appearing to St Joachim [Giusto de' Menabuoi (outer inset panel)] *238–42*
Angel appearing to St Zacharias Dalmation School (side panel); attr. Niccolò di Pietro Gerini (predella)] *206*
Angel appears to Hagar and Ishmael [Guercino; after Rosa] *113–15*
 see also *Hagar and the Angel*
Angelica saved by Ruggiero [Ingres] *7–8*
Anna and the Blind Tobit [Rembrandt] *227–8*
 see also *Tobit and Anna*
Annunciation to the Virgin [follower of Fra Angelico; Crivelli; Duccio; Gaudenzio; attr. Giannicola di Paolo; Giovanni del Ponte (inset panel); Giusto de' Menabuoi (inset panel); Filippo Lippi; Master of Leisborn; attr. Pietro Orioli (side panel); Nicolas Poussin; Tura; Tuscan School (inset panel)] *236–7*
Annunciation with St Emidius [Crivelli] *236–7*
Apis see *Worship of the Egyptian Bull God, Apis*
Apollo and Daphne [attr. Antonio del Pollaiuolo] *8–9*
Apollo killing the Cyclops [Domenichino and assistants] *9–10*
Apollo and Neptune advising Laomedon on the Building of Troy [Domenichino and assistants] *10–12*

Apollo pursuing Daphne [Domenichino and assistants] *8–9*

Apollo slaying Coronis [Domenichino and assistants] *13*

Apollo see also *Flaying of Marsyas, Judgement of Midas, Mercury stealing the Herds of Admetus guarded by Apollo*

Appearance of St Jerome with St John the Baptist to St Augustine [Botticini (predella)] *184–5*

Appian Way see *Christ appearing to St Peter on the Appian Way*

Archangel Raphael see *Tobias and the Archangel Raphael returning with the Fish*

Argus see *Mercury piping to Argus*

Ariadne see *Bacchus and Ariadne*

Ark see *Return of the Ark, Plague at Ashdod*

Armida see *Carlo and Ubaldo see Rinaldo conquered by Love for Armida*

Ascanius see *Dido receiving Aeneas and Cupid disguised as Ascanius*

Ascension of Christ [Jacopo di Cione] *83*

Ascension of St John the Evangelist [Giovanni del Ponte] *208–10*

Ashdod see *Plague at Ashdod*

Assassination of St Peter Martyr [Giovanni Bellini] *216–17*

see also *Death of St Peter Martyr*

Assumption of the Virgin [attr. Botticini; Gerolamo da Vicenza; Matteo di Giovanni] *243–4*

see also *Death of the Virgin*

Attack on Cartagena [Italian School] *14–15*

Augustus and the Sibyl [Venetian School] *15*

see also *Virgil reading the Aeneid to Augustus and Octavia*

Aurora abducting Cephalus [Rubens] *22–3*

see also *Cephalus and Aurora, Cephalus carried off by Aurora in her Chariot*

Babel see *Tower of Babel*

Bacchanal [Dosso Dossi; Nicolas Poussin (also known as *The Nurture of Bacchus*)] *15–17*

Bacchanalian Festival (also known as *The Triumph of Silenus*) [follower of Nicolas Poussin] *15–17*

Bacchanalian Revel before a Term of Pan [Nicholas Poussin] *15–17*

Bacchanalia

see also *Drunken Silenus supported by Satyrs, Silenus gathering Grapes, Triumph of Pan*

Bacchus and Ariadne [Ricci; Titian] *18–19*

Bacchus

see also *Nurture of Bacchus*

Baker see *Pharoah with his Butler and Baker*

Banquet of Cleopatra [Giovanni Battista Tiepolo] *84–5*

Baptism of Christ [Elsheimer; Florentine School; Giovanni di Paolo; attr. Niccolò di Pietro Gerini; after Perugino; Piero della Francesca; Zaganelli] *27–9*

Baptist see Saints: John the Baptist

Barque of Charon (also known as *Aeneas descends into the Underworld*) [after Subleyras] *19*

Bathsheba see *Toilet of Bathsheba*

Battle of San Romano (also known as *Niccolò Mauruzi da Tolentino at the Battle of San Romano*) [Uccello] *19*

Beatrice of Burgundy see *Marriage of Frederick Barbarossa and Beatrice of Burgundy*

Beheading of St James [Pesellino (predella)] *202*

Beheading of St John the Baptist [Puvis de Chavannes] *207–8*

see also *St John the Baptist decapitated, Daughter of Herodias, Feast of Herod, Head of St John the Baptist brought to Herod, Salome receives the Head of St John the Baptist, Salome, Salome bringing the Baptist's Head to Herodias*

Belshazzar's Feast [Rembrandt] *20–1*

Benedictine Order see *St Benedict admitting Sts Maurus and Placidus into the Benedictine Order*

Bethesda, Pool of see Christ: Healing – *Christ healing the Paralytic at the Pool of Bethesda*

Betrayal [Ugolino di Nerio] *68*

Betrayal of Christ [attr. Pietro Orioli (predella)] *68*

Birth of St John the Baptist [attr. Niccolò di Pietro Gerini (predella); Giovanni di Paolo] *205–6*

Birth of Venus [Rubens] *233*

Birth of the Virgin [Giusto de' Menabuoi (outer inset panel); Master of the Osservanza; after Murillo; Netherlandish(?); Dalmatian School (side panel)] *237–8*

Boreas see *Sons of Boreas pursuing the Harpies*

Brazen Serpent [Giaquinto; Rubens] *147*

Bread see Saints: Anthony of Padua – *St Anthony of Padua(?) distributing the Bread*

Building of the Trojan Horse [Giovanni Domenico Tiepolo] *231–2*

Bull God see *Worship of the Egyptian Bull God, Apis*

Butler see *Pharoah with his Butler and Baker*

Cadmus see *Two Followers of Cadmus devoured by a Dragon*

Callisto see *Diana and Callisto*

Calvary see Christ: Crucifixion – *Christ carrying the Cross, Procession to Calvary, Way to Calvary*

Cana see *Marriage at Cana*

Capture of the Golden Fleece [Detroy] *121–3*

see also *Jason swearing Eternal Affection to Medea*

Carlo and Ubaldo see Rinaldo conquered by Love for Armida [Van Dyck] *179–80*

Cartagena see *Attack on Cartagena*

Carthage see *Dido building Carthage, Attack on Cartagena*

Carthaginian Empire see *Dido building Carthage*

Cave see *David at the Cave of Adullam*

Centaurs see *Fight between the Lapiths and the Centaurs*

Cephalus and Aurora [Nicolas Poussin] *22–3*

Cephalus carried off by Aurora in her Chariot [Agostino Carracci] *22–3*

Cephalus and Procris reunited by Diana
[Claude] 23–4
see also *Death of Procris*
Ceres and Harvesting Cupids [Studio of
Vouet] 24–5
*Charlemagne, and the Meeting of Sts Joachim and
Anne at the Golden Gate* [Master of
Moulins] 238–42
see also Virgin Mary: Conception
Charon see *Baroque of Charon*
Children see Christ: Blessing – *Christ Blessing the
Children*
Chloë see *Daphnis and Chloë*
Christ addressing a Kneeling Woman
[Veronese] 42–4
Christ
 Adultery: *Christ and the Woman taken in
 Adultery* [Mazzolino] 42–4
 see also *Woman taken in Adultery*, Christ:
 Conversion, Christ: Magdalen
 Agony: see *Agony in the Garden, Agony in the
 Garden at Gethsemane*, Christ:
 Gethsemane
 Apparition: *Christ appearing to the Magdalen*
 [Byzantine School] 79–80 *Christ
 appearing to St Anthony Abbot during his
 Temptation* [Annibale Carracci] 182–3
 *Christ appearing to St Peter on the Appian
 Way* (also known as *Domine quo vadis?*)
 [Annibale Carracci] 25–6 *Christ
 appearing to the Virgin* [Workshop of Van
 der Weyden] 77–8 *Christ appearing to
 the Virgin with the Redeemed of the Old
 Testament* [Studio of Juan de
 Flandes] 77–8
 see also *Noli me tangere*
 Baptism: see *Baptism of Christ*
 see also Christ: Blessing
 Baptising: *Christ baptising St John Martyr,
 Duke of Alexandria* [Bordone] 29
 Betrayed: see *Betrayal of Christ*
 Birth: see *Nativity*, Christ: Childhood
 Blessing: *Christ blessing the Children* (also
 known as *Suffer the little Children to come
 unto Me*) [Maes] 56–7 *Christ blessing St
 John the Baptist* [Moretto] 27
 Childhood: see *Nativity, Adoration of the
 Shepherds, Adoration of the Kings,
 Adoration of the Magi, Presentation in the
 Temple, Presentation of Jesus in the Temple,
 Circumcision, Flight into Egypt, Rest on
 Flight into Egypt, Massacre of the Innocents,*
 Christ: Doctors
 Conversion: *Conversion of the Magdalen*
 [Follower of Zuccari] 42–4
 see also *Christ addressing a Kneeling Woman*,
 Christ: Adultery – *Christ and the Woman
 taken in Adultery, Woman taken in
 Adultery*
 Cross: see Christ: Crucifixion
 Crowned: *Christ crowned with Thorns* [early
 sixteenth–century Italian School] 71–2
 see also *Crowning with Thorns*

Crucifixion: *Christ carrying the Cross*
 [Bergognone; Giampietrino; Niccolò di
 Liberatore (side panel); North German
 School] 73–4
 see also *Procession to Calvary, Way to Calvary
 Christ Nailed to the Cross* [David] 44–6
 Christ on the Cross [attr. Bonfigli;
 Delacroix; Niccolò di Liberatore] 44–6
 Christ Crucified [Antonello; Master of
 Leisborn] 44–6
 see also *Crucified Christ with the Virgin Mary,
 Saints and Angels* (also known as *The
 Mond Crucifixion*), *Coup de Lance, Scenes
 from the Passion, Symbolic Representation
 of the Crucifixion*
 Dead: see Christ: Crucifixion, *Deposition from
 the Cross, Dead Christ, Dead Christ
 mourned* (also known as *The Three
 Maries*), *Lamentation over the Dead Christ,
 Mourning over the Dead Christ*, Christ:
 Tomb, *Entombment of Christ, Dead Christ
 in the Tomb, with the Virgin Mary and
 Saints, Pietà, Pietà with Two Angels*
 Disciples: *Christ washing his Disciples' Feet*
 [Tintoretto] 63–4
 Doctors: *Christ among the Doctors*
 [Luini] 40–2 *Christ disputing with the
 Doctors* [Mazzolino; Neapolitan
 School] 40–2
 Ecce Homo: *Christ Presented to the People* (also
 known as *Ecce Homo*) [Correggio; after
 Correggio; Master of the Bruges Passion
 scenes; Rembrandt] 72–3
 Flagellation: *Christ after the Flagellation
 contemplated by the Christian Soul*
 [Velázquez] 70–1
 Gethsemane: *Christ at Gethsemane* [attr. Lo
 Spagna] 66–8
 see also *Agony in the Garden, Agony in the
 Garden of Gethsemane*
 Healing: *Christ healing the Paralytic at the Pool
 of Bethesda* [Murillo] 53–4
 see also *Jesus opens the Eyes of a Man born
 Blind*, Christ: Ministry
 High Priest: *Christ before the High Priest*
 [Gerrit van Honthorst] 68–9
 Light: *Christ as the Light of the World*
 [Bordone] 58
 Magdalen: see *Christ addressing a Kneeling
 Woman, Christ appearing to the Magdalen,
 Conversion of the Magdalen*, Christ:
 Adultery, Christ: Apparition, Christ:
 Resurrection
 Martha and Mary: see *Kitchen Scene with
 Christ in the House of Martha and Mary*
 Ministry: see Christ: Teaching, *Miraculous
 Draught of Fishes, Marriage at Cana*,
 Christ: Healing, *Transfiguration, Tribute
 Money*, Christ: Blessing, *Jesus opens the
 Eyes of the Man born Blind*, Christ:
 Adultery, Christ: Light, Christ: Temple,
 Christ: Martha and Mary, *Raising of
 Lazarus*

Christ *cont.*
 Mother: *Christ taking leave of his Mother*
 [Altdorfer; Correggio] *62–3*
 see also Christ: Apparition, Christ: Birth,
 Christ: Childhood
 Passion: see *Scenes from the Passion*, Christ:
 Disciples, *Last Supper*, Christ: Gethsemane,
 Christ: Agony, Christ: High Priest, Christ:
 Flagellation, Christ: Crowned, Christ:
 Pilate, Christ: Ecce Homo
 Pentecost: see *Pentecost*
 Pilate: *Christ before Pilate* [Master of
 Cappenberg[*70–1*
 Resurrection: *Christ rising from the Tomb*
 [Gaudenzio] *75–7*
 see also *Ascension of Christ, Resurrection,*
 Maries at the Sepulchre, St Mary Magdalene
 approaching the Sepulchre, Noli me tangere,
 Christ: Apparition, *Christ Appearing to the*
 Magdalen, Incredulity of St Thomas, Supper
 at Emmaus, Walk to Emmaus
 Teaching: *Christ teaching from St Peter's Boat*
 on the Lake of Gennesaret [Saftleven] *51*
 Temple: *Christ driving the Traders from the*
 Temple [Cavallino; El Greco] *58–9*
 Tomb: *Christ carried to the Tomb*
 [Badalocchio] *49–51*
 see also Christ: Dead, *Entombment,*
 Entombment of Christ
Cimon and Efigenia [Venetian School] *83*
Circumcision [Workshop of Giovanni Bellini;
 Marziale; Signorelli] *36–7*
Clare see *Vision of the Blessed Clare of Rimini*
Clement of Volterra see Saints: Justus
Cleopatra [School of Fontainebleau] *84–5*
 see also *Banquet of Cleopatra*
Close of the Silver Age [Lucas Cranach the
 Elder] *85*
Clotho [after Prud'hon] *85*
Conception see *Immaculate Conception,*
 Immaculate Conception of the Virgin with Two
 Donors
Consecration of St Nicholas [Veronese] *212–13*
Continence of Scipio [Italian School] *85*
Conversion of the Magdalen [follower of
 Zuccari] *42–4*
 see also Christ: Conversion
Conversion of St Hubert [Master of the Life of the
 Virgin] *199–201*
 see also *Exhumation of St Hubert*
Conversion of St Paul [Dujardin; Ferrarese
 School] *214–16*
Coriolanus persuaded by his Family to spare Rome
 [Michele da Verona; Signorelli] *86–7*
Cornelia and her Sons [after Padovanino] *87–8*
Coronation of the Virgin [Barnaba da Modena
 (side panel); attr. Agnolo Gaddi; Giusto de'
 Menabuoi; Lorenzo Monaco; Master of
 Cappenberg; Jacopo di Cione; Reni;
 Rottenhammer] *241–2*
Coronis see *Apollo slaying Coronis*
Coup de Lance [Rubens] *44–6*
Croesus and Solon [Steenwyck] *88*

Crowning with Thorns [Hieronymous
 Bosch] *71–2*
Crowning see Christ: crowned, *Coronation of the*
 Virgin
Crucified Christ with the Virgin Mary, Saints and
 Angels (also known as *The Mond Crucifixion*)
 [Raphael] *44–6*
Crucifixion [Castagno; Barnaba da Modena (side
 panel); Giusto de' Menabuoi (side panel); attr.
 Jacopo di Cione and his workshop; studio of
 Massys; Master of the Aachen Altarpiece;
 follower of the Master of the Death of the
 Virgin; attr. Master of Liesborn; Master of
 Riglos; studio of the Master of 1518; attr.
 Pietro Orioli (predella)] *44–6*
Cupid complaining to Venus [Lucas Cranach the
 Elder] *88*
Cupid see *Dido receiving Aeneas and Cupid*
 disguised as Ascanius, Psyche outside the Palace
 of Cupid, Psyche showing her Sisters her Gifts
 from Cupid
Curtius see *Marcus Curtius*
Cybele see *Introduction of the Cult of Cybele at*
 Rome
Cyclops see *Apollo killing the Cyclops*
Cyparissus see *Transformation of Cyparissus*

Damon broods on his Unrequited Love (Scenes from
 an Eclogue of Tebaldeo) [attr. Previtali] *88–9*
Damon takes his Life (Scenes from an Eclogue of
 Tebaldeo) [attr. Previtali] *88–9*
 see also *Thyrsis asks Damon the Cause of his*
 Sorrow, Thyrsis finds the Body of Damon
Dance of Miriam [follower of Costa] *146–7*
Daphne see *Apollo and Daphne, Apollo pursuing*
 Daphne
Daphnis and Chloë (recently retitled *A Pair of*
 Lovers) [Bordone] *89*
Darius see *Family of Darius before Alexander*
Daughter of Herodias [Sebastiano del
 Piombo] *207–8*
David at the Cave of Adullam [Claude] *91–2*
David and Goliath, Story of [Pesellino] *90–1*
David and Jonathan [Cima] *90–1*
David
 see also *Triumph of David over Saul*
Dead Christ mourned (also known as *The Three*
 Maries) [Annibale Carracci] *47–9*
Dead Christ in the Tomb, with the Virgin Mary and
 Saints [Palmezzano] *49–51*
Death of Actaeon [Titian] *92–4*
Death of Eurydice [Niccolò dell'Abate] *94–5*
Death of Procris, Landscape with the [after
 Claude] *23–4*
Death of St Benedict [Lorenzo Monaco] *187–8*
Death of St Jerome [Botticini (predella)] *202–5*
Death of St Peter Martyr [attr. Bernardino da
 Asola] *216–17*
Death of the Virgin [imitator of Campin;
 Gerolamo da Vicenza] *242–3*
 see also Virgin Mary: Assumption, Virgin
 Mary: Death, Virgin Mary: Entombment

Decapitation of St Catherine [Margarito (side
 scene)] *189–91*
Dejanira see *Nessus and Dejanira*
Delilah see *Samson and Delilah*
Delos see *Aeneas at Delos*
Departure of Abraham [after Jacopo
 Bassano] *3–4*
Deposition [David; Master of the St Bartholomew
 Altarpiece; Ugolino di Nerio] *46–7*
 see also *Lamentation*
Deposition from the Cross [Giovanni Domenico
 Tiepolo: Giovanni Domenico Tiepolo] *46–7*
Desert see Saints: Jerome, John the Baptist
Diana and Callisto [attr. Tassi] *95–6*
Diana bathing Surprised by a Satyr(?) [follower of
 Rembrandt] *96–7*
Diana
 see also *Cephalus and Procris reunited by
 Diana, Death of Actaeon*
Dido building Carthage (also known as *The Rise of
 the Carthaginian Empire*) [Turner] *97–8*
*Dido receiving Aeneas and Cupid disguised as
 Ascanius* [Solimena] *98–100*
Dido's Suicide [Liberale da Verona] *100–2*
Dido
 see also *Union of Dido and Aeneas*
Disciples see Christ: Disciples
Dives and Lazarus [after Bonifazio] *102–3*
 see also *Rich Man being led to Hell*
Doctors see Christ: Doctors
Domine quo vadis? see Christ: Apparition – *Christ
 appearing to St Peter on the Appian Way*
Dominican see *Vision of the Dominican Habit*
Don Quixote and Sancho Panza [Daumier] *103*
Dormition of the Virgin [Tyrolese School] *242–3*
Dragon see *Two Followers of Cadmus devoured by
 a Dragon*; Saints: George, Margaret
Drunken Silenus supported by Satyrs [studio of
 Rubens] *15–17*
 see also *Silenus gathering Grapes*

Ecce Homo see Christ: Passion – *Christ presented to
 the People*
Echo see *Narcissus and Echo*
Eclogue of Tebaldeo see *Damon broods on his
 Unrequited Love, Damon takes his Life, Thyrsis
 asks Damon the Cause of his Sorrow, Thyrsis
 finds the Body of Damon*
Efigenia see *Cimon and Efigenia*
Egypt see *Flight into Egypt, Rest on the Flight into
 Egypt, Joseph sold to Potiphar, Joseph receives
 his Brothers on their Second Visit to Egypt,
 Joseph pardons his Brothers, Joseph's Brothers
 beg for Help, Joseph with Jacob in Egypt*
Egyptian see *Worship of the Egyptian Bull God, Apis*
El Hechizado por Fuerza, Scene from (also known
 as *The Forcibly Betwitched*) [Goya] *104*
Elders see *Susannah and the Elders*
Eliezer see *Rebekah and Eliezer at the Well*
Elijah and the Angel, Landscape with
 [Dughet] *104–5*
Elijah fed by Ravens [Guercino] *104–5*

Embarkation of the Queen Sheba, Seaport with
 [Claude] *174–6*
Embarkation of St Ursula, Seaport with
 [Claude] *219*
Emmaus see *Supper at Emmaus, Walk to Emmaus*
*Emperor Theodosius is forbidden by St Ambrose to
 enter Milan Cathedral* [Van Dyck] *105–6*
Enchanted Castle see *Psyche outside the Palace of
 Cupid*
Entombment [Francia; Michelangelo] *49–51*
Entombment of Christ [Bouts; Busati; Guercino;
 style of Ysenbrandt] *49–51*
 see also *Christ: Dead, Christ: Tomb*
Entombment of the Virgin [Byzantine] *242–3*
Ephesus see *St Paul preaching at Ephesus*
Erminia takes Refuge with the Shepherds [circle of
 Annibale Carracci] *106–7*
Esther before Ahasuerus [Ricci; Signorelli] *107–9*
Europa see *Rape of Europa*
Eurydice see *Death of Eurydice*
Eve see *Adam and Eve*
Execution of Lady Jane Grey [Delaroche] *109–10*
Execution of Maximilian [Manet] *110*
Execution of Savonarola and Two Companions
 (reverse) [Florentine School] *223*
Exhumation of St Hubert [workshop of Van der
 Weyden] *201–2*

Falerii see *Schoolmaster of Falerii*
Family of Darius before Alexander
 [Veronese] *110–12*
Fantastic Ruins with St Augustine and the Child [de
 Nomé] *184–5*
Father Simon see *Vision of Father Simon*
Feast see *Belshazzar's Feast*
Feast of Herod [Giovanni di Paolo; attr. Niccolò di
 Pietro Gerini (predella)] *207–8*
Fight between the Lapiths and the Centaurs [Piero
 di Cosimo] *112–13*
Finding of the Infant Moses by Pharaoh's daughter
 [Breenbergh] *144–6*
Finding of Moses [attr. Antonio de Bellis, Nicolas
 Poussin; attr. Zugno] *144–6*
Fish see *Tobias, Landscape with, Tobias and the
 Angel, Tobias and the Archangel returning with
 the Fish*
Fishes see *Miraculous Draught of Fishes*
Flaying of Marsyas [Domenichino and
 assistants] *138–9*
Flight into Egypt [Studio of the Master of
 1518] *38–9*
 see also *Rest on the Flight into Egypt*
Flowers see *Ophelia among the Flowers*
Forcibly Bewitched see *El Hechizado por Fuerza*
Four Scenes from the Early Life of St Zenobius
 [Botticelli] *220–1*
Franciscan Order see *Pope accords Recognition to
 the Franciscan Order*
Frederick Barbarossa see *Marriage of Frederick
 Barbarossa and Beatrice of Burgundy*
*Funeral of St Francis and the Verification of the
 Stigmata* [Sassetta] *193–6*

Gabriel see *Annunciation to the Virgin*
Gabriele see *Vision of the Blessed Gabriele*
Ganymede see *Rape of Ganymede*
Garden see *Agony in the Garden*
Gennesaret, Lake of see *Christ: teaching*
Ghent see *Saints: Bavo*
Golden Apple see *Judgement of Paris*
Golden Calf see *Adoration of the Golden Calf*
Golden Fleece see *Capture of the Golden Fleece*
Golden Gate see *Charlemagne, and the Meeting of
 Sts Joachim and Anne at the Golden Gate*
Goliath see *David and Goliath, David and
 Jonathan*
Good Samaritan [Jacopo Bassano] 113
Governor see *Saints: Sabinus*
Griselda see *Patient Griselda*
Gubbio see *Legend of the Wolf of Gubbio*

Hagar and the Angel [Claude] 113–15
 see also *Angel appearing to Hagar and Ishmael,
 Angel appears to Hagar and Ishmael*
Harpies see *Sons of Boreas pursuing the Harpies*
Helen see *Abduction of Helen by Paris*
Hell see *Rich Man being led to Hell*
Helsinus preaching in favour of the Celebration of
 the Conception [Dalmatian School] (side
 panel) 115
Helsinus saved from Shipwreck [Dalmation School
 (side panel)] 115
Hero see *Parting of Hero and Leander – from the
 Greek of Musaeus*
Herod see *Feast of Herod*, Saints: John the Baptist,
 Massacre of the Innocents
Herodias see *Daughter of Herodias*
High Priest see *Christ before the High Priest*
Hind see *Saints: Giles*
Holofernes see *Judith in the Tent of Holofernes*
Holy Family with Saints in a Landscape [attr.
 studio of Rubens] 30–1
Holy House of Loreto see *Miraculous Translation
 of the Holy House of Loreto*
Horses of Achilles [style of Van Dyck] 115–17

Immaculate Conception [Crivelli; Murillo;
 Velázquez] 238–42
 see also *Virgin Mary: Conception*
Immaculate Conception of the Virgin, with Two
 Donors [Valdés Leal] 238–42
Incidents in the Life of St Benedict see *St
 Benedict* 187–8
Incredulity of St Thomas [Cima da Conegliano;
 Giovanni Battista da Faenza; Guercino] 80–1
Infancy of Jupiter [studio of Giulio
 Romano] 132–3
Innocents see *Massacre of the Innocents*
Institution of the Eucharist [Roberti] 64–6
Introduction of the Cult of Cybele at Rome (also
 known as *The Triumph of Scipio*)
 [Mantegna] 117–18
Io see *Juno discovering Jupiter with Io*
Isaac see *Departure of Abraham, Abraham and*

Isaac, Abraham and Isaac approaching the Place
 of Sacrifice, Sacrifice of Isaac, Marriage of Isaac
 and Rebekah
Ishmael see *Angel appearing to Hagar and Ishmael,
 Angel appears to Hagar and Ishmael in the Desert*
Israelites gathering Manna [follower of Costa;
 Roberti] 147–8

Jacob reproaching Laban for giving him Leah in
 place of Rachel [Saraceni; (?) ter
 Brugghen] 119–20
 see also *Moses Defending the Daughters of
 Jethro, Joseph with Jacob in Egypt*
Jacob with the Flock of Laban [Ribera] 120–1
Jason swearing Eternal Affection to Medea
 [Detroy] 121–3
Jesus opens the Eyes of a Man born Blind
 [Duccio] 52
Jethro see *Moses defending the Daughters of Jethro*
Joachim see *Saints: Joachim*
Jonathan see *David and Jonathan*
Joseph with Jacob in Egypt [Pontormo] 127–9
Joseph pardons his Brothers [Bacchiacca] 126–7
Joseph receives his Brothers on their Second Visit to
 Egypt [Bacchiacca] 125–6
Joseph sold to Potiphar [Pontormo] 123–4
Joseph's Brothers beg for Help [Pontormo] 126–7
Joseph
 see also *Saints: Joseph*
Judgement of Midas [Domenichino and
 assistants] 129
Judgement of Paris, Landscape with [Both and
 Poelenberg; Wtewael] 163–4
 see also *Paris awards the Golden Apple to Venus*
Judith [Eglon van der Neer] 130–1
Judith in the Tent of Holofernes [Liss] 130–1
Juno discovering Jupiter with Io [Lastman] 131–2
 see also *Mercury piping to Argus*
Jupiter and Semele [attr. Tintoretto] 133
Jupiter see *Infancy of Jupiter, Juno discovers Jupiter
 with Io, Leda and the Swan, Origin of the Milky
 Way, Rape of Europa, Rape of Ganymede*

Kings see *Adoration of the Kings*
Kitchen Scene with Christ in the House of Martha
 and Mary [Velázquez] 59–60

Laban see *Jacob with the Flock of Laban, Jacob
 reproaching Laban*
Lady Jane Grey see *Execution of Lady Jane Grey*
Lamentation [Studio of the Master of the Prodigal
 Son] 47–9
Lamentation over the Body of Christ [Dosso
 Dossi] 47–9
Lamentation over the Dead Christ [attr. Francia;
 Guercino; Niccolò di Liberatore (side panel);
 attr. Pietro Orioli (predella); Rembrandt;
 Ribera; Giovanni Domenico Tiepolo;
 Giovanni Domenico Tiepolo; workshop of
 Van der Weyden] 47–9, 49–51
 see also *Pietà*

Laomedon see *Apollo and Neptune advising Laomedon on the Building of Troy*

Lapiths see *Fight between the Lapiths and the Centaurs*

Last Supper see *Institution of the Eucharist*

Lazarus see *Dives and Lazarus, Rich Man being led to Hell, Raising of Lazarus*

Leah see *Jacob reproaching Laban for giving him Leah*

Leander see *Parting of Hero and Leander – from the Greek of Musaeus*

Leda and the Swan [after Michelangelo; style of Mola] *134*

Legend of the Wolf of Gubbio [Sassetta] *193–6*

Light see *Christ as the Light of the World*

Lot and his Daughters leaving Sodom [Reni] *135–6*

Lot's Daughters make their Father drink Wine [style of Lucas van Leyden] *135–6*

Magdalen see Saints: Mary Magdalene

Magi see *Adoration of the Magi*

Manna see *Israelites gathering Manna*

Malta see *St Paul on Malta*

Marcia [Beccafumi] *136*

Marcus Curtius [attr. Bacchiacca] *136*

Maries at the Sepulchre [Jacopo di Cione; imitator of Mantegna] *75–7*

Marriage at Cana [Preti] *52–3*

Marriage of Frederick Barbarossa and Beatrice of Burgundy [Giovanni Domenico Tiepolo] *136–7*

Marriage of Isaac and Rebekah (also known as *The Mill*) [Claude] *118–19*

Marriage of St Catherine of Siena [Lorenzo d'Alessandro da Sanseverino] *136–7*

Marriage of the Virgin [Ludovico Carracci; Daddi; Giusto de' Menabuoi (outer inset panel); Niccolò di Buonaccorso; Sienese School] *244–5*

Mars and Venus [Palma Giovane] *234–5*
 see also *Venus and Mars*

Marsyas see *Flaying of Marsyas*

Marsyas(?) and Olympus [Annibale Carracci] *137–8*

Martha see *Kitchen Scene with Christ in the House of Martha and Mary*

Martyr see Saints: John Martyr, Lawrence, Peter Martyr

Martyrdom of St Januarius [Giordano] *139*

Martyrdom of St Sebastian [Crivelli (predella); attr. Antonio and Piero del Pollaiuolo] *217–19*
 see also Saints: Sebastian

Martyrdom of St Stephen [attr. Antonio Carracci] *140*

Mary see Saints: Mary Magdalene, *Maries at the Sepulchre*, Three Maries, Virgin Mary

Mary, Sister of Martha see *Kitchen Scene with Christ in the House of Martha and Mary*

Mass of St Giles [Master of St Giles] *198–9*

Mass of St Hubert [Master of the Life of the Virgin] *199–201*

Massacre of the Innocents [Mocetto; Mocetto] *39–41*

Maximilian see *Execution of Maximilian*

Medea see *Jason swearing Eternal Affection to Medea*

Meeting at the Golden Gate [Giusto de' Menabuoi (outer inset panel); Dalmation School (side panel)] *238–42*

Mercury and the Dishonest Woodman [Rosa] *141*

Mercury piping to Argus [Loth] *141–2*

Mercury stealing the Herds of Admetus guarded by Apollo [Domenichino and assistants] *142*

Midas see *Judgement of Midas*

Milan Cathedral see *Emperor Theodosius forbidden by St Ambrose to enter Milan Cathedral*

Milky Way see *Origin of the Milky Way*

Mill see *Marriage of Isaac and Rebekah*

Miracle of St Mark [after Tintoretto] *143–4*

Miracle of St Nicholas [Margarito (side scene)] *212–13*

Miraculous Draught of Fishes [Rubens] *51–2*

Miraculous Translation of the Holy House of Loreto [Giovanni Battista Tiepolo] *144*

Miriam see *Dance of Miriam*

Moses brings forth Water out of the Rock [follower of Filippino Lippi] *148–9*

Moses defending the Daughters of Jethro [Saraceni] *119–20*
 see also *Jacob reproaching Laban for giving him Leah in place of Rachel*

Moses striking Water from the Rock [Giaquinto] *149*

Moses see *Finding of Moses, Finding of the Infant Moses, Dance of Miriam, Brazen Serpent, Israelites gathering Manna, Adoration of the Golden Calf, Worship of the Egyptian Bull God, Apis*

Mourning over the Dead Christ [attr. Francia; Niccolò di Liberatore (side panel)] *49–51*

Musaeus see *Parting of Hero and Leander – from the Greek of Musaeus*

Muses see *Pegasus and the Muses*

Mystic Marriage of St Catherine of Alexandria [Parmigianino; Portuguese School] *189–91*

Mystic Nativity [Botticelli] *30–1*

Naming of St John the Baptist [Fabritius] *205–6*

Narcissus [follower of Leonardo; Pynas] *151–3*

Narcissus, Landscape with [Claude] *151–3*

Nativity [Jacopo di Cione; Costa; Crivelli (predella); Giusto de' Menabuoi (side panel); Margarito (side scene); follower of Masaccio; Mazzolino; attr. Pietro Orioli; Piero della Francesca; Pittoni; Romanino; Rubens; follower of Sodoma; Venetian School] *30–1*
 see also *Mystic Nativity*

Nativity with God the Father and the Holy Ghost [Pittoni] *30–1*

Nativity at Night [Geertgen tot Sint Jans; after Van der Goes] *30–1*

Nativity with Saints [attr. Pietro Orioli] *30–1*

Neptune see *Apollo and Neptune advising Laomedon on the Building of Troy*
Nessus and Dejanira [Louis de Boullongne] 153
Niccolò Mauruzi da Tolentino at the Battle of San Romano see *Battle of San Romano*
Noli me tangere [imitator of Mantegna; Master of the Lehman Crucifixion; Titian] 79–80
 see also Christ: Apparition – *Christ appearing to the Magdalen*
Nurture of Bacchus see *Bacchanal*

Octavia see *Virgil reading the Aeneid to Augustus and Octavia*
Oedipus and the Sphinx [Ingres] 157–8
Olympus see *Marsyas(?) and Olympus*
Ophelia among the Flowers [Redon] 158–9
Origin of the Milky Way [Tintoretto] 159–60
Orpheus [Savery] 160
Ovid among the Scythians [Delacroix] 160–1

Padua see Saints: Anthony of Padua
Pair of Lovers [Bordone] 89
Pan and Syrinx [Boucher] 161–3
Pan pursuing Syrinx [Van Balen the Elder and a follower of Jan Bruegel] 161–3
Pan
 see also *Bacchanalian Revel before a Term of Pan, Triumph of Pan*
Paris awards the Golden Apple to Venus (also known as *The Judgement of Paris*) [Rubens; Rubens] 163–4
Paris
 see also *Abduction of Helen by Paris*
Parting of Hero and Leander – from the Greek of Musaeus [Turner] 165–6
Passion see Christ: Passion
Patient Griselda [Master of the Story of Griselda] 166–8
Patmos see Saints: John the Evangelist – *St John on Patmos*
Pegasus and the Muses [attr. Romanino] 168
Penelope with the Suitors [Pintoricchio] 155–7
Pentecost [Barnaba da Modena; Giotto] 74–5
Perseus and Andromeda [after Reni] 168–70
Perseus turning Phineas and his Followers to Stone [Giordano] 170–2
 see also *Phineas and his Followers turned to Stone*
Pharaoh see *Pharaoh with his Butler and Baker*
Pharaoh with his Butler and Baker [Pontormo] 124–5
Phineas and his Followers turned to Stone [French School] 170–2
Pietà (recently retitled *Lamentation*) [Studio of the Master of the Prodigal Son] 49–51
Pietà with Two Angels [Francia] 49–51
 see also Christ: Death
Pilate see Christ: Pilate
Plague at Ashdod [after Nicolas Poussin] 13–14
Polyphemus see *Ulysses deriding Polyphemus*
Pope accords Recognition to the Franciscan Order [Sassetta] 193–6

Potiphar see *Joseph sold to Potiphar*
Preaching of St John the Baptist [Cornelis van Haarlem] 206–7
 see also Saints: John the Baptist
Prefect see Saints: Lawrence – *St Lawrence showing the Prefect the Treasures of the Church*
Presentation of Jesus in the Temple [Guercino] 35–6
Presentation in the Temple [Master of Liesborn; Master of the Life of the Virgin] 35–6
Presentation of the Virgin [Giusto de' Menabuoi (outer inset panel)] 237–8
Procession to Calvary [Ridolfo Ghirlandaio; Raphael] 73–4
Procession of the Trojan Horse into Troy [Giovanni Domenico Tiepolo] 232
Procris see *Death of Procris, Cephalus and Procris reunited by Diana*
Psyche outside the Palace of Cupid (also known as *The Enchanted Castle*) [Claude] 172–3
Psyche showing her Sisters her Gifts from Cupid [Fragonard] 173–4
Purification of the Temple [Jacopo Bassano; Michelangelo] 58–9

Queen of Sheba see *Embarkation of the Queen of Sheba, Solomon and the Queen of Sheba*
Quixote see *Don Quixote and Sancho Panza*
Quo vadis? see Christ: Apparition – *Christ appearing to St Peter on the Appian Way*

Rachel see *Jacob reproaching Laban for giving him Leah in place of Rachel*
Raising of Lazarus [Sebastiano del Piombo; attr. De Vos] 60–2
Rape of Europa [after Veronese] 176–7
Rape of Ganymede [attr. Mazza] 177–8
Rape of the Sabines (Before the Signal) [Domenico Morone] 181–2
Rape of the Sabines (After the Signal) [Domenico Morone] 181–2
Rape of the Sabine Women [Italian School; Rubens] 180–2
Rape of Tamar by Amnon [Santvoort] 178–9
Raphael see *Archangel Raphael*
Ravens see *Elijah fed by Ravens*
Rebecca at the Well [Pellegrini] 118–19
Rebekah and Eliezer at the Well [Van den Eeckhout] 118–19
Rebekah
 see also *Marriage of Isaac and Rebekah*
Reconciliation of Romans and Sabines [Italian School] 181–2
Rest on the Flight into Egypt [Lastman; studio of the Master of the Female Half-Lengths; Mola; Patel; workshop of Patenier; Van der Werff] 38–9
Resurrection of Christ [Jacopo di Cione; imitator of Mantegna; Niccolò di Liberatore (side panel); attr. Pietro Orioli (predella); Ugolino di Nerio] 75–7
 see also *Maries at the Sepulchre*

Return of the Ark [Bourdon] *14*
Rich Man being led to Hell [Teniers] *102–3*
Rimini see *Vision of the Blessed Clare of Rimini*
Rinaldo turning in Shame from the Magic Shield
 [Giovanni Battista Tiepolo] *179–80*
Rinaldo
 see also *Carlo and Ubaldo see Rinaldo
 conquered by Love for Armida*
Rock see *Moses brings forth Water out of the Rock*
Romans see *Rape of the Sabines (Before the Signal),
 Rape of the Sabines (After the Signal), Rape of
 the Sabine Women, Reconciliation of Romans
 and Sabines*
Rome see *Coriolanus persuaded by his Family to
 Spare Rome, Introduction of the Cult of Cybele
 at Rome*
Ruggiero see *Angelica saved by Ruggiero*

Sabine Women see *Rape of the Sabine Women*
Sabines see *Rape of the Sabines (Before the Signal),
 Rape of the Sabines (After the Signal),
 Reconciliation of Romans and Sabines*
Sacrifice of Isaac [Piazzetta] *3–4*
Sacro Speco see Saints: Benedict – *St Benedict in
 the Sacro Speco at Subiaco*
Saints
 Ambrose see *Emperor Theodosius forbidden by
 St Ambrose to enter Milan Cathedral*
 Anne, mother of the Virgin Mary see
 *Charlemagne, and the Meeting of Sts
 Joachim and Anne at the Golden Gate,*
 Saints: Joachim, Virgin Mary: Conception,
 Virgin Mary: Birth, Virgin Mary: Marriage,
 Virgin Mary: Presentation
 Anthony Abbot see Christ: Apparition – *Christ
 appearing to St Anthony Abbot during his
 Temptation, Temptation of St Anthony*
 Anthony of Padua *St Anthony of Padua(?)
 distributing Bread* [Willem van Herp the
 Elder] *183 St Anthony of Padua with the
 Infant Christ* [Bazzani] *183 St Anthony of
 Padua miraculously restores the Foot of a
 Self-Mutilated Man* [Giordano] *183*
 Augustine *St Augustine with the Holy Family
 and St Catherine of Alexandria* (also known
 as *The Vision of Saint Augustine*)
 [Garofalo] *184–5 Sts Augustine and
 Monica* [Scheffer] *186*
 see also *Fantastic Ruins with St Augustine and
 the Child, Appearance of St Jerome with St
 John the Baptist to St Augustine*
 Bavo *St Bavo about to receive the Monastic
 Habit at Ghent* [Rubens] *186–7*
 Benedict *St Benedict, Incidents in the Life of*
 [Lorenzo Monaco] *187–8 St Benedict
 tempted in the Sacro Speco at Subiaco*
 [Margarito (side scene)] *187–8 St
 Benedict in the Sacro Speco at Subiaco* [attr.
 Lorenzo Monaco] *187–8 St Benedict
 admitting Sts Maurus and Placidus into the
 Benedictine Order* [Lorenzo
 Monaco] *187–8*

see also *Death of St Benedict*
Bernard *St Bernard's Vision of the Virgin*
 [Filippo Lippi] *188–9*
Bertin see *Soul of St Bertin carried up to God*
Catherine of Alexandria see Saints: Augustine
 – *St Augustine with the Holy Family and St
 Catherine of Alexandria, Decapitation of St
 Catherine, Mystic Marriage of St Catherine
 of Alexandria*
Catherine of Siena see *Marriage of St Catherine
 of Siena*
Christopher *St Christopher carrying the Infant
 Christ* [German School; attr. Studio of the
 Master of the Female Half-
 Lengths] *191–2*
Dominic see *Vision of the Dominican Habit*
Dorothy *St Dorothy and the Infant Christ*
 [Francesco di Giorgio] *192*
Elizabeth see *Visitation*, Saints: John the
 Baptist
Eustace see *Vision of Saint Eustace*
Francis *St Francis giving away his Clothes and
 St Francis Dreaming* [Sassetta] *192–6 St
 Francis renounces his Earthly Father*
 [Sassetta] *192–6 St Francis bears Witness
 to the Christian Faith before the Sultan*
 [Sassetta] *193–6*
see also *Pope accords Recognition to the
 Franciscan Order, Legend of the Wolf of
 Gubbio, Stigmatisation of St Francis,
 Funeral of St Francis and the Verification of
 the Stigmata*
George *St George and the Dragon* [Moreau;
 Tintoretto; Uccello] *196–7 St George
 killing the Dragon* [Crivelli (predella);
 Domenichino] *196–7*
Giles *St Giles and the Hind* [Master of St
 Giles] *197–8*
see also *Mass of St Giles*
Helen see *Vision of St Helen*
Hubert see *Conversion of St Hubert,
 Exhumation of St Hubert, Mass of St Hubert*
James *St James being visited by the Virgin with
 a Statue of the Madonna of the Pillar*
 [Bayeu] *202*
see also *Beheading of St James*
Januarius see *Martyrdom of St Januarius*
Jerome *St Jerome* [Savoldo; Tura] *202–5 St
 Jerome before a Crucifix* [Crivelli
 (predella)] *202–5 St Jerome in the Desert*
 [Crespi] *202–5 St Jerome in a Landscape*
 [Bono da Ferrara; Cima da Conegliano;
 Cretan School; studio of David] *202–5 St
 Jerome in a Rocky Landscape*
 [Patenier] *202–5 St Jerome in Penitence*
 [Botticini (predella panel);
 Sodoma] *202–5 St Jerome in his Study*
 [Antonello da Messina; Catena] *202–5 St
 Jerome reading in a Landscape* [follower of
 Giovanni Bellini] *202–5 St Jerome taking
 a Thorn from the Lion's Paw* [Botticini
 (predella); Pesellino (predella)] *202–5 St
 Jerome's Vision when ill that he was*

Saints *cont.*
 beaten at *God's Command* [Botticini
 (predella)] *202–5*
 see also *Appearance of St Jerome with St John
 the Baptist to St Augustine, Death of St
 Jerome, Vision of St Jerome*
 Joachim *St Joachim's Offering rejected*
 [Dalmatian School (side panel); Giusto de'
 Menabuoi (outer inset panel)] *238–42*
 see also *Angel appearing to St Joachim, Meeting
 at the Golden Gate, Charlemagne, and the
 Meeting of Sts Joachim and Anne at the
 Golden Gate,* Virgin Mary: Conception,
 Virgin Mary: Birth, Virgin Mary: Marriage,
 Virgin Mary: Presentation
 John the Baptist *St John the Baptist in the
 Desert* [attr. Piazza] *206–7 St John the
 Baptist retiring to the Desert* [Giovanni di
 Paolo] *206–7 St John the Baptist
 preaching* [Raphael] *206–7 St John the
 Baptist seated in the Wilderness* [circle of
 Annibale Carracci; Murillo] *206–7 St
 John the Baptist decapitated* [attr. Niccolò
 di Pietro Gerini (predella)] *207–8*
 see also *Angel appearing to St Zaccharias, Birth
 of St John the Baptist, Naming of St John the
 Baptist, Preaching of St John the Baptist,
 Christ blessing St John the Baptist,
 Beheading of St John the Baptist, Feast of
 Herod, Daughter of Herodias, Salome,
 Salome receives the Head of St John the
 Baptist, Salome bringing the Baptist's Head
 to Herodias, Appearance of St Jerome with
 St John the Baptist to St Augustine*
 John the Evangelist *St John the Evangelist
 baptising* [Giovanni del Ponte
 (predella)] *208–10 St John on Patmos*
 [Master of the Female Half-Lengths; South
 German School] *208–10 St John the
 Evangelist on the Island of Patmos*
 [Velázquez] *208–10 St John
 resuscitating Drusiana* [Margarito (side
 panel)] *208–10 St John saved from a
 Cauldron of Boiling Oil* [Giovanni del
 Ponte (predella); Margarito (side
 scene)] *208–10*
 see also *Vision on Patmos, Ascension of St John
 the Evangelist*
 John Martyr see Christ: Baptising – *Christ
 baptising St John Martyr, Duke of
 Alexandria*
 Joseph see *Vision of St Joseph, Nativity,
 Adoration of the Kings, Adoration of the
 Magi, Adoration of the Shepherds,
 Presentation in the Temple, Presentation of
 Jesus in the Temple, Flight into Egypt*
 Justus see *Sts Justus and Clement of Volterra,
 Legend of* [Domenico Ghirlandaio] *210*
 Lawrence *St Lawrence prepared for Martyrdom*
 [Elsheimer] *210–11 St Lawrence showing
 the Prefect the Treasures of the Church*
 [circle of the Master of the St Ursula
 Legend] *210–11*

Mammas *St Mammas with the Lions* [Pesellino
 (predella)] *211*
 Margaret *St Margaret swallowed by a Dragon*
 [Margarito (side scene)] *212*
 Mark see *Miracle of St Mark*
 Mary Magdalene *St Mary Magdalene
 approaching the Sepulchre*
 [Savoldo] *79–80*
 see also Christ: Conversion, Christ: Magdalen
 – *Conversion of the Magdalen,* Christ:
 Resurrection, *Noli me tangere*
 Mary, Mother of Christ see Virgin Mary
 Maurus see *St Benedict admitting Sts Maurus
 and Placidus into the Benedictine Order*
 Monica see Saints: Augustine
 Nicholas *St Nicholas by Miracle saves Three
 Innocent Men from Decapitation*
 [Margarito (side scene)] *212–13*
 see also *Consecration of St Nicholas, Miracle of
 St Nicholas*
 Paul *St Paul preaching at Ephesus* [Le
 Sueur] *214–16 St Paul on Malta*
 [Elsheimer] *214–16*
 see also *Conversion of St Paul*
 Peter see Christ: Apparition – *Christ appearing
 to St Peter on the Appian Way,* Christ:
 Teaching – *Christ teaching from St Peter's
 Boat on the Lake of Gennesaret*
 Peter Martyr see *Assassination of St Peter
 Martyr, Death of St Peter Martyr*
 Placidus see *St Benedict admitting Sts Maurus
 and Placidus into the Benedictine Order*
 Sabinus *St Sabinus before the Governor of
 Tuscany* (?) [attr. Pietro Lorenzetti] *217*
 Sebastian *St Sebastian* [Gerrit von Honthorst;
 Bernardino Zaganelli] *217–19*
 see also *Martyrdom of St Sebastian*
 Stephen see *Martyrdom of St Stephen*
 Thomas see *Incredulity of St Thomas*
 Ursula *St Ursula taking Leave of her Father* (?)
 [Carpaccio] *219*
 see also *Embarkation of St Ursula, Seaport with
 Veronica* see *Way to Calvary*
 Vincent Ferrer *Scenes from the life of St Vincent
 Ferrer* [after Cossa] *220*
 Zeno *St Zeno exorcising the Daughter of the
 Emperor Gallienus* [Pesellino
 (predella)] *220*
 Zenobius *St Zenobius revives a dead boy*
 [Bilivert] *220–1*
 see also *Four Scenes from the Early Life of St
 Zenobius, Three Miracles of St Zenobius,
 Miracle of St Zenobius*
Salome [studio of Cesare da Sesto;
 Giampietrino] *207–8*
Salome bringing the Baptist's head to Herodias
 [attr. Niccolò di Pietro Gerini
 (predella)] *207–8*
Salome receives the Head of St John the Baptist
 [Caravaggio] *207–8*
Samson and Delilah [Mantegna; Rubens] *221–3*
San Romano see *Battle of San Romano*
Sancho Panza see *Don Quixote and Sancho Panza*

Saul see *Triumph of David over Saul*
Savonarola [Florentine School (?)] *223*
 see also *Execution of Savonarola and Two
 Companions*
Scenes from the Life of St Vincent Ferrer see Saints:
 Vincent Ferrer
Scenes from the Passion [Master of Delft] *44–6*
Schoolmaster of Falerii, Story of [Master of
 Marradi] *223–4*
Scipio see *Continence of Scipio, Introduction of the
 Cult of Cybele at Rome (The Triumph of Scipio)*
Scythians see *Ovid among the Scythians*
Semele see *Jupiter and Semele*
Sepulchre see Saints: Mary Magdalene – *Mary
 Magdalene approaching the Sepulchre, Maries
 at the Sepulchre*
Serpent see *Adam and Eve, Brazen Serpent*
Sheba see *Queen of Sheba*
Shepherds see *Adoration of the Shepherds, Erminia*
Sibyl see *Augustus and the Sibyl*
Siena see *Marriage of St Catherine of Siena*
Sieve see *Tuccia*
Silenus gathering Grapes [Annibale
 Carracci] *15–17*
Silenus
 see also *Drunken Silenus supported by Satyrs,
 Bacchanalian Festival (Triumph of Silenus)*
Silver Age see *Close of the Silver Age*
Sodom see *Lot and his Daughters leaving Sodom*
Solomon and the Queen of Sheba [Venetian
 School] *174–6*
Solon see *Croesus and Solon*
Sons of Boreas pursuing the Harpies
 [Pozzoserrato] *224–5*
Sophonisba see *Woman drinking Poison*
Soul of St Bertin carried up to God
 [Marmion] *225–6*
*Stigmatisation of St Francis and the Verification of
 the Stigmata* [Sassetta] *193–6*
Sphinx see *Oedipus and the Sphinx*
Subiaco see Saints: Benedict – *St Benedict in the
 Sacro Speco at Subiaco*
Suicide see *Dido's Suicide*
Supper at Emmaus [Caravaggio] *81–2*
Supper
 see also *Last Supper*
Susannah and the Elders [Ludovico Carracci;
 Reni] *226–7*
Swan see *Leda and the Swan*
Symbolic Representation of the Crucifixion
 [Mansueti] *44–6*
Syrinx see *Pan and Syrinx, Pan Pursuing Syrinx*

Tamar see *Judah and Tamar, Rape of Tamar by
 Amnon*
Tanaquil [Beccafumi] *227*
Tebaldeo see *Eclogue of Tebaldeo, Scenes from*
Temple see *Presentation in the Temple,
 Presentation of Jesus in the Temple, Christ
 driving the Traders from the Temple,
 Purification of the Temple*
Temptation of St Anthony [Savery] *182–3*

Theodosius see *Emperor Theodosius is forbidden by
 St Ambrose to enter Milan Cathedral*
Thorns see Christ: Crowned
Three Maries see *Dead Christ mourned*
Three Miracles of St Zenobius [Botticelli] *220–1*
*Thyrsis asks Damon the Cause of his Sorrow (Scenes
 from an Eclogue of Tebaldeo)* [attr.
 Previtali] *88–9*
*Thyrsis finds the Body of Damon (Scenes from an
 Eclogue of Tebaldeo)* [attr. Previtali] *88–9*
Tobias and the Angel [Lievens; Rosa; style of Rosa;
 follower of Verrocchio] *227–8*
*Tobias and the Archangel Raphael returning with
 the Fish* [after Elsheimer] *227–8*
Tobias, Landscape with [Domenichino] *227–8*
Tobit and Anna [de Pape] *228*
 see also *Anna and the Blind Tobit*
Toilet of Bathsheba [style of Giordano] *228–9*
Tomb see Christ: Tomb, Christ: Resurrection,
 *Entombment of Christ, Entombment of the
 Virgin*
Tower of Babel [Leandro Bassano] *229*
Trajan and the Widow I 1135 [Veronese School; II
 1136 Veronese School] *229–30*
Transfiguration [Duccio; Russian School] *54–5*
Transformation of Cyparissus [Domenichino and
 assistants] *230–1*
Translation see *Miraculous Translation of the Holy
 House of Loreto*
Tribute Money [Titian] *55*
Triumph of David over Saul [Pesellino] *90–1*
Triumph of Pan [Nicolas Poussin] *15–17*
Triumph of Scipio see *Introduction of Cult of
 Cybele*
Trojan Horse see *Building of the Trojan Horse,
 Procession of the Trojan Horse into Troy*
Troy see *Apollo and Neptune advising Laomedon
 on the Building of Troy, Procession of the Trojan
 Horse into Troy*
Tuccia see *Vestal Virgin Tuccia with a Sieve*
Two Followers of Cadmus devoured by a Dragon
 [Cornelis van Haarlem] *21–2*

Ubaldo see *Carlo and Ubaldo* see *Rinaldo
 conquered by Love for Armida*
Ulysses deriding Polyphemus [Turner] *153–5*
Union of Dido and Aeneas [Dughet] *100*
Ursula see Saints: Ursula

Venus and Adonis [studio of Titian] *233–4*
Venus and Mars [Botticelli] *234–5*
 see also *Mars and Venus, Birth of Venus, Cupid
 complaining to Venus, Judgement of Paris,
 Paris awards the Golden Apple to Venus
 (The Judgement of Paris)*
Vestal Virgin Tuccia with a Sieve [Mantegna;
 Moroni] *235*
Virgil reading the Aeneid to Augustus and Octavia
 [Taillasson] *235–6*
Virgin Mary
 Annunciation see *Annunciation to the Virgin*

Virgin Mary *cont.*
 Assumption see *Assumption of the Virgin*
 Birth see *Birth of the Virgin*
 Conception see *Immaculate Conception*, Saints:
 Joachim
 Coronation see *Coronation of the Virgin*
 Death see *Death of the Virgin, Dormition of the*
 Virgin
 Entombment see *Entombment of the Virgin*
 Marriage see *Marriage of the Virgin*
 Mother of Christ see Christ: Childhood,
 Christ: Passion – *Christ taking leave of his*
 Mother, Christ: Resurrection – *Christ*
 appearing to the Virgin
 Presentation see *Presentation of the Virgin*
 Visitation see *Visitation*
 see also *Augustus and the Sibyl, Vision of the*
 Blessed Gabriele, Saints: Bernard, James,
 Joseph, Luke
Virgin and Child with Saints Catherine of
 Alexandria and Siena [Bergognone] *189–91*
Vision of the Blessed Clare of Rimini [Master of the
 Blessed Clare] *246*
Vision of the Blessed Gabriele [Crivelli] *246–7*
Vision of the Dominican Habit [follower of Fra
 Angelico] *247*
Vision of Father Simon [Ribalta] *247–8*
Vision on Patmos [Giovanni del Ponte
 (predella)] *208–10*

Vision of St Augustine see Saints: Augustine
Vision of St Bernard see Saints: Bernard
Vision of St Eustace [Pisanello] *248*
Vision of St Helena [Veronese] *248–9*
Vision of St Jerome [Domenichino] *202–5*
Vision of St Joseph [Champaigne] *249–50*
Visitation [Italian School (?); studio of the Master
 of 1518] *245–6*
Volterra see *Clement of Volterra*

Walk to Emmaus [Melone; Orsi] *81–2*
Water see *Moses brings forth Water out of the Rock*
 (*Moses Striking Water from the Rock*)
Way to Calvary [attr. Boccaccino; Jacopo Bassano
 (side panel); Niccolò di Liberatore; Ugolino di
 Nerio] *73–4*
Well see *Rebecca at the Well, Rebekah and Eliezer*
 at the Well
Widow see *Trajan and the Widow*
Wilderness see Saints: Jerome, John the Baptist
Woodman see *Mercury and the Dishonest*
 Woodman
Wolf of Gubbio see *Legend of the Wolf of Gubbio*
Woman taken in Adultery [Rembrandt] *42–4*
Woman drinking Poison [Mantegna] *250*
Worship of the Egyptian Bull God, Apis [follower of
 Filippino Lippi] *149–51*